HELP

PLEASE do not return
this item in the drop box.

The weight or size will
result in damage to this
item or other materials
already in the drop box.

RETURN THIS ITEM
to the
**FRONT
CIRCULATION
DESK**
during regular library
hours.

THANK YOU

LIFE

The eye and its lens

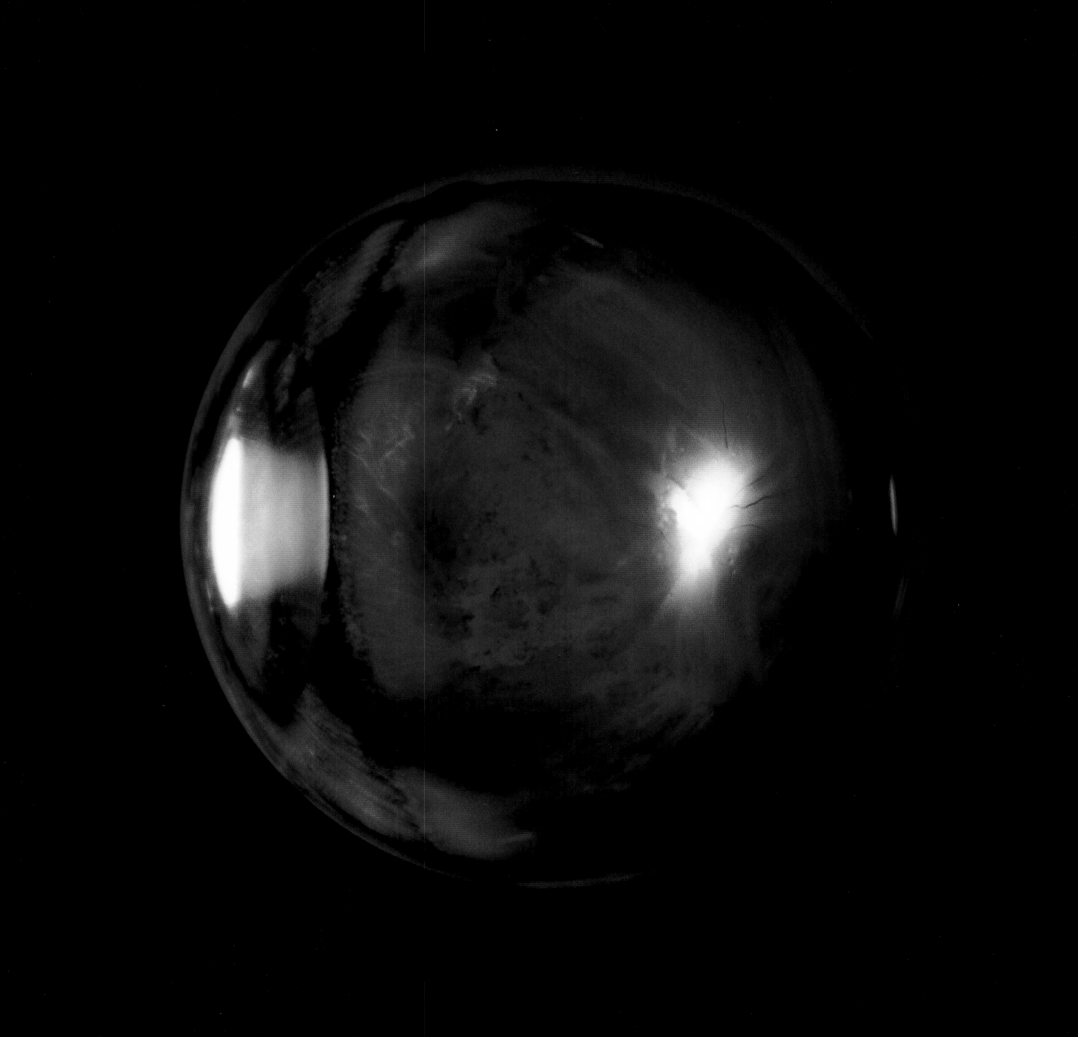

The eye

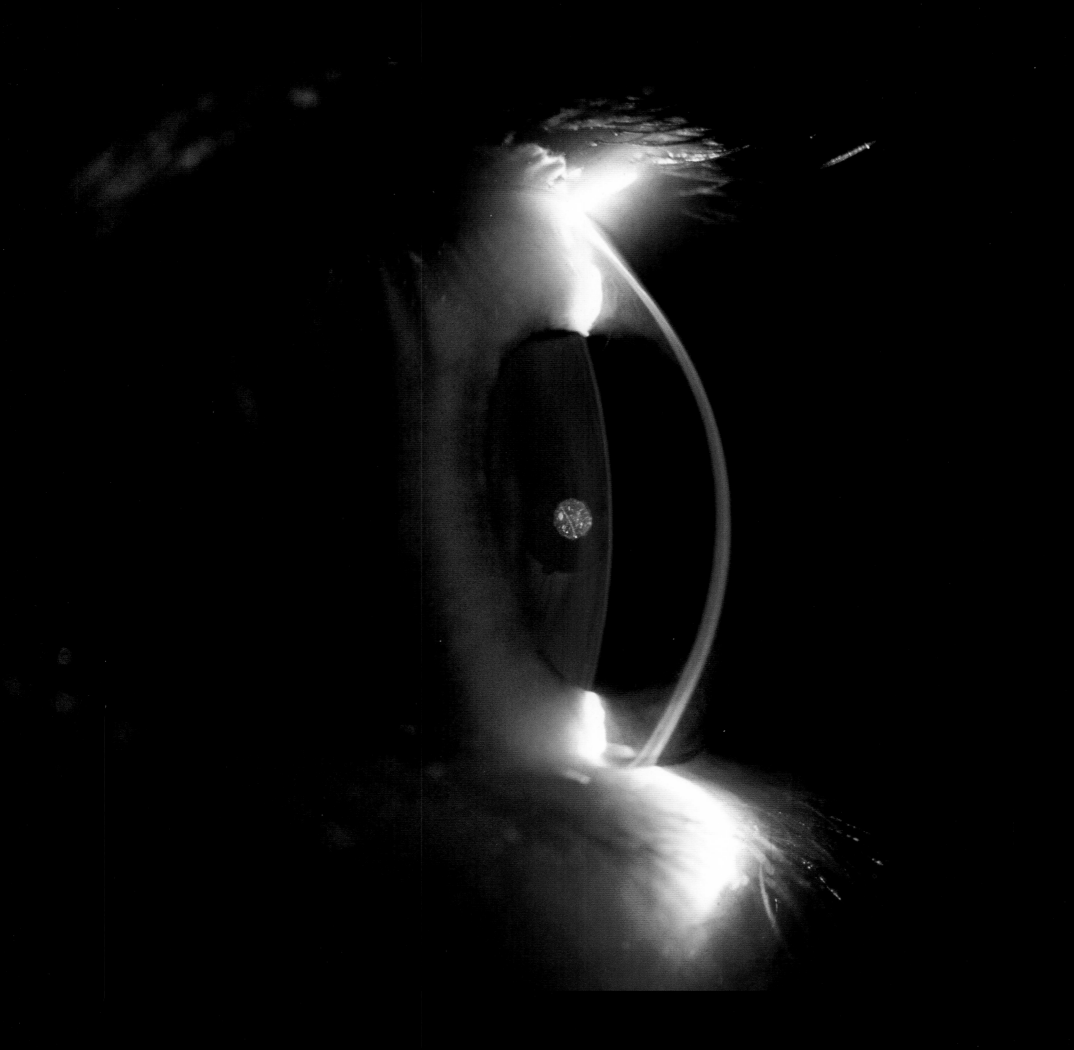

Light reaching the retina of the eye

Blood vessels in the brain (following pages)

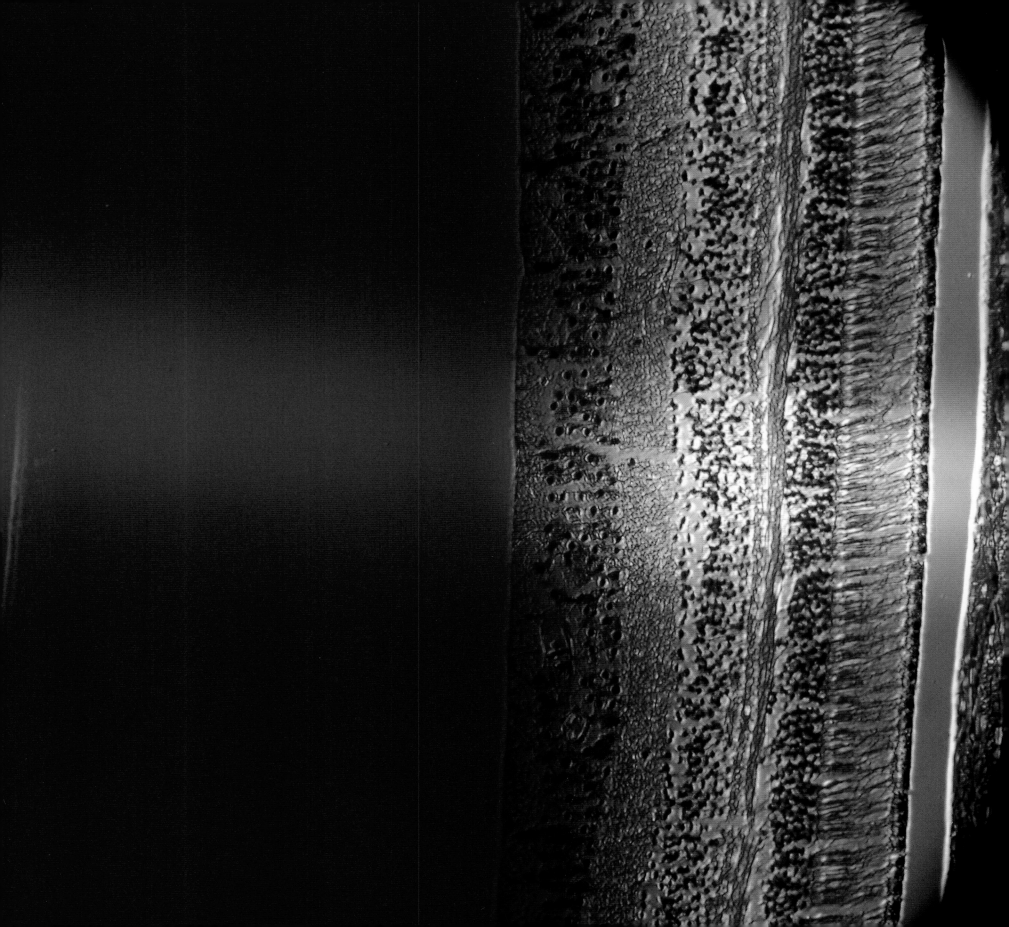

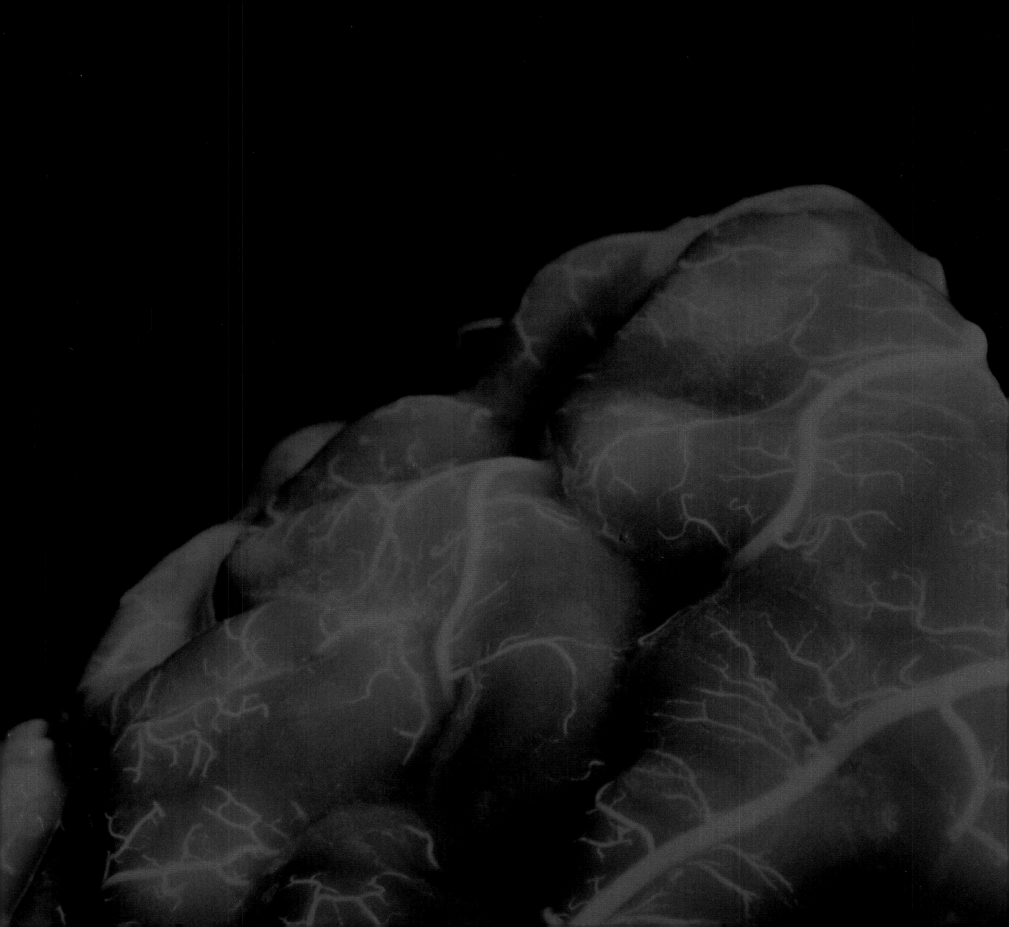

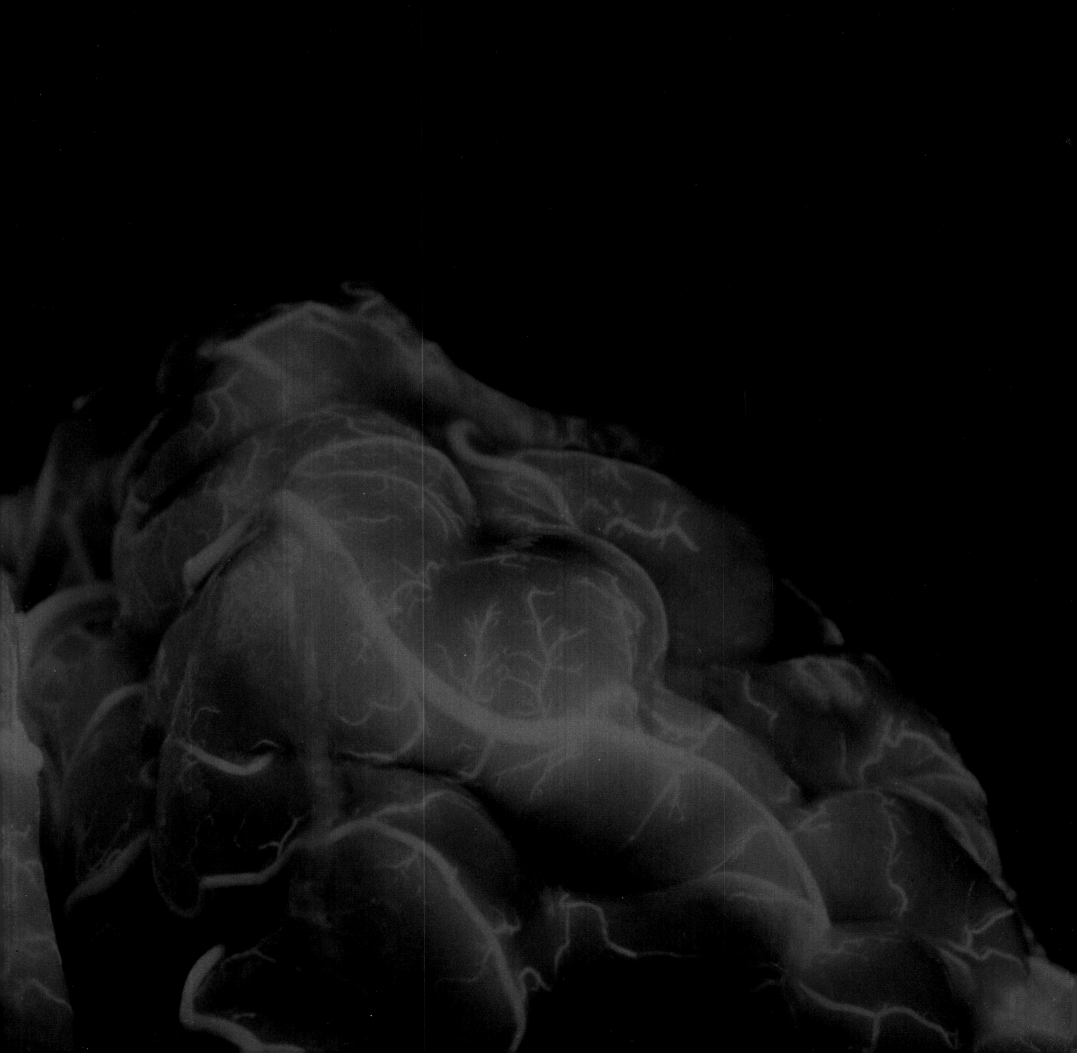

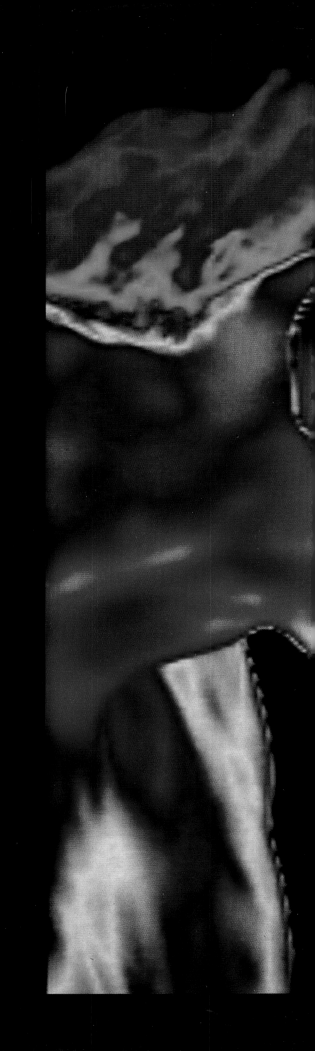

Thermal photograph of a kiss. Red tones indicate
the hottest zones and blue tones indicate the coldest

Thermal photograph of a human couple (following page)

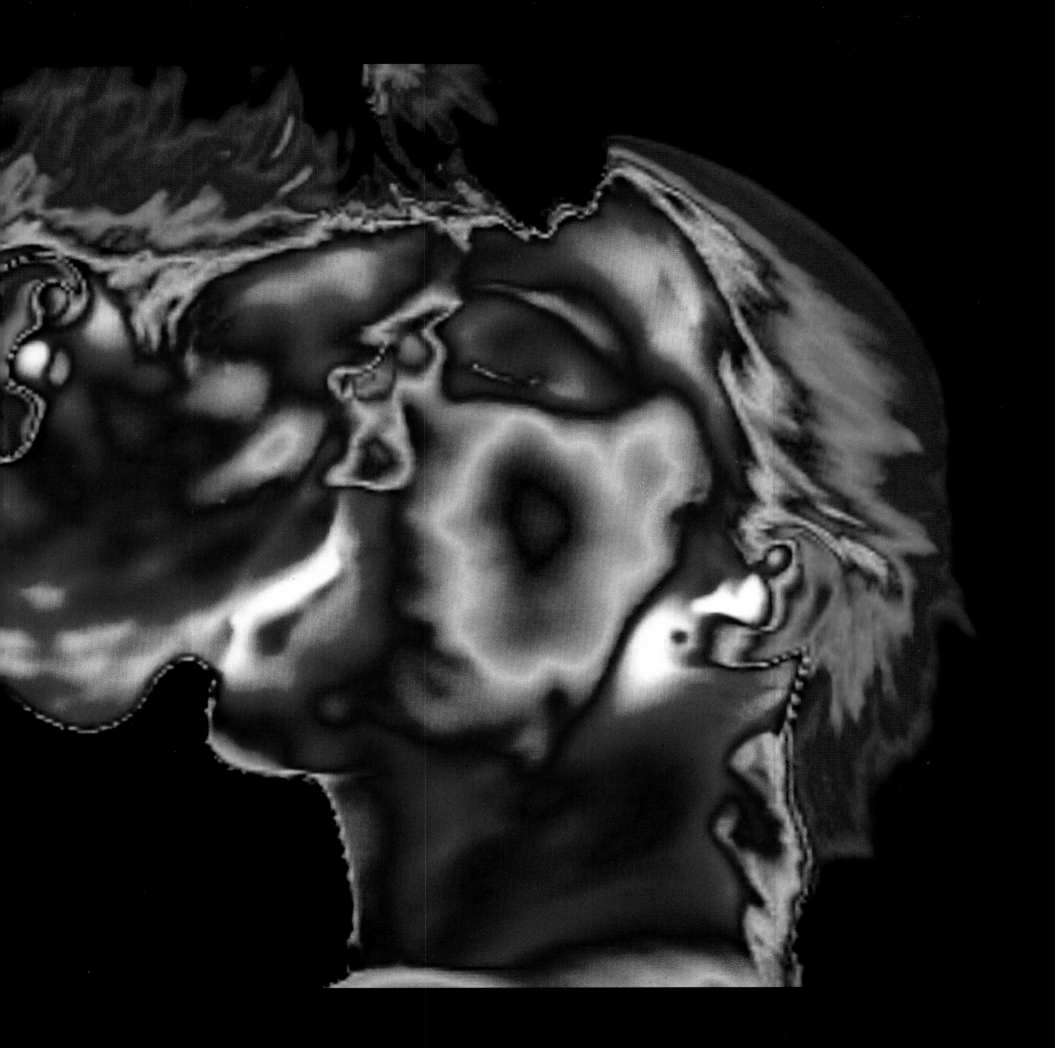

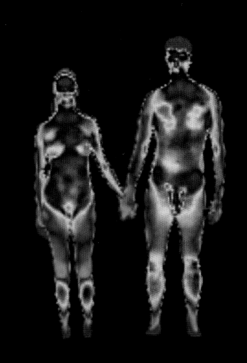

LIFE

LENNART NILSSON

ABRAMS, NEW YORK

CONTENTS

DNA AND CHROMOSOMES

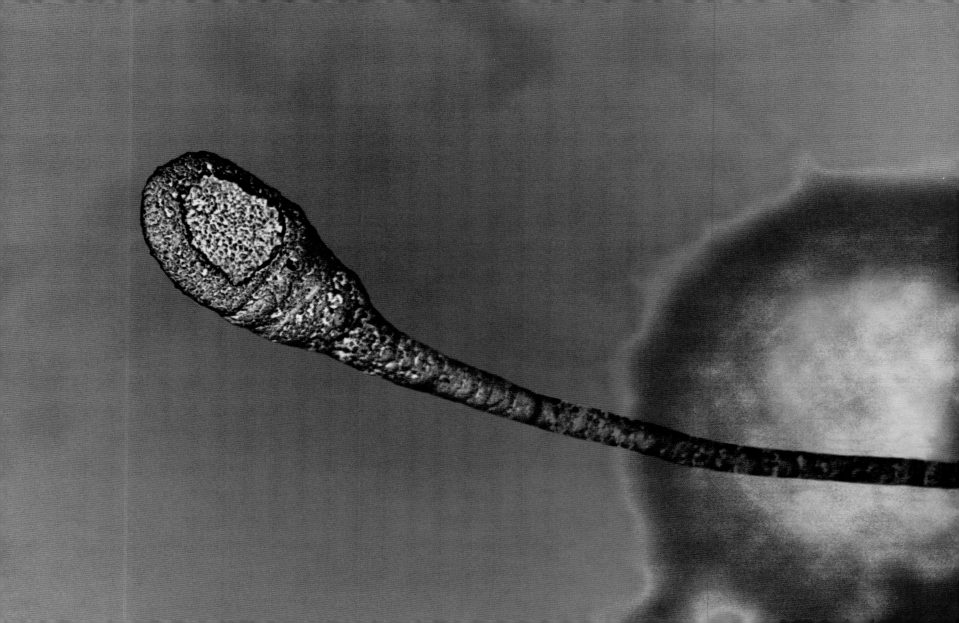

Chromosomes. The entire genetic code of a human being is contained in the 46 chromosomes that exist in every cell in the body

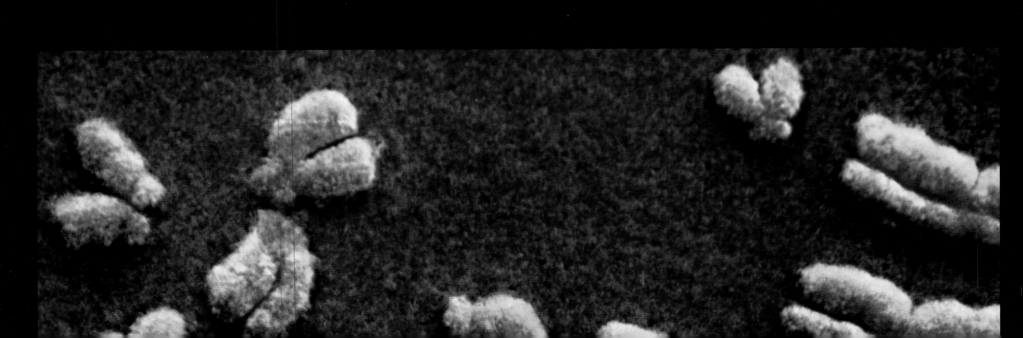

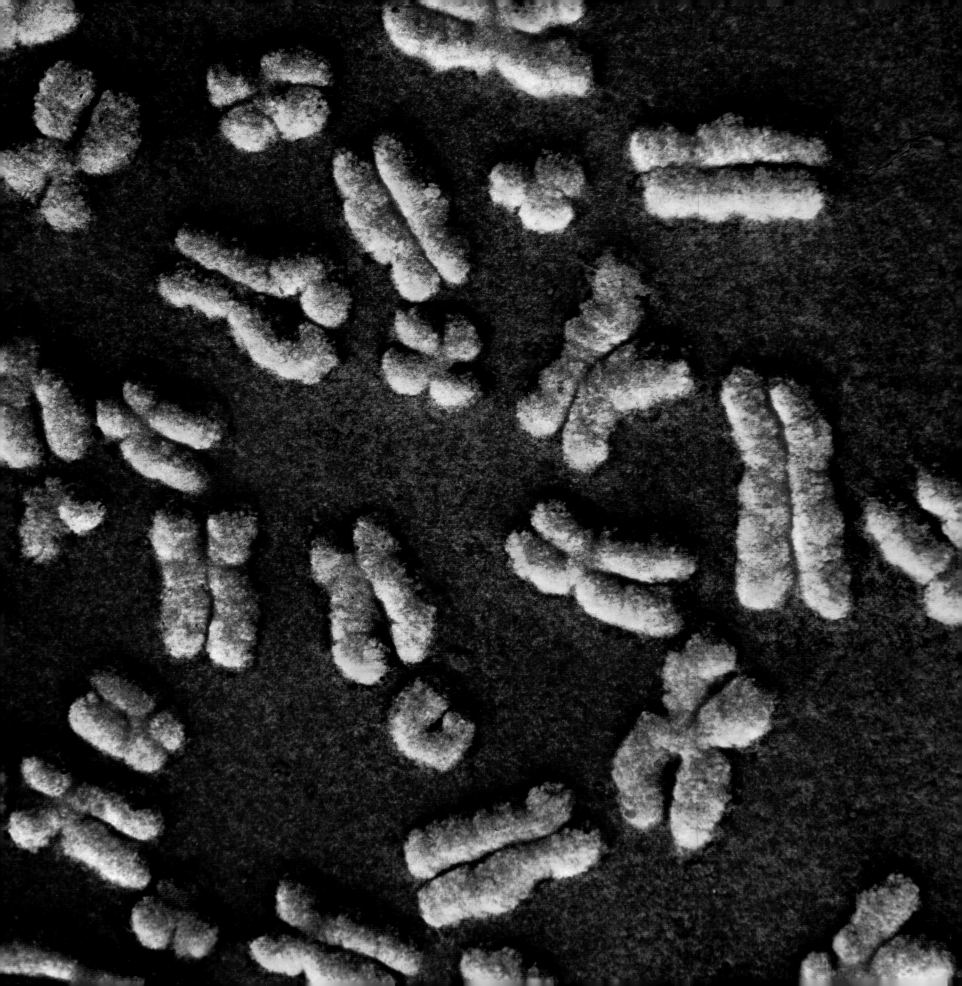

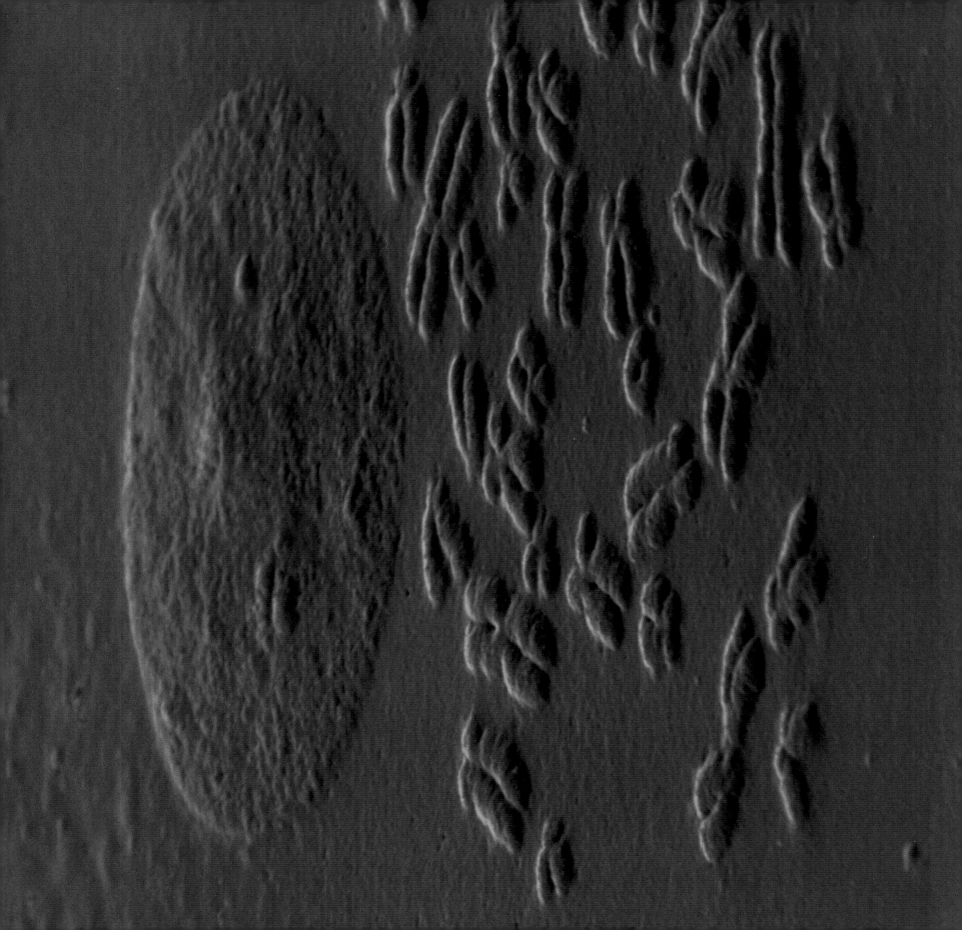

Sperm with X chromosomes and sperm with Y chromosomes.
The Y chromosome is only found in the male

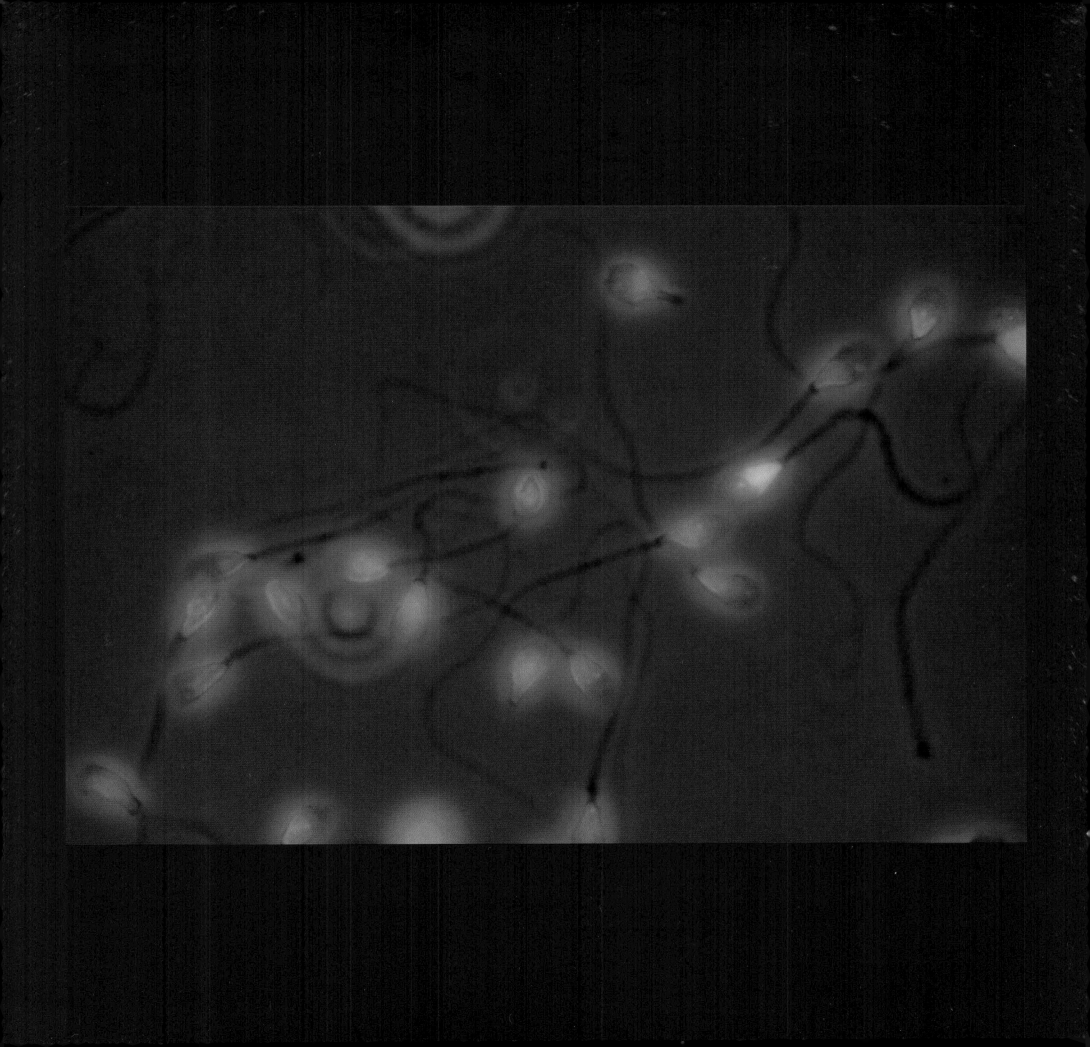

HORMONES

The female hormone, estrogen

The female hormone, progesterone (page 30)

Sex hormones in crystalline form.
The male hormone, testosterone, is stiletto-shaped,
the female, estrogen, is rhomboid (page 31)

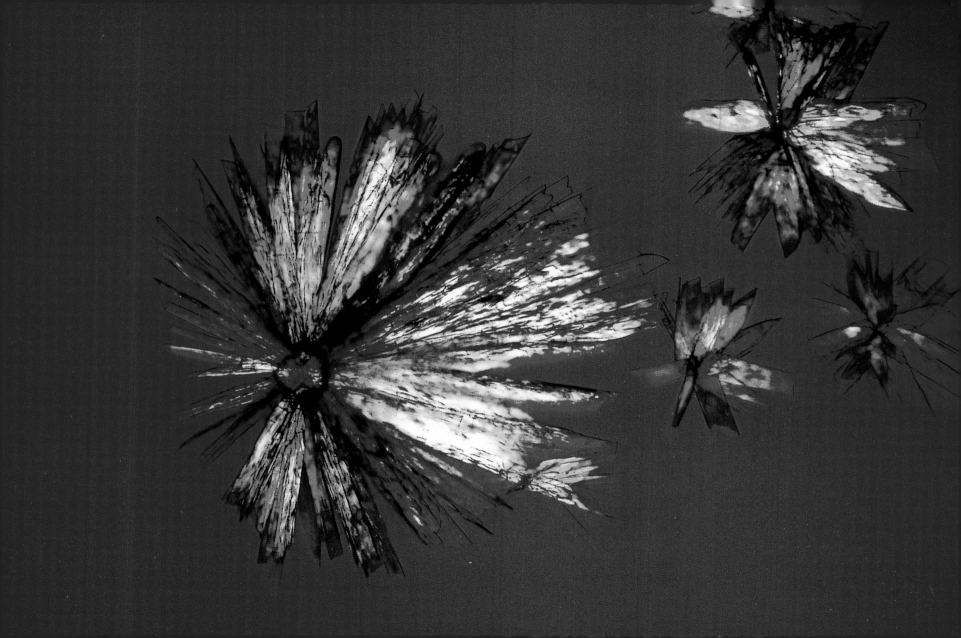

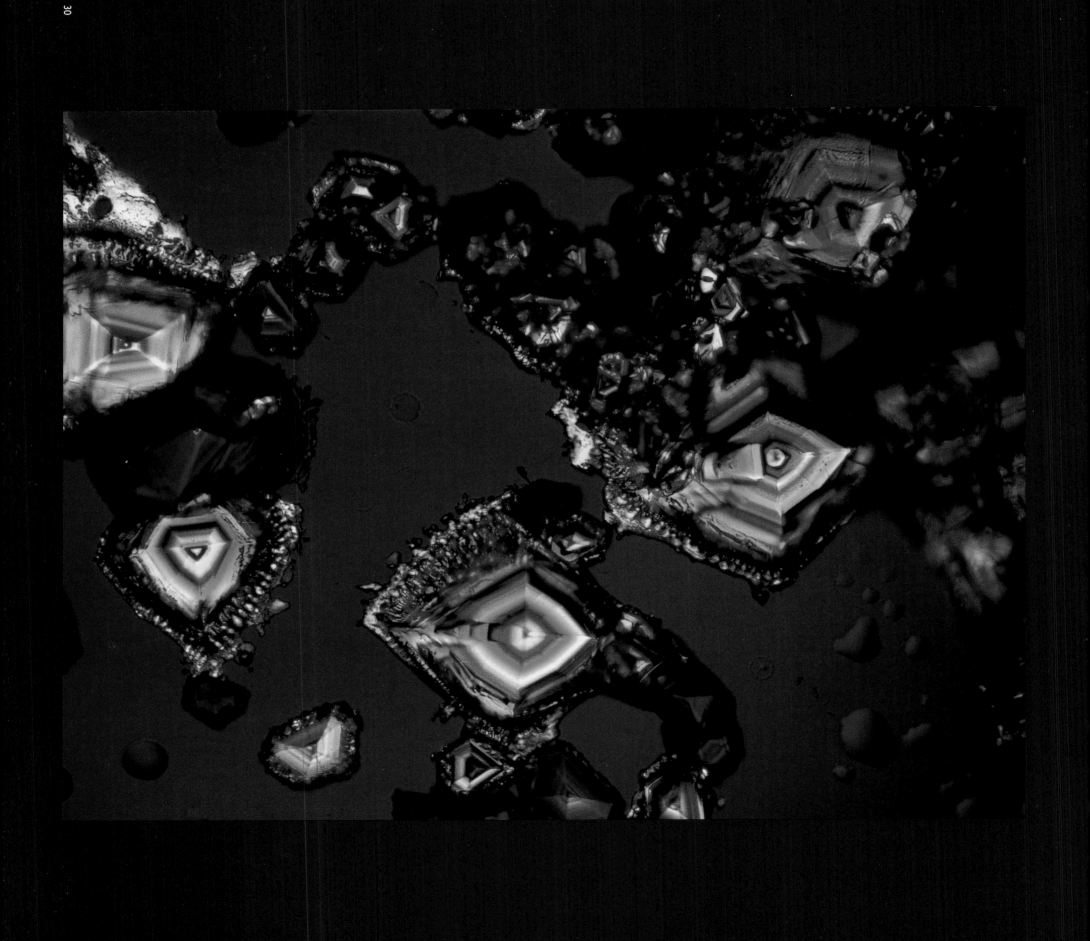

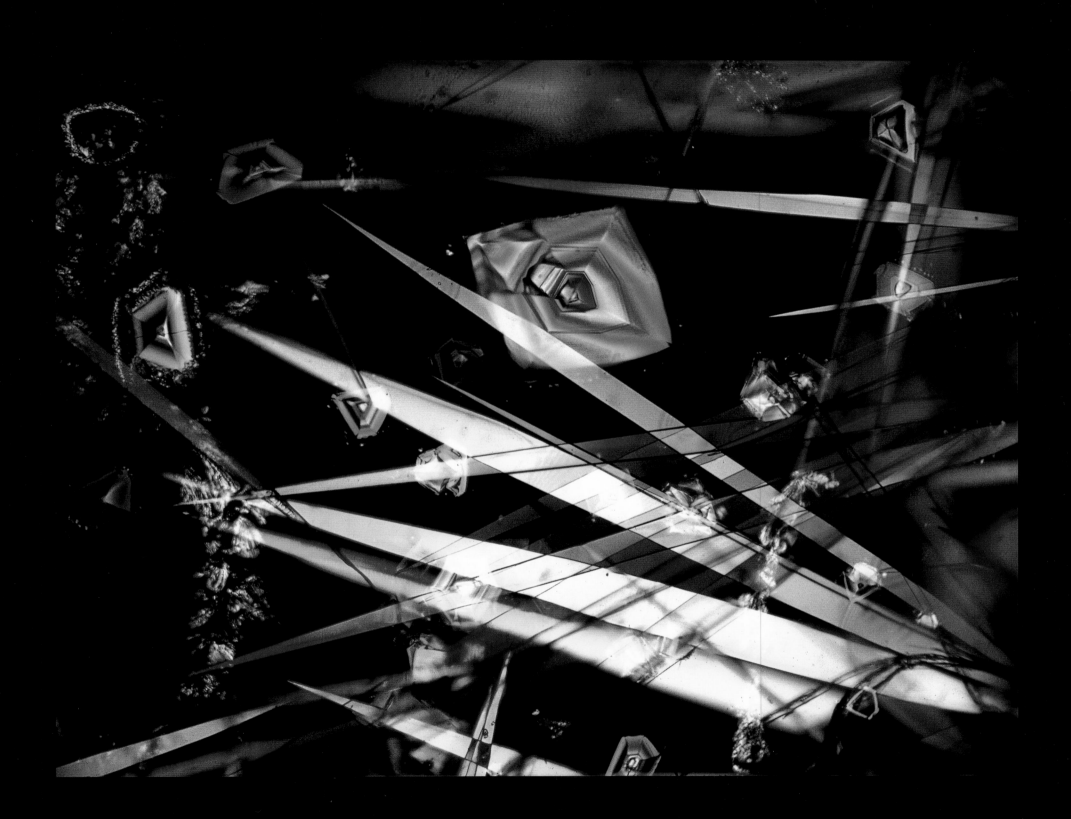

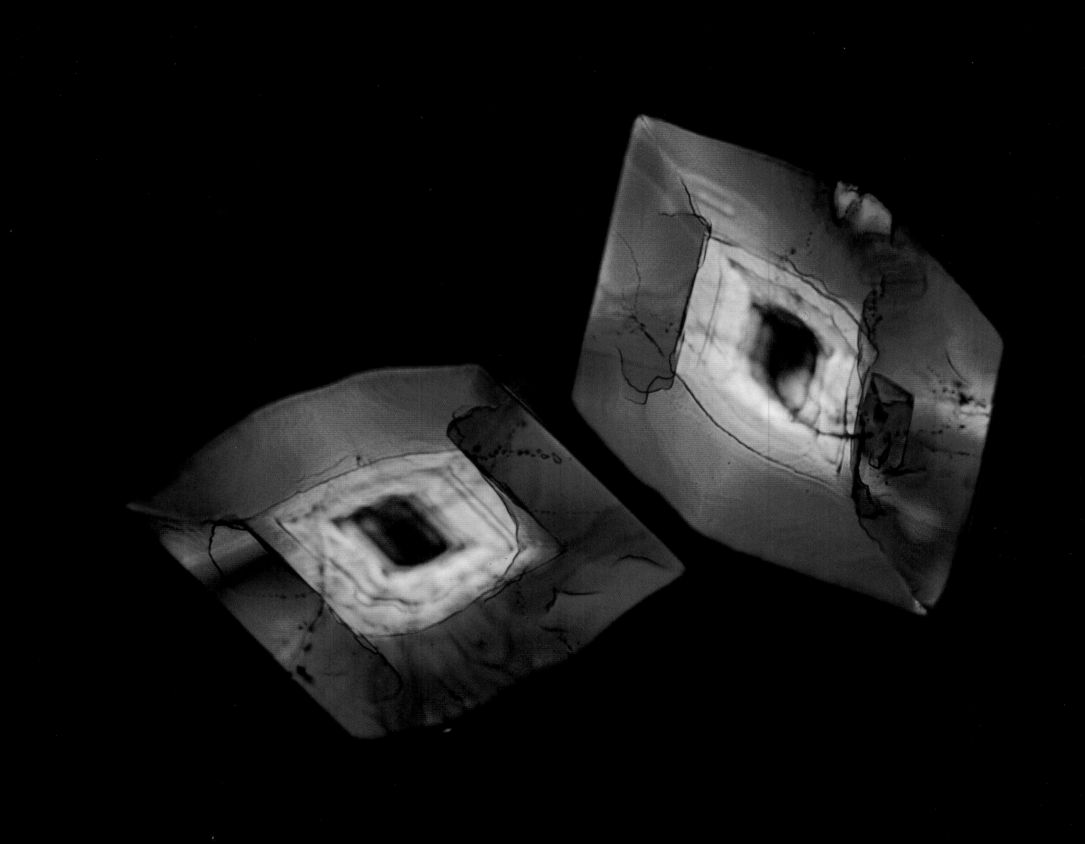

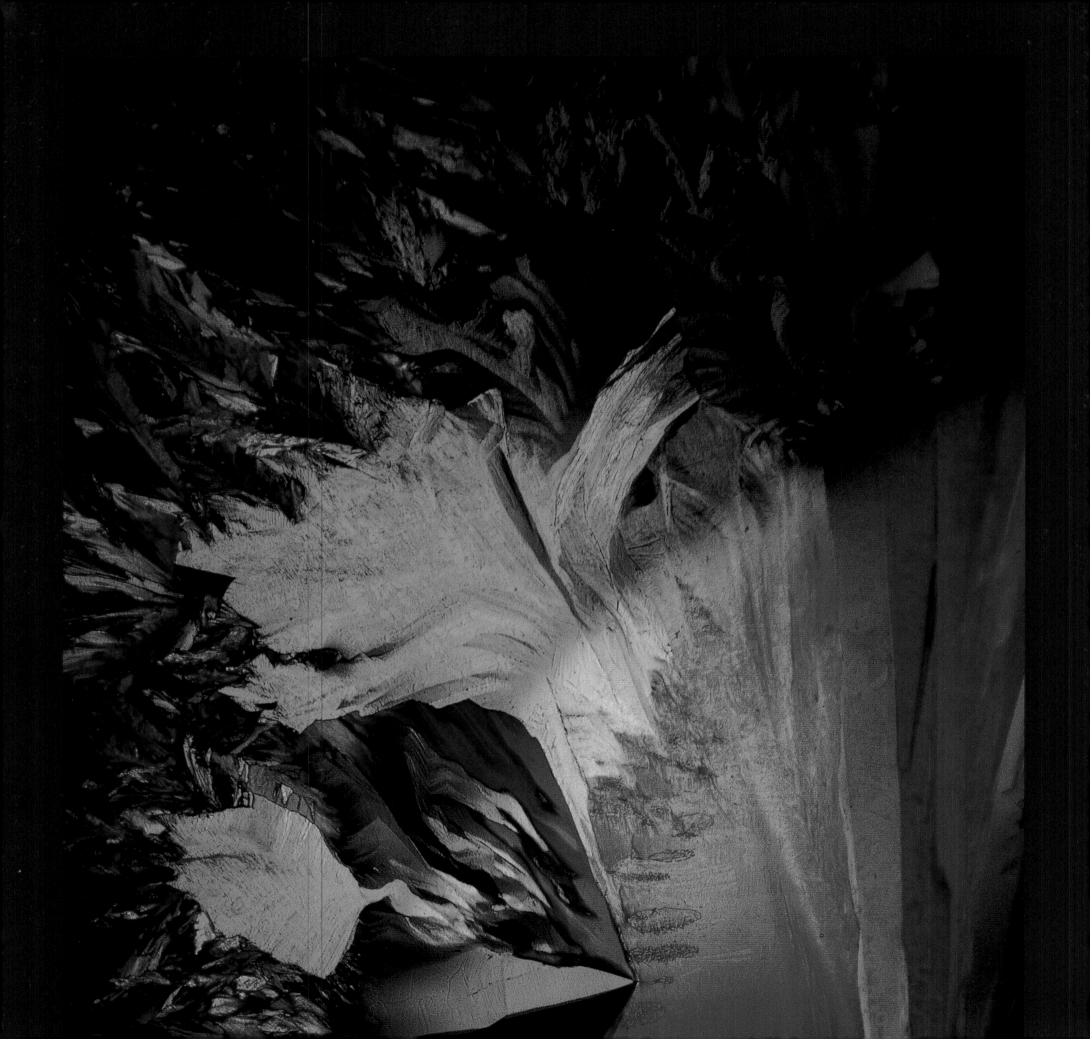

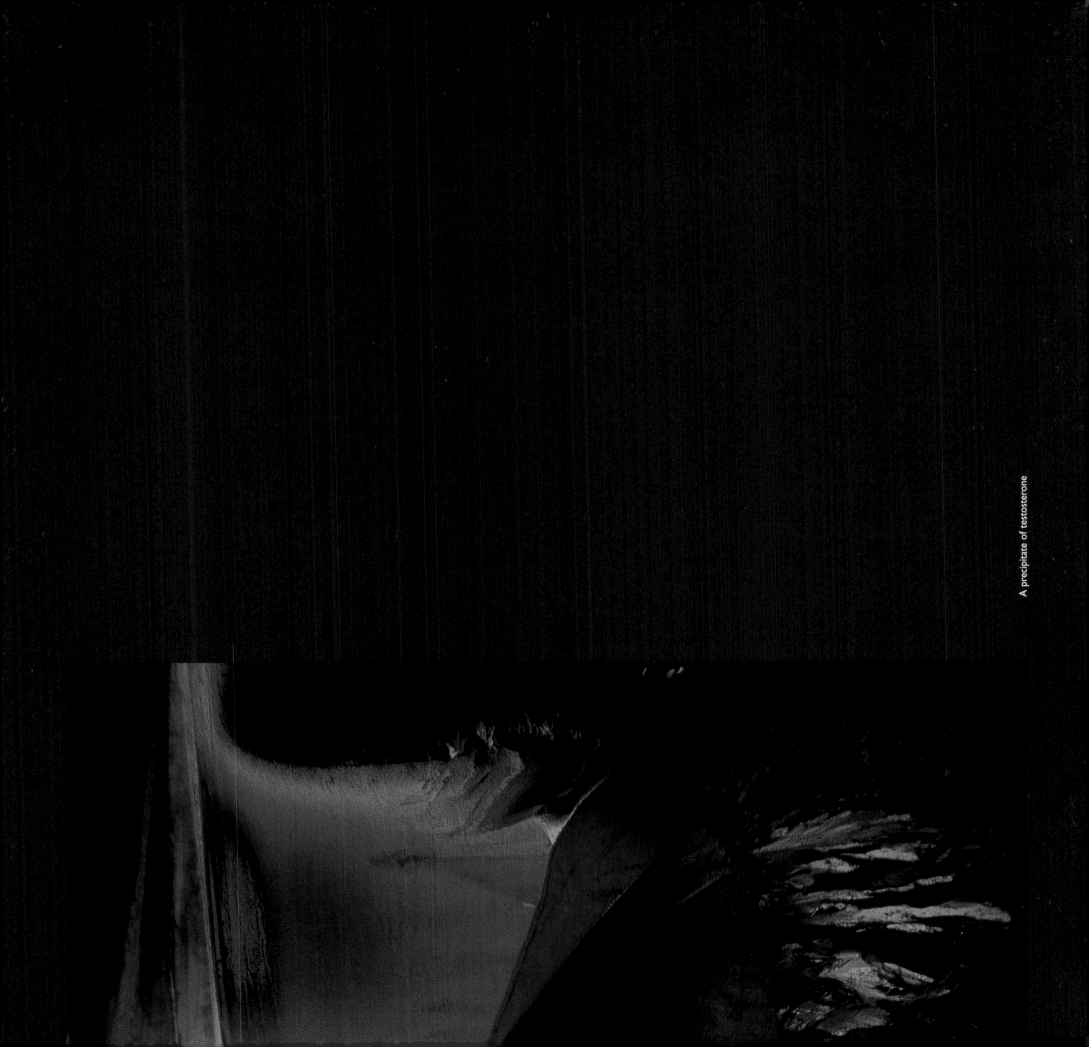

A precipitate of testosterone

CONCEPTION

The testes, the male sex glands producing hormones and sperm

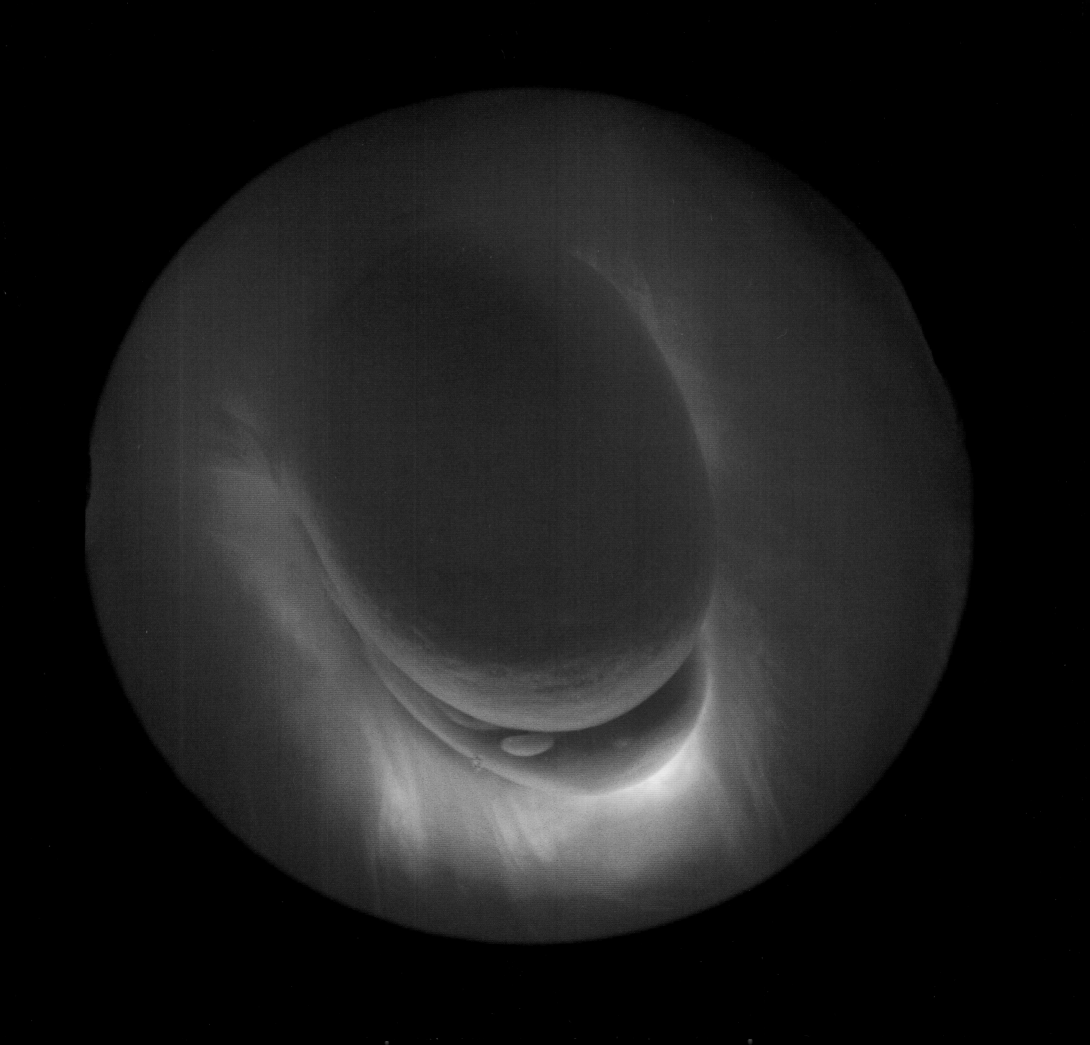

The testes, the male sex glands producing hormones and sperm

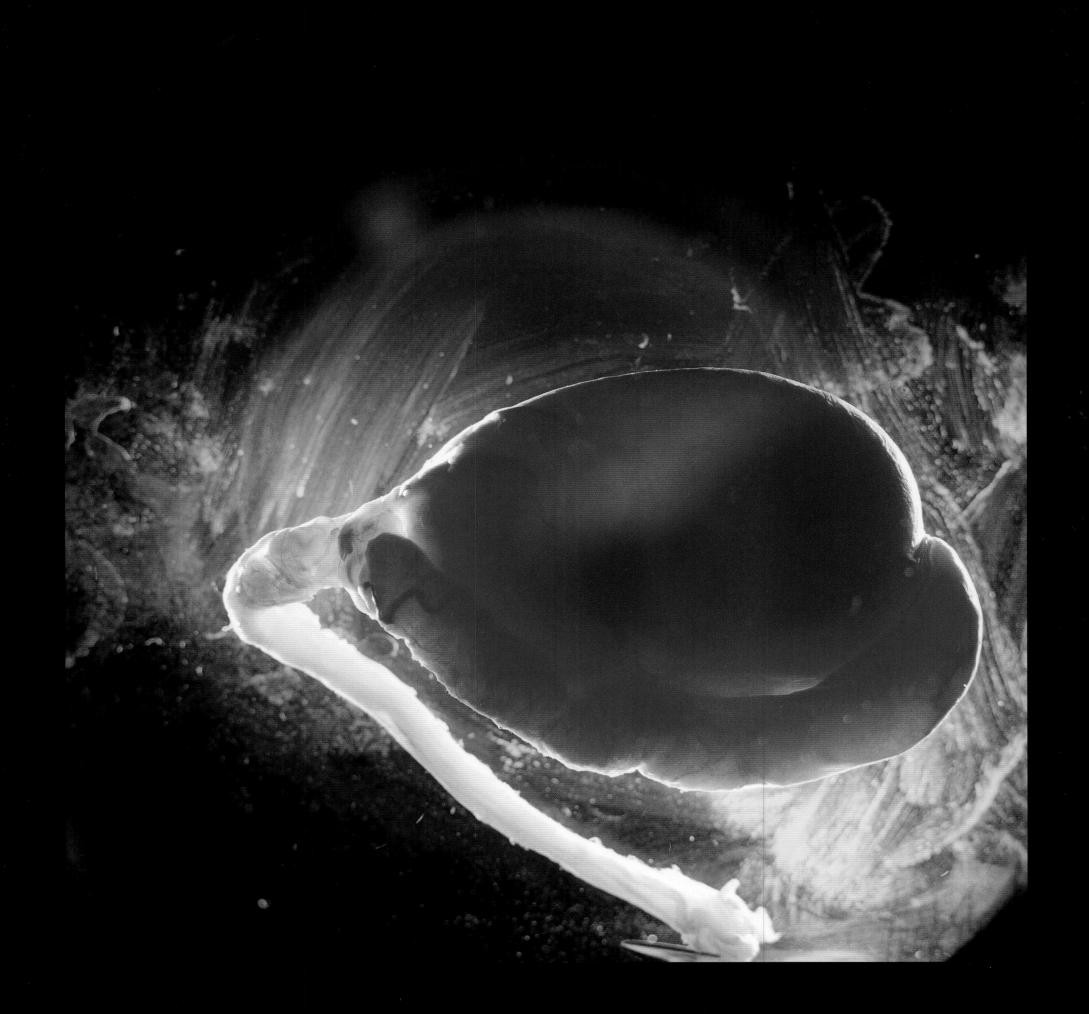

Cross section of a seminiferous tubule showing
the Leydig cells, which produce testosterone

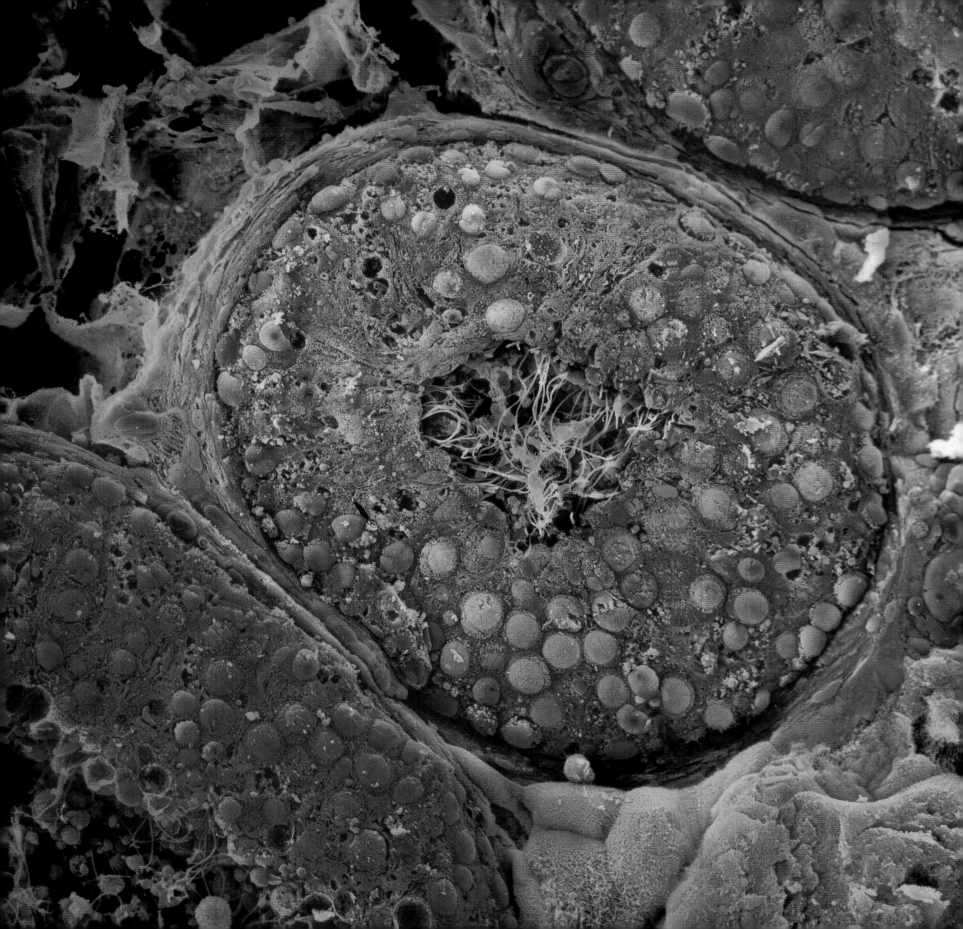

—

Cross section of mature sperm
containing tightly packed genetic information

In a system of passages near the center of the seminal canal
sperm wait to reach maturity. Most have tails (page 44)

As the sperm approach maturity,
the rounded cells become more streamlined (page 45)

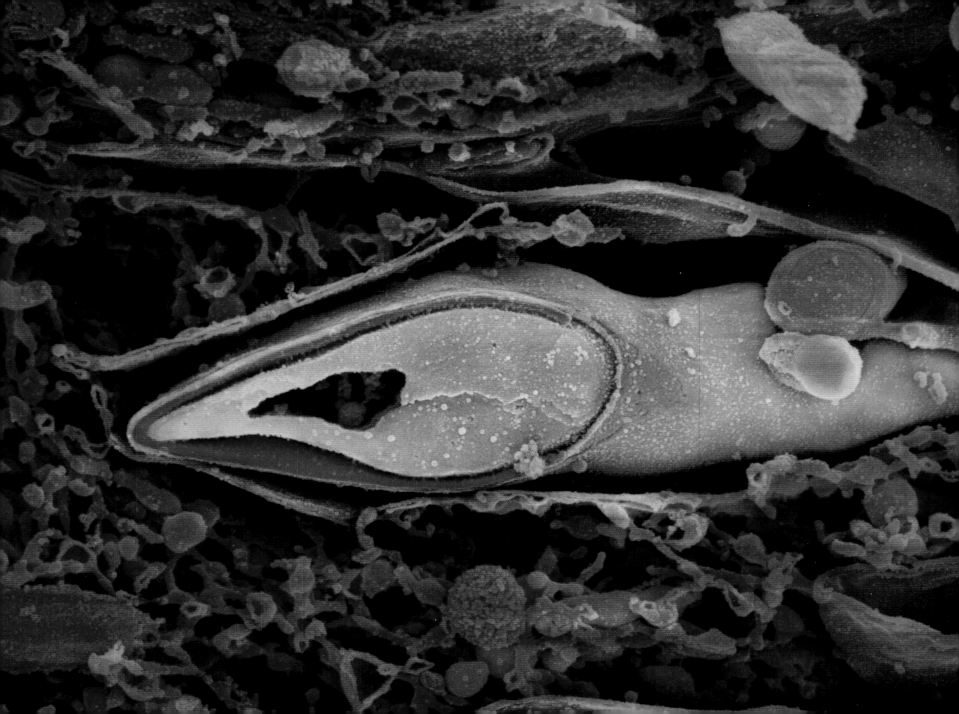

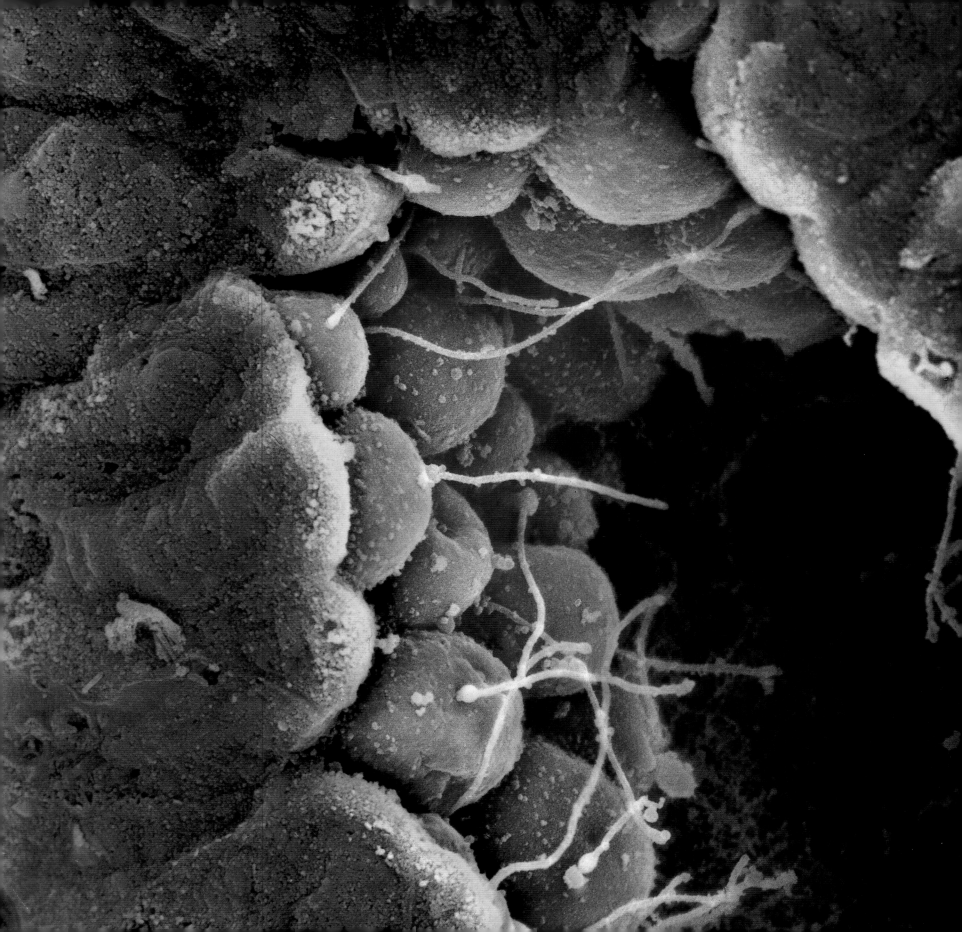

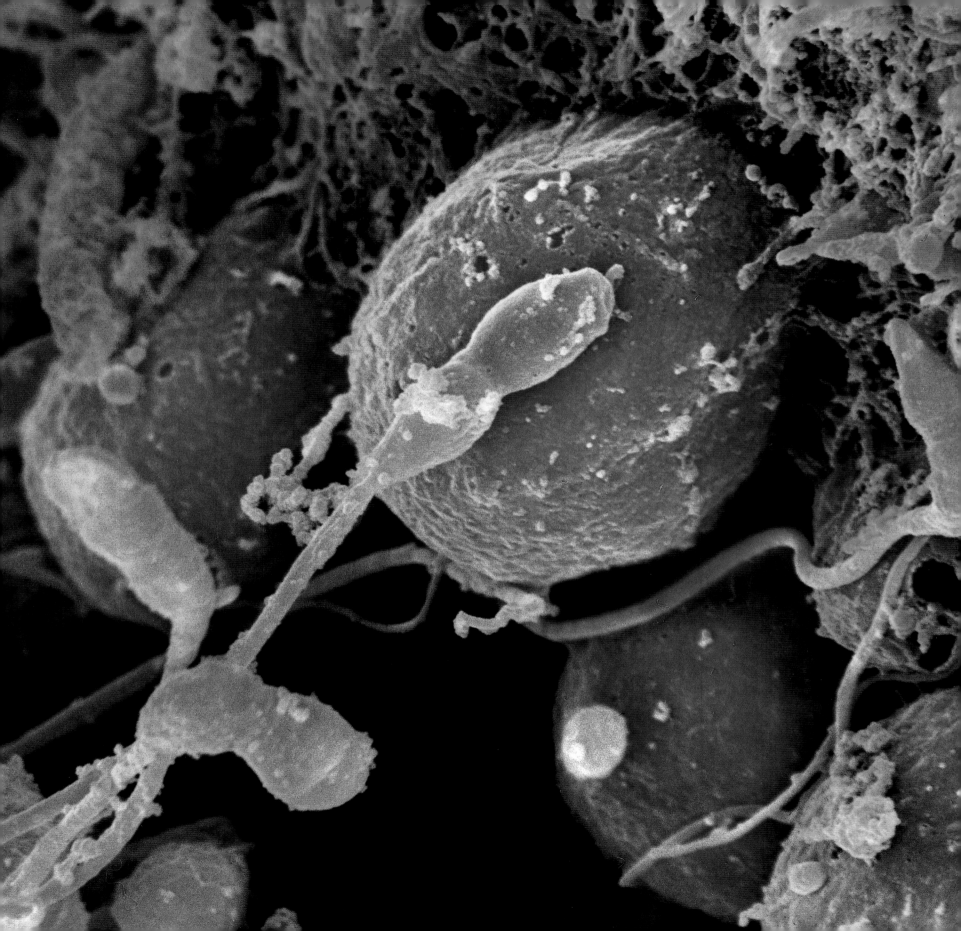

An area in the epididymis, to which the sperm have been transported by a fluid. Here the tails become capable of propulsion

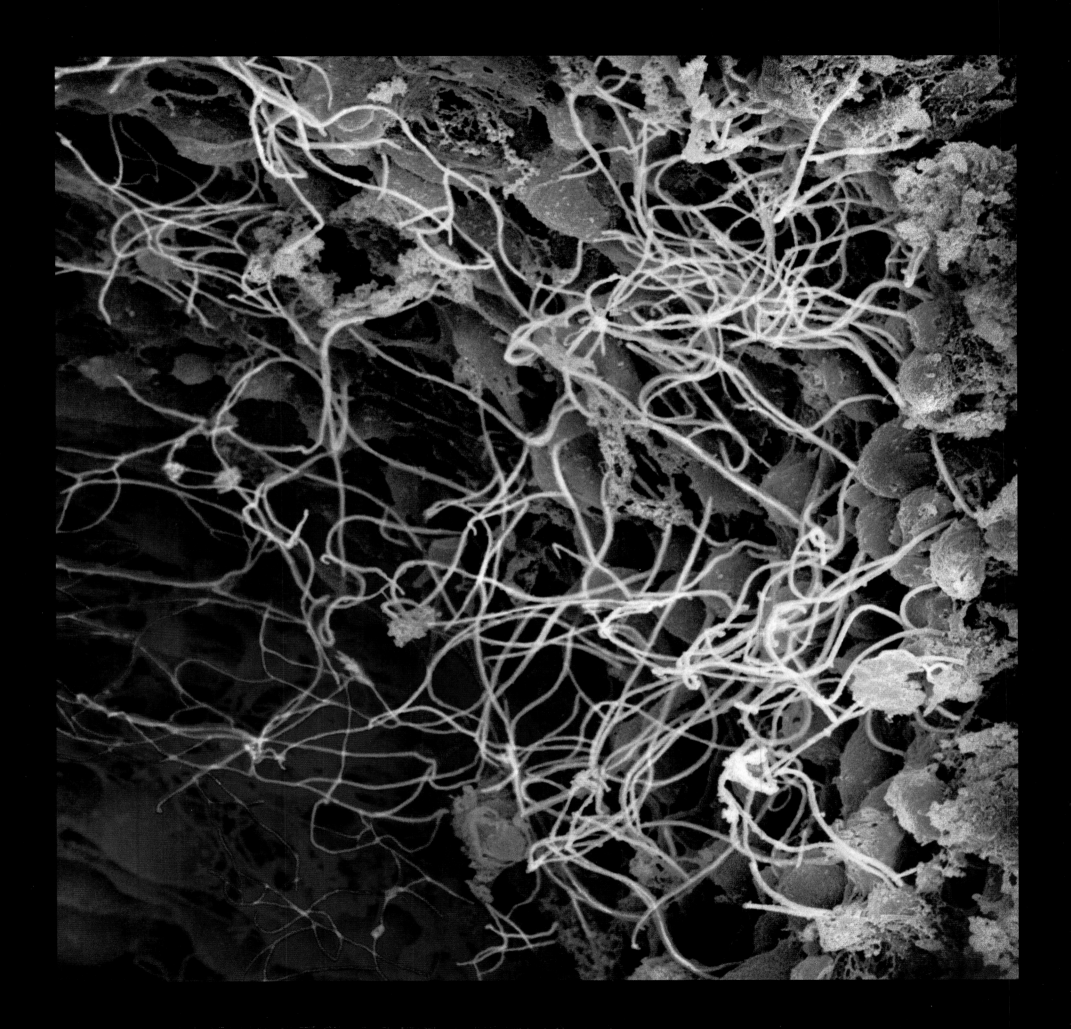

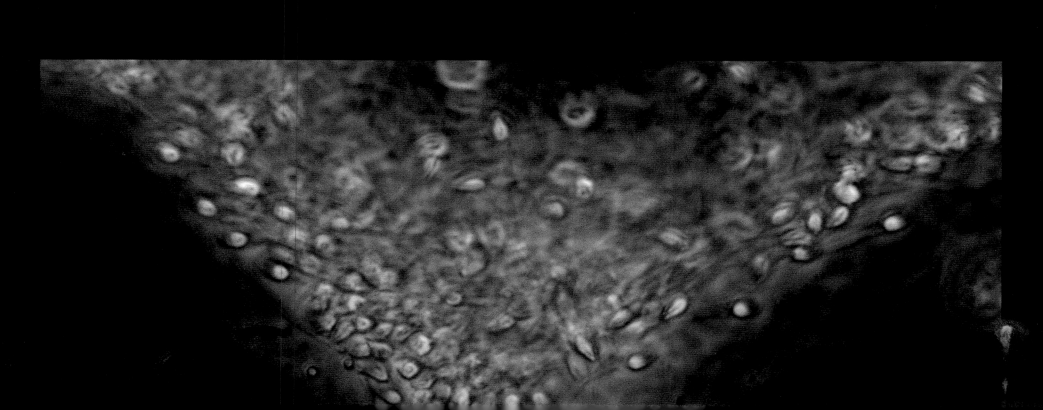

Sperm attempting to move towards the womb through a barrier of cervical mucus

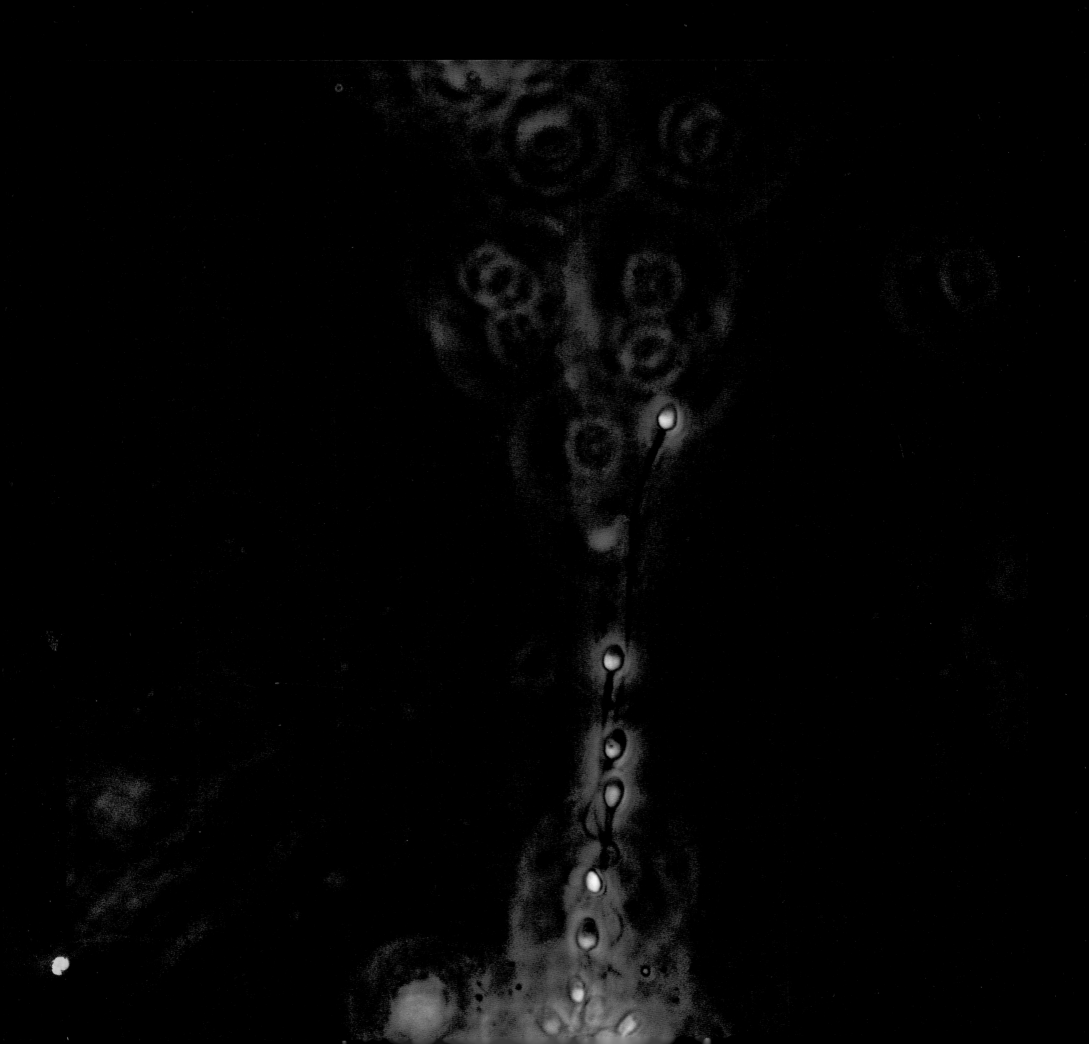

The egg or ovum, the female sex cell, just before ovulation

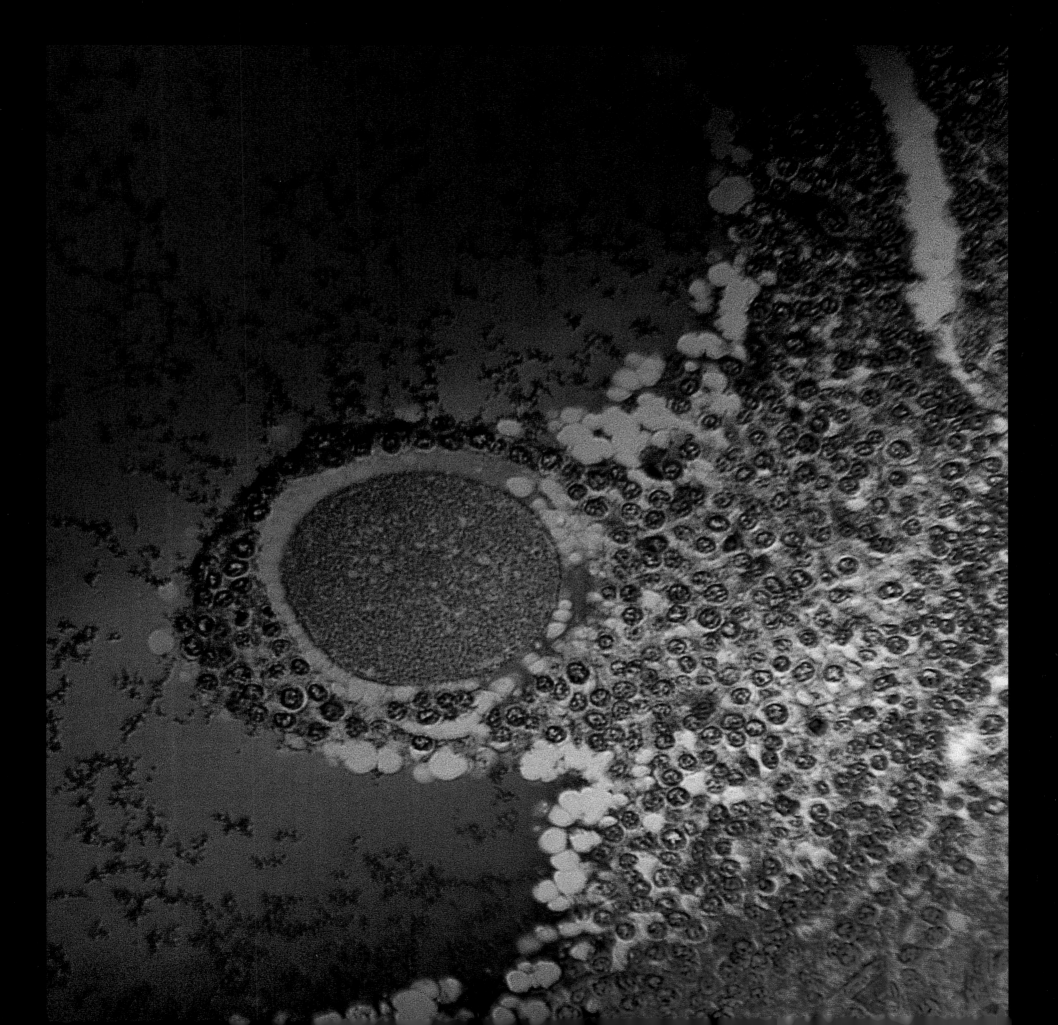

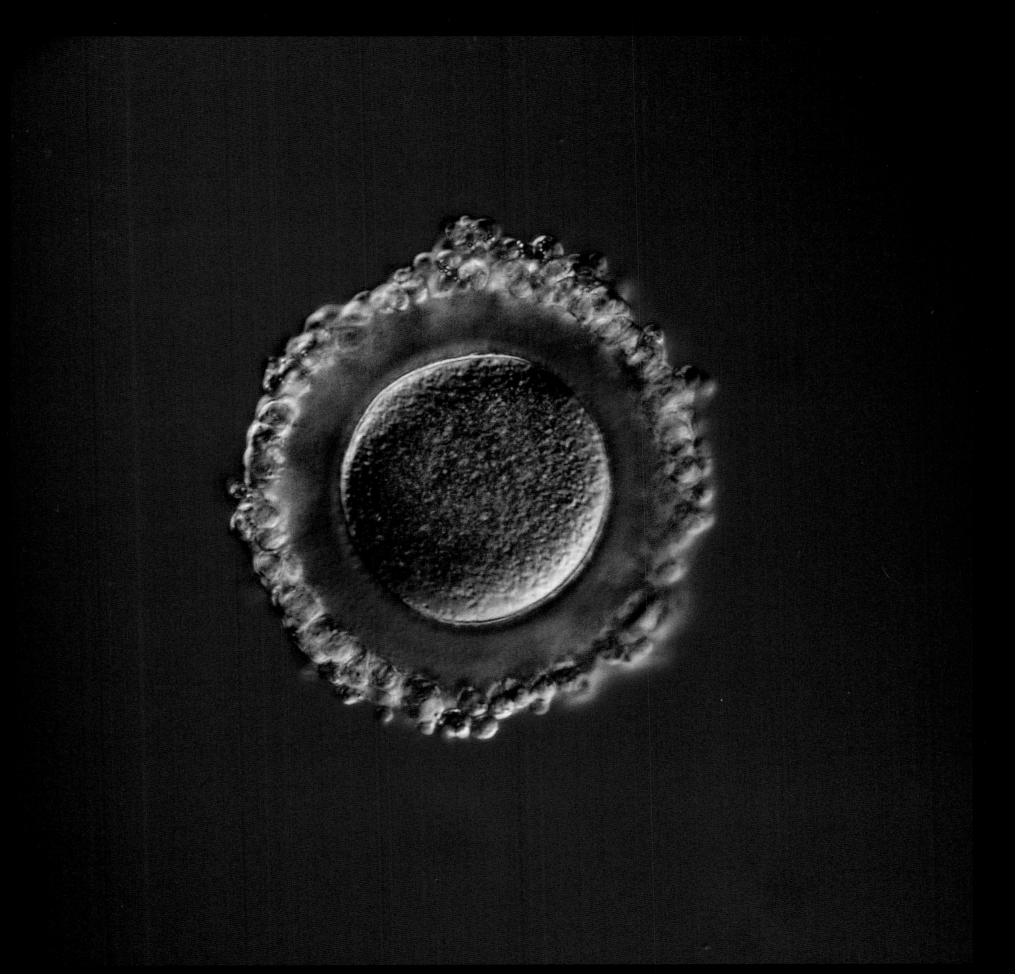

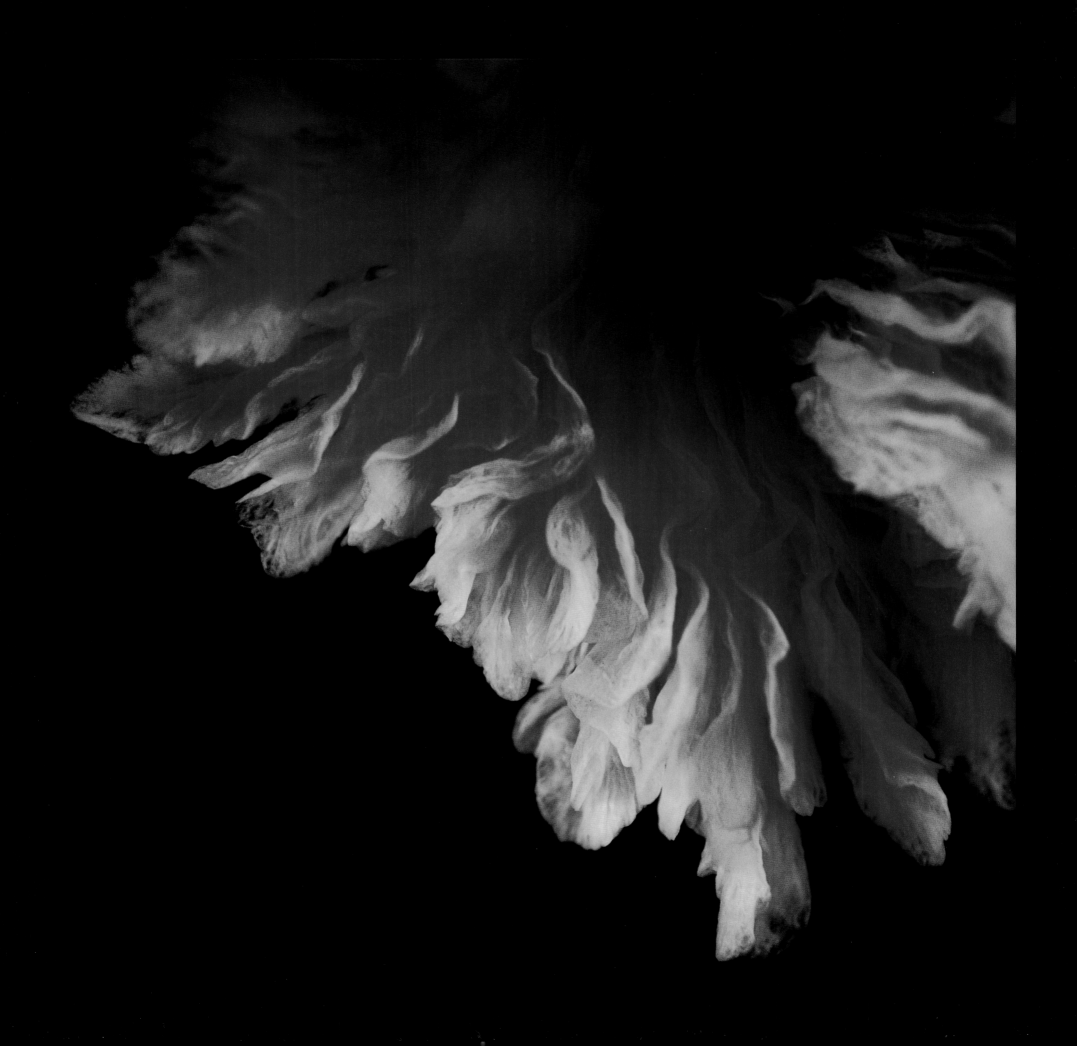

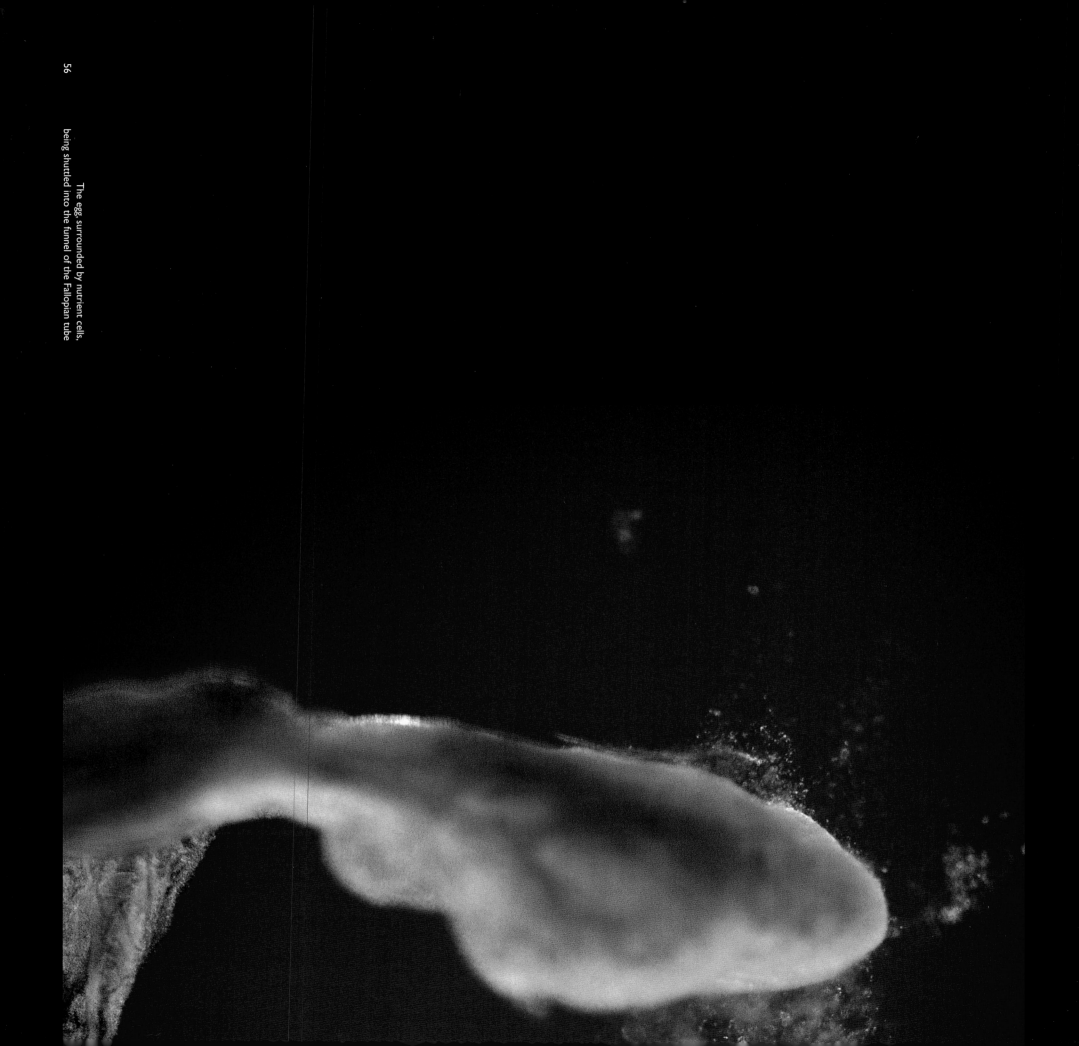

The egg, surrounded by nutrient cells, being shuttled into the funnel of the Fallopian tube

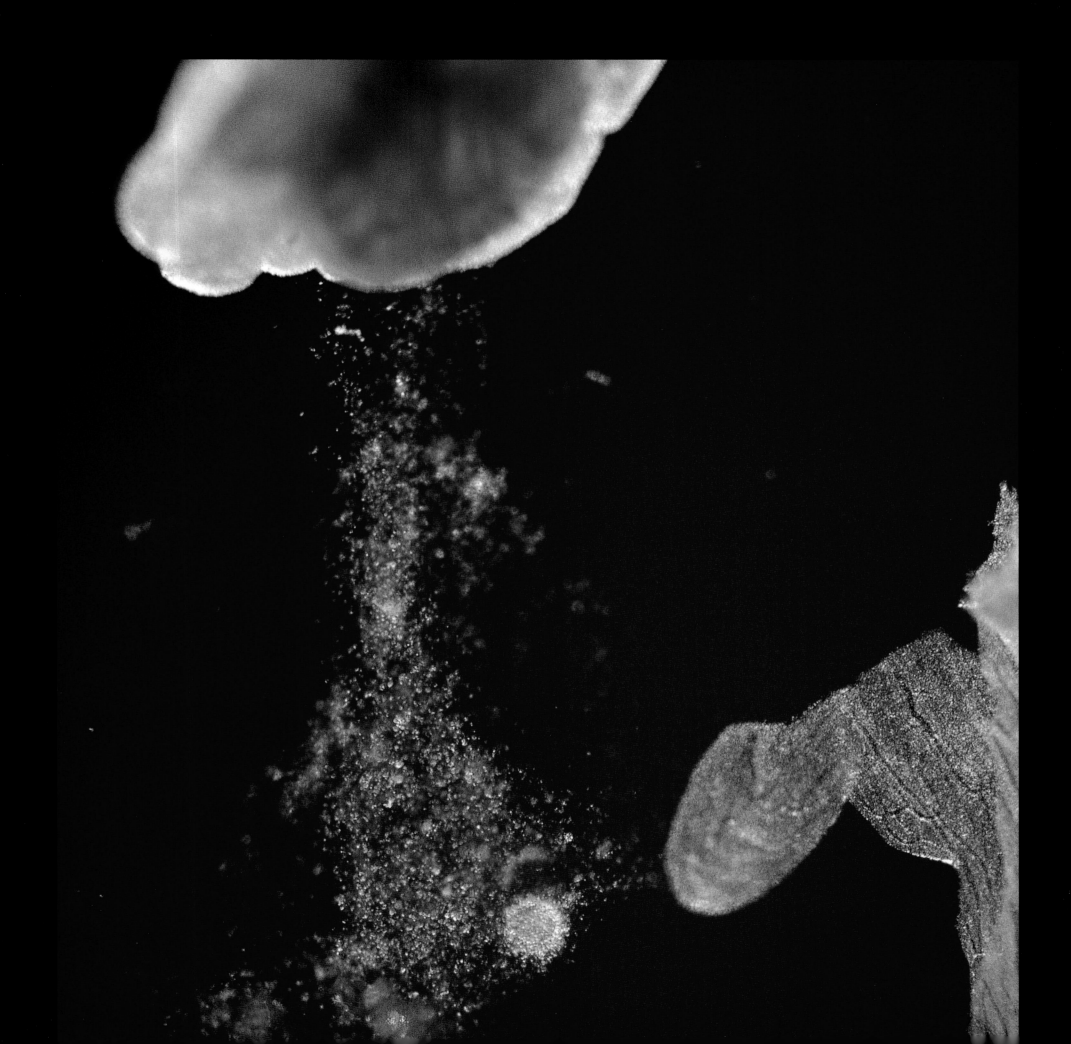

The egg in the Fallopian tube,
where it remains for 24 hours in readiness
for fertilization by a single sperm

The dissolving ring of nutrient cells, *corona radiata*,
surrounding the egg in the Fallopian tube (pages 60–61)

Millions of sperm enter the vagina and swim towards
the opening of the cervix (pages 62–63)

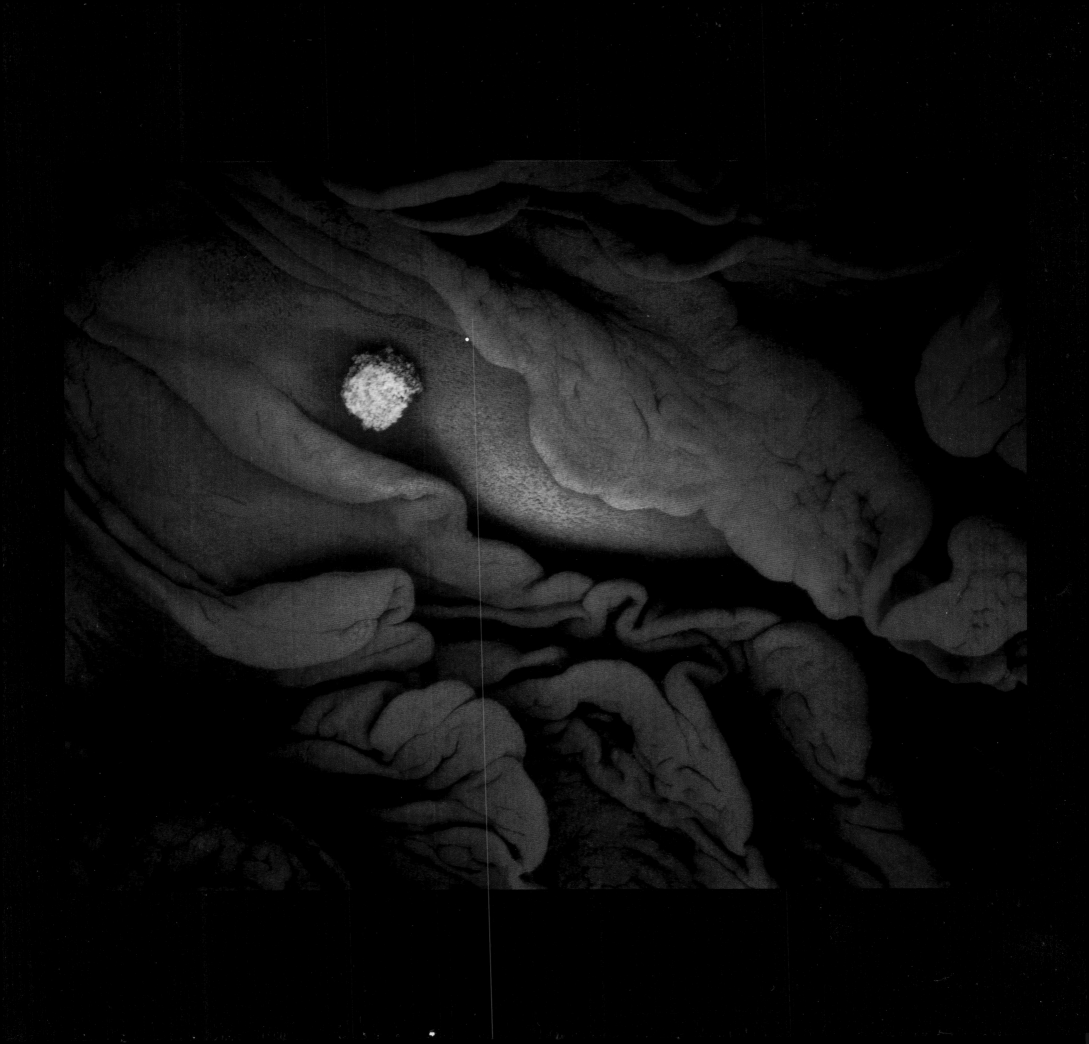

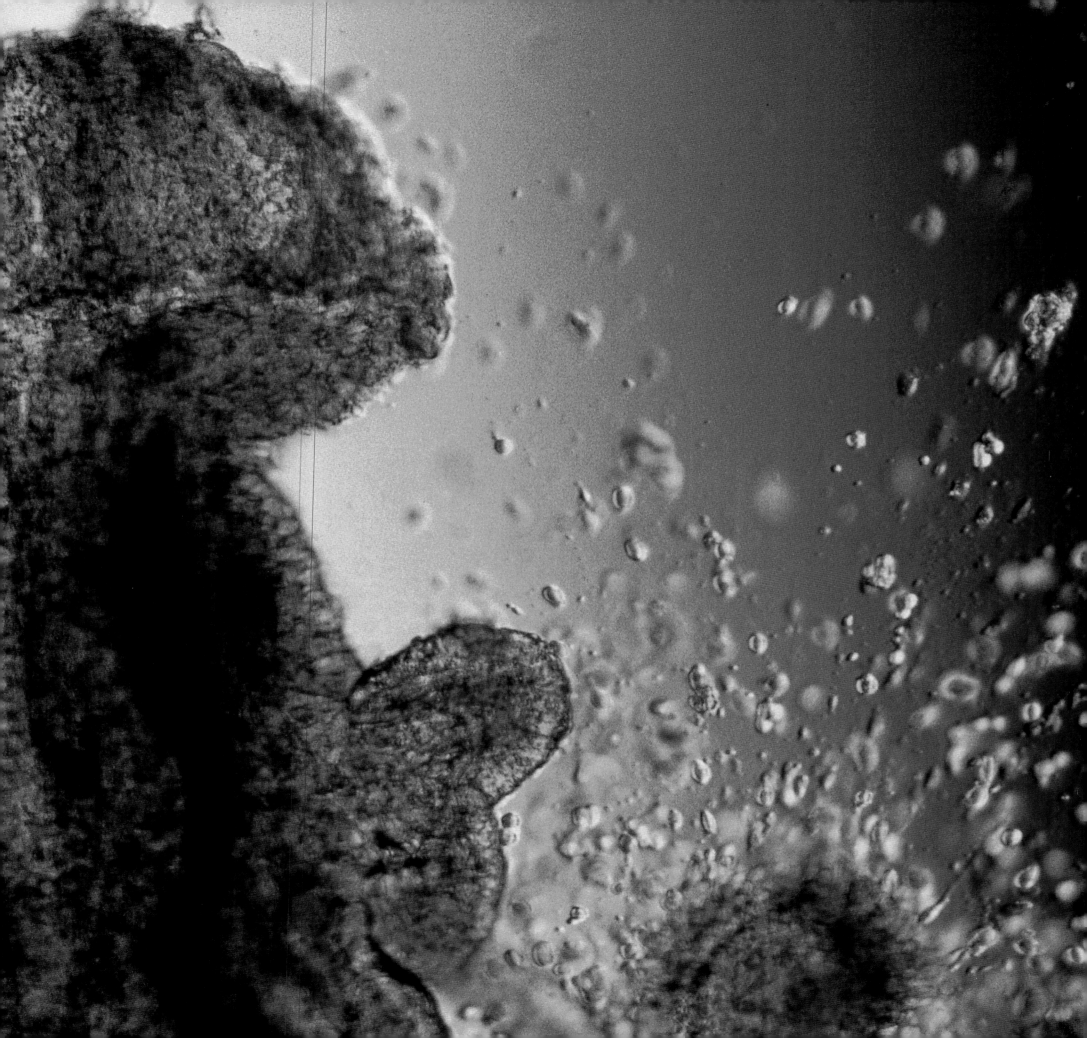

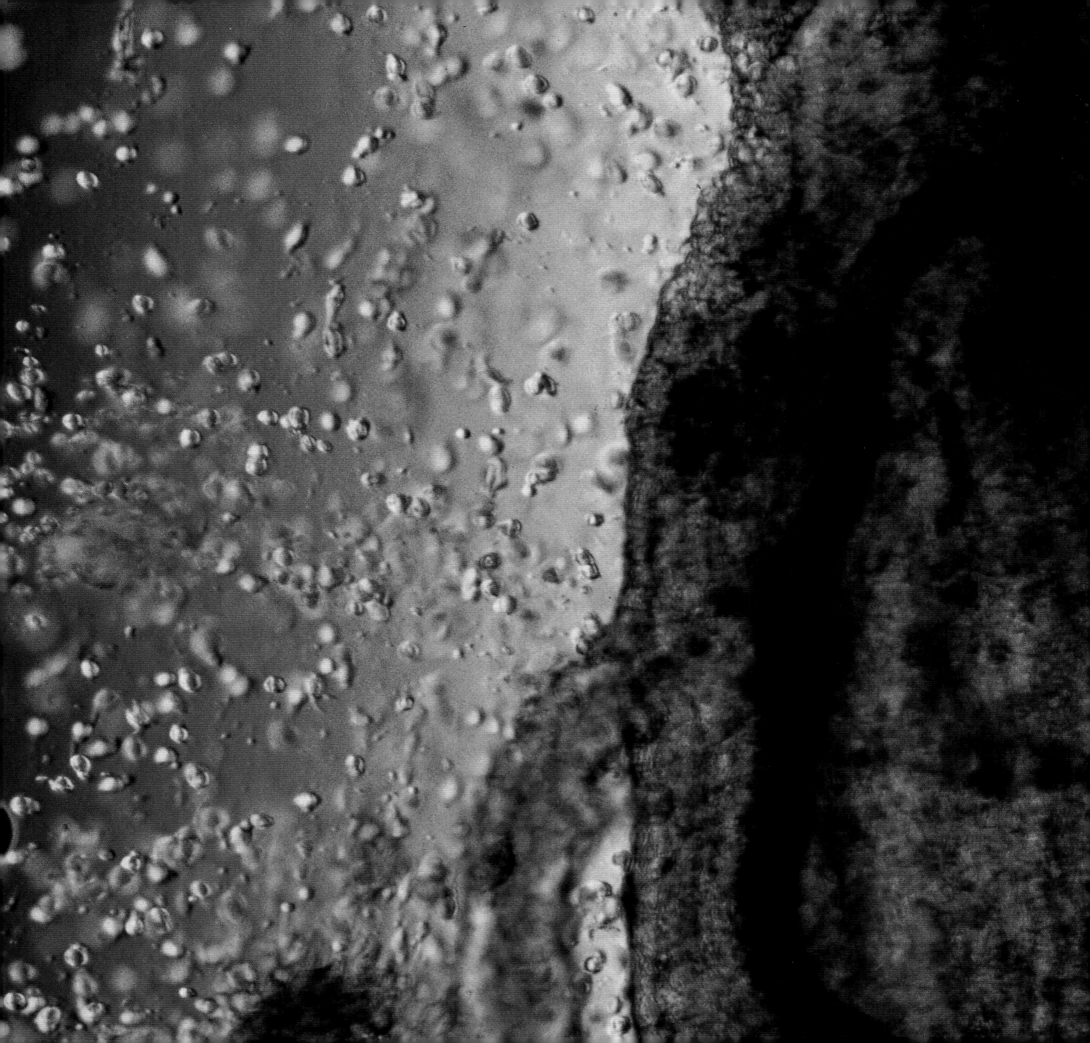

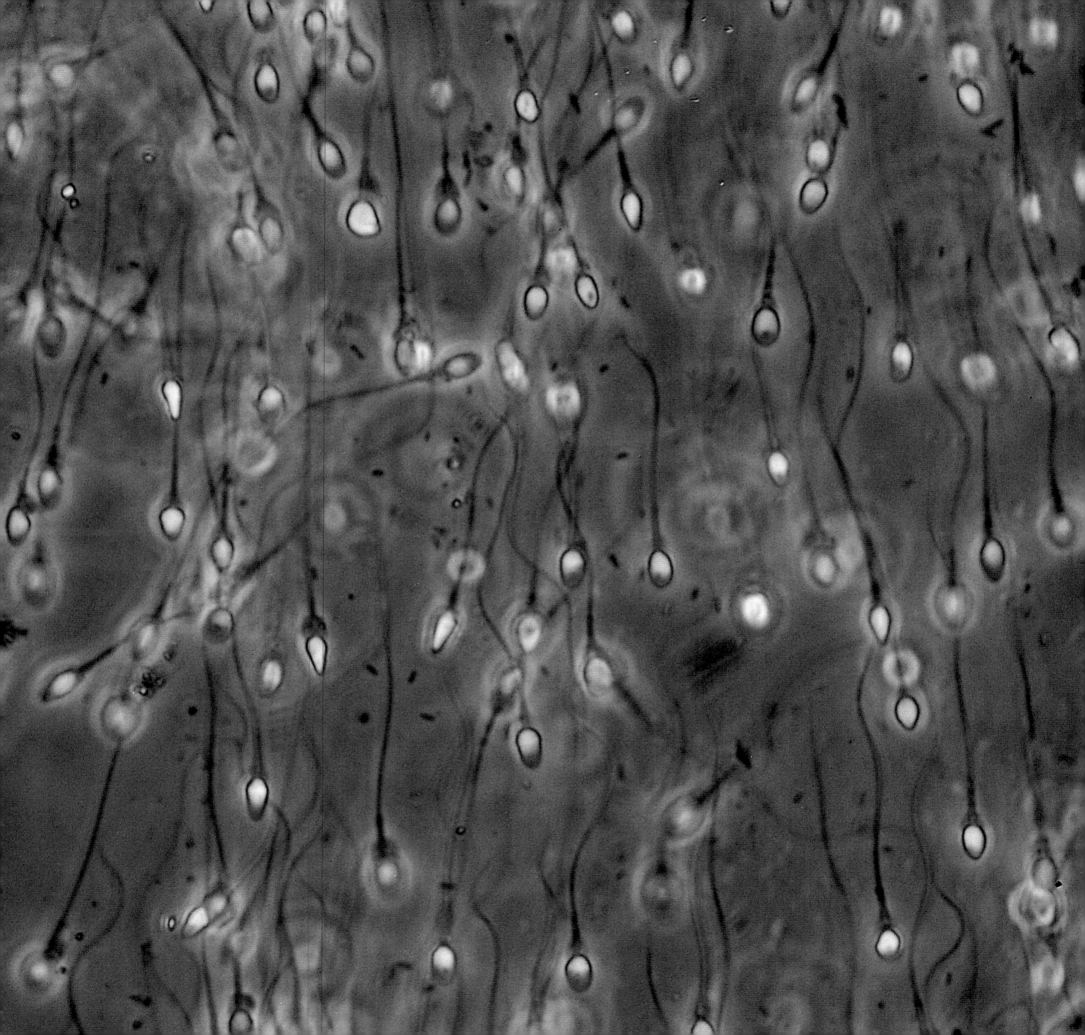

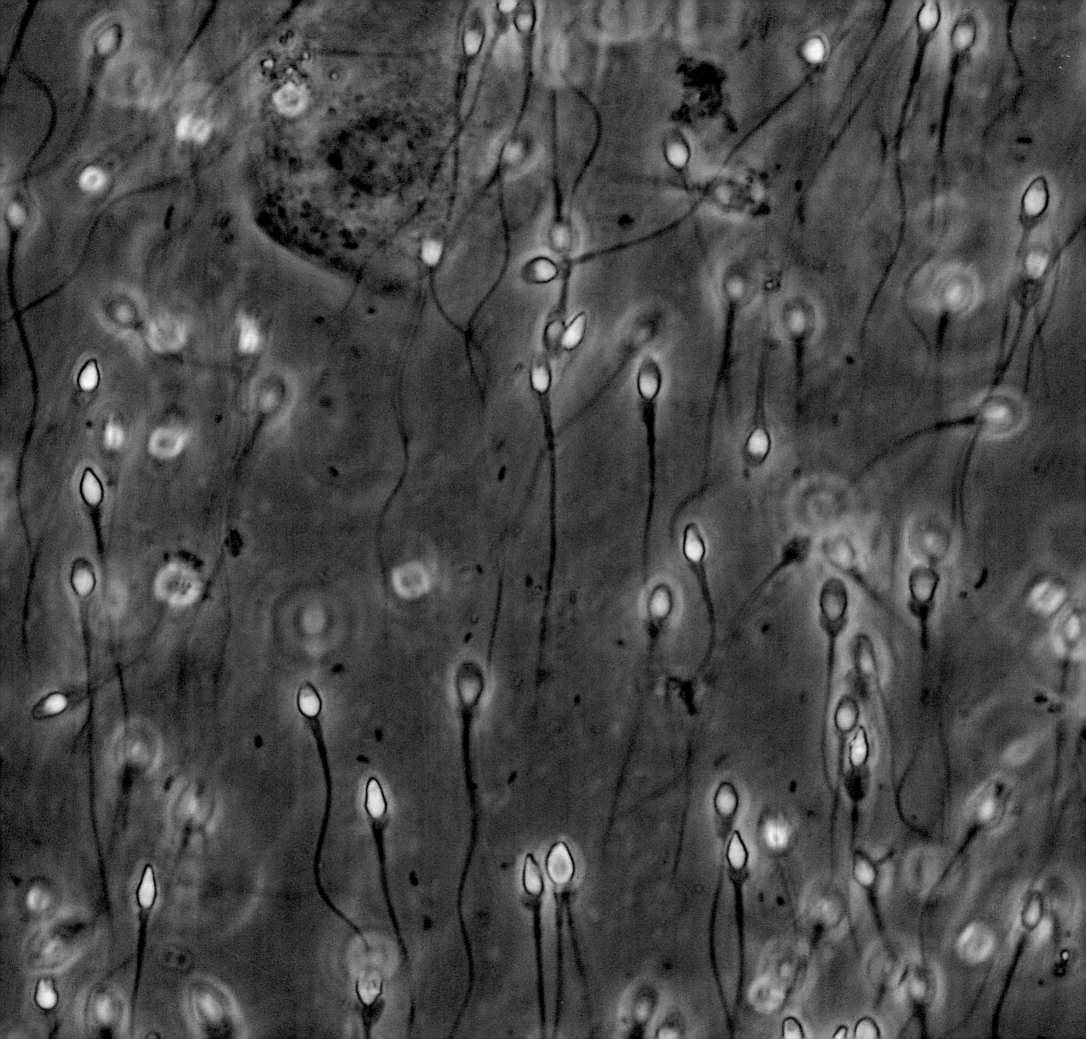

Sperm

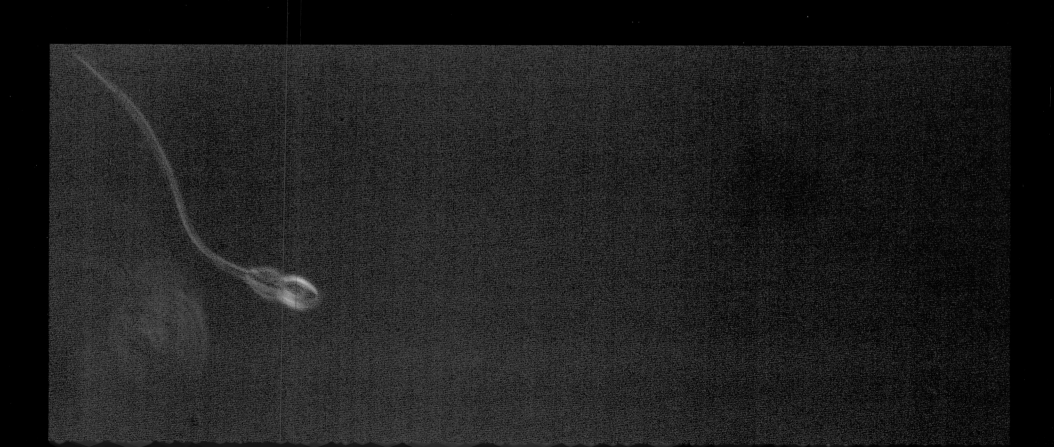

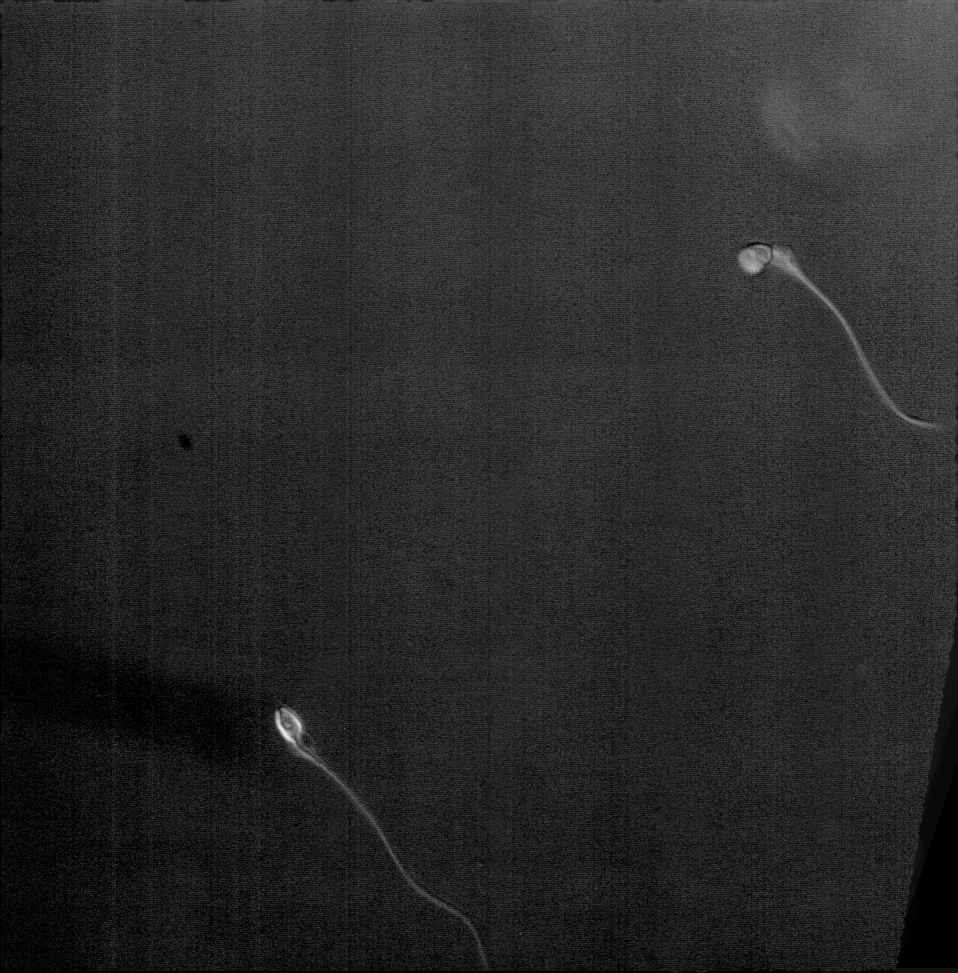

3–7 hours from ejaculation: the sperm, visible at the bottom left, and the egg

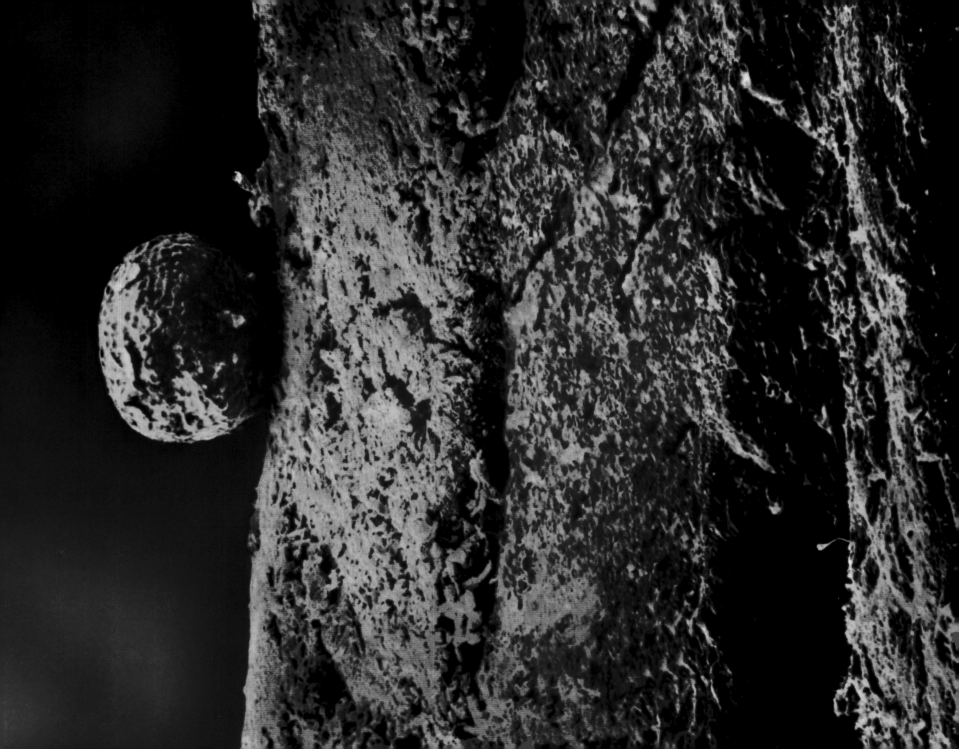

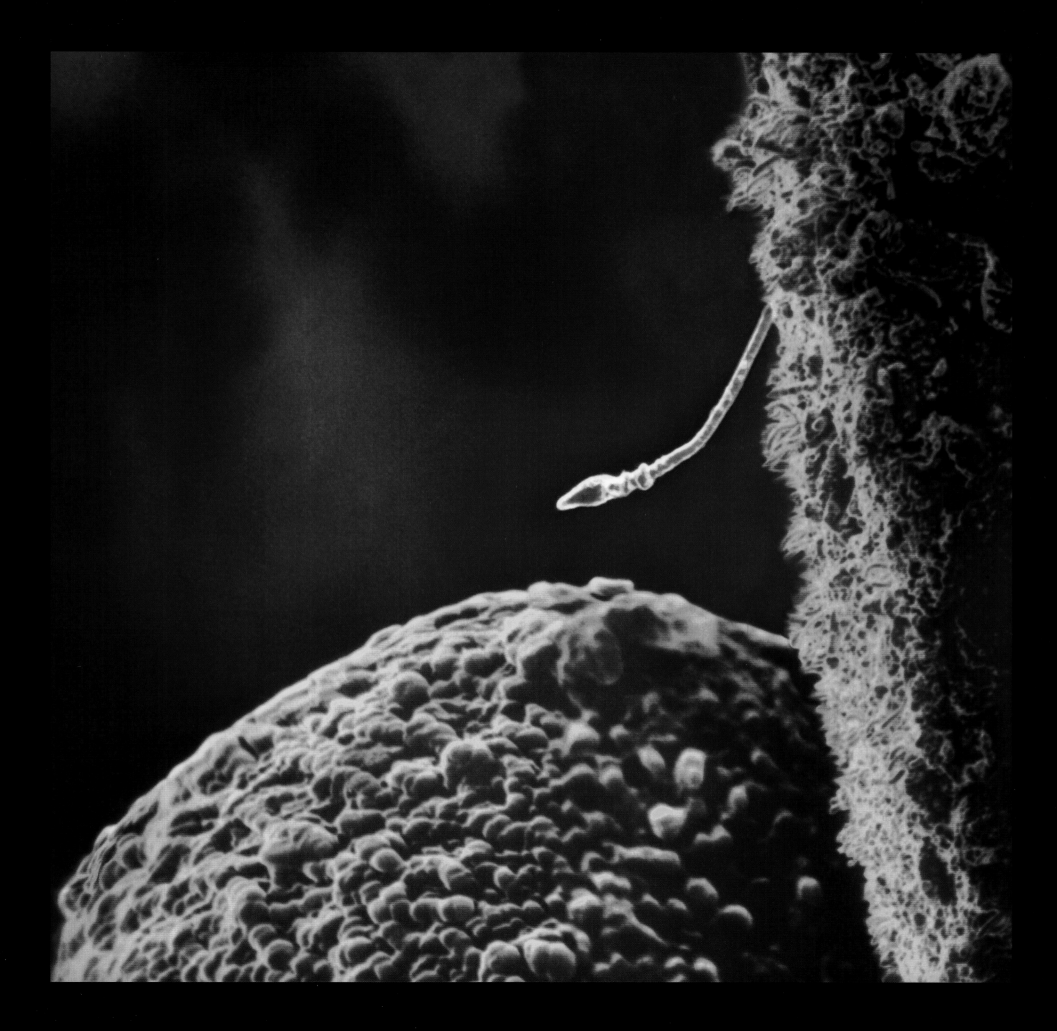

3–7 hours from ejaculation: before the sperm can penetrate the ovum, remaining nutrient cells are cleared by the invading sperm

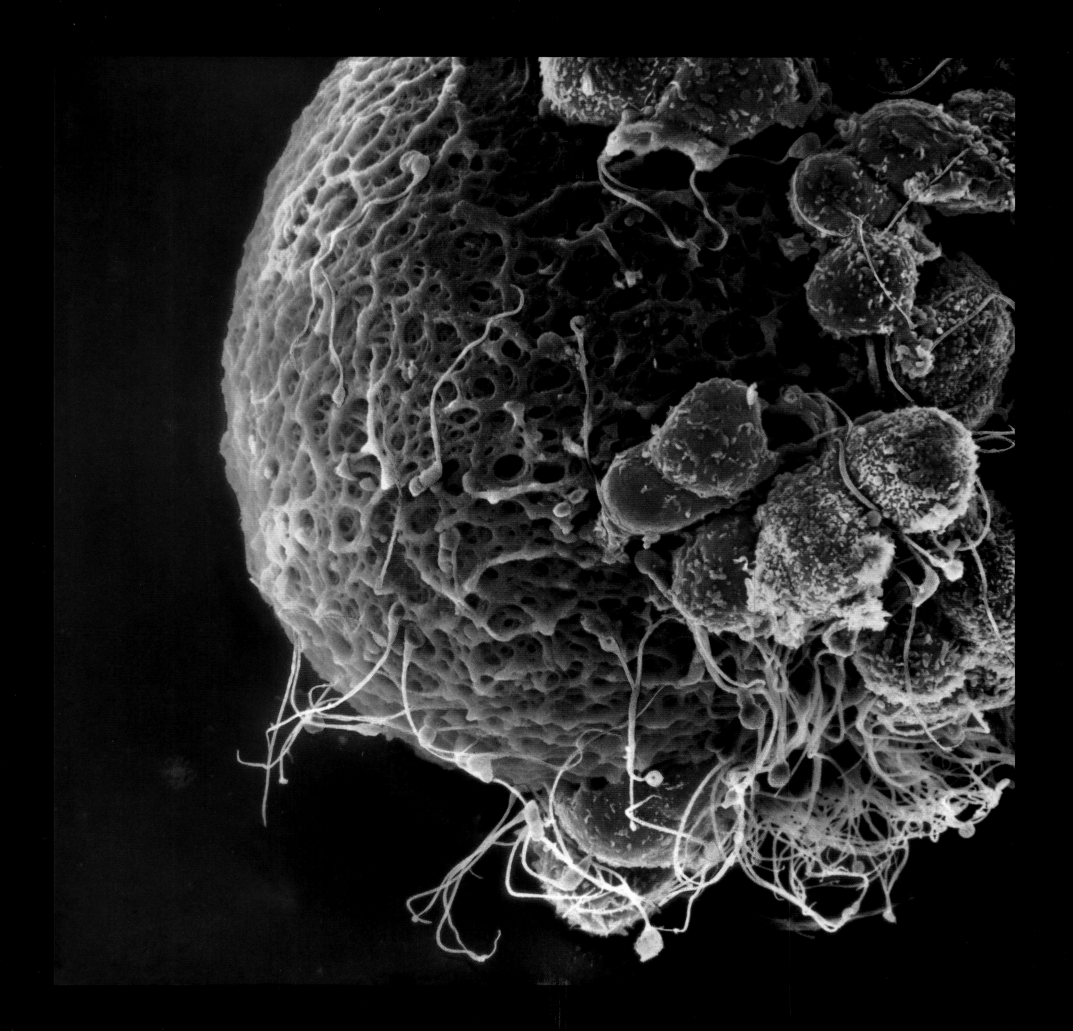

Several sperm reach the gap between the outer shell and the membrane of the oocyte, but only one can fertilize the egg

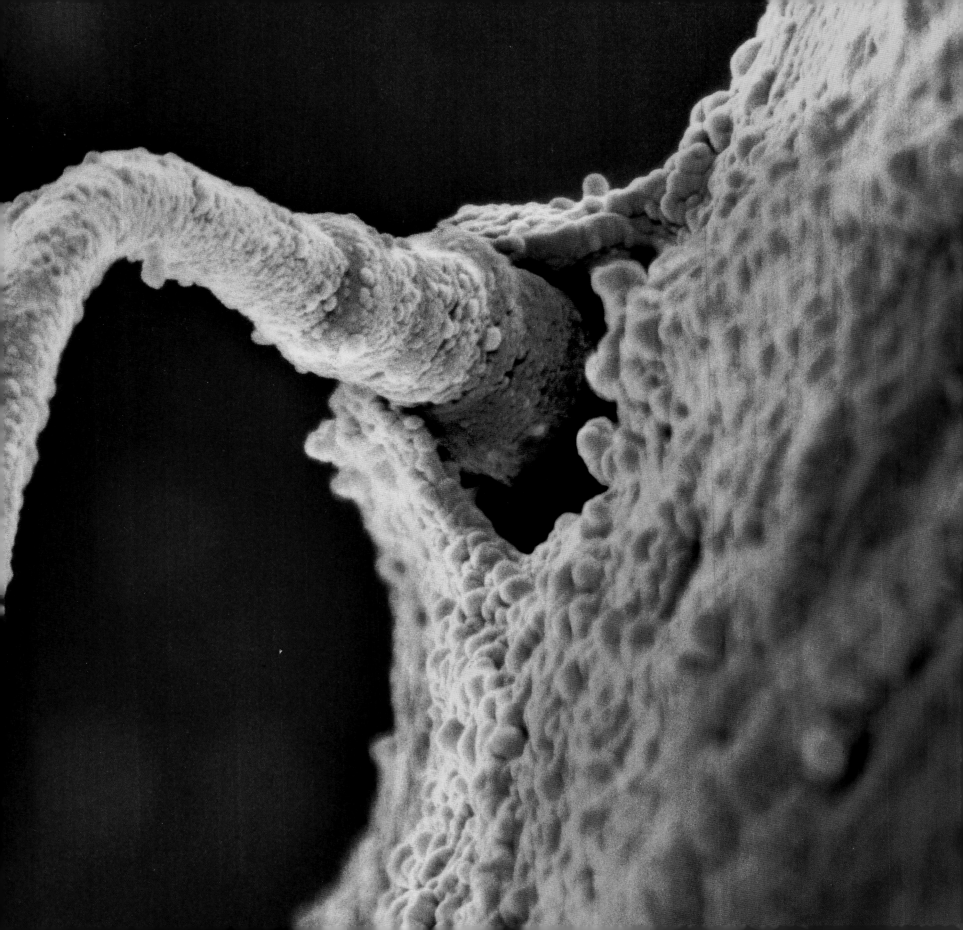

20 hours after ejaculation: inside the fertilized egg the nuclei of the male and female cells meet and new chromosomes are created

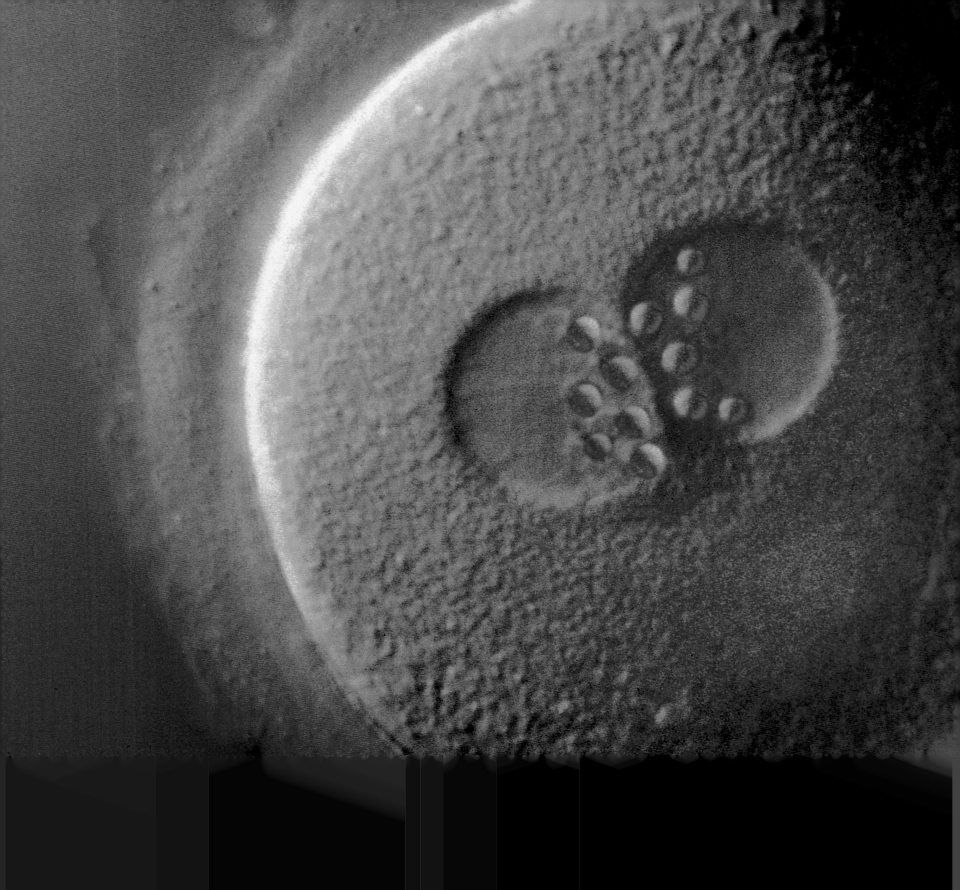

1 day after fertilization: the cell's journey to the uterus begins.
The cell divides for the first time to create a precise copy of itself.
This cell division is the fundamental process in the creation of life

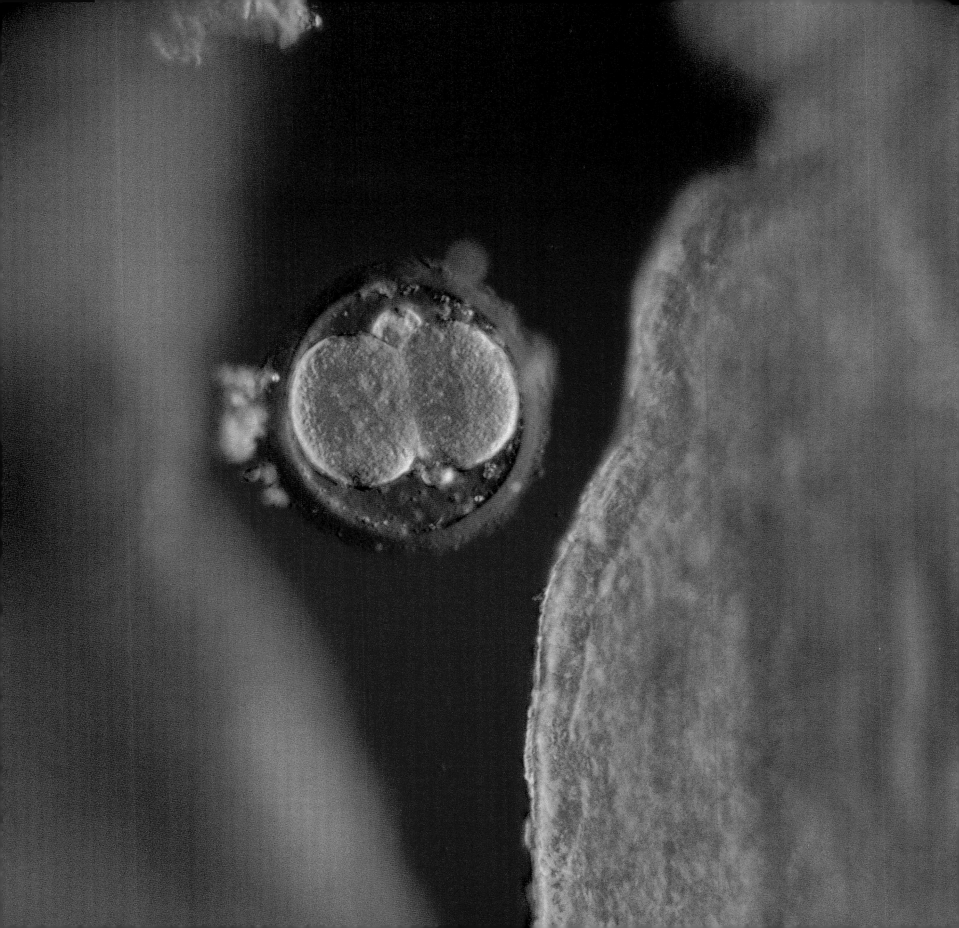

2–3 days: the egg is now composed of 4 to 8 cells

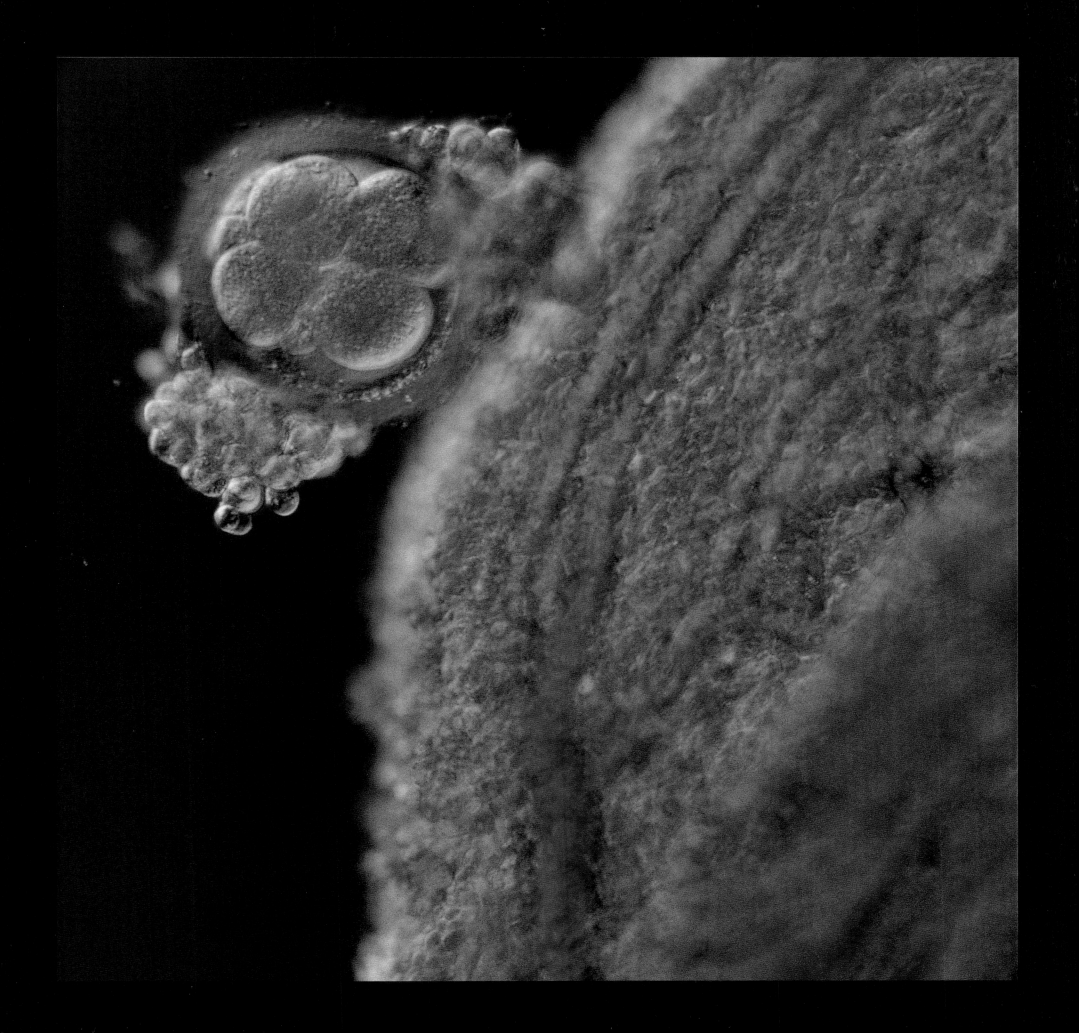

4 days: the Morula stage. The clump consists of 25 to 30 cells

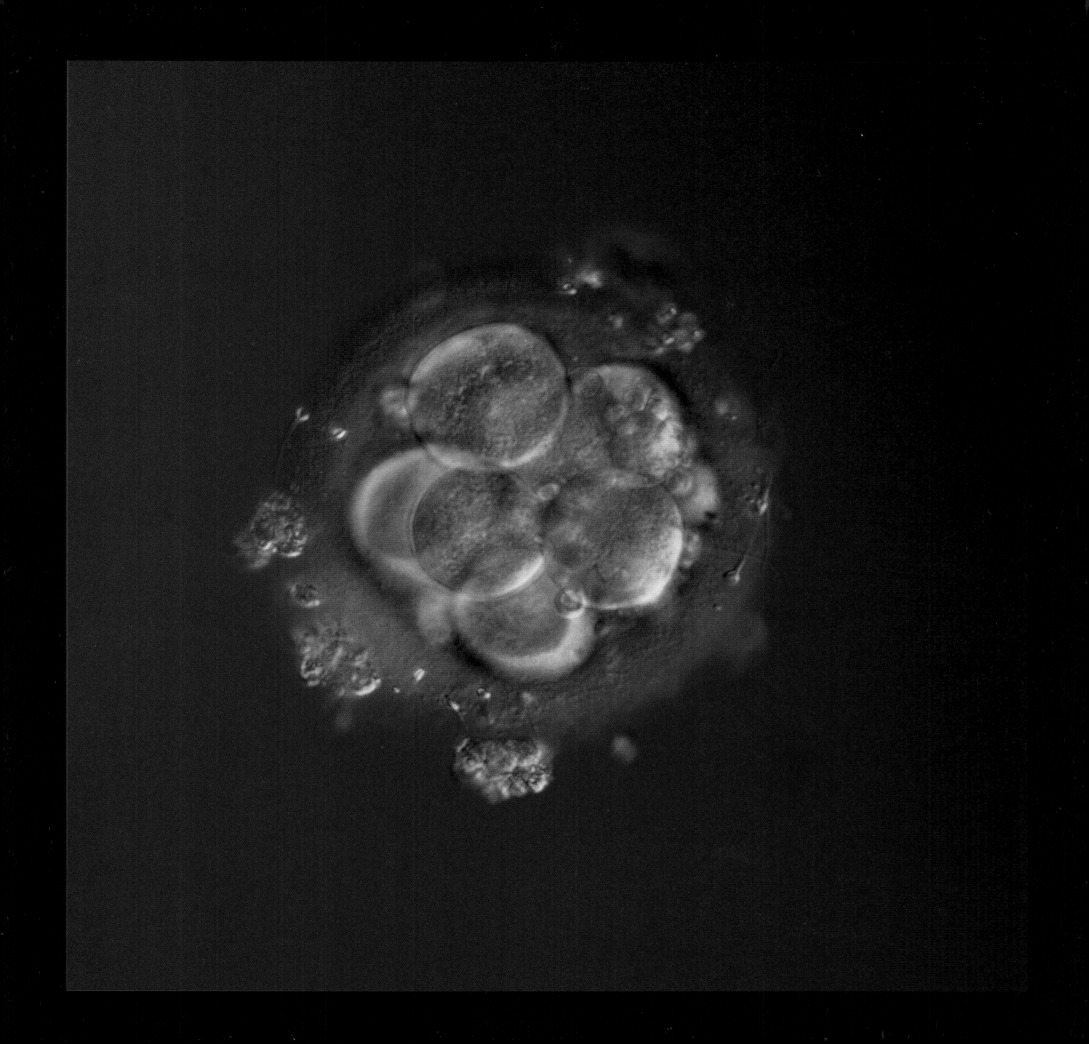

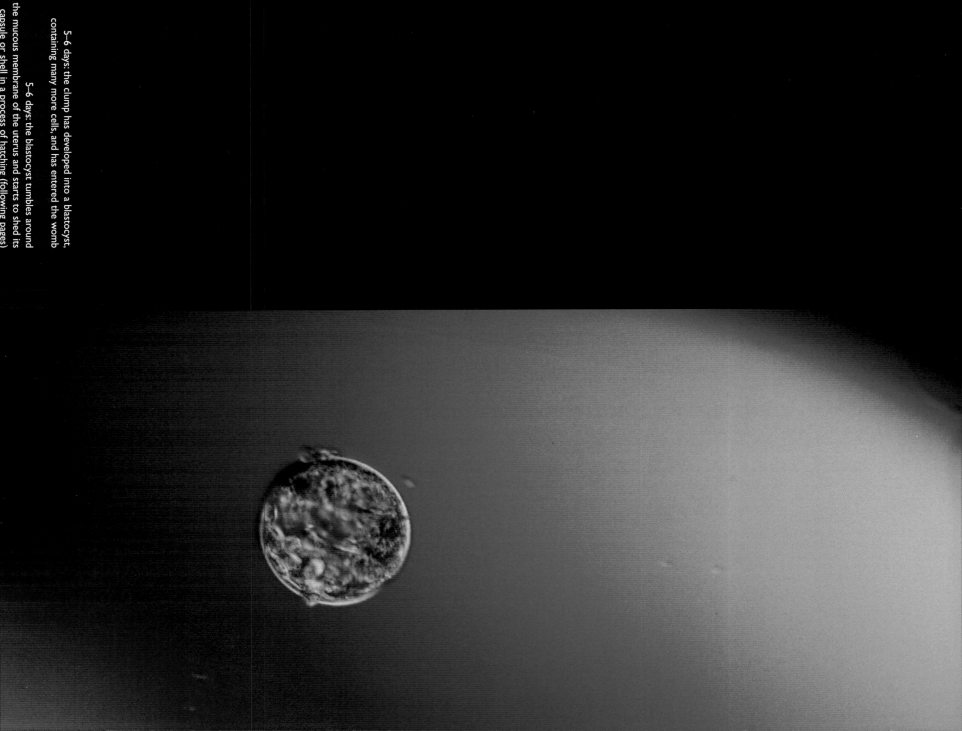

5–6 days: the clump has developed into a blastocyst, containing many more cells, and has entered the womb

5–6 days: the blastocyst tumbles around the mucous membrane of the uterus and starts to shed its capsule or shell in a process of hatching (following pages)

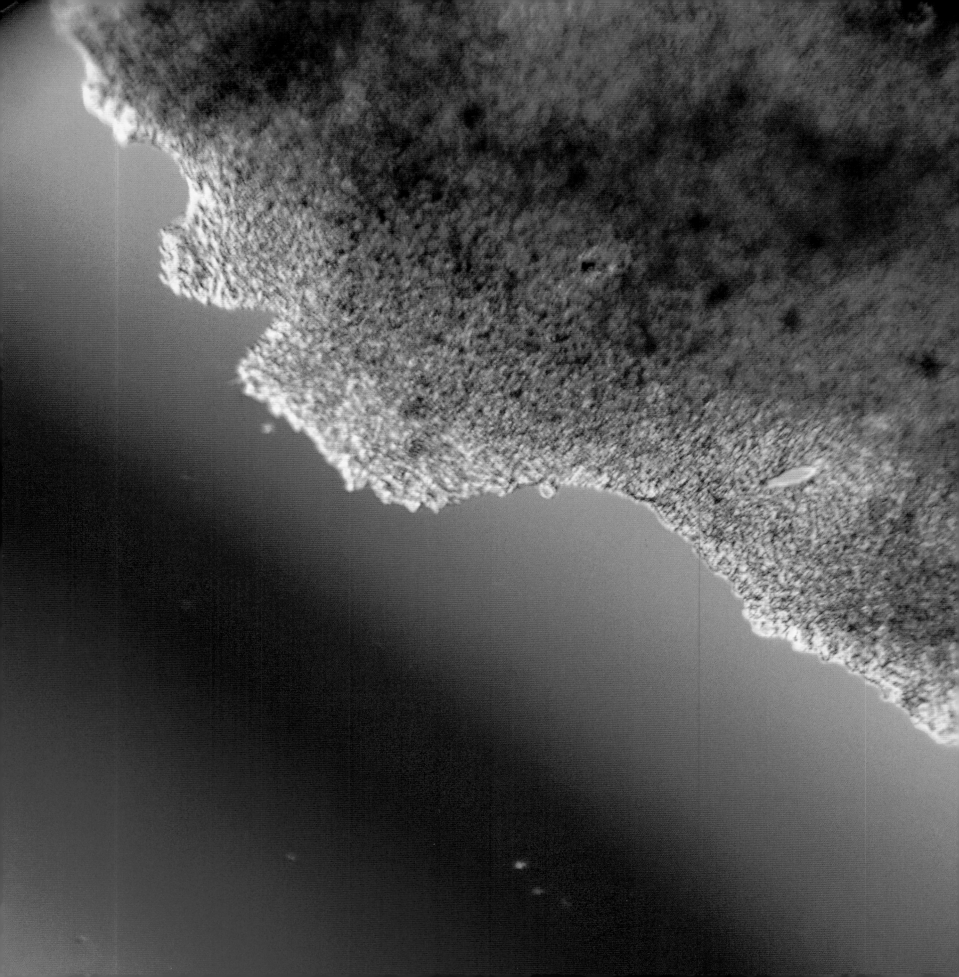

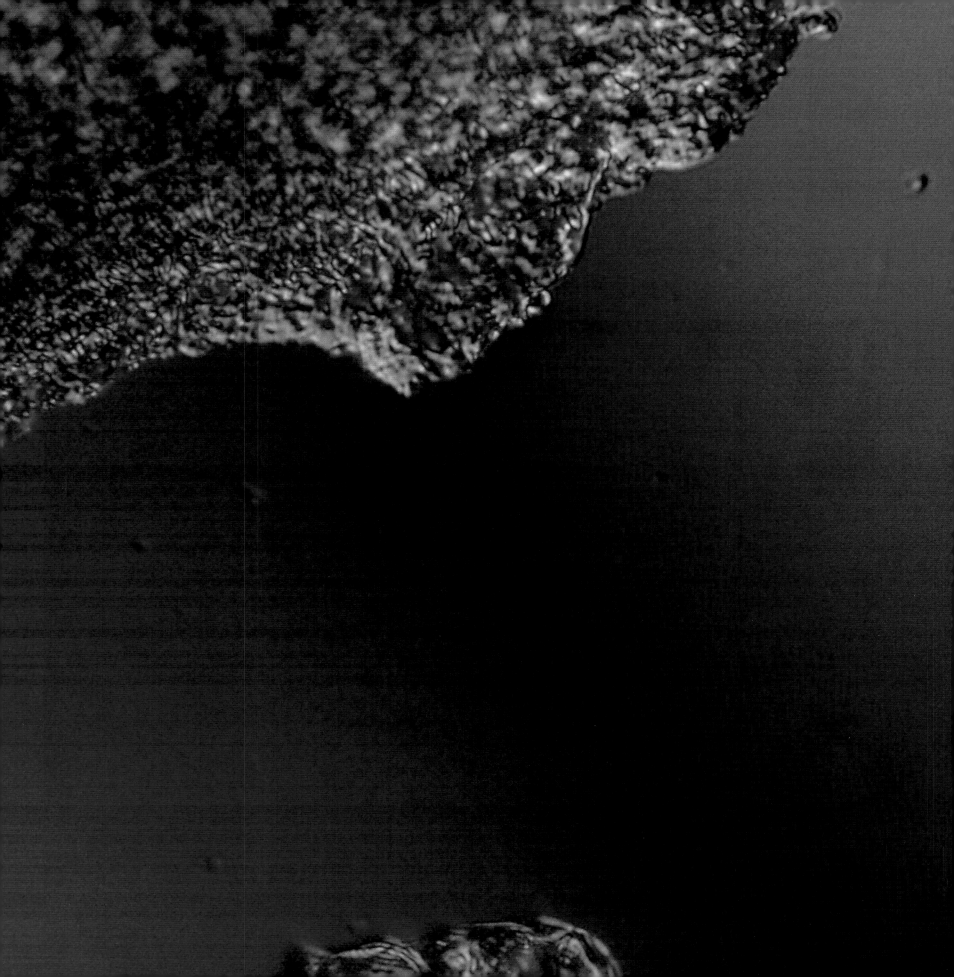

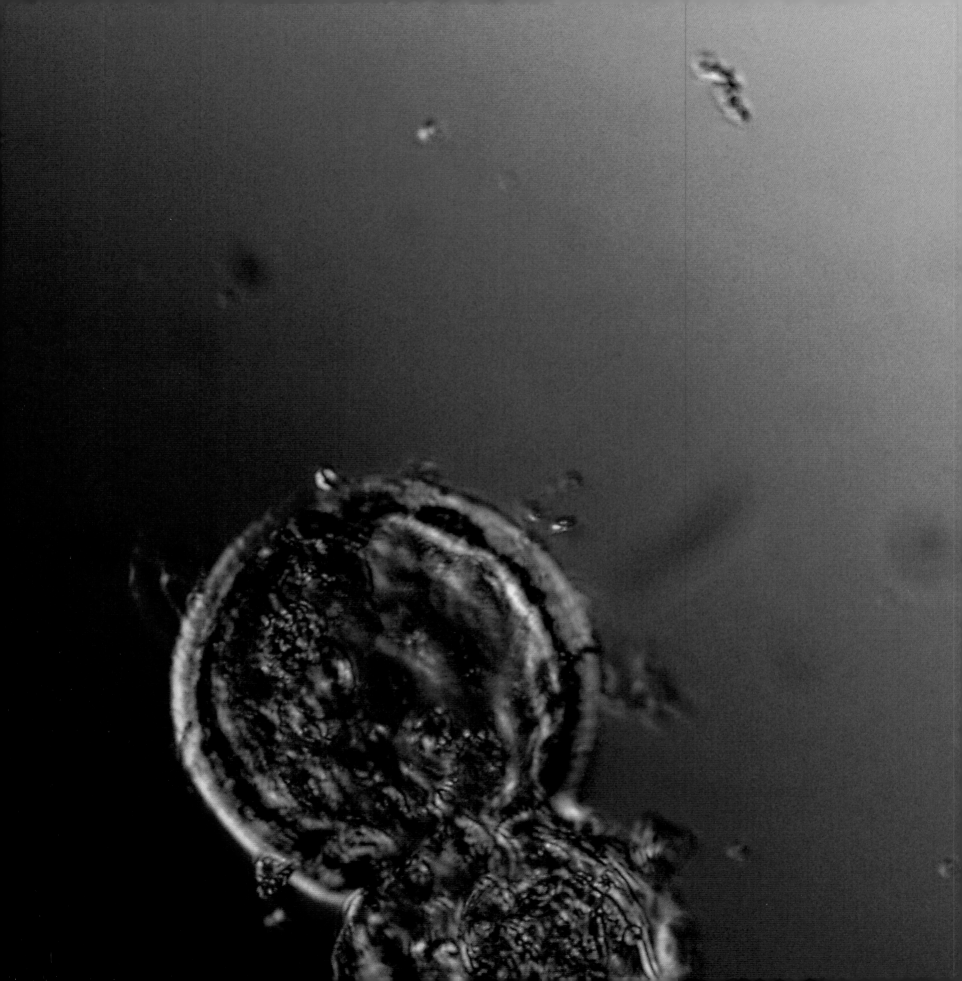

6–7 days: the mucous membrane starts
to embrace the newly hatched cell mass

7 days: the egg's shell is broken. The mass of embryonic
and surrounding placenta cells expands rapidly and settles
into the mucous membrane of the uterus (following pages)

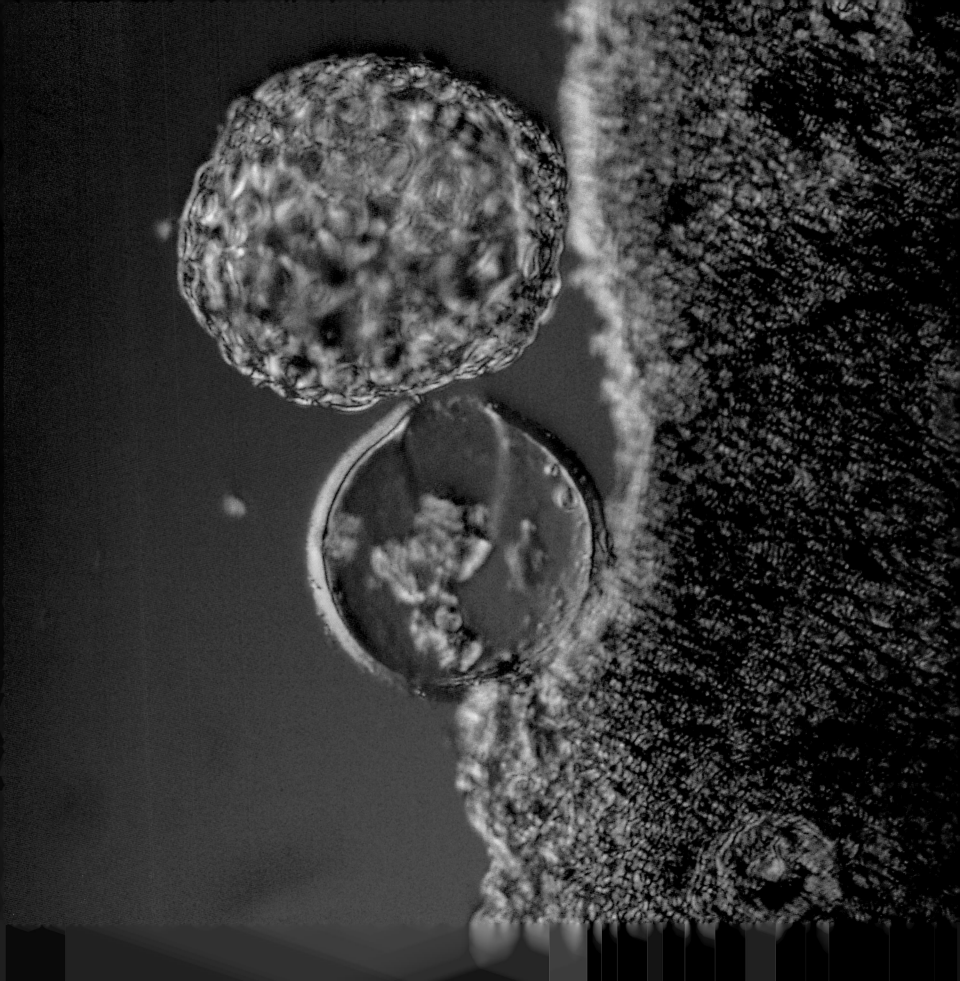

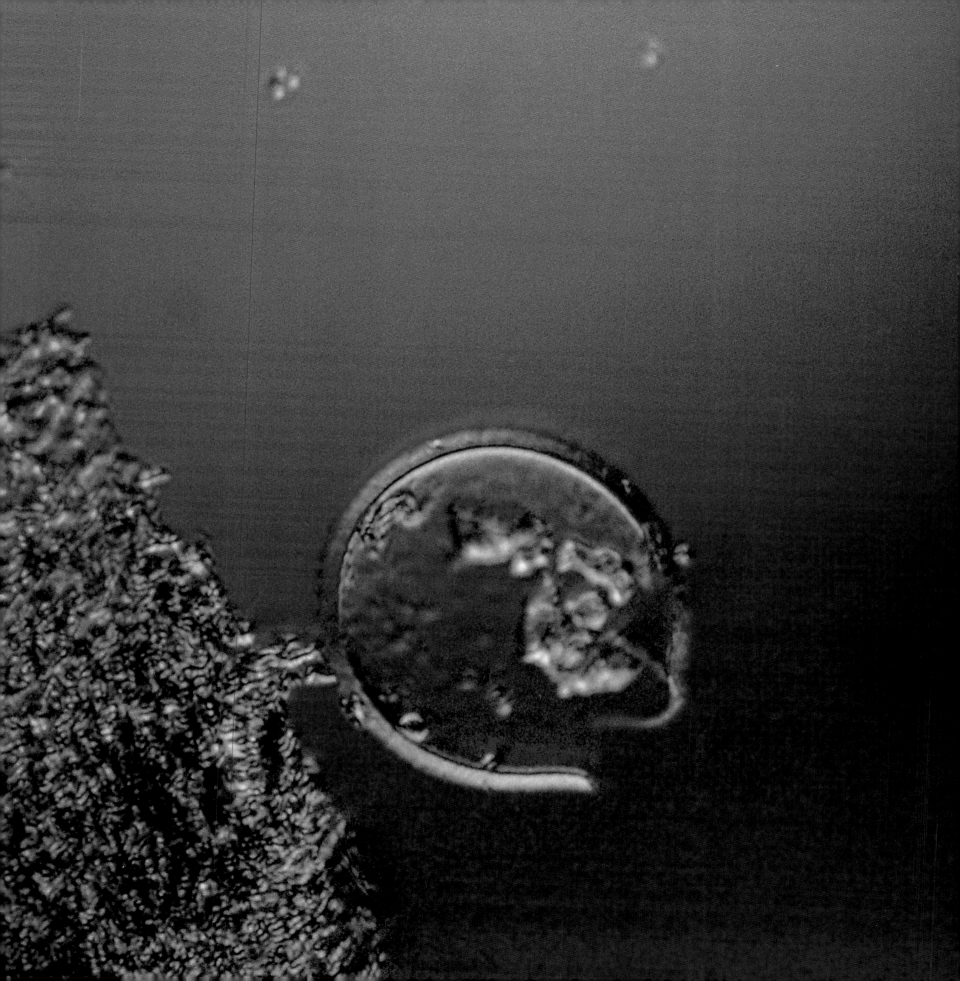

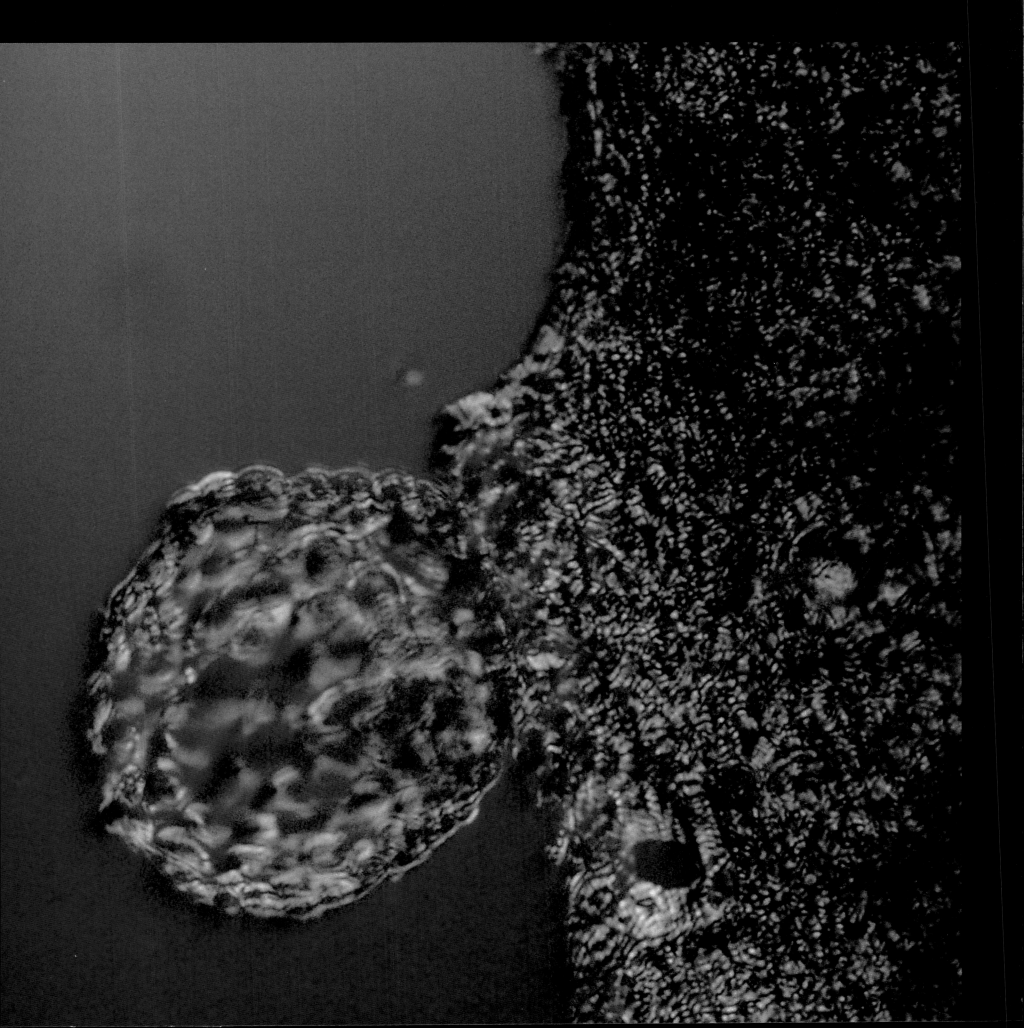

THE EMBRYO

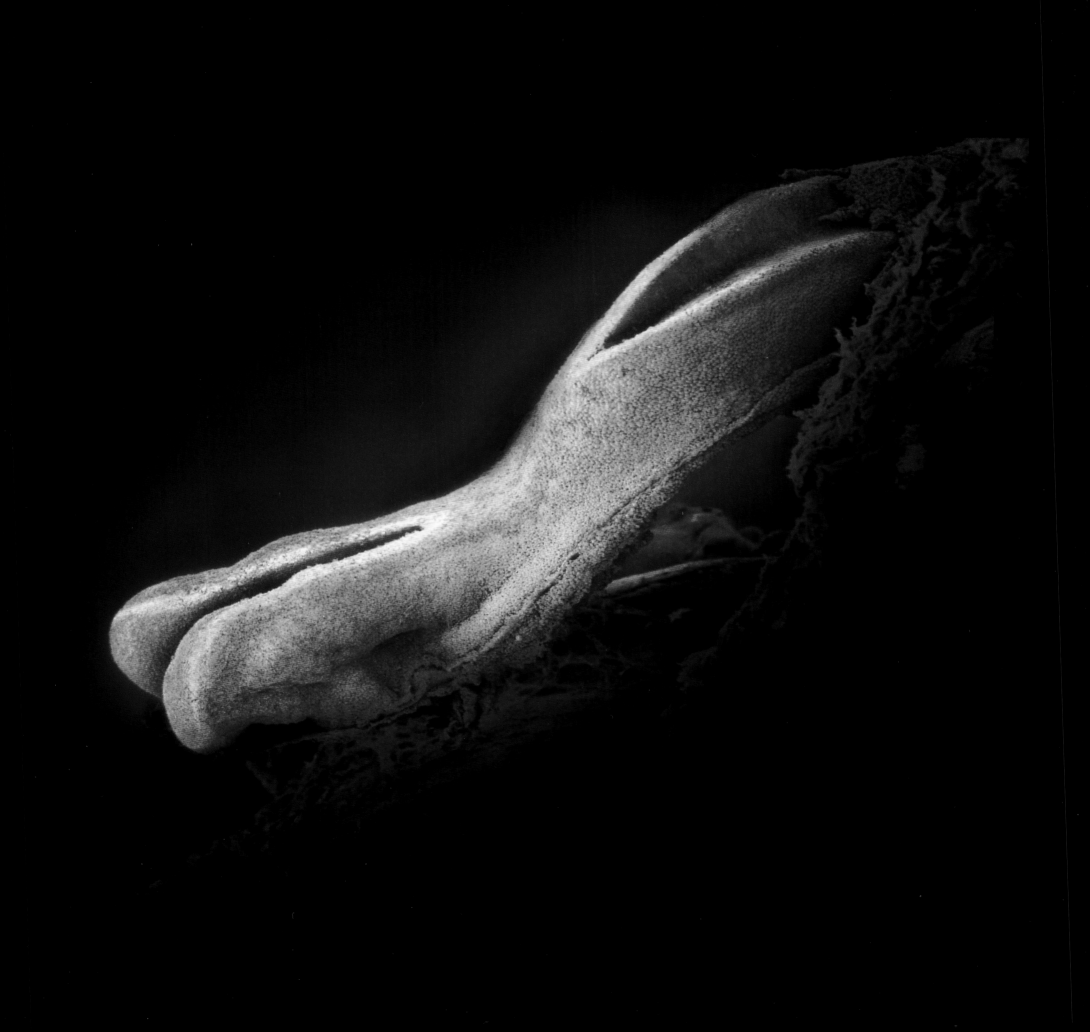

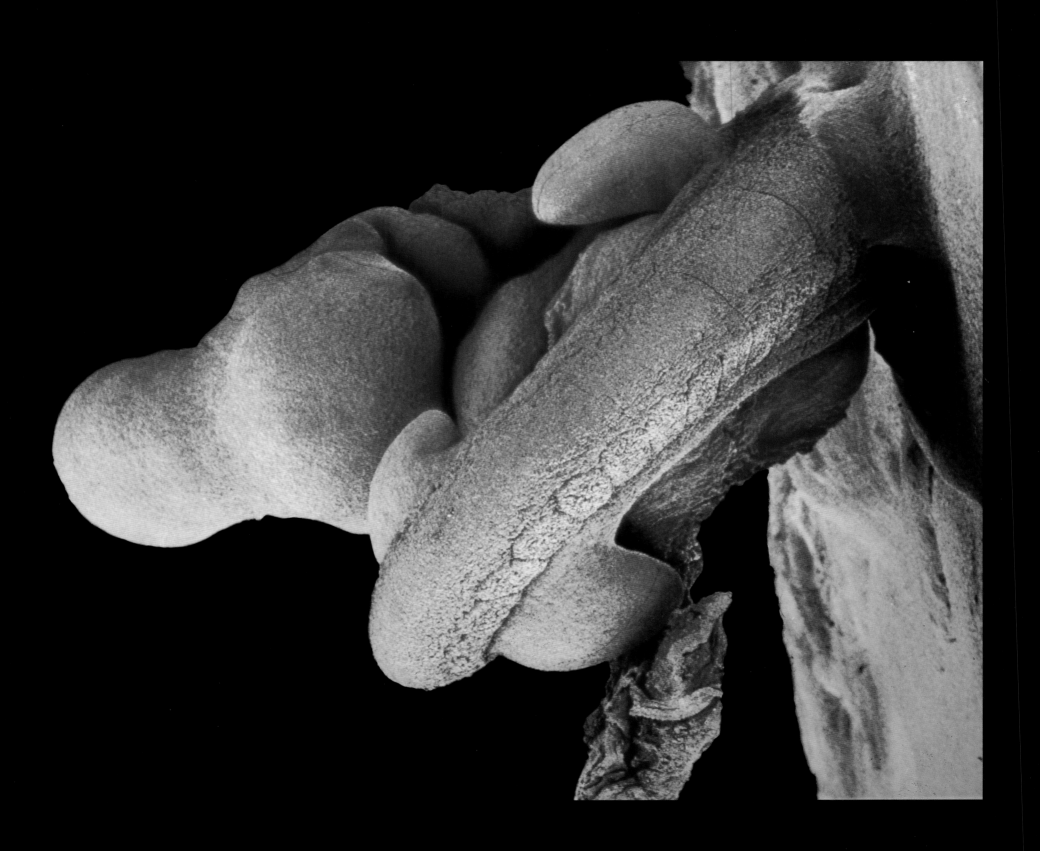

22 days: primitive nerve cells are already in place in the brain

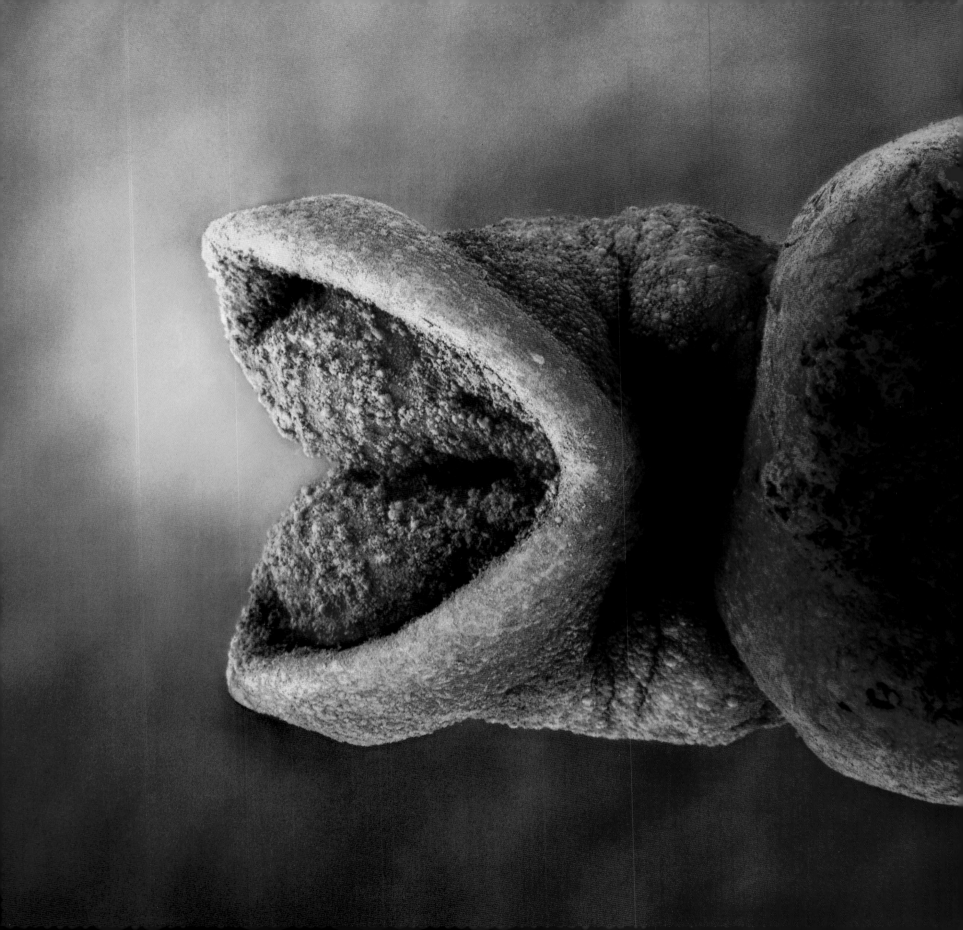

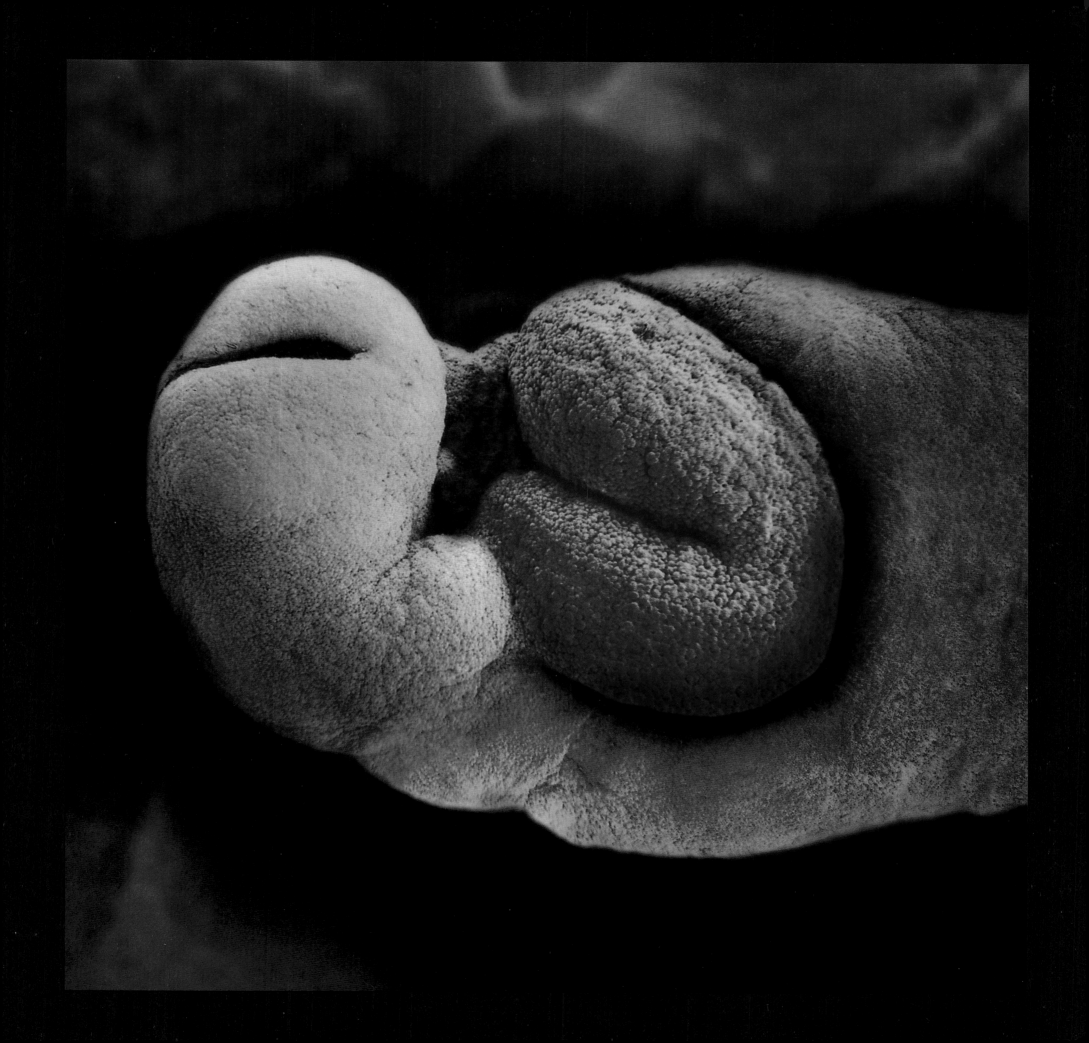

5 weeks: heart muscle cells

Blood corpuscles circulate in the capillaries of the placenta (following pages)

Blue corpuscles, indicating oxygen-depleted blood,
pass through the placenta from the embryo. Red corpuscles
carrying oxygen return to the embryo (pages 104–105)

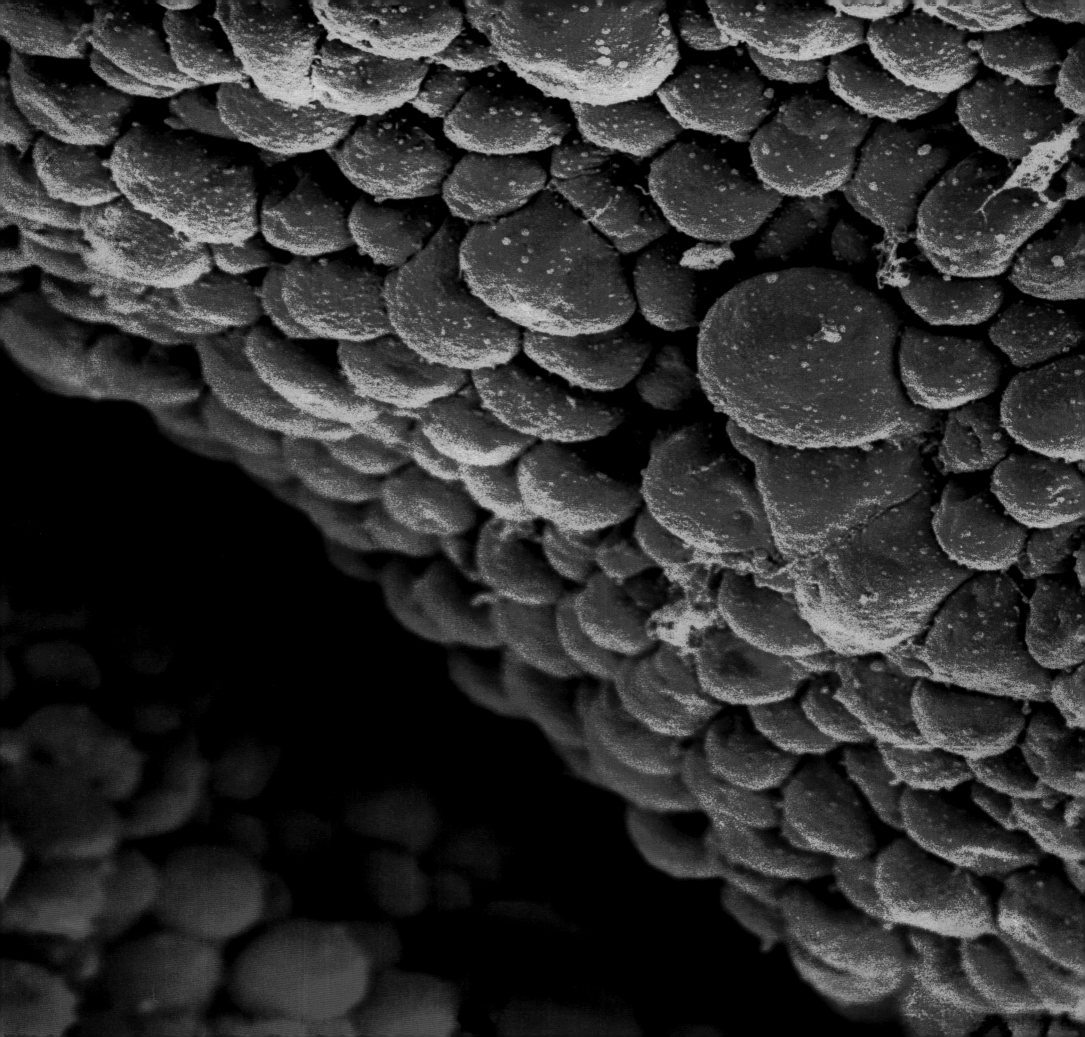

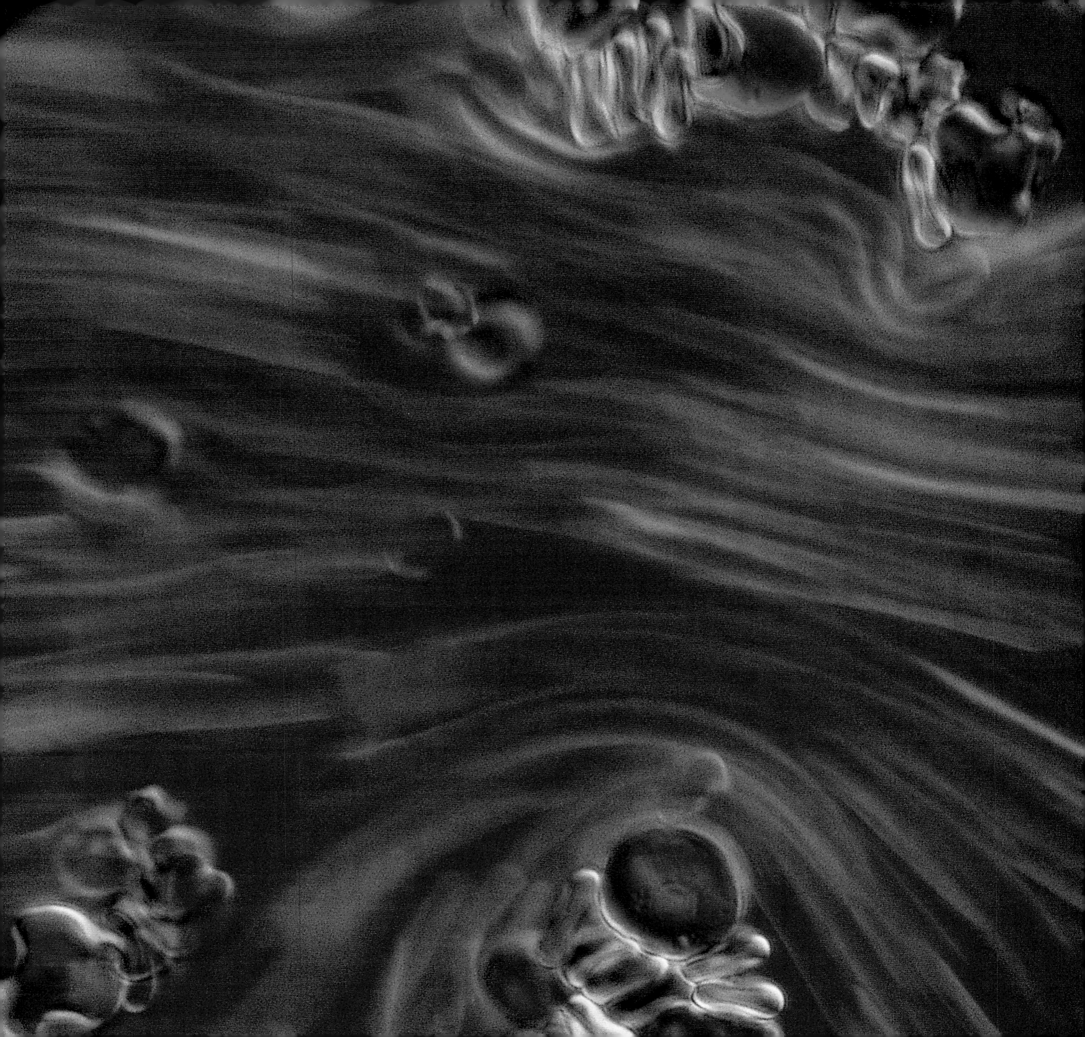

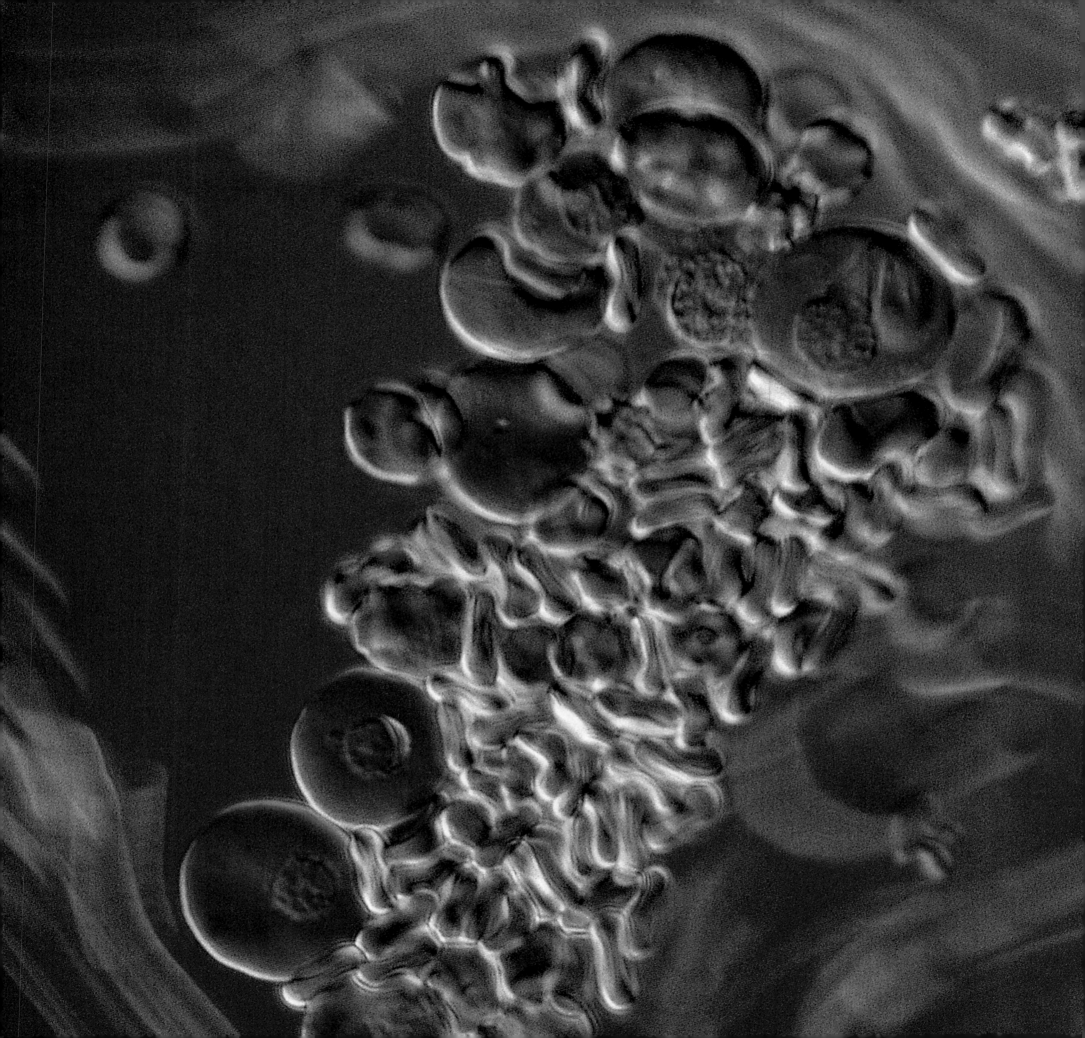

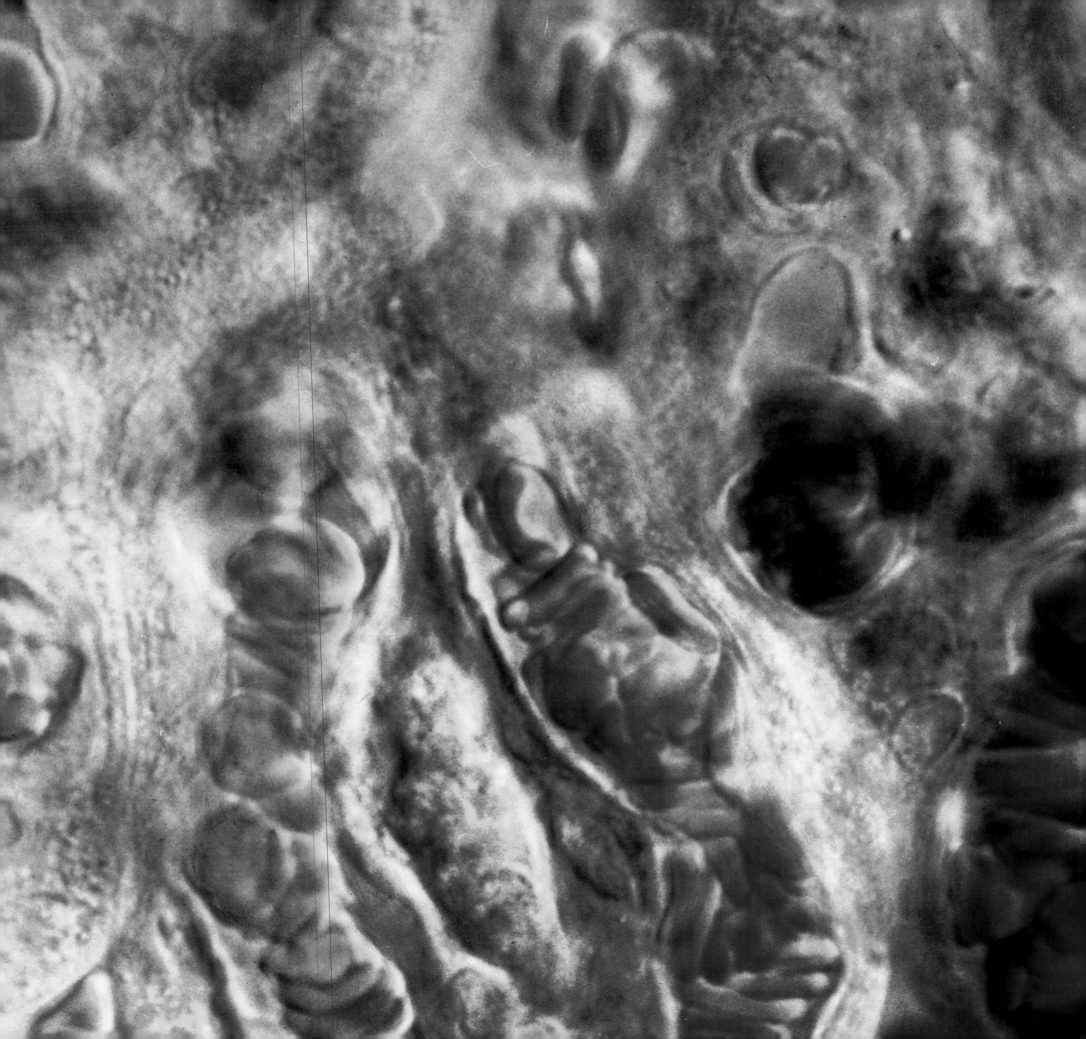

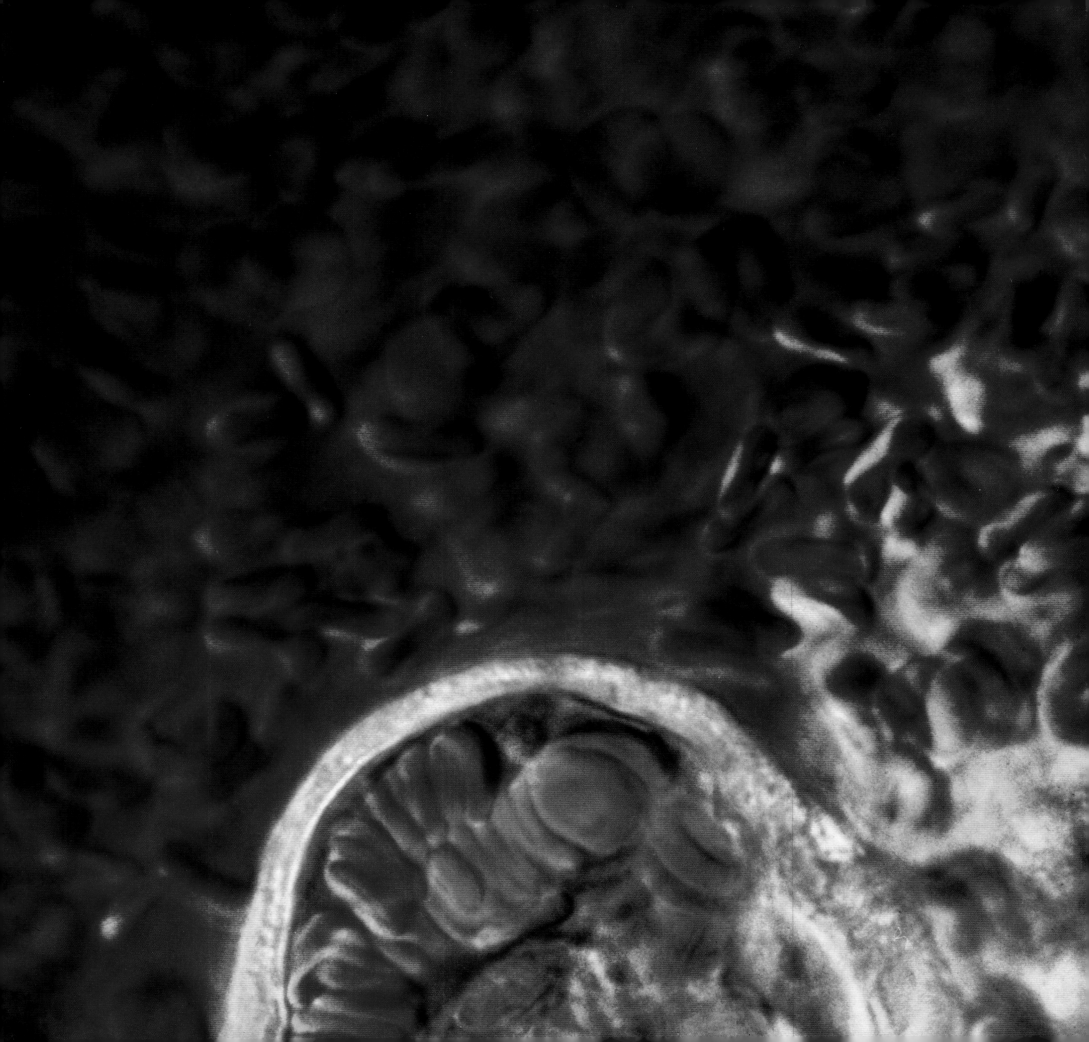

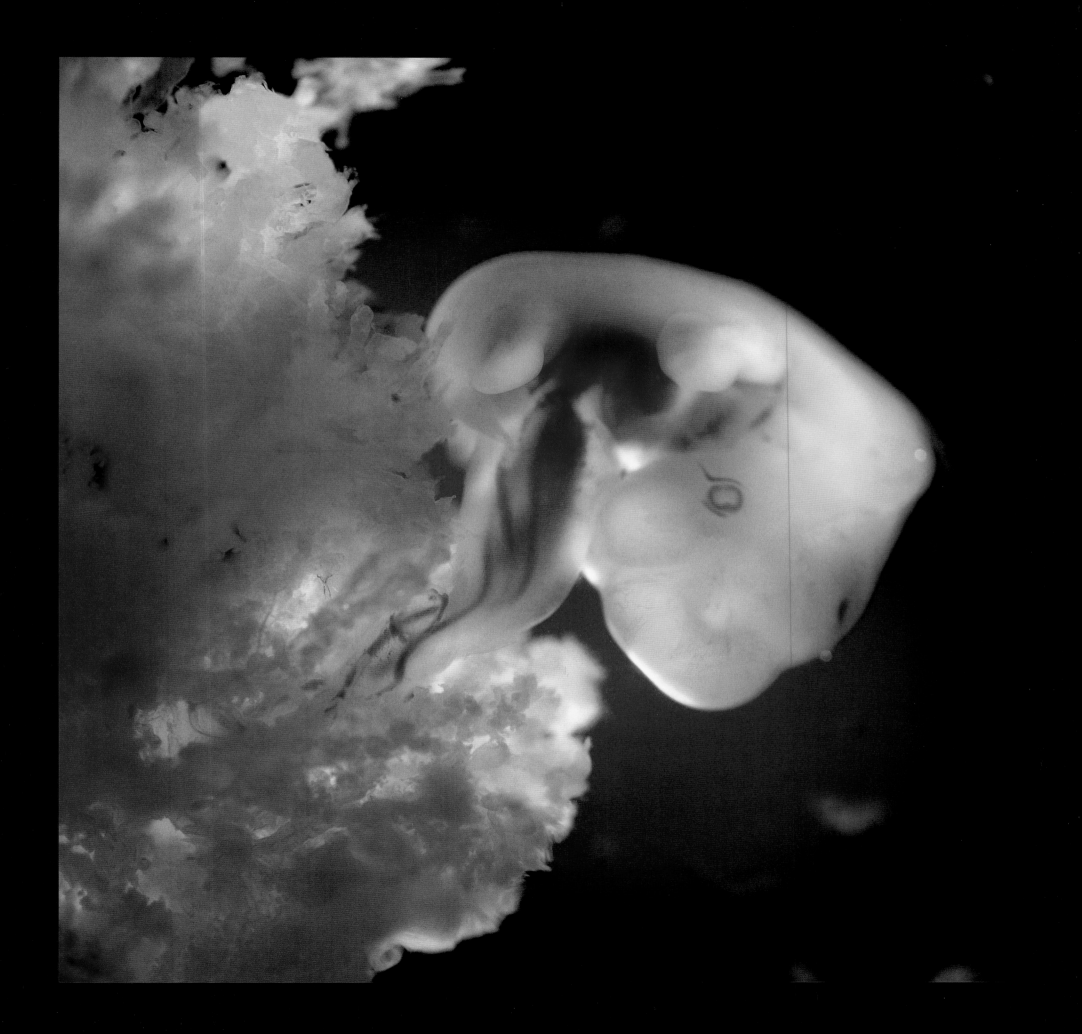

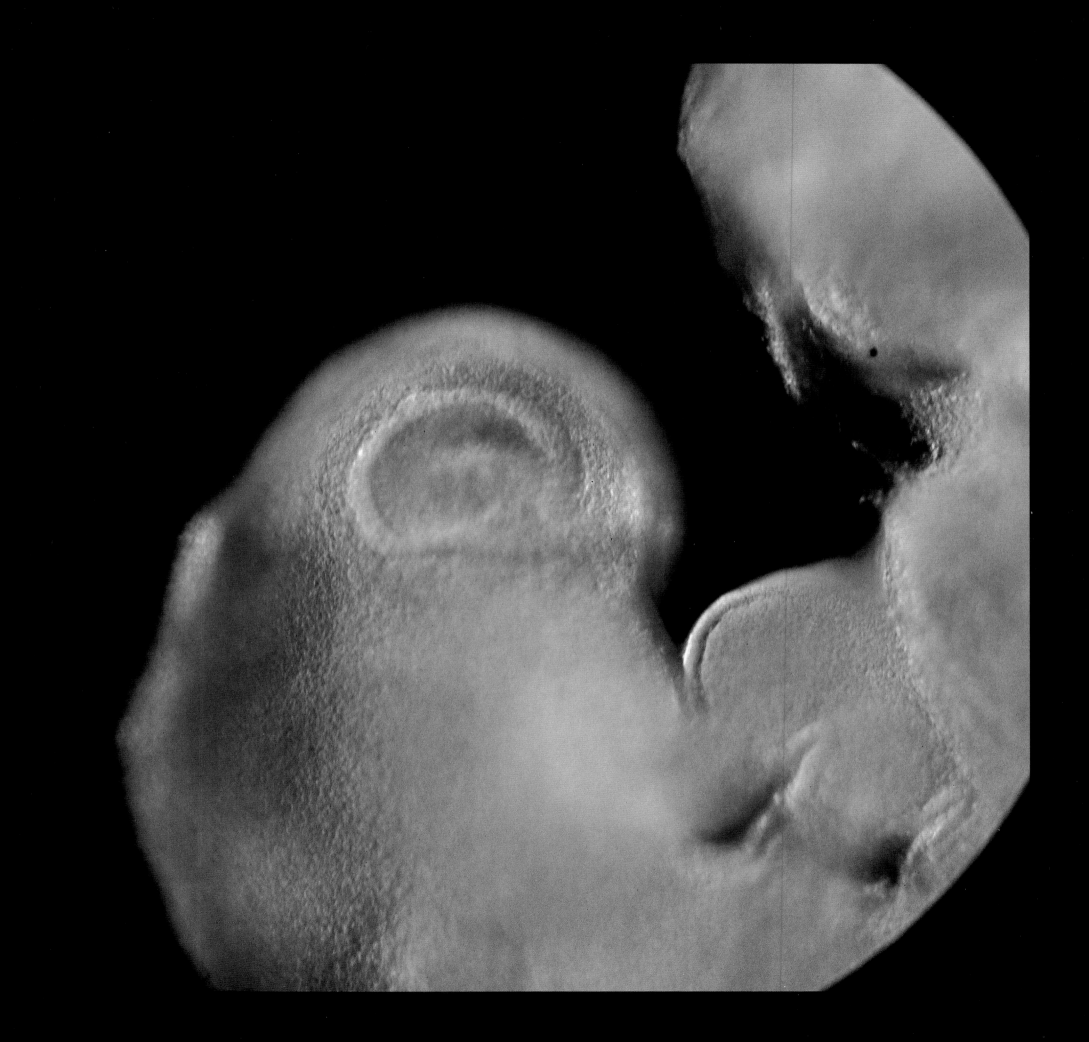

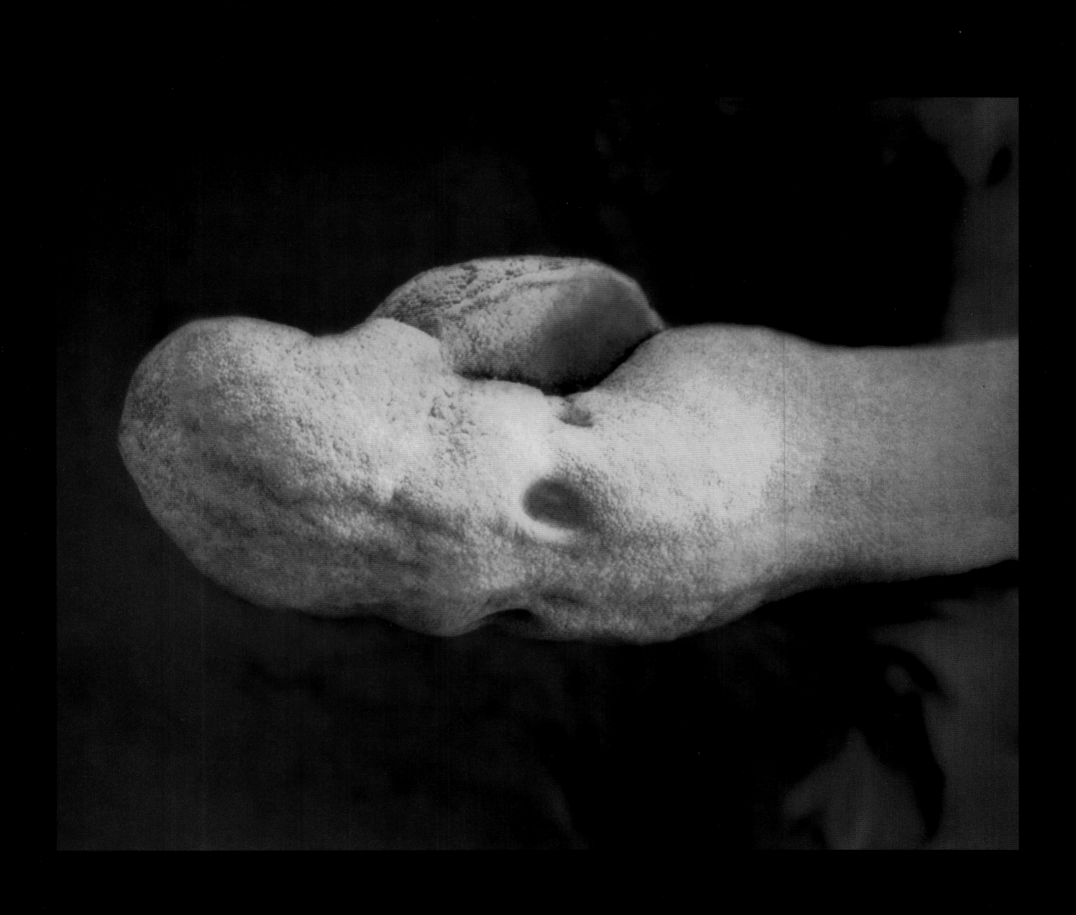

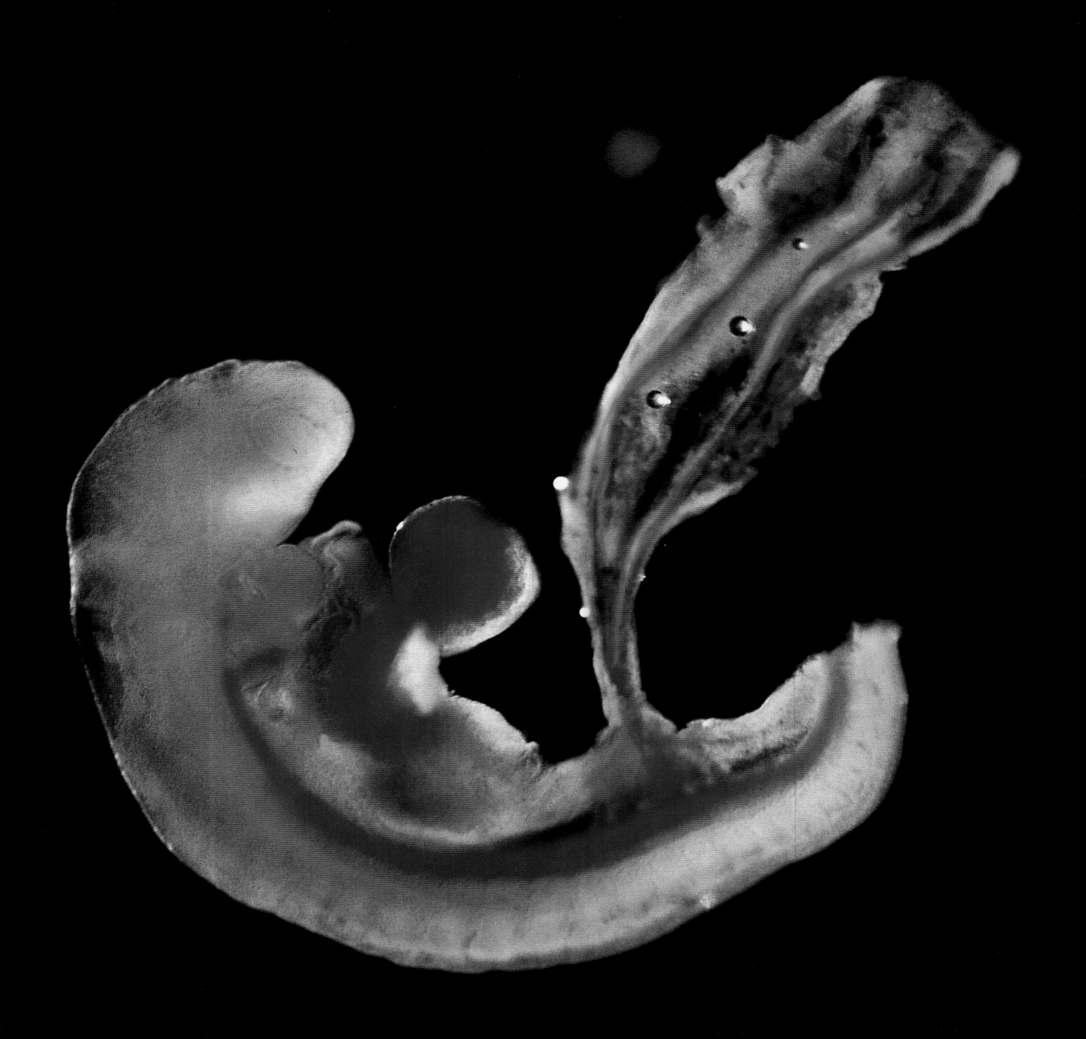

28 days: the vertebral column of the spine.
The yolk-sac on the left influences the development of the genitals

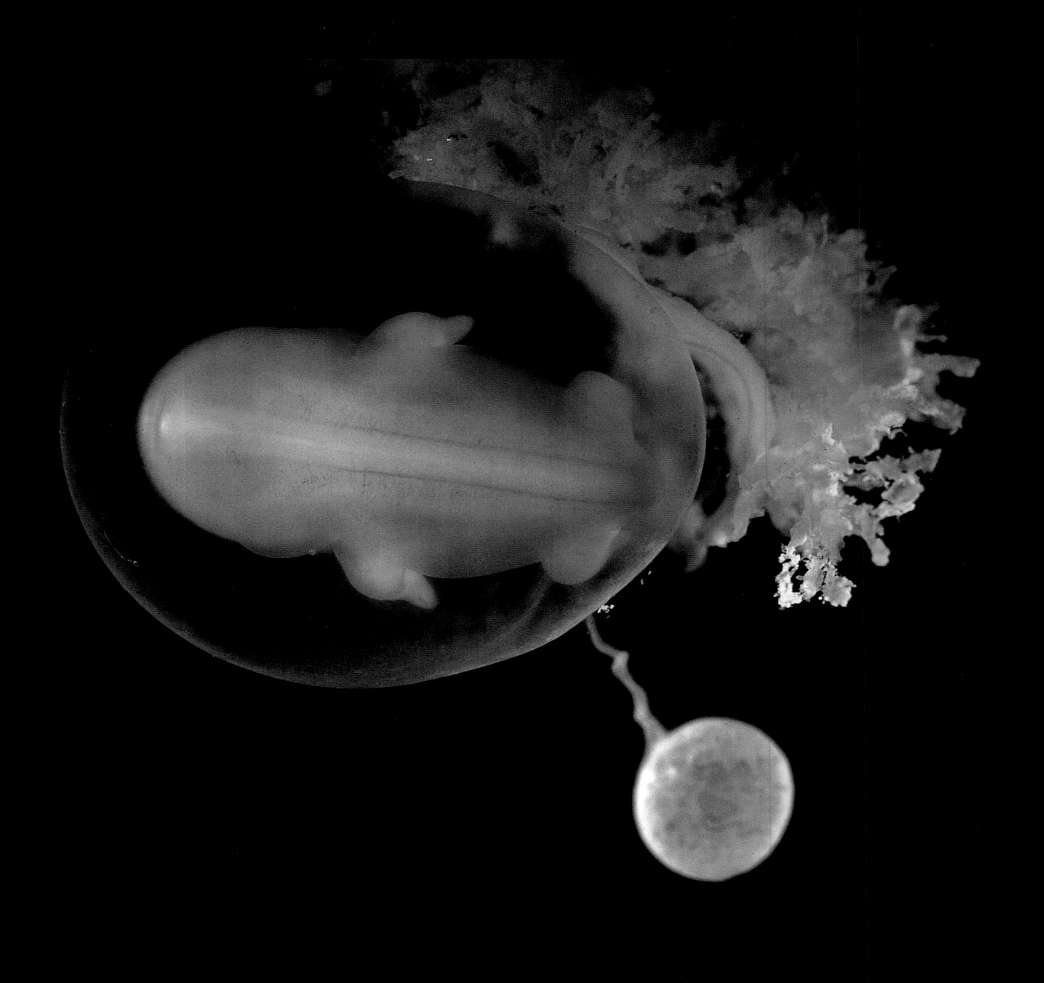

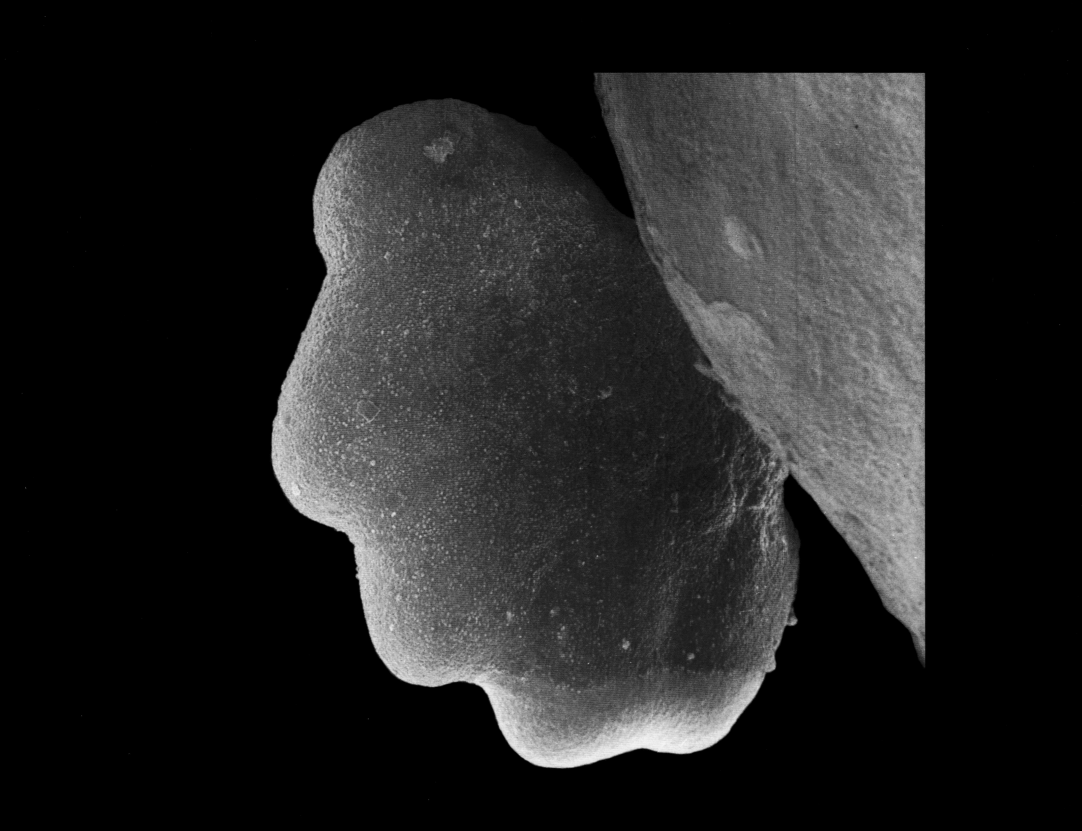

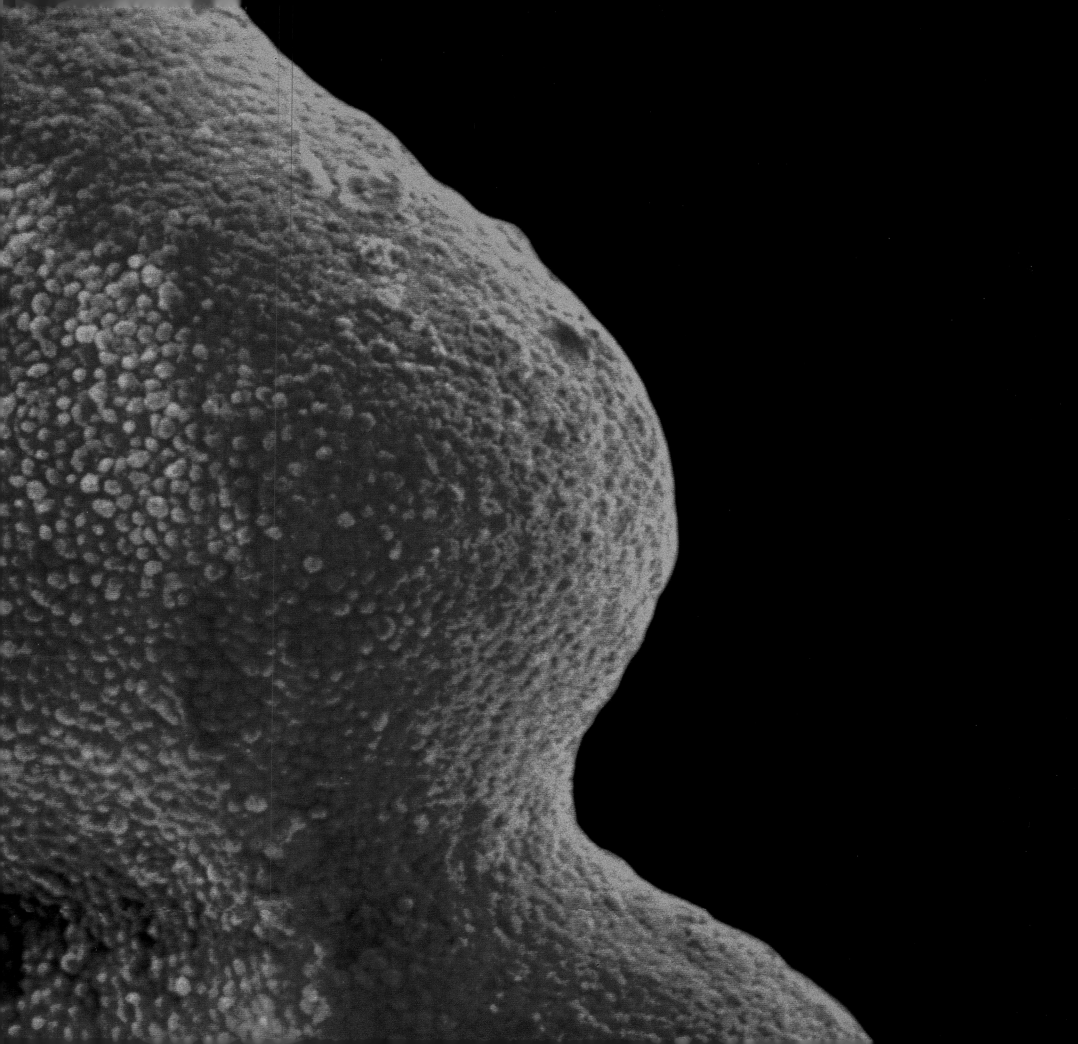

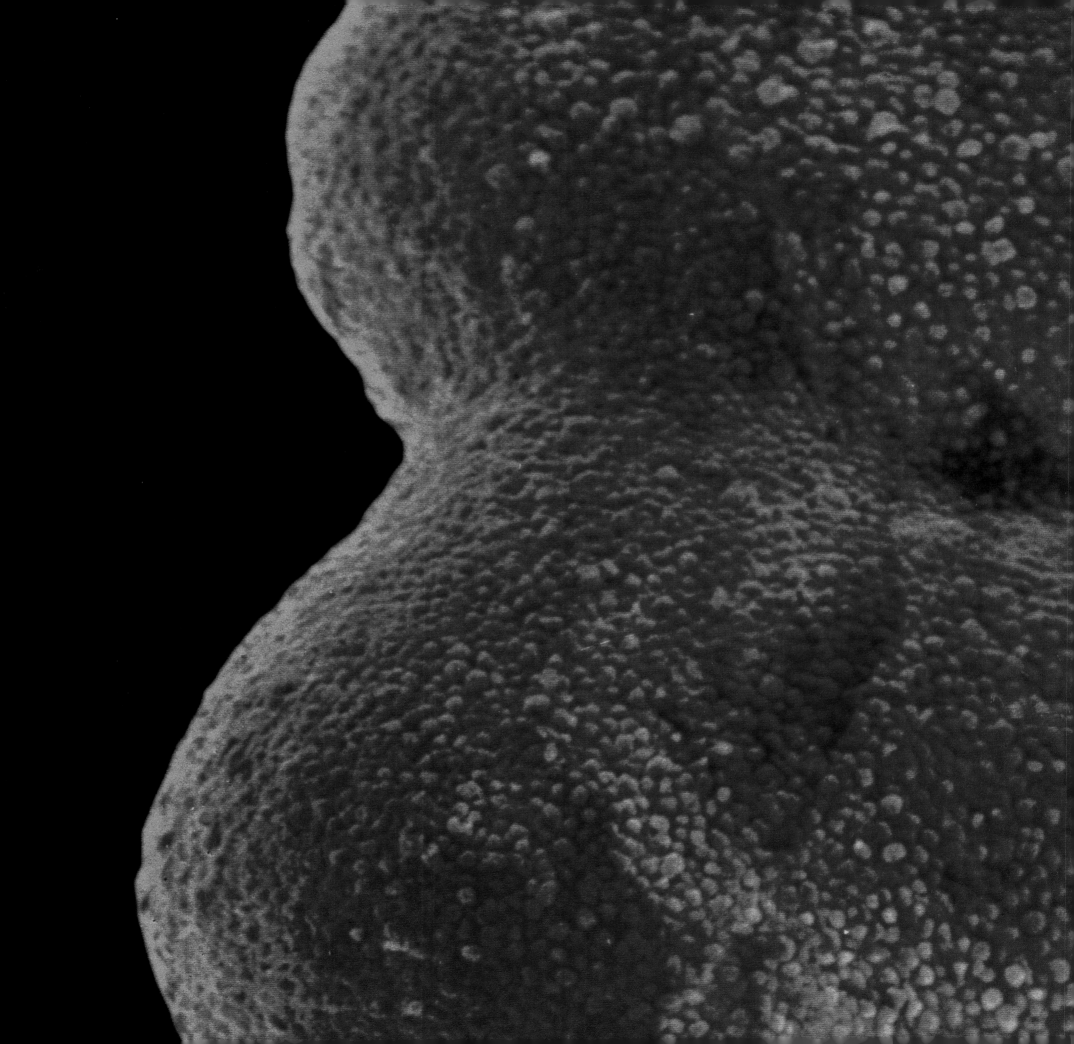

11 weeks: fingers emerge. At the beginning of the 10th week after fertilization, all the body organs are in place and the embryo becomes a fetus

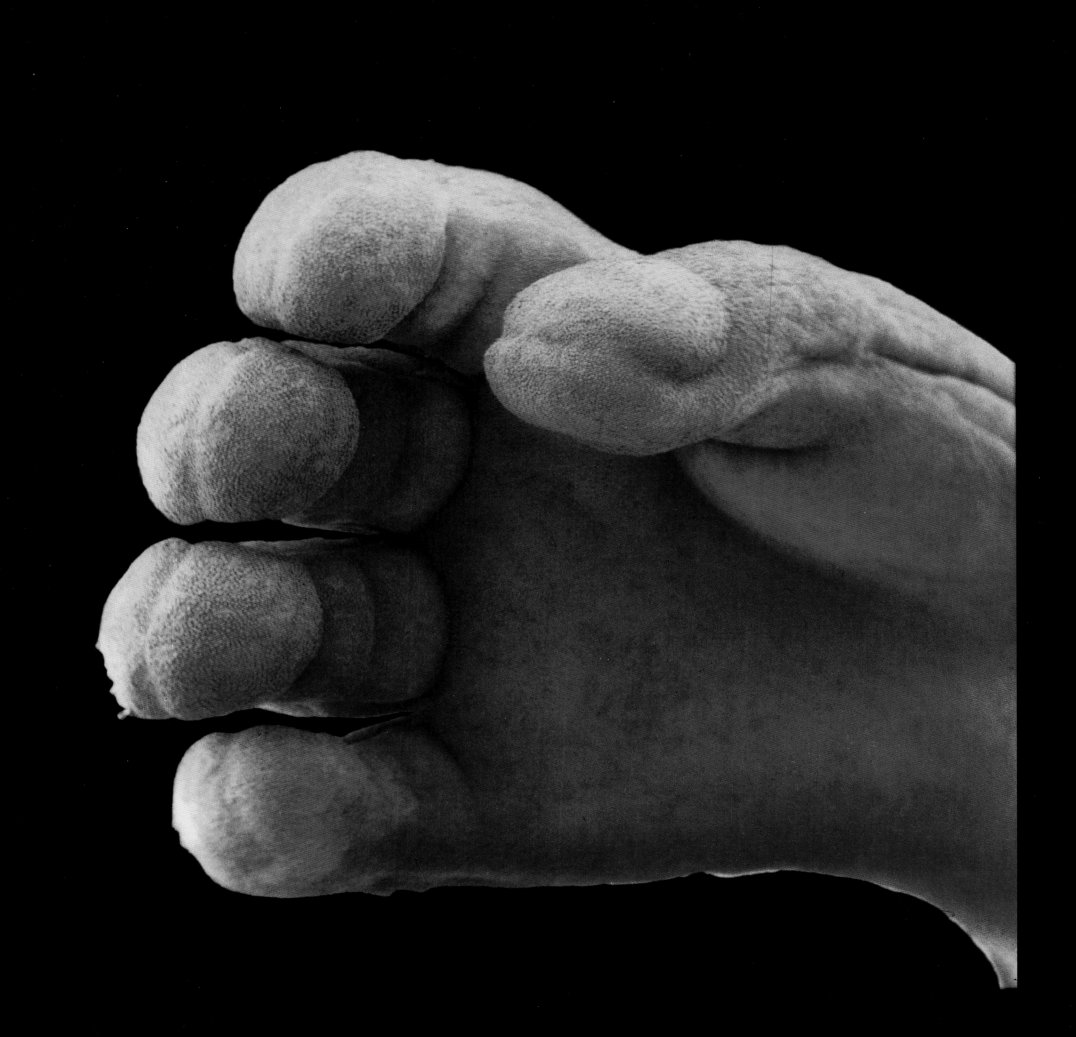

9 weeks: external sex organs of both sexes are still similar

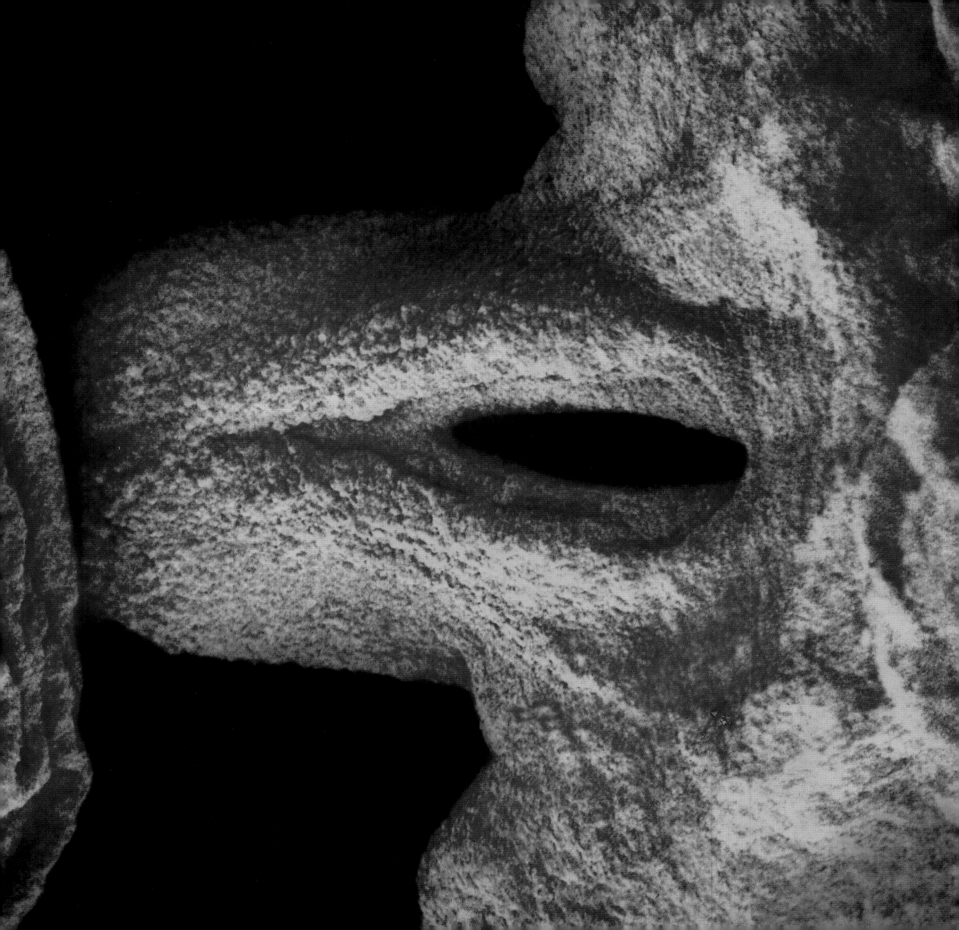

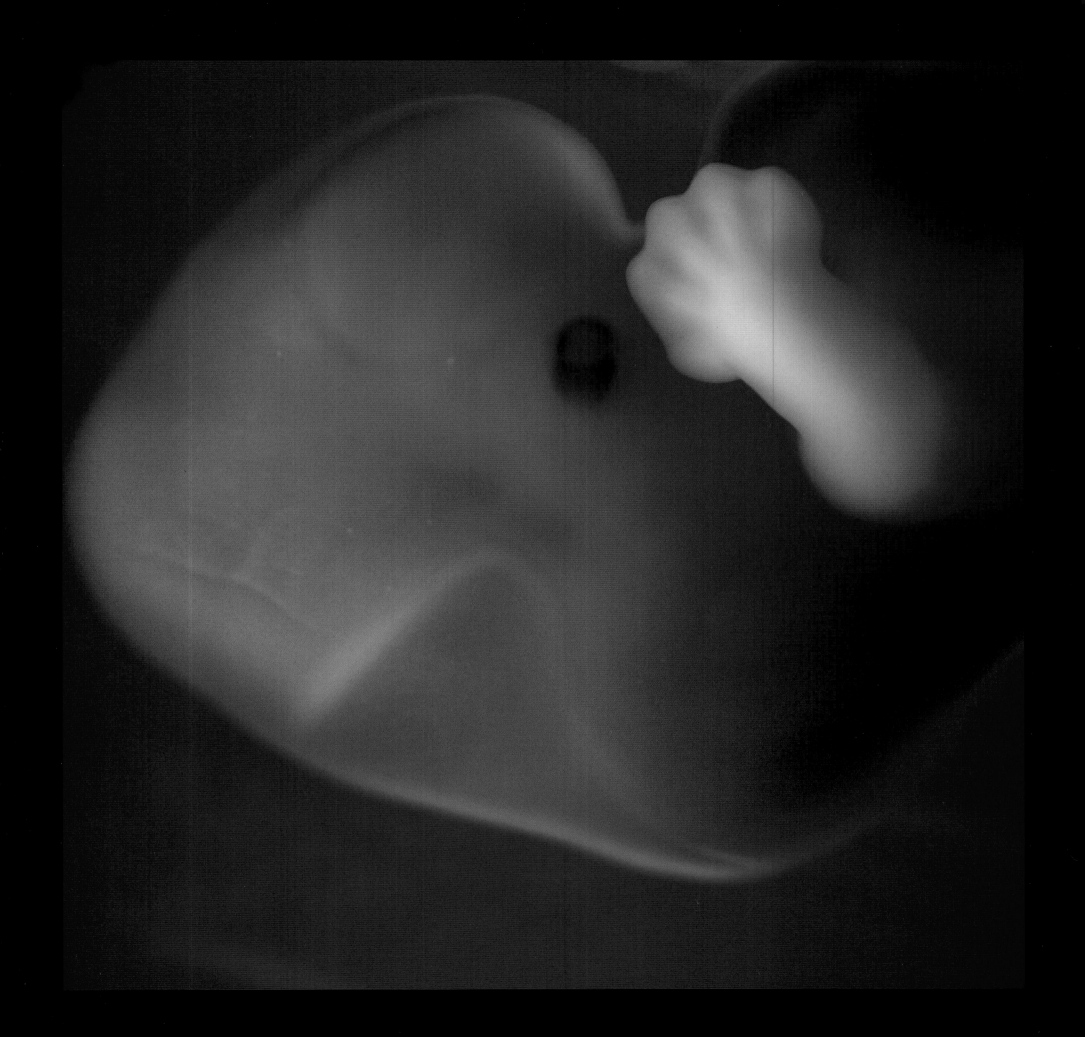

THE FETUS

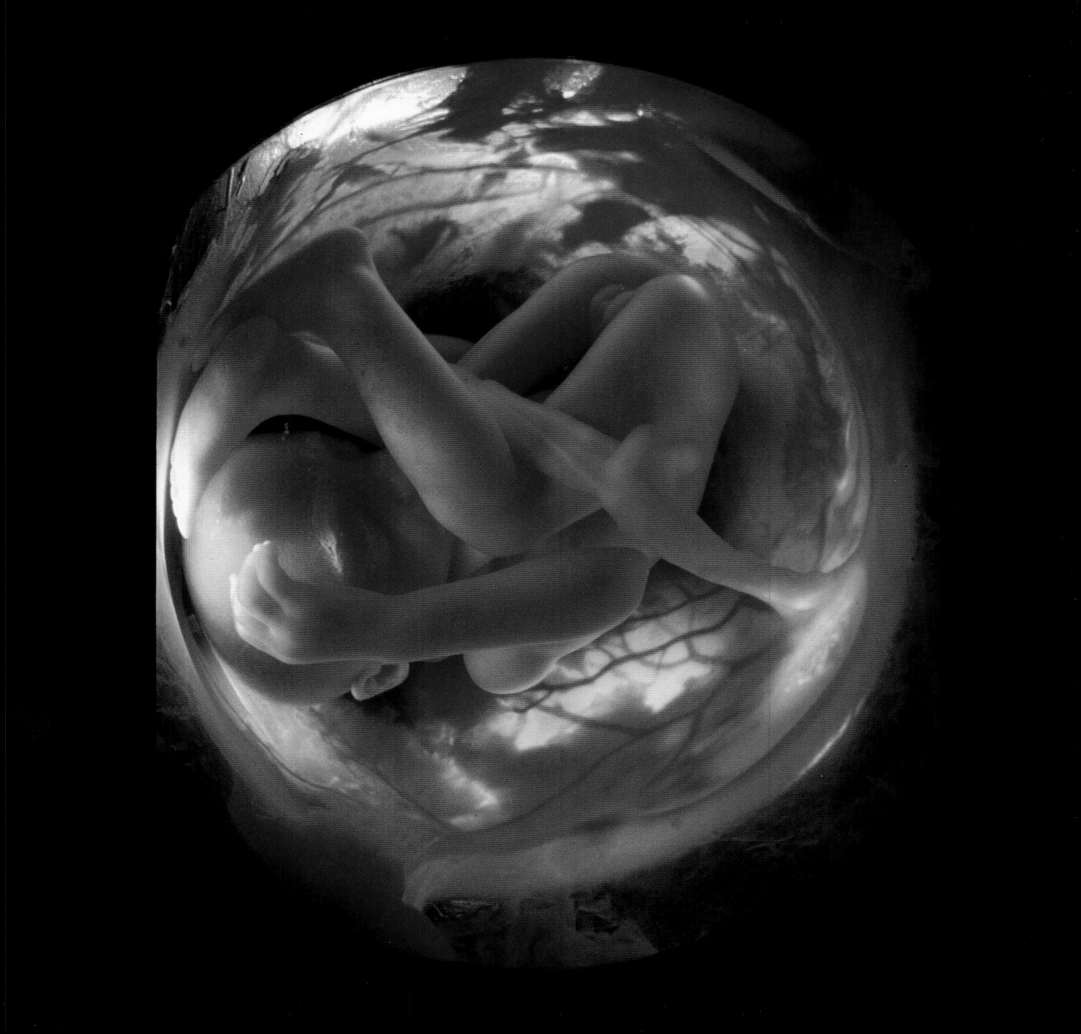

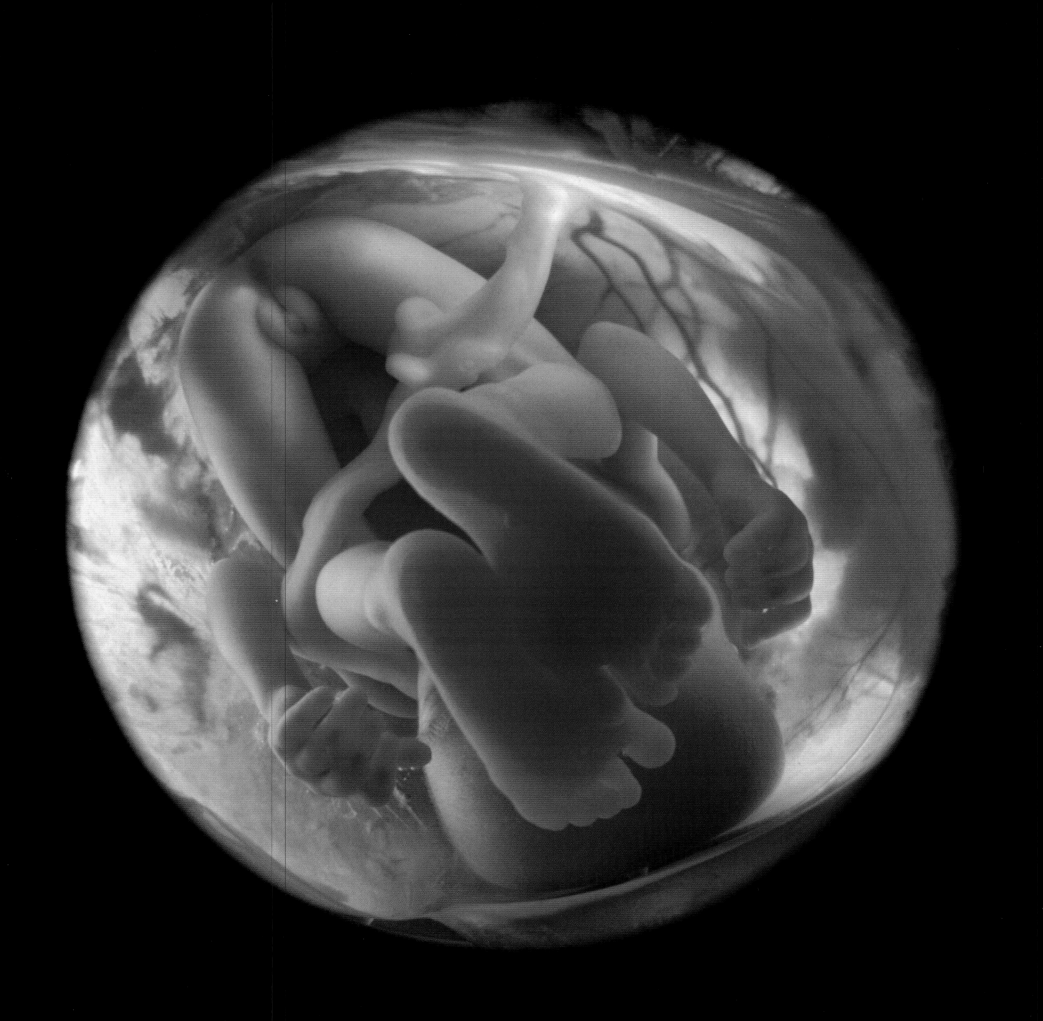

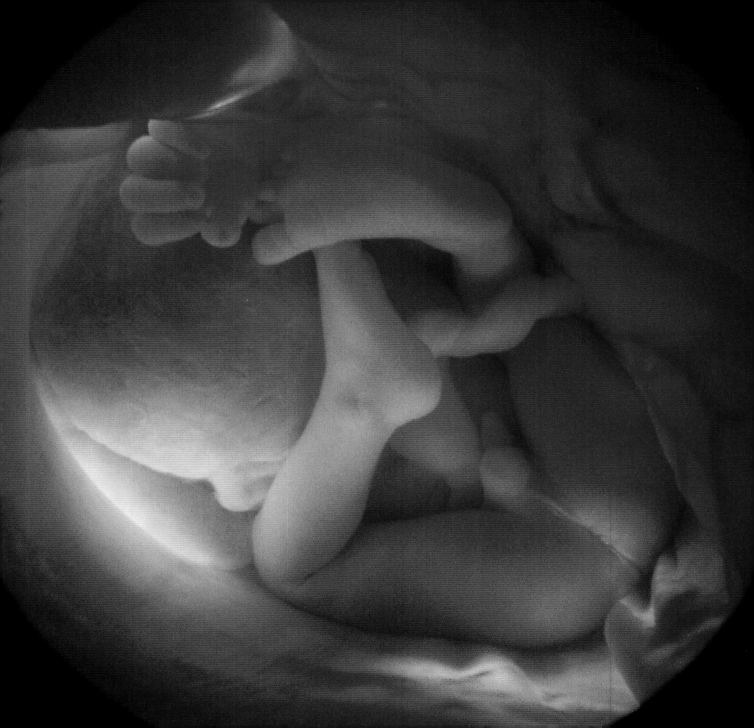

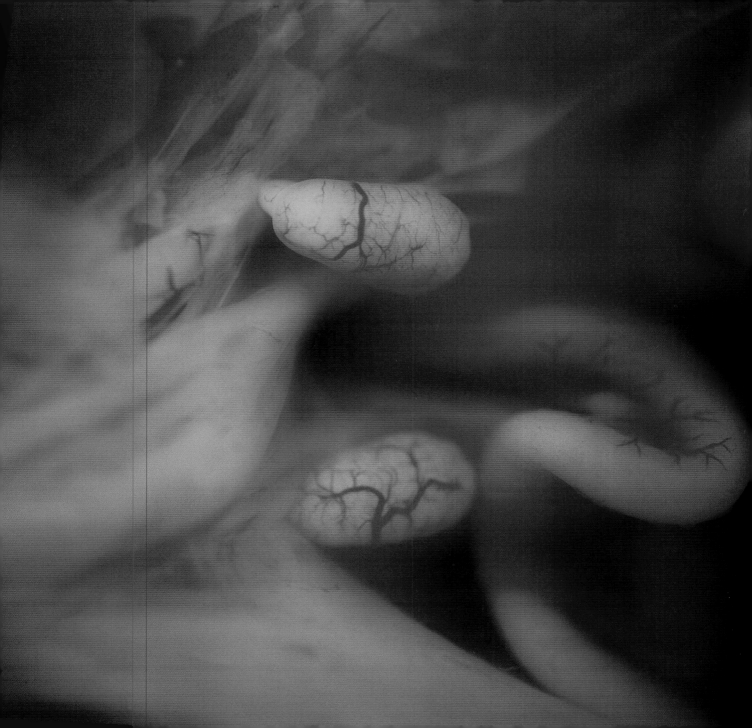

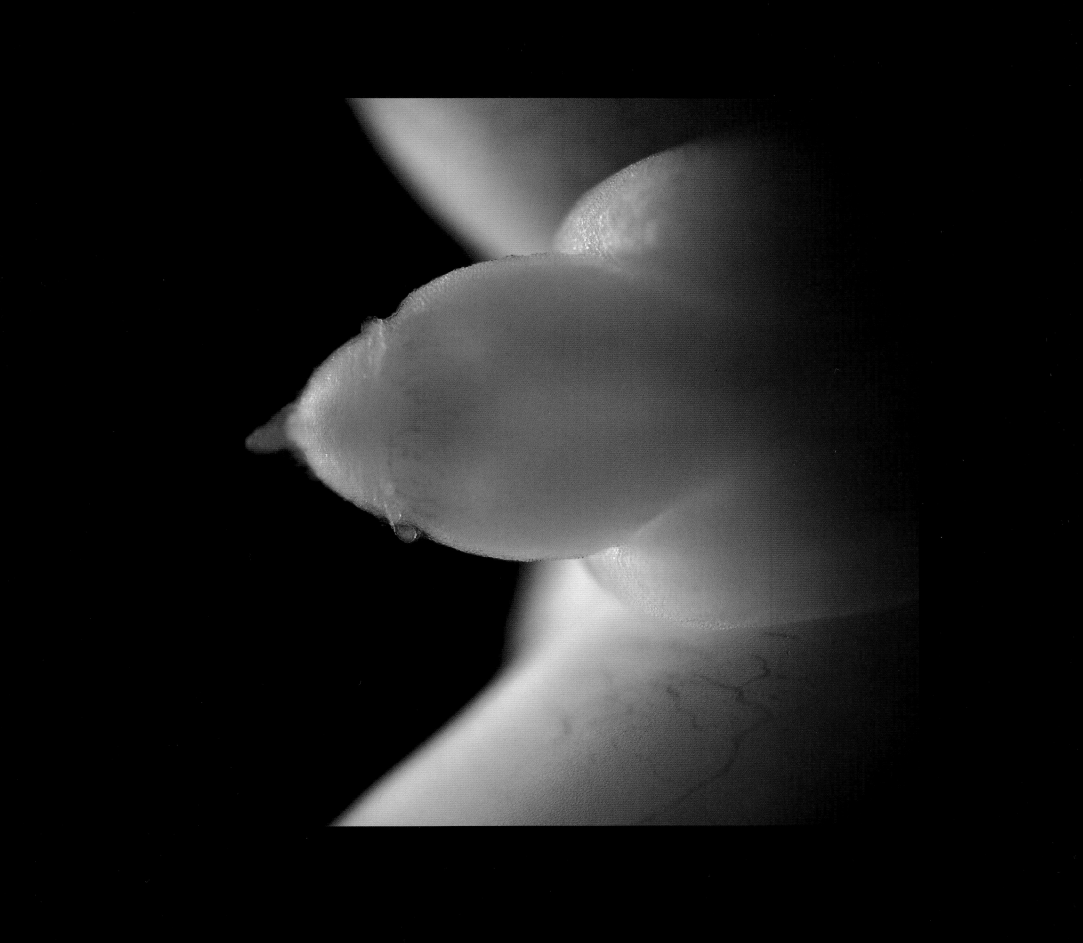

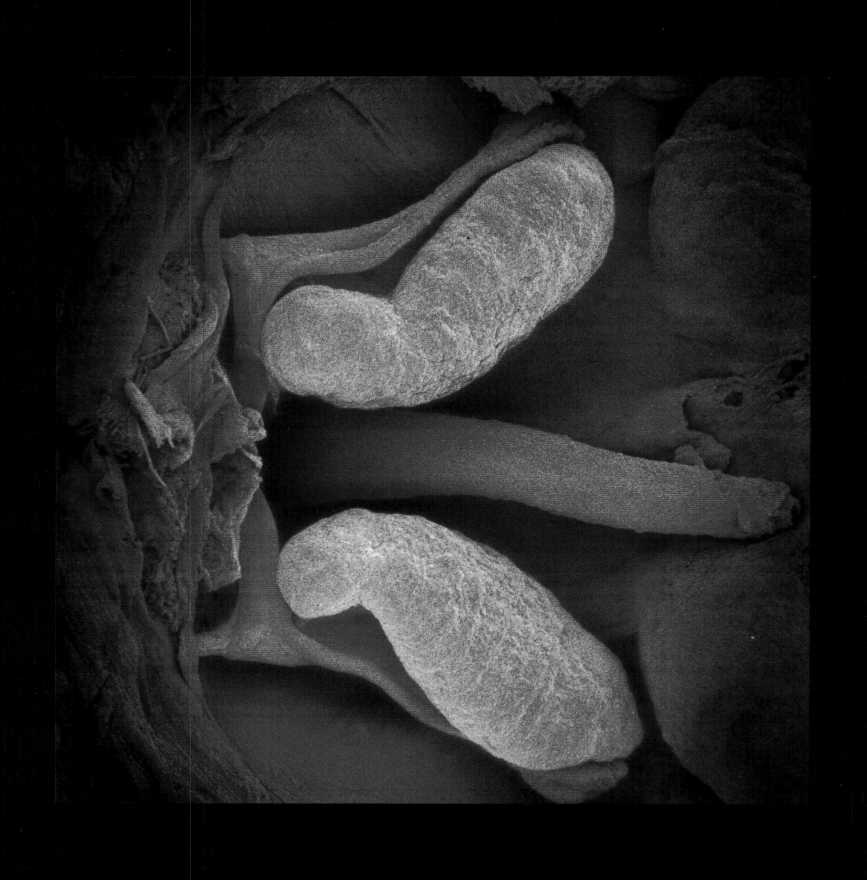

20 weeks: the fetal ovaries

20 weeks: the fetal clitoris (opposite)

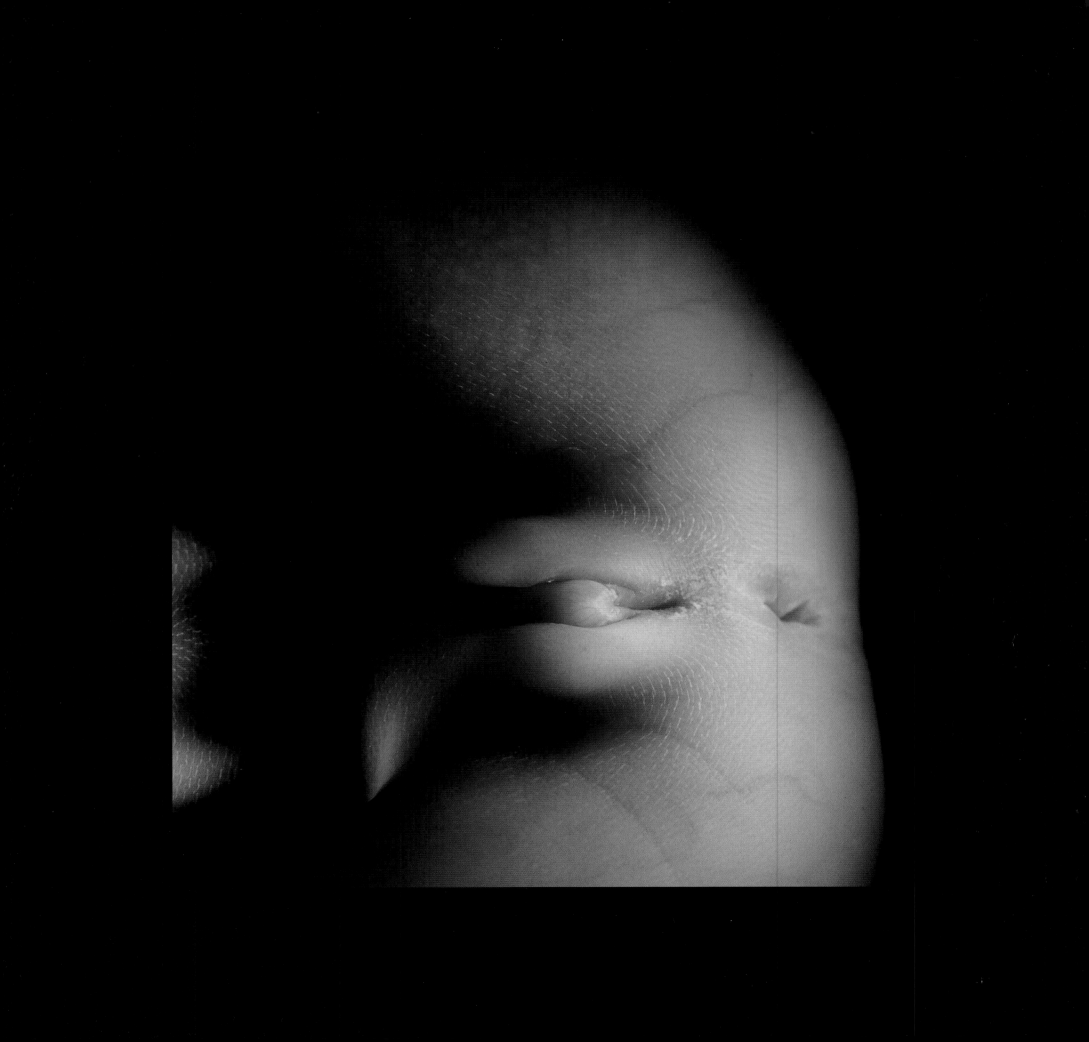

4 months: the yolk-sac above the embryo

10 weeks: the umbilical cord with one artery and two veins (page 138)

13 weeks: the calcification process begins in the arm and leg bones (page 139)

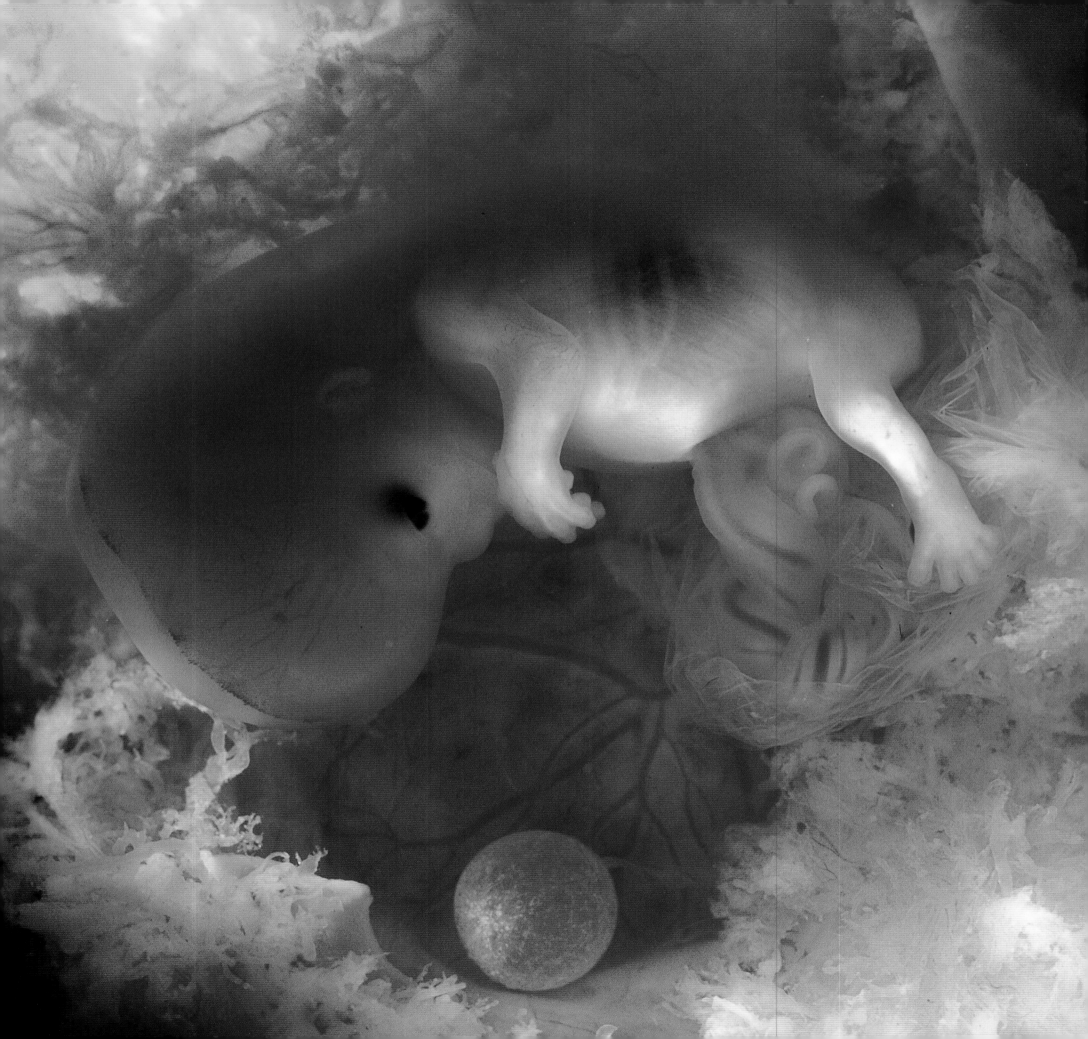

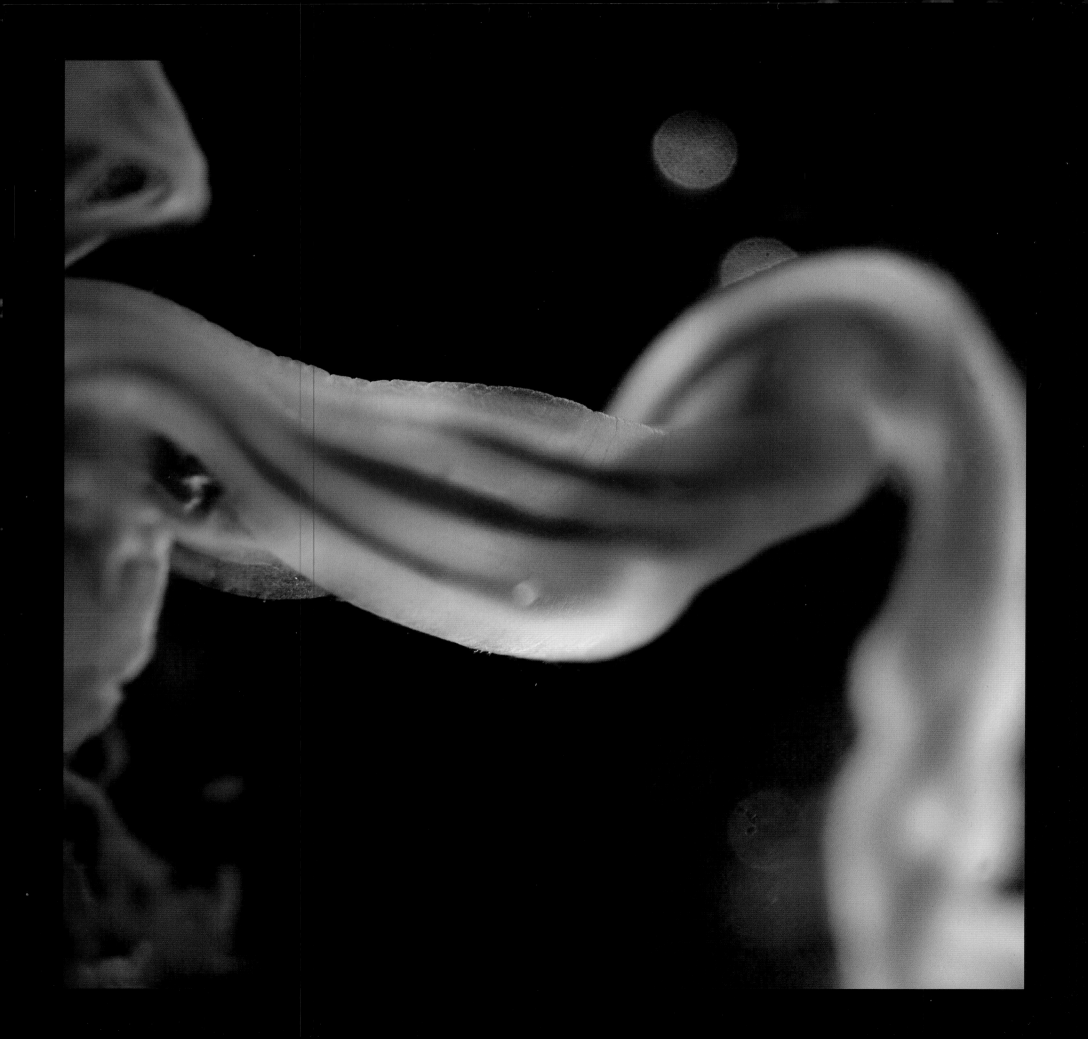

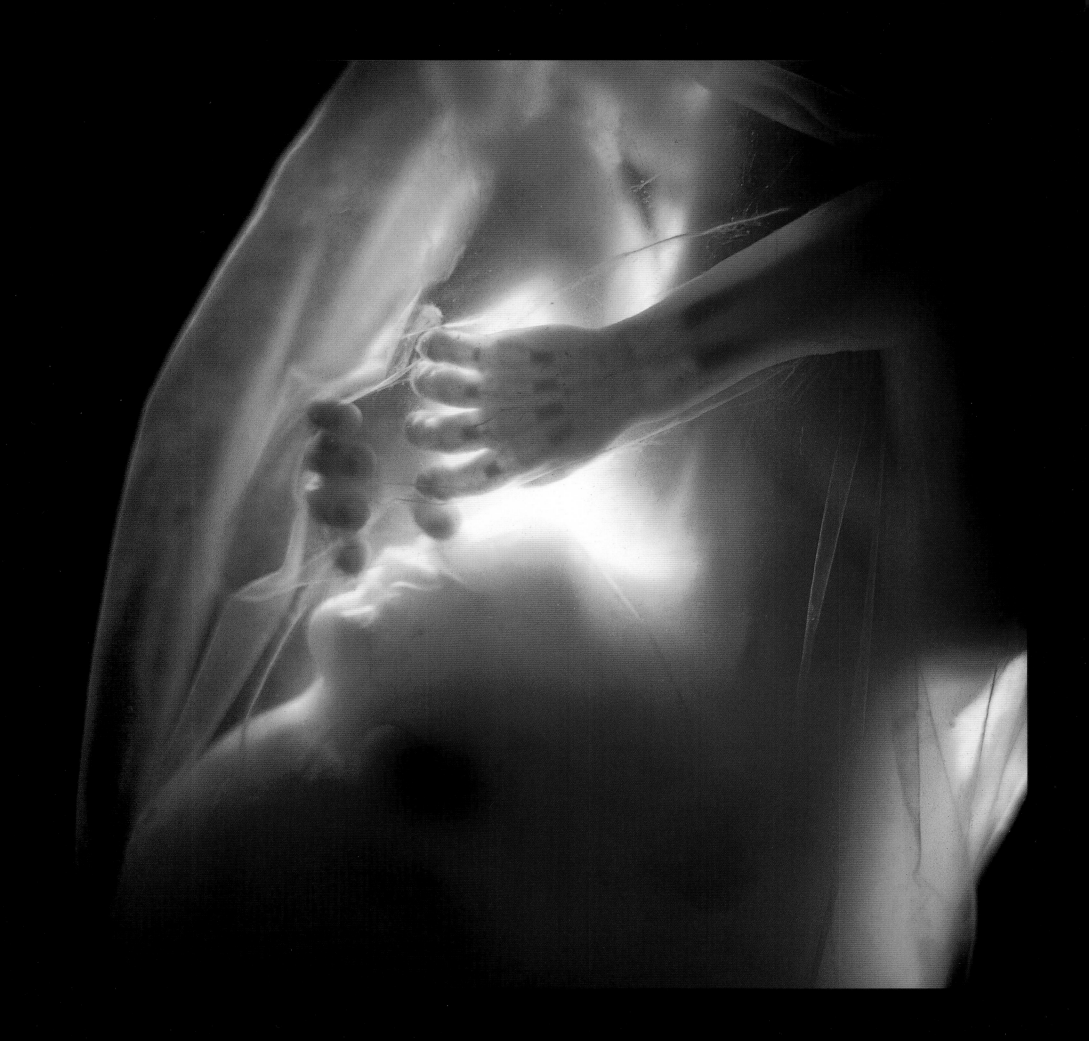

6 months (page 142) and 5 months (page 143)

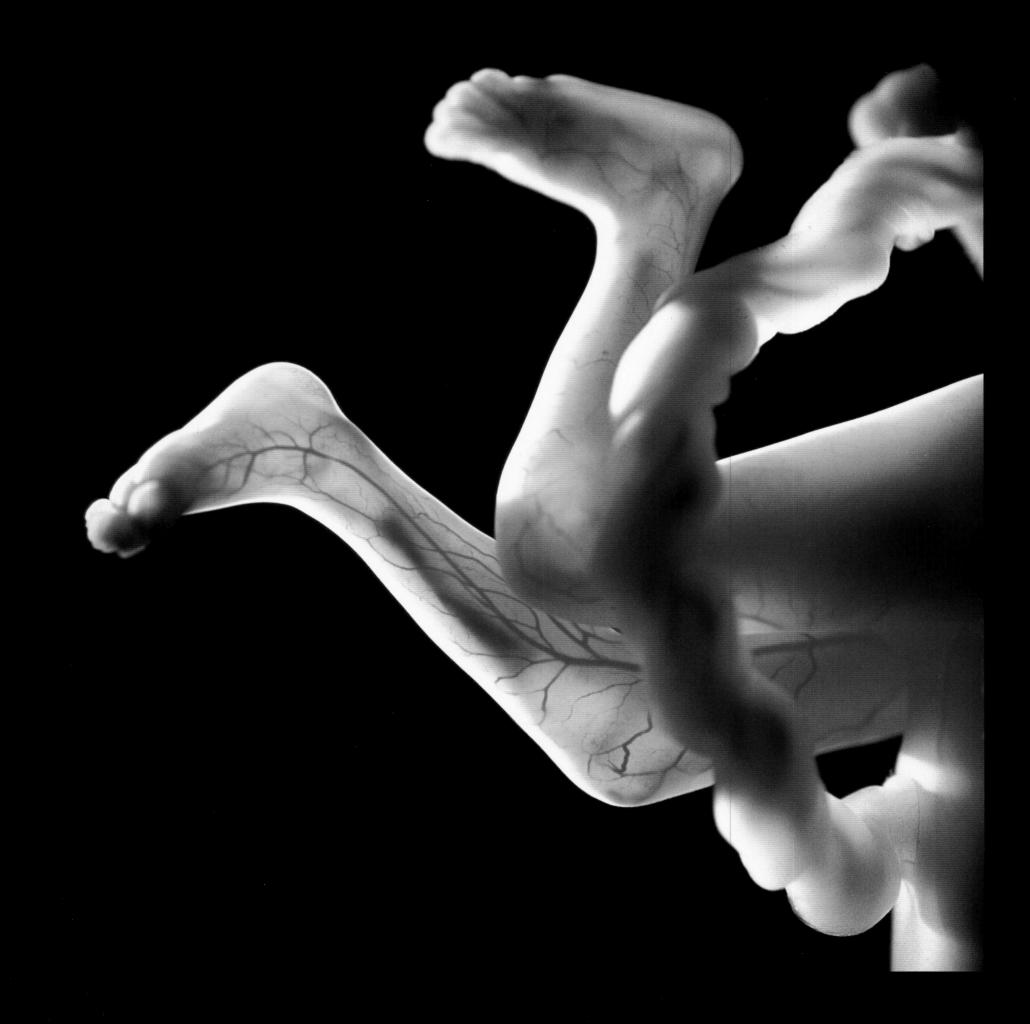

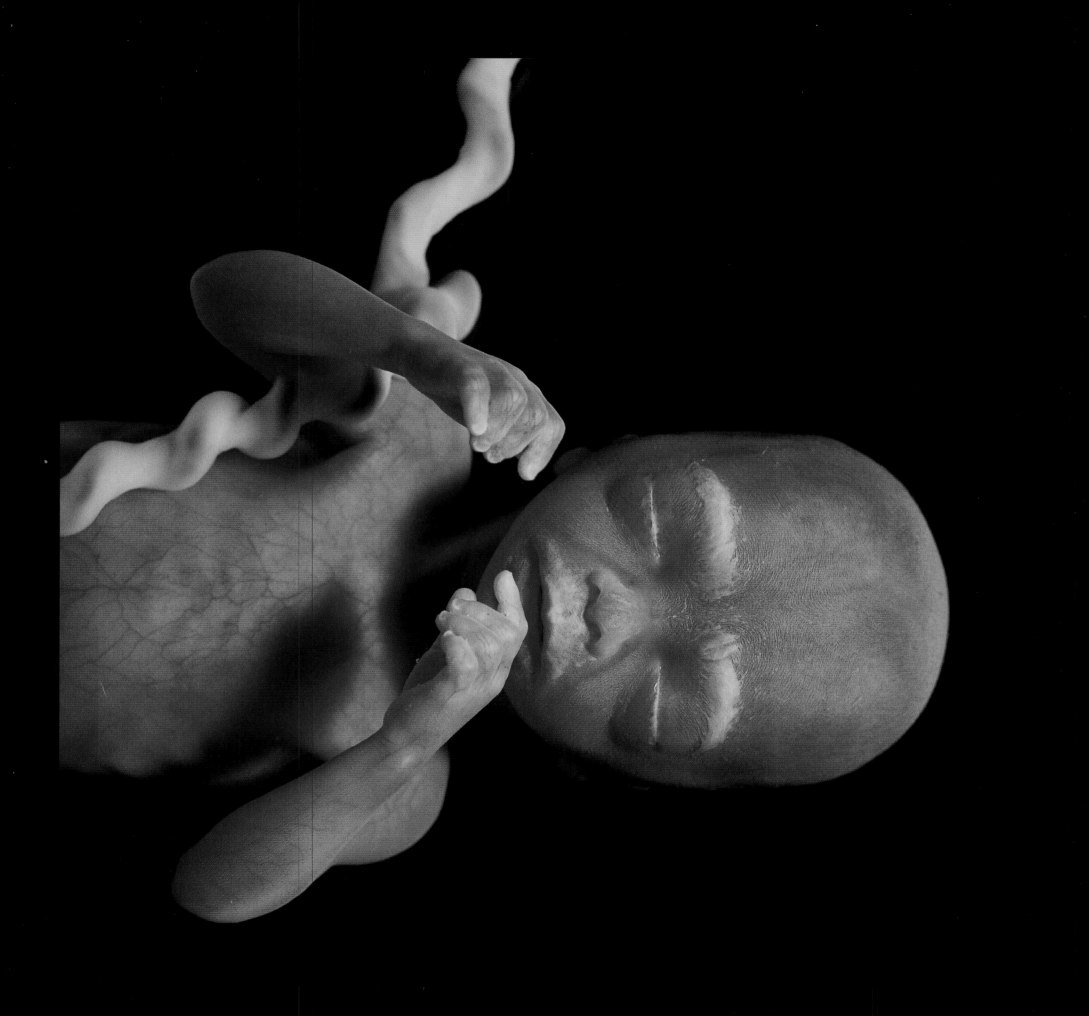

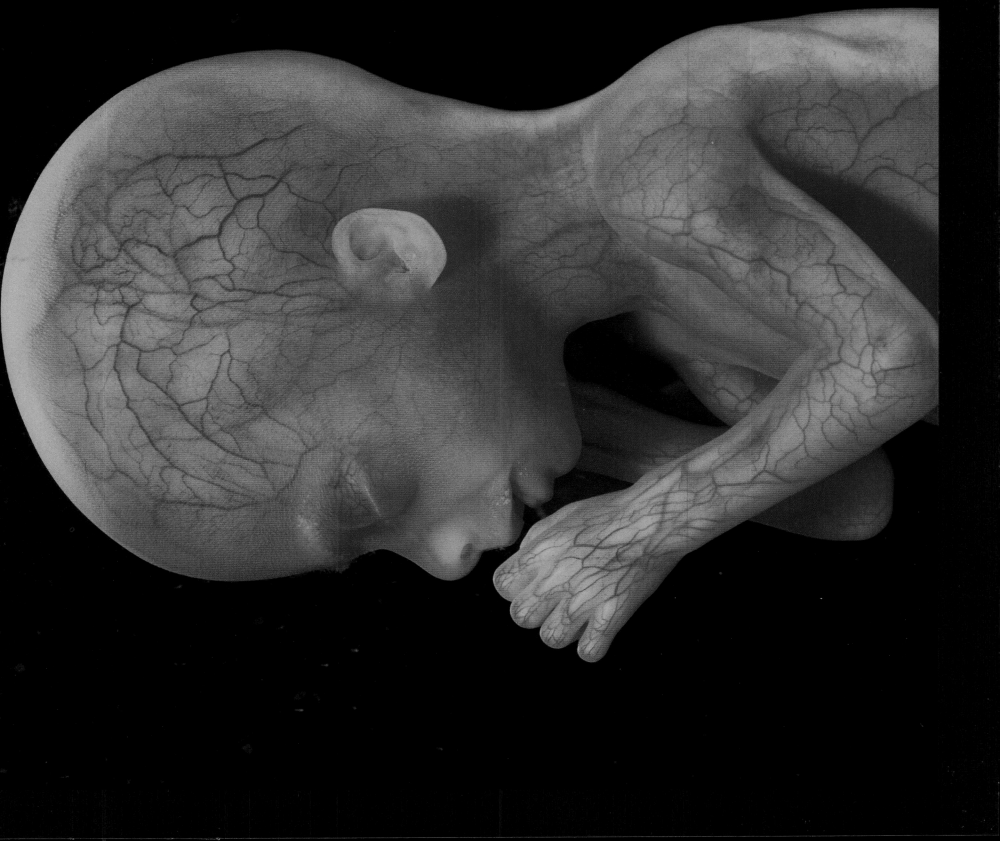

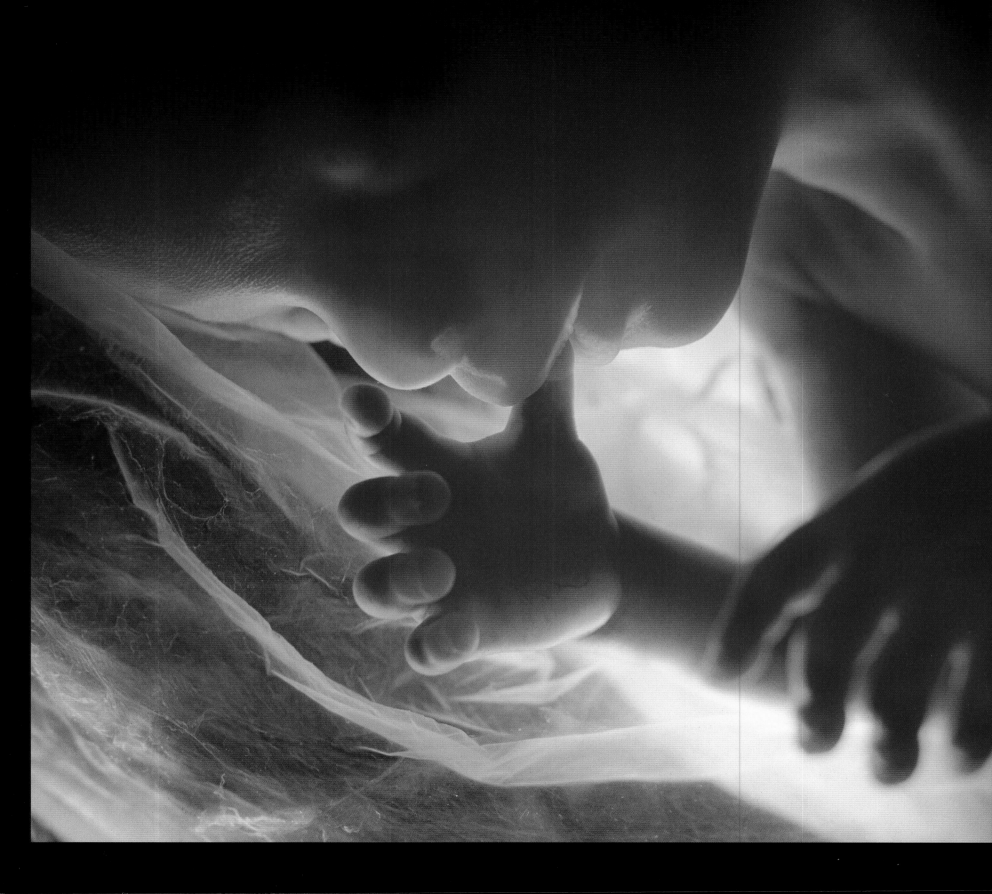

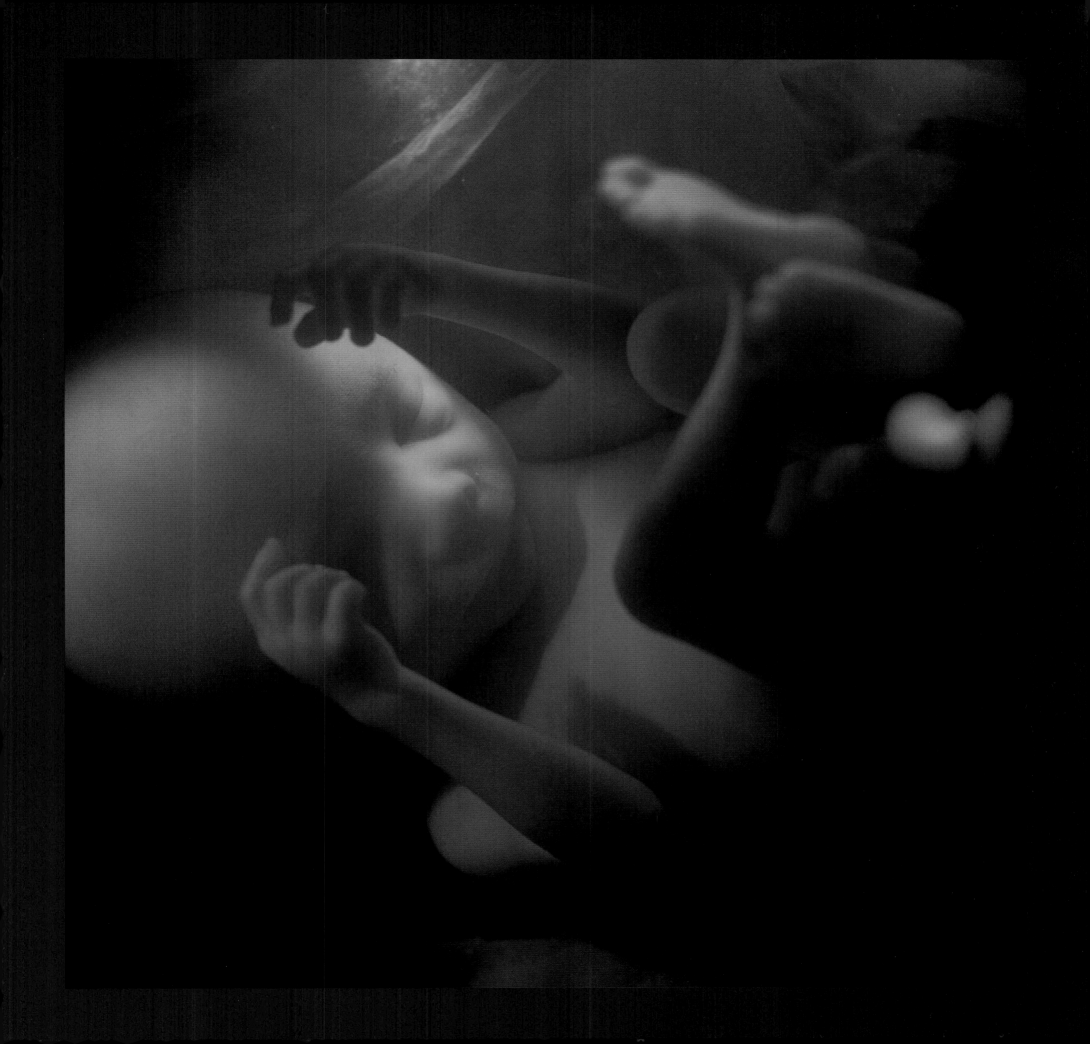

17 weeks: the eyelids are now complete and cover the eyes, which will not reopen until week 26

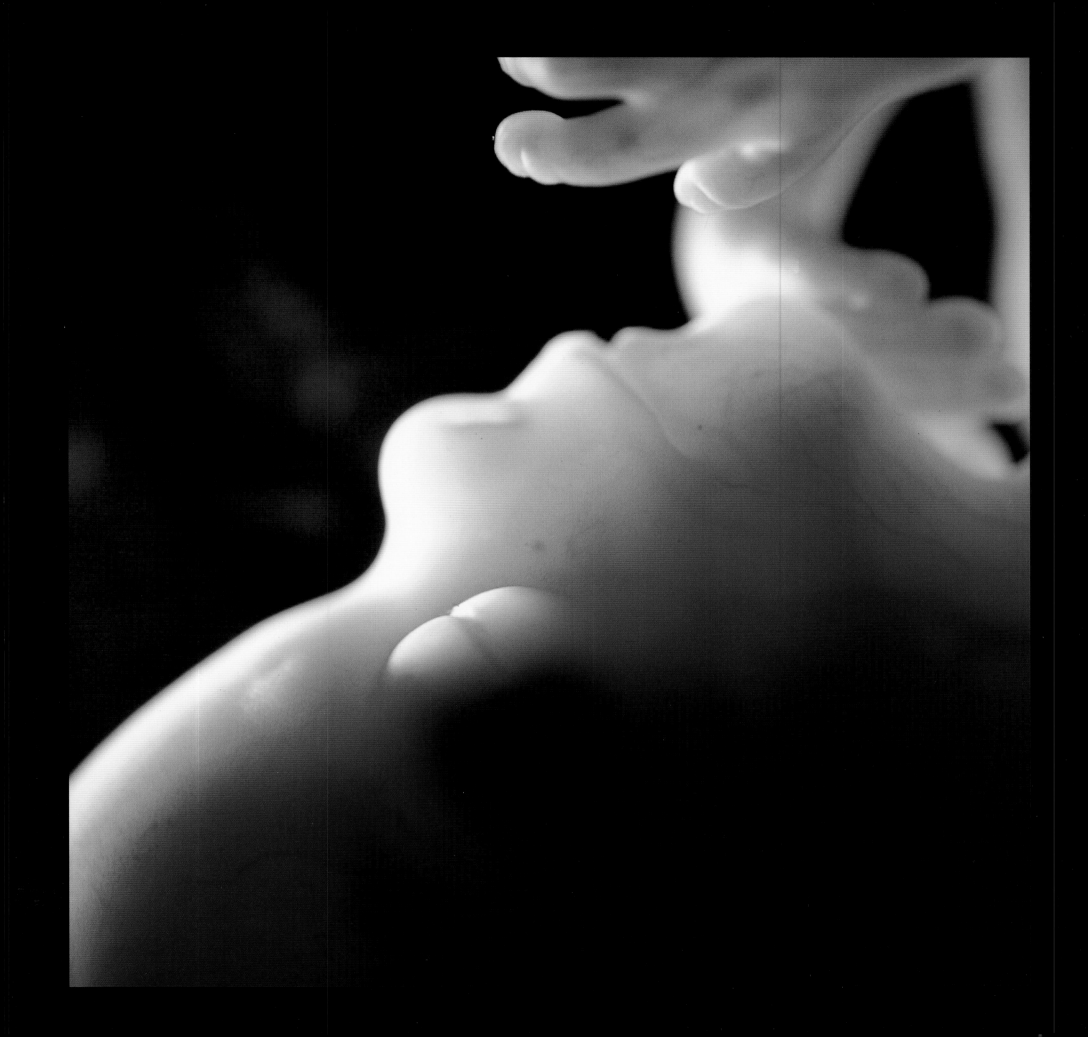

BIRTH

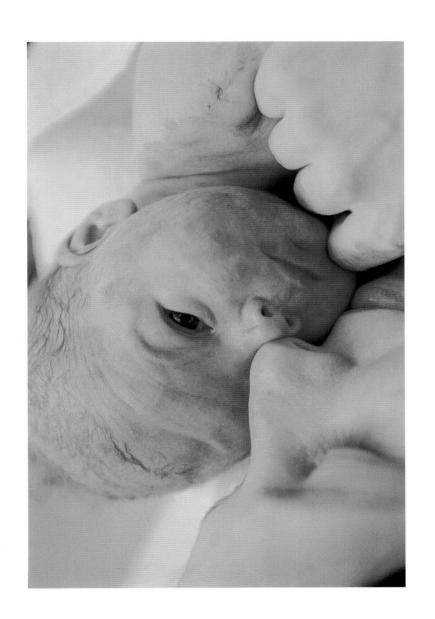

THE ORGANS

THE HEART

Blood vessels in the heart (page 158)

The aortic valve from below (page 159)

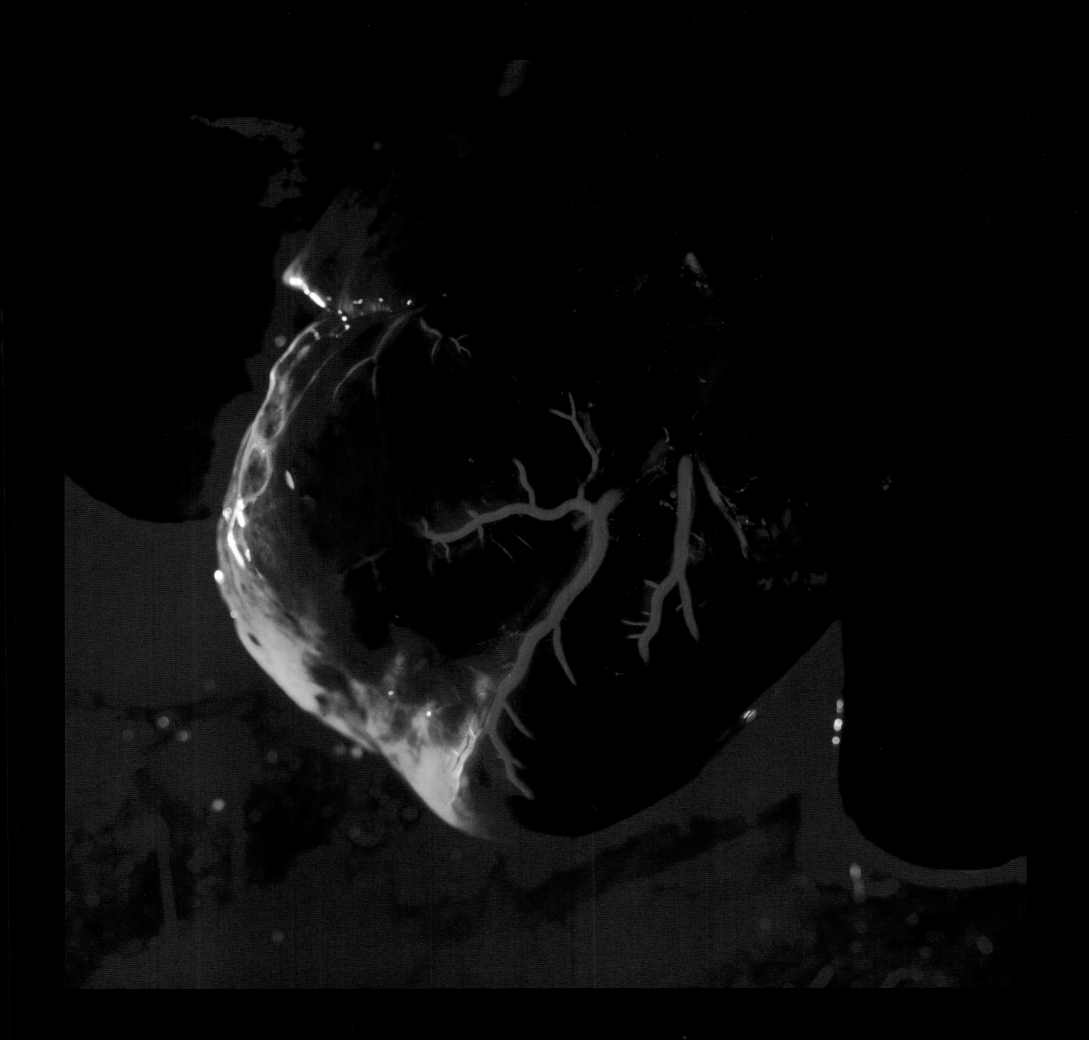

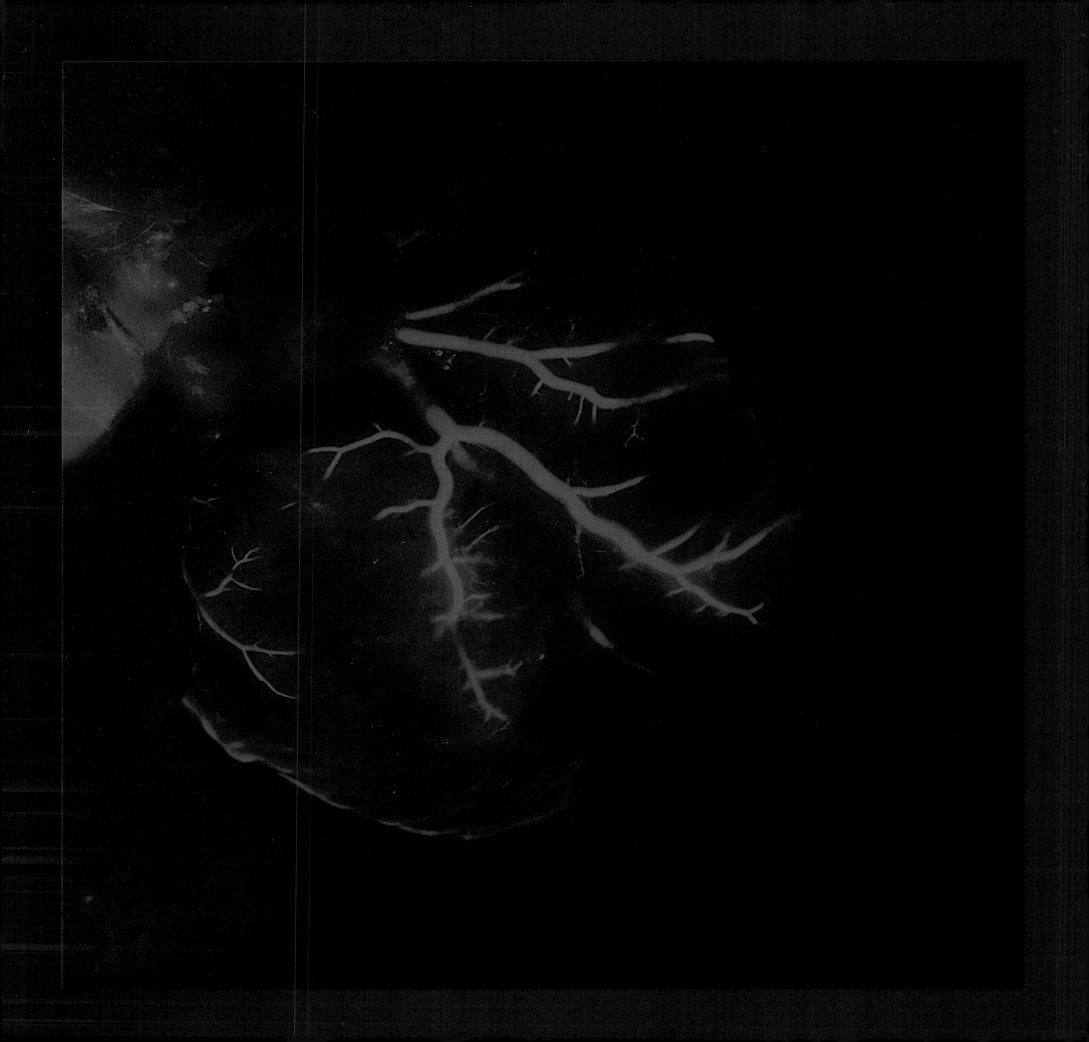

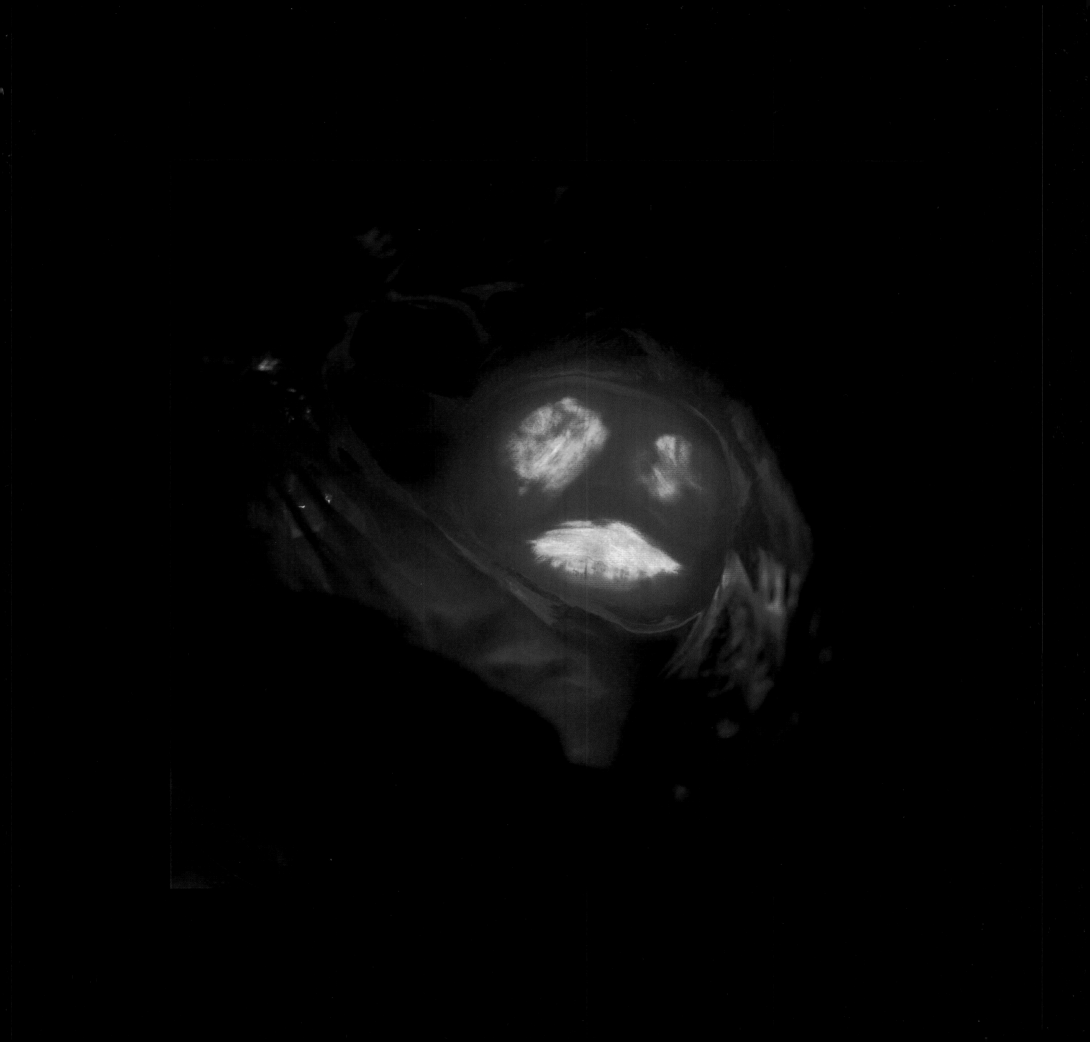

The right ventricle with the tricuspid valve

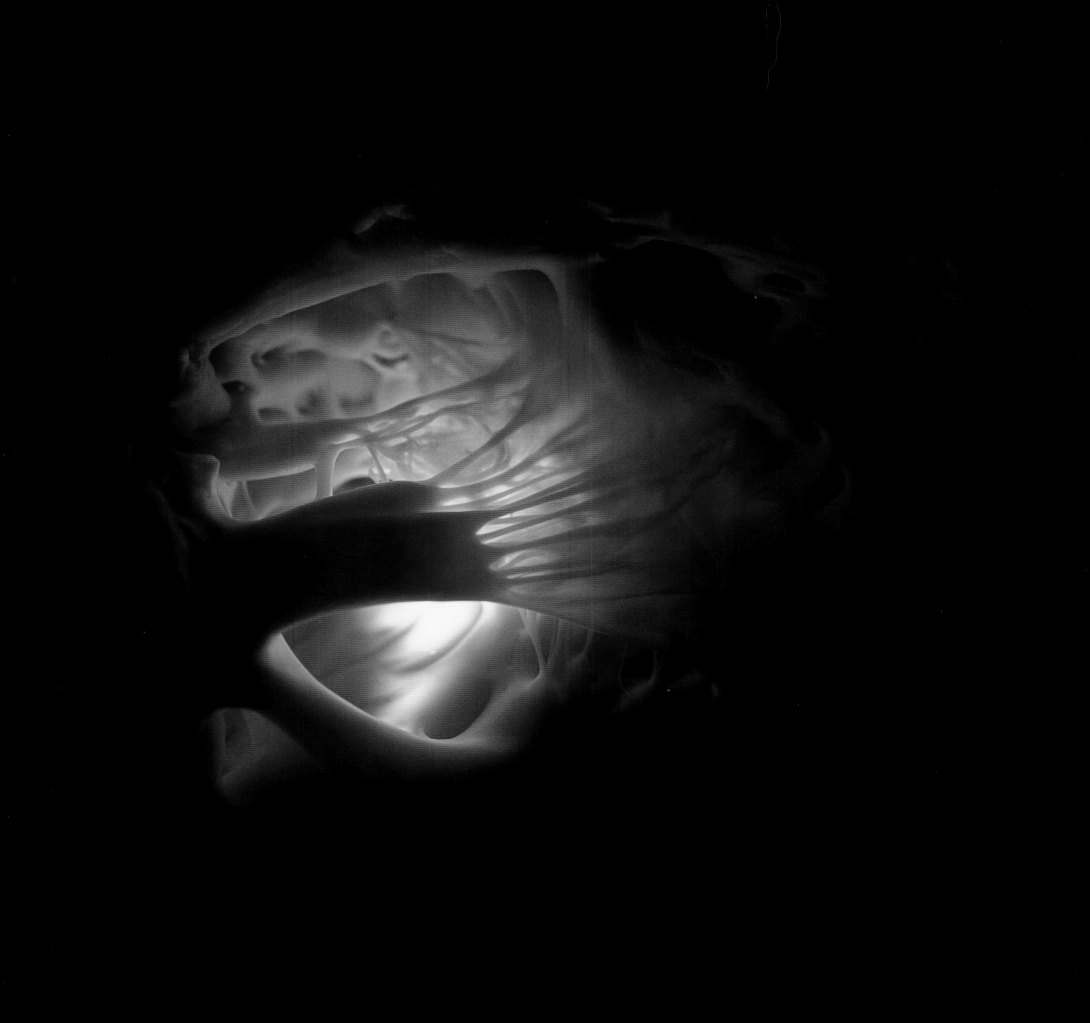

162

The aortic arch in a child

The left ventricle filled with blood (page 164)

The left ventricle (page 165)

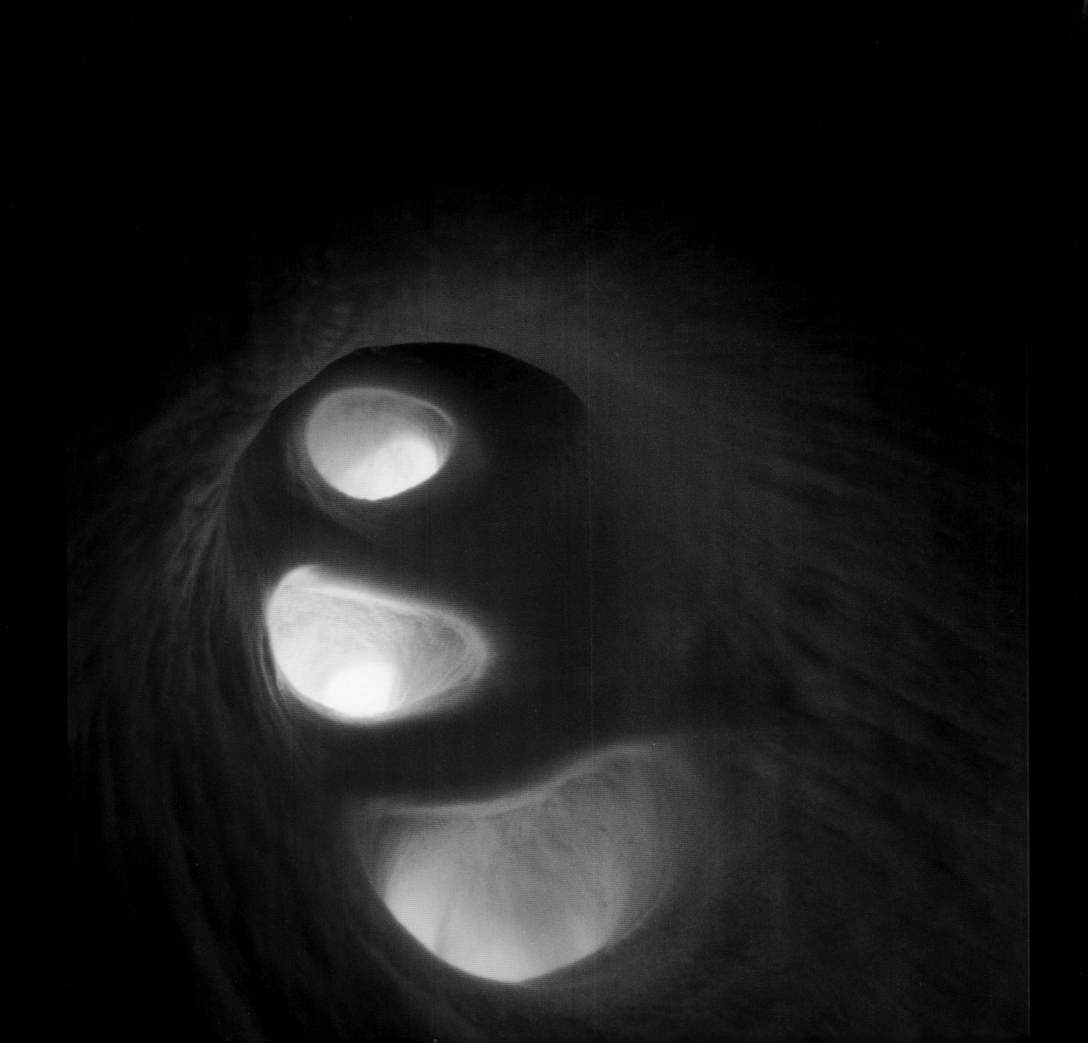

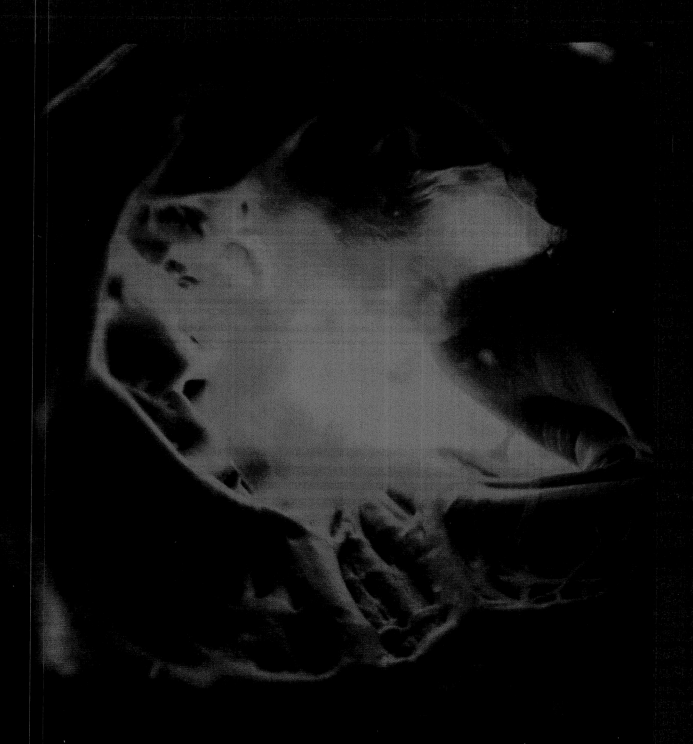

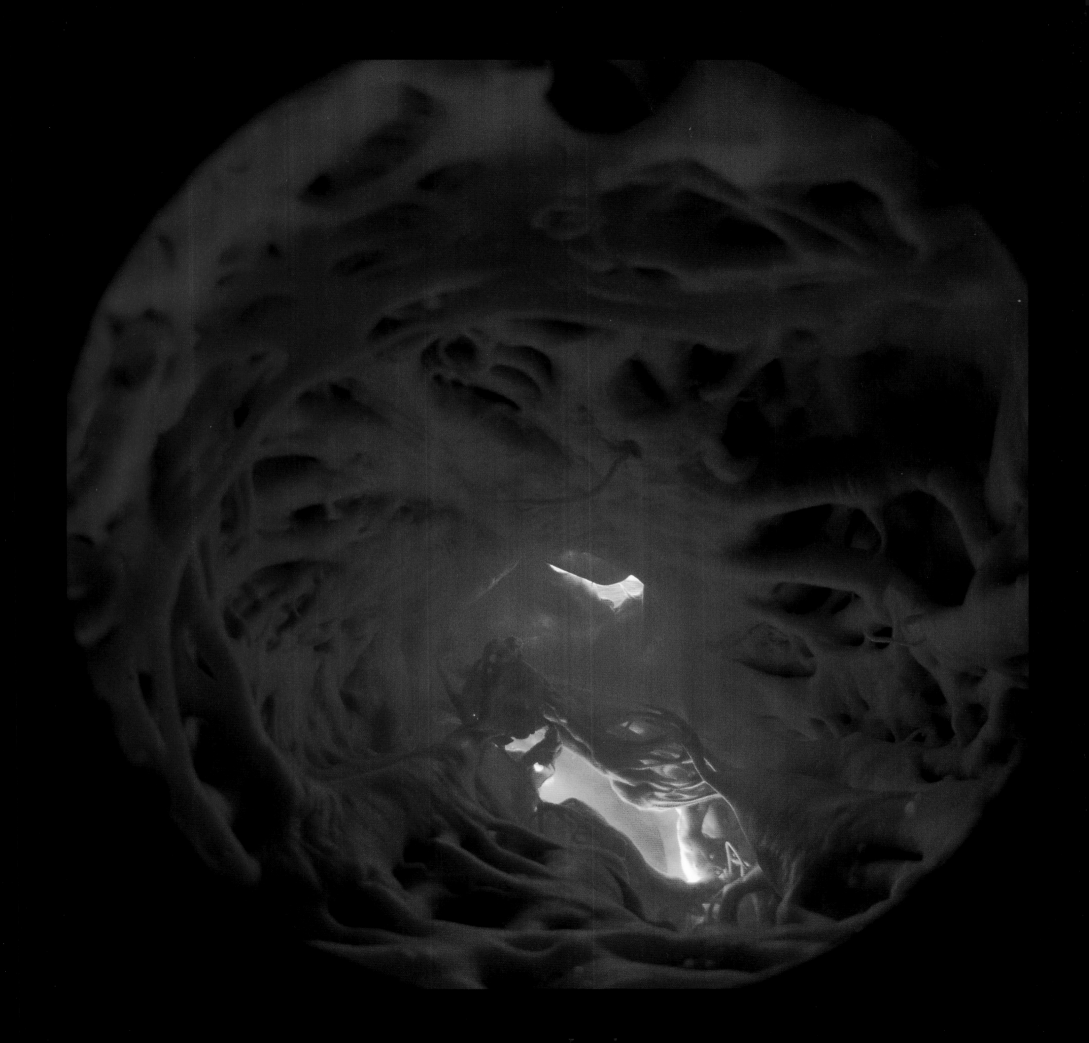

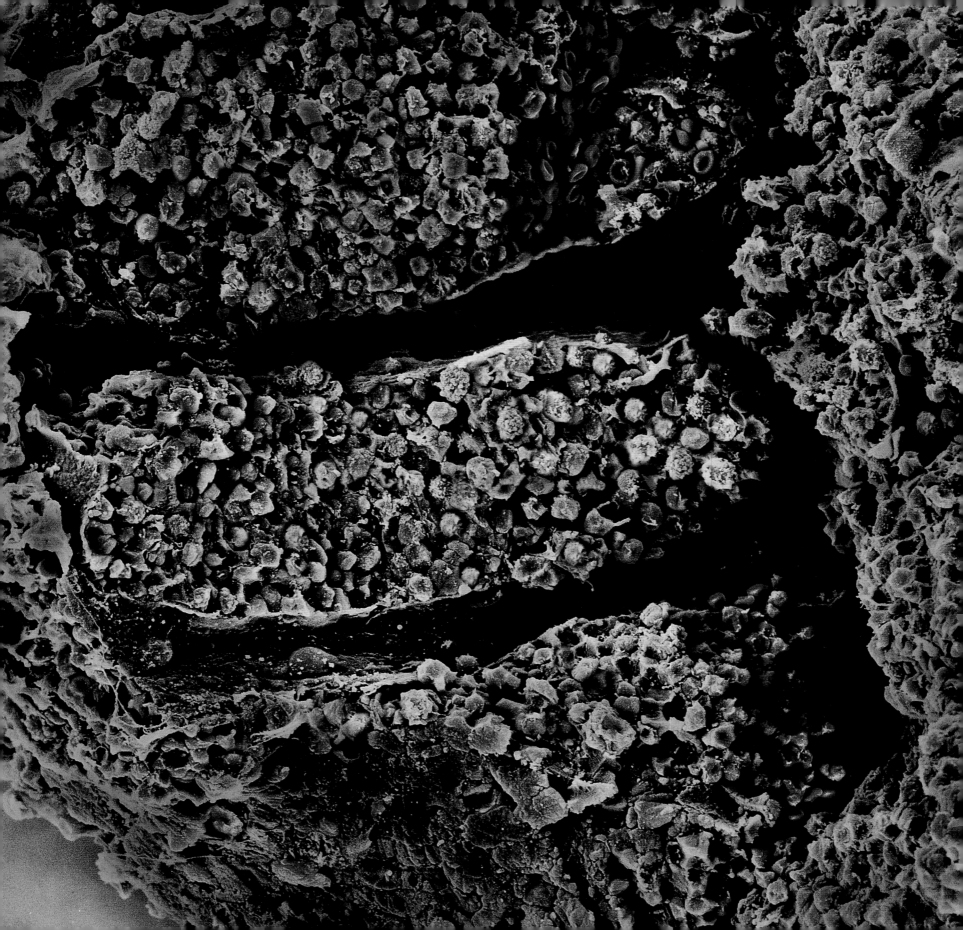

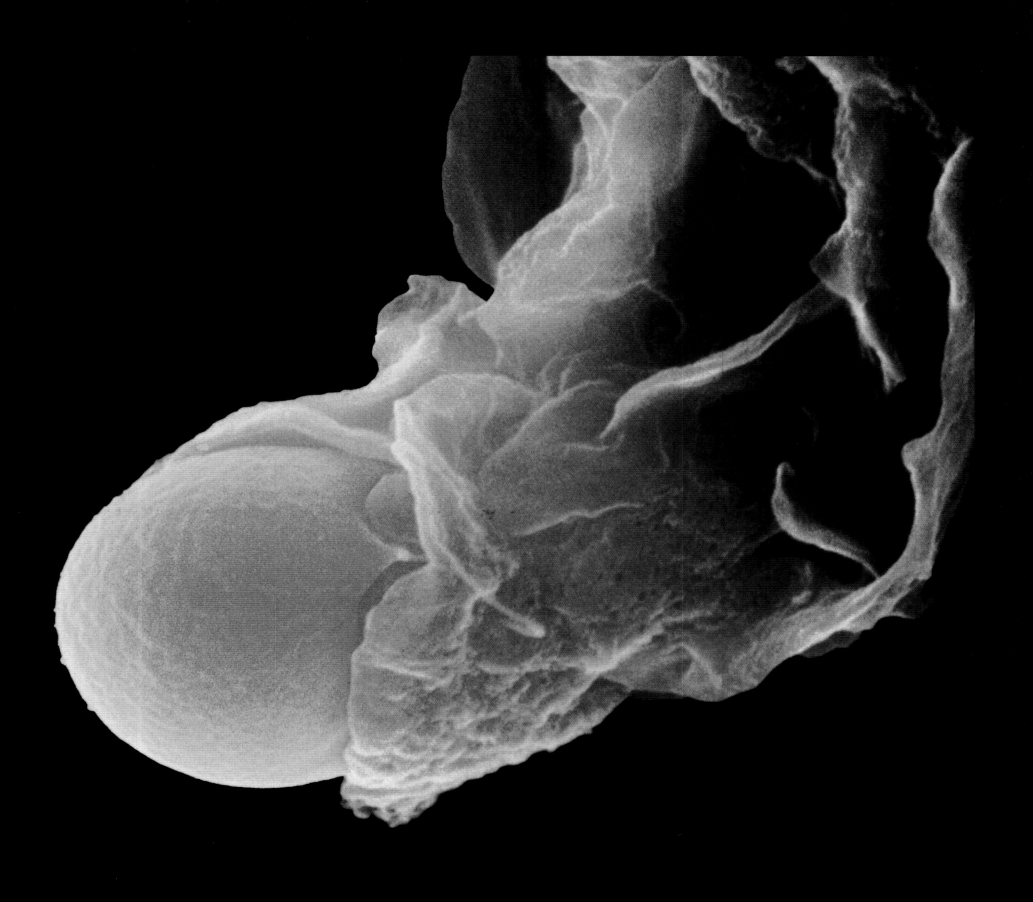

Blood cells in the capillaries

Coagulation of the blood. A net of fibrin threads
is produced by immune cells (following pages)

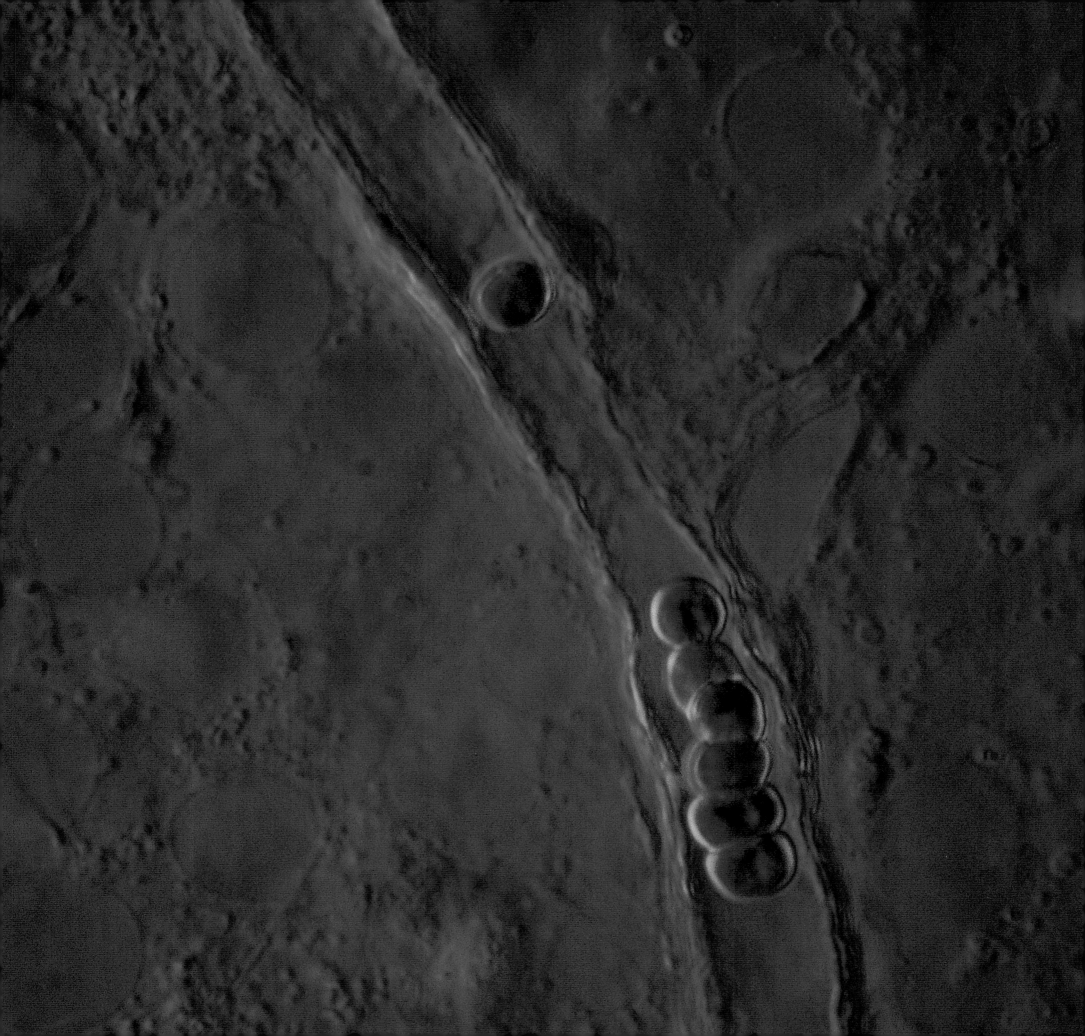

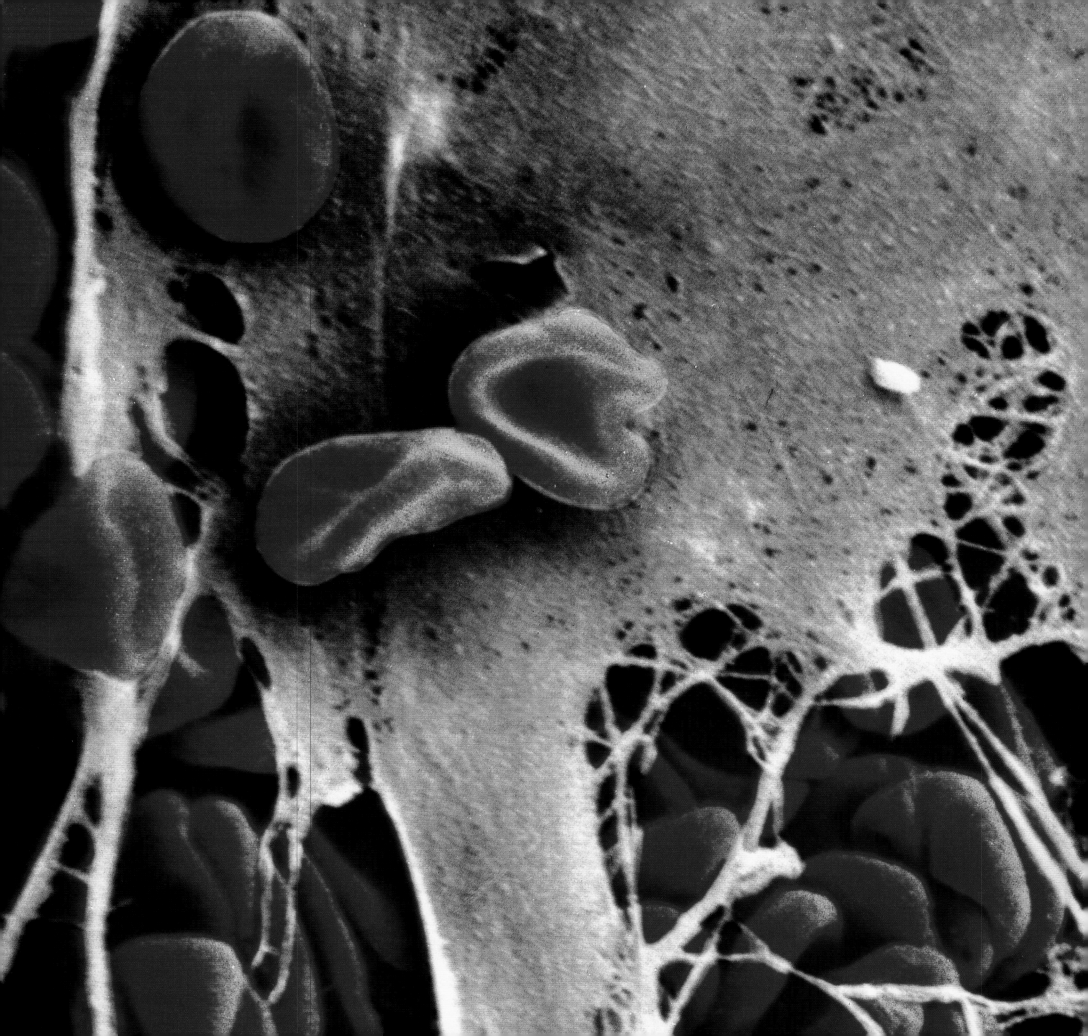

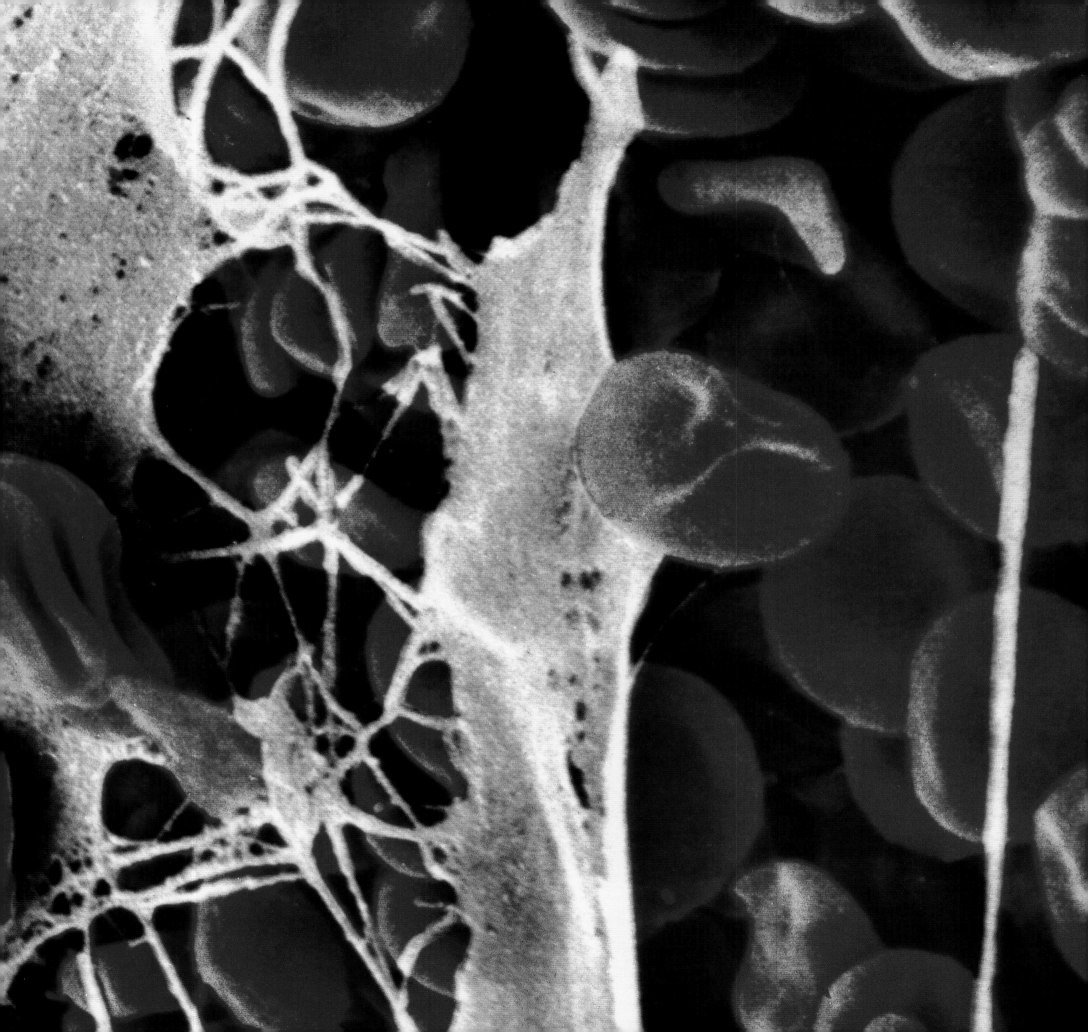

THE KIDNEYS

A child's kidney

Cross section of a glomerulus, the capillary network with blood cells in the center, surrounded by Bowman's capsule. This part of the kidney filters the blood to form urine (following pages)

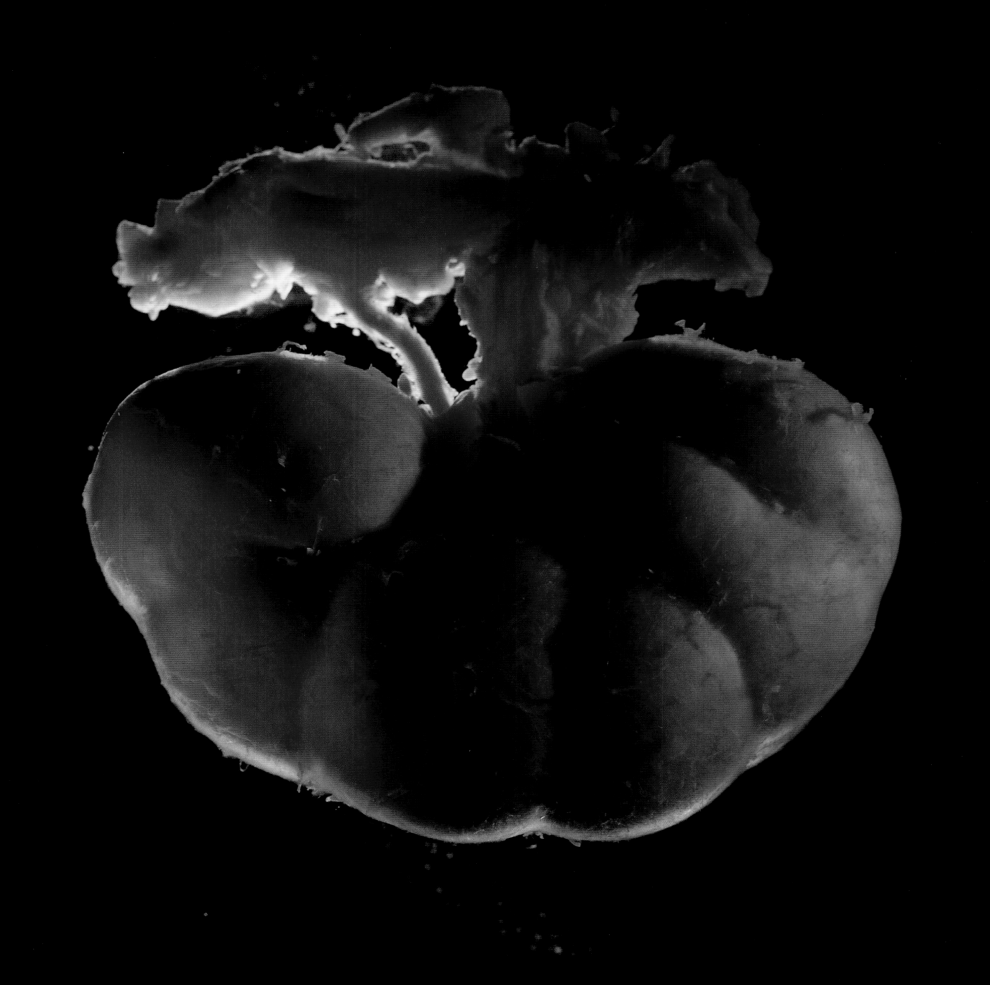

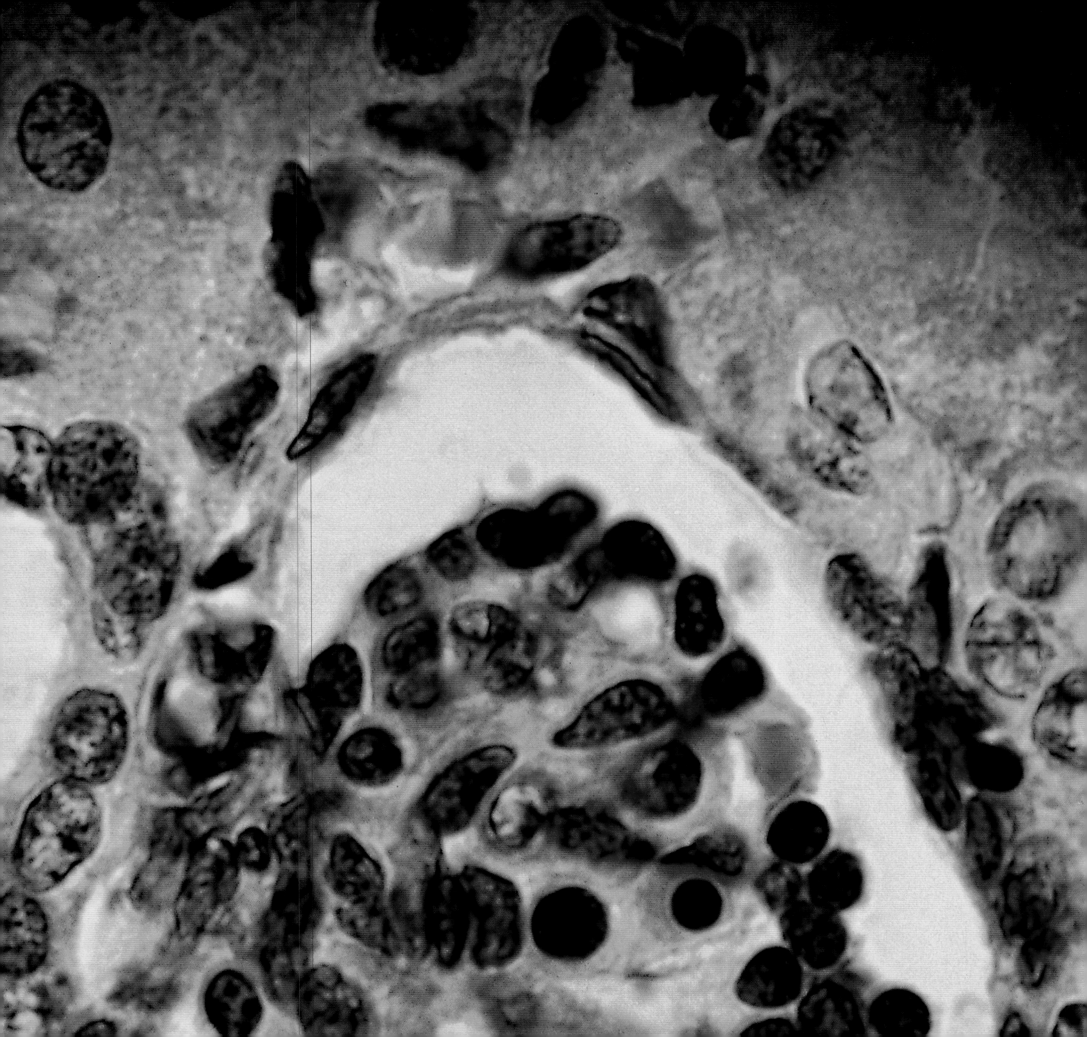

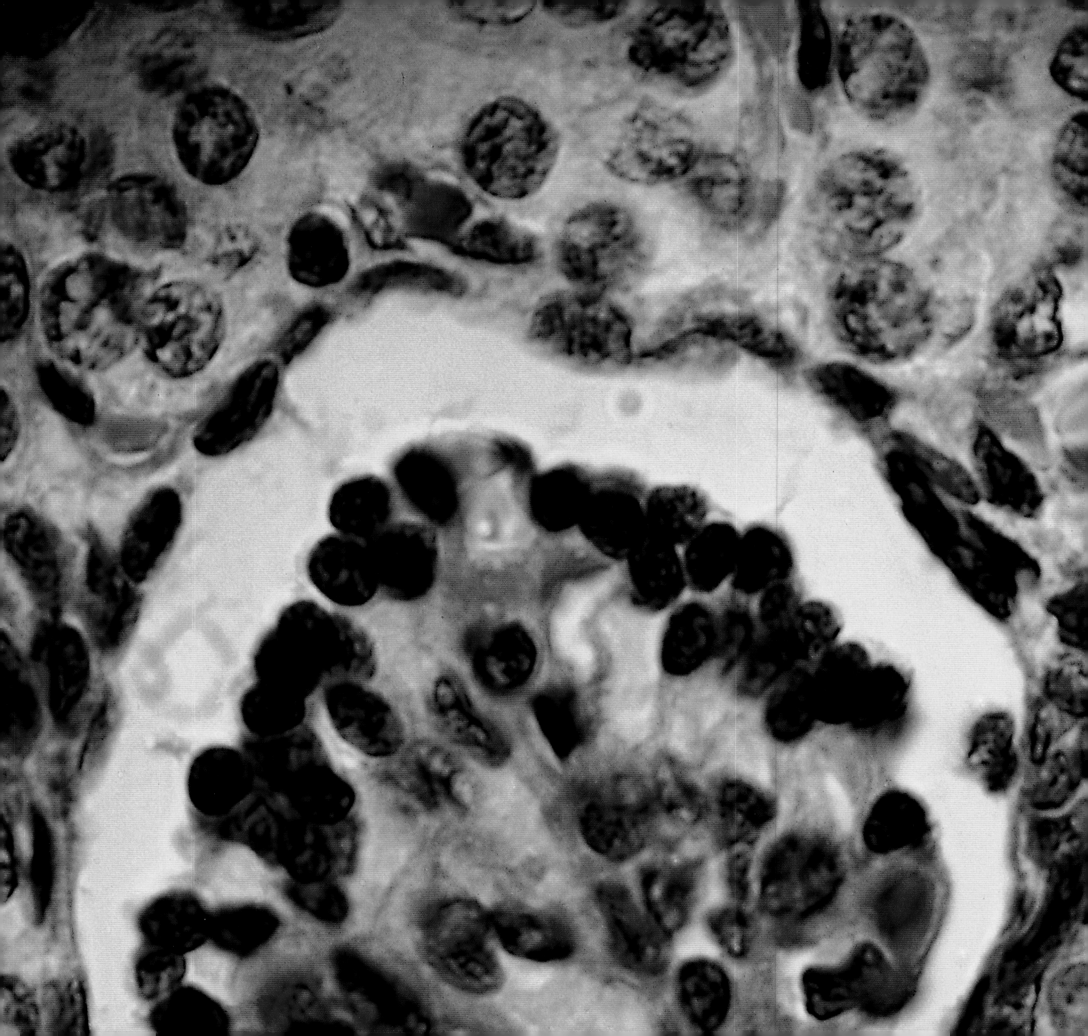

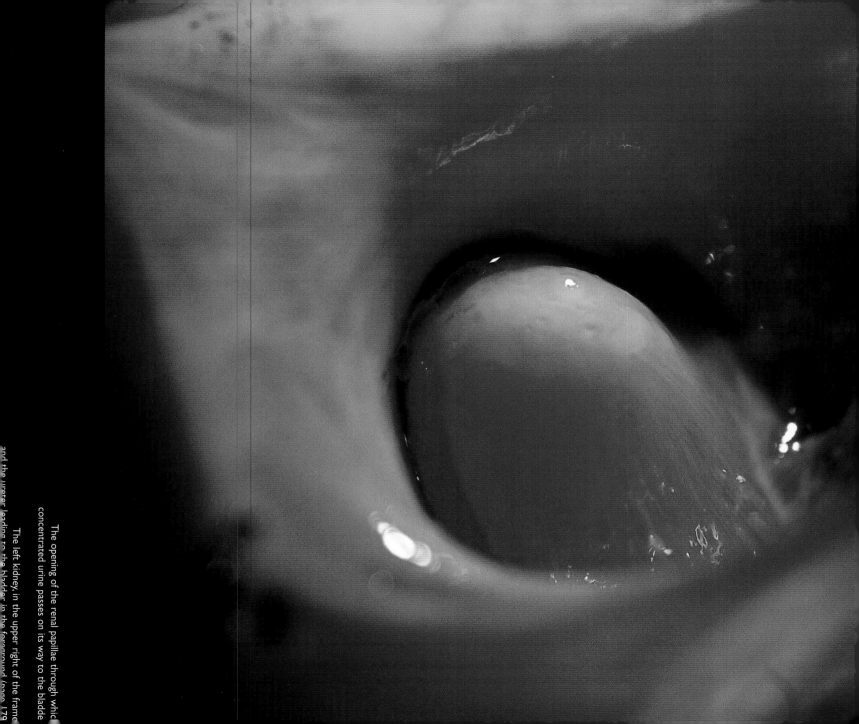

The opening of the renal papilla through which concentrated urine passes on its way to the bladde

The left kidney, in the upper right of the frame and the ureter leading to the bladder in the foreground (page 179

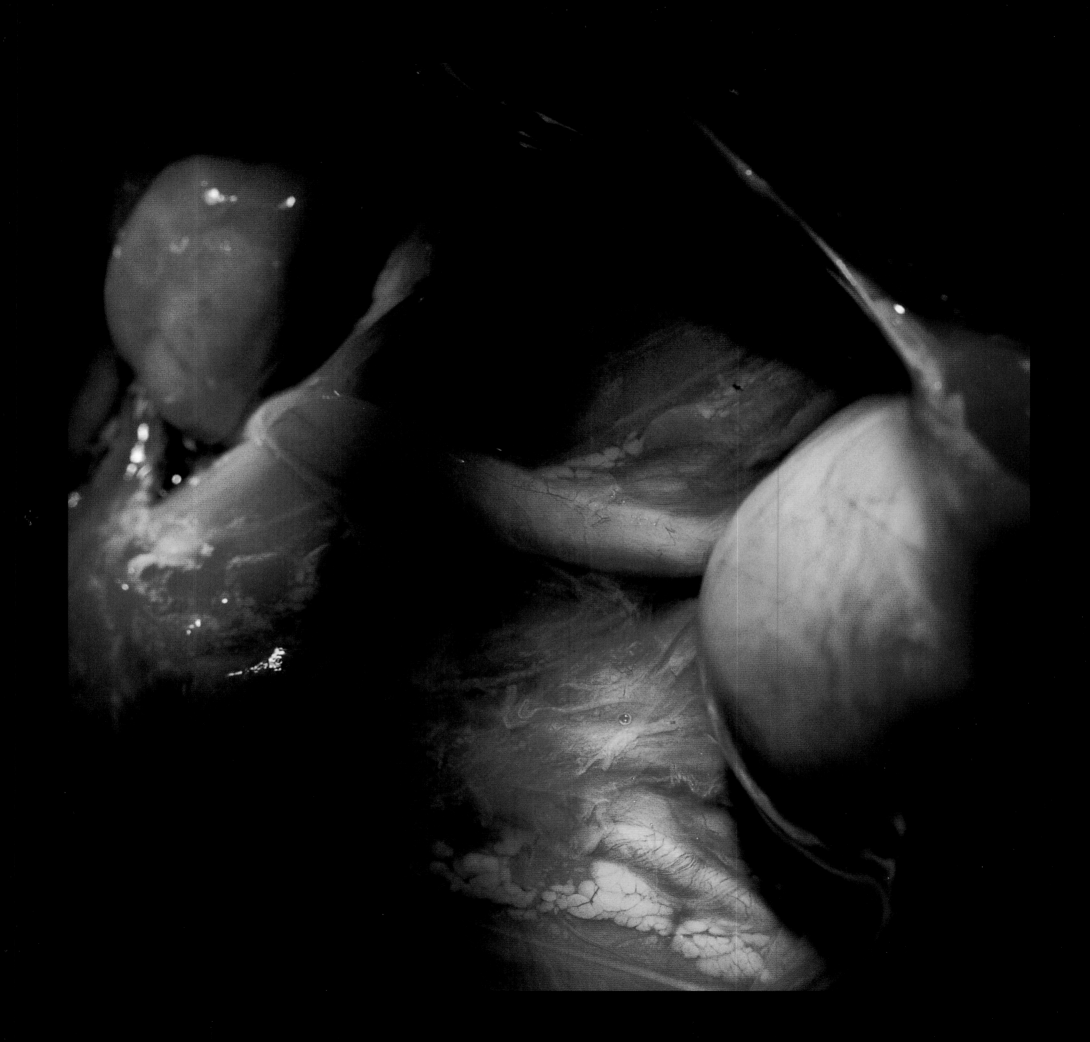

THE LIVER

The liver, the largest gland in the body, is highlighted

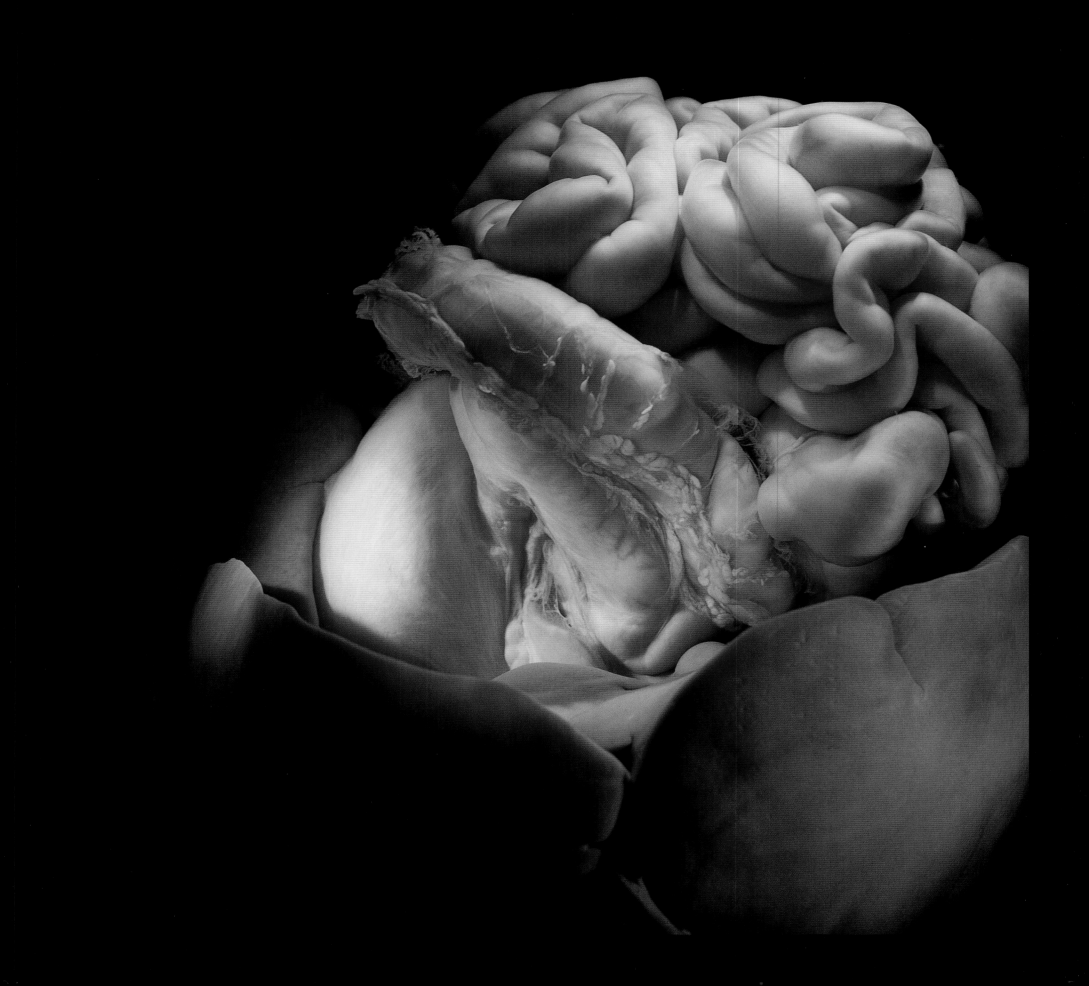

Cholesterol, in crystalline form, which is important for the production of nerve tissue, bile, and certain hormones

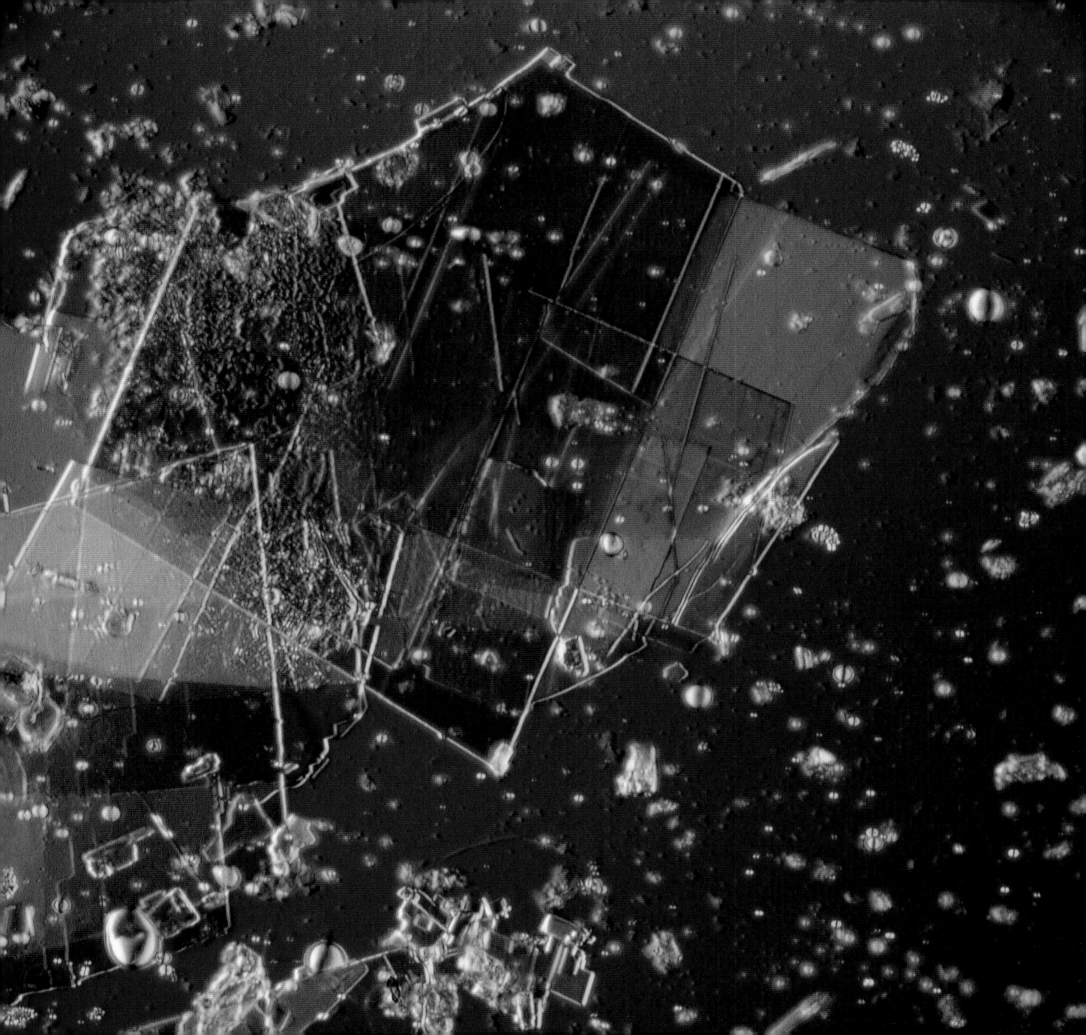

THE LUNGS

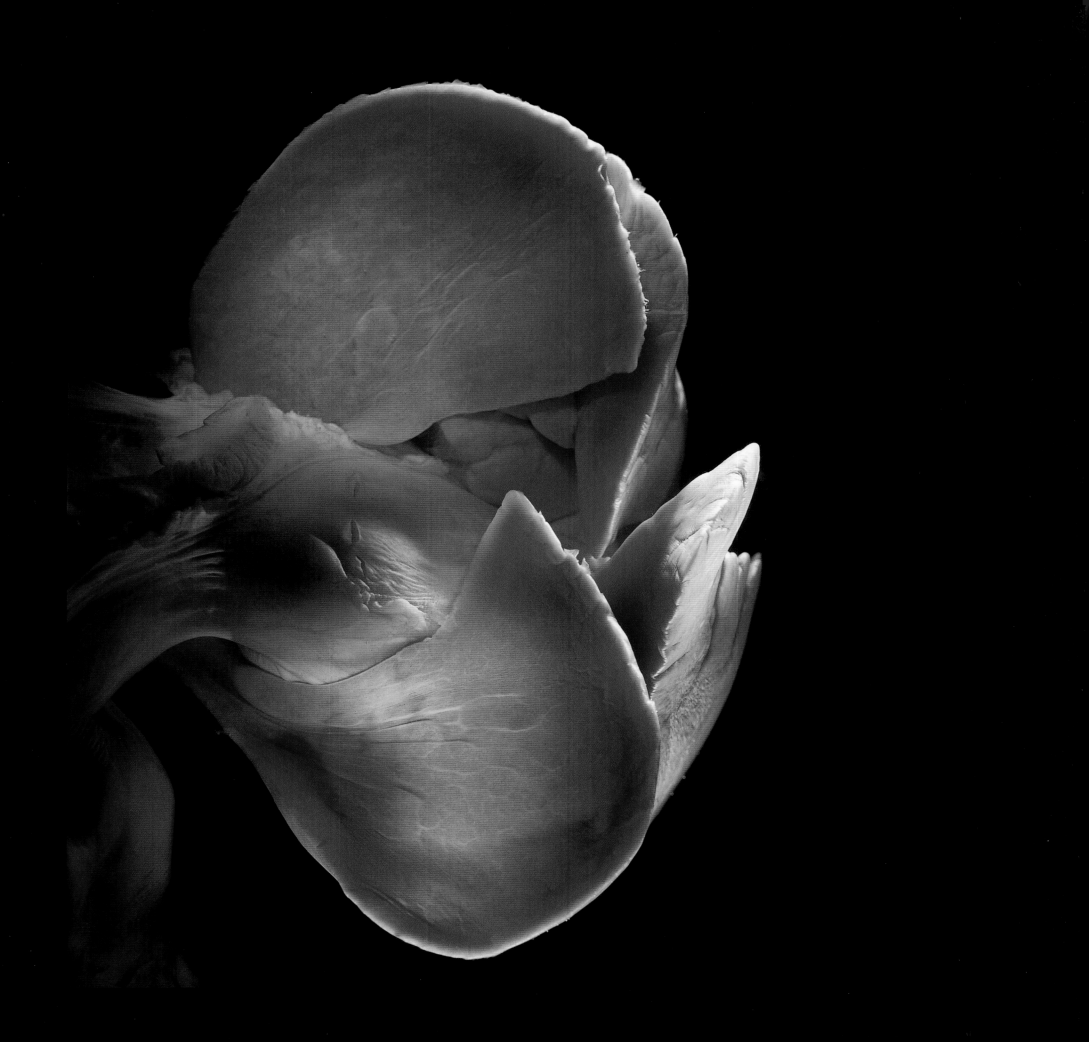

The windpipe, dividing into the left and right bronchi, leading to the lungs

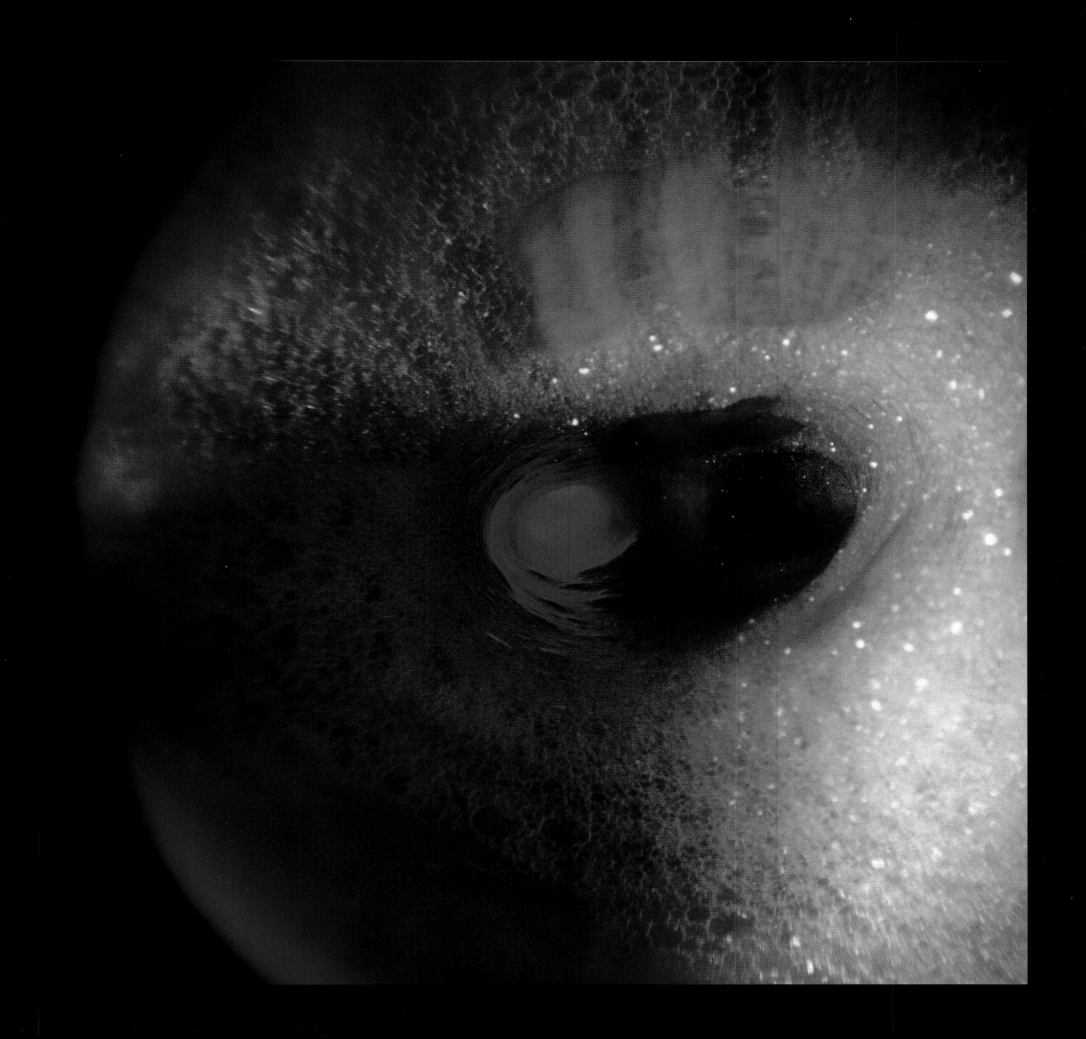

STEM CELLS

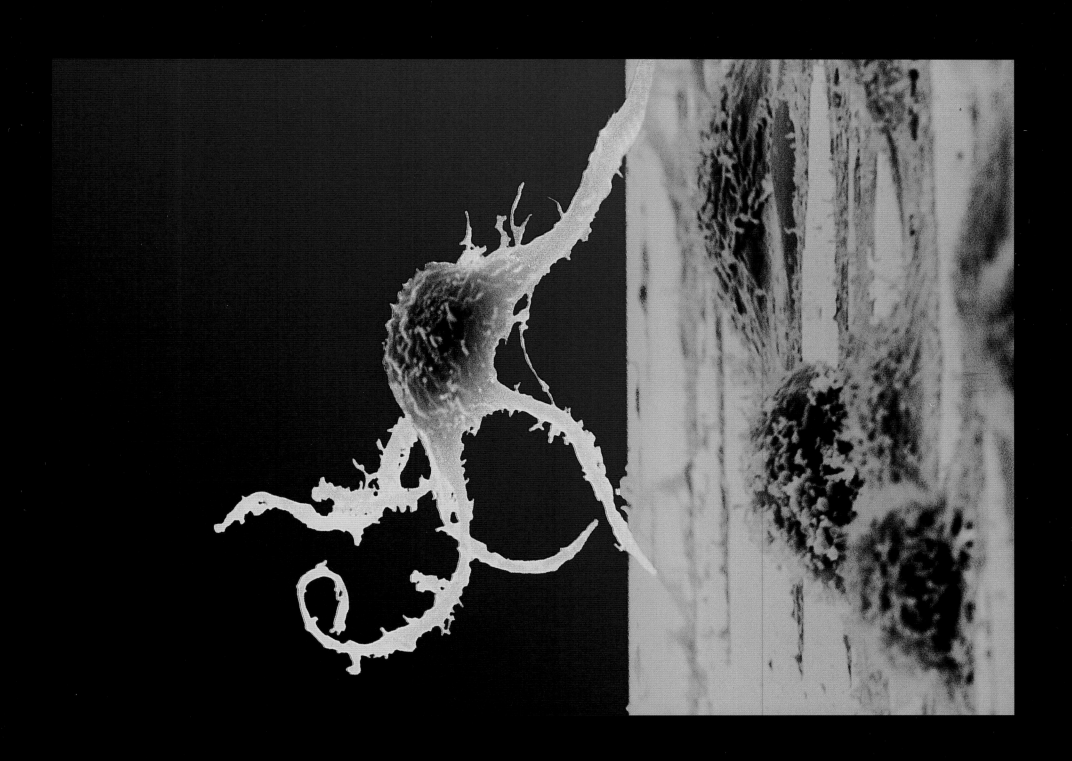

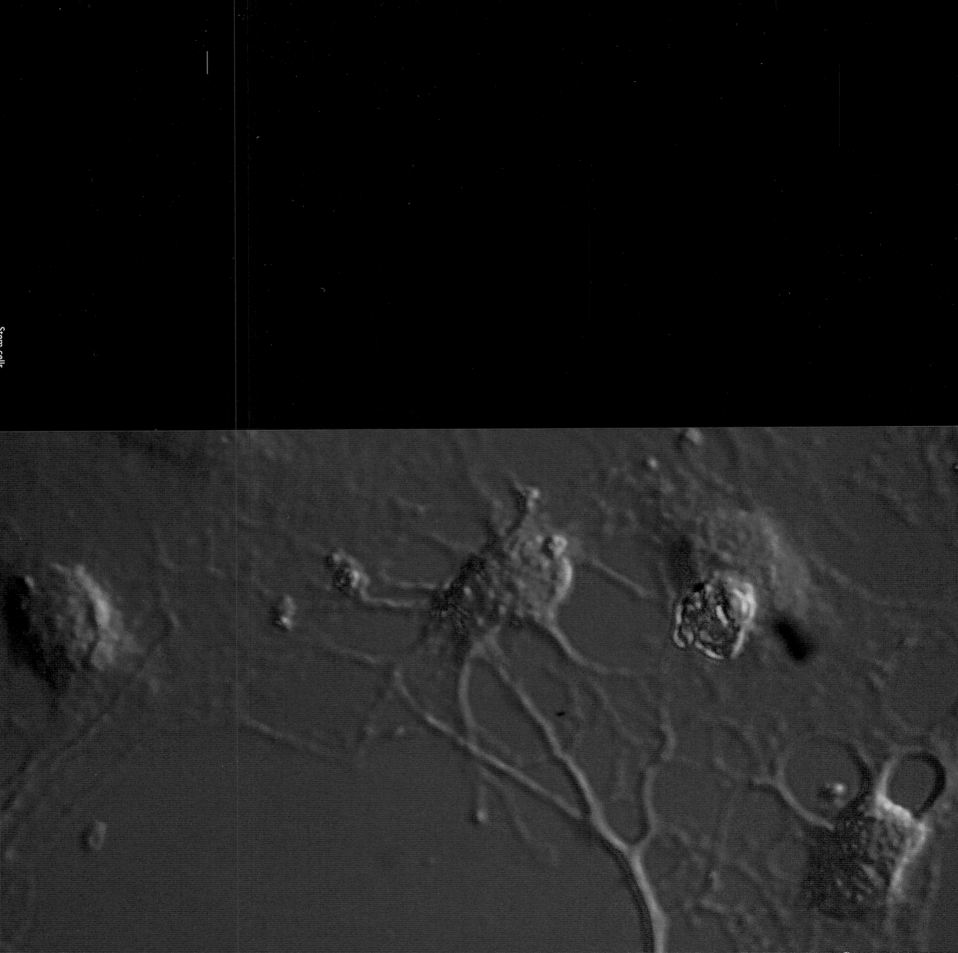

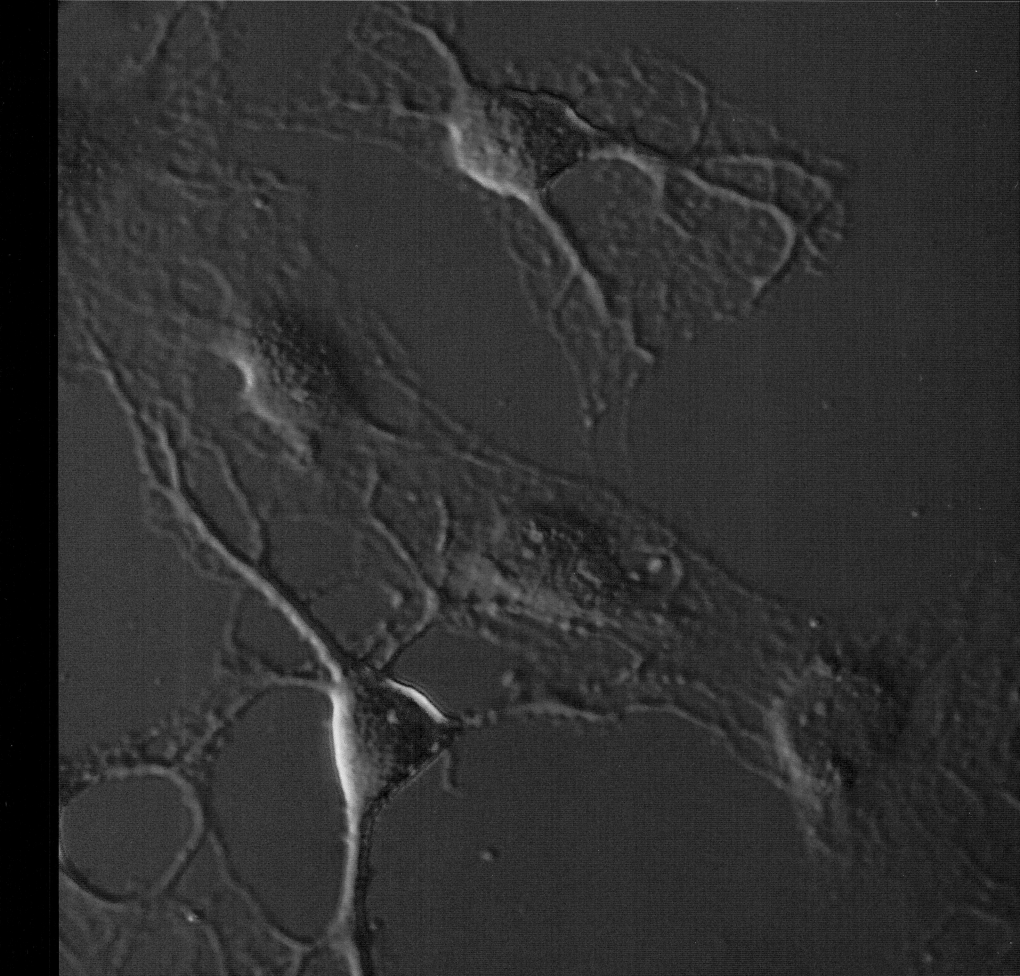

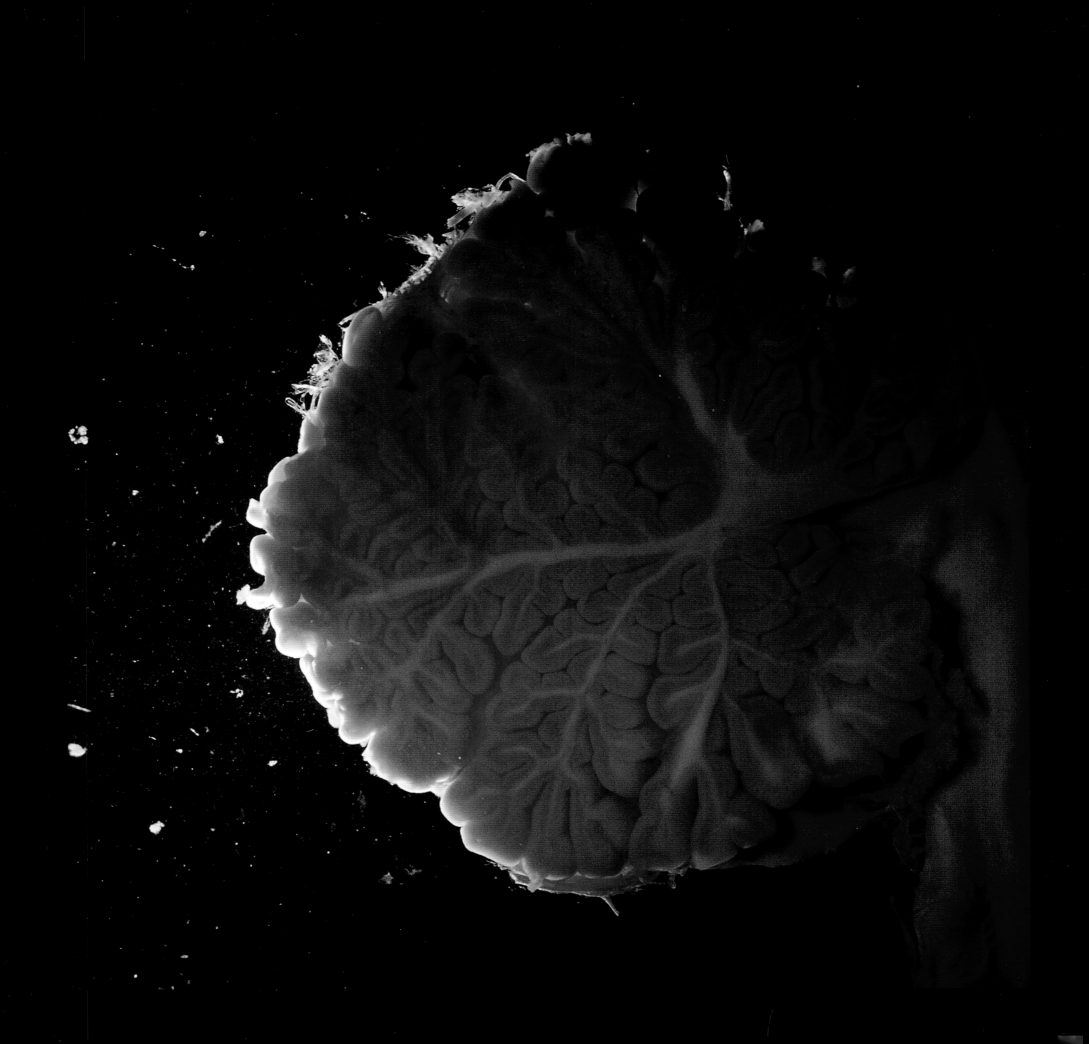

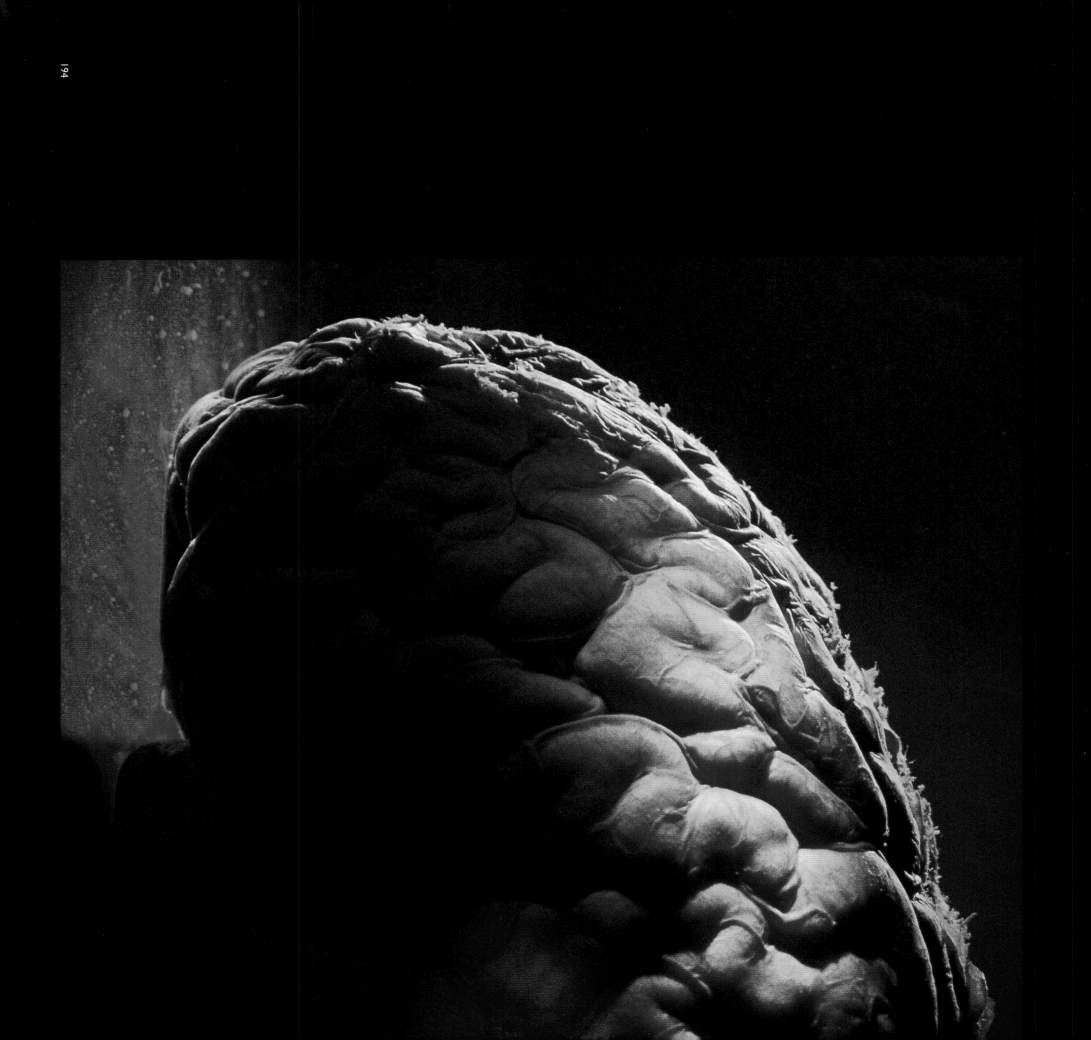

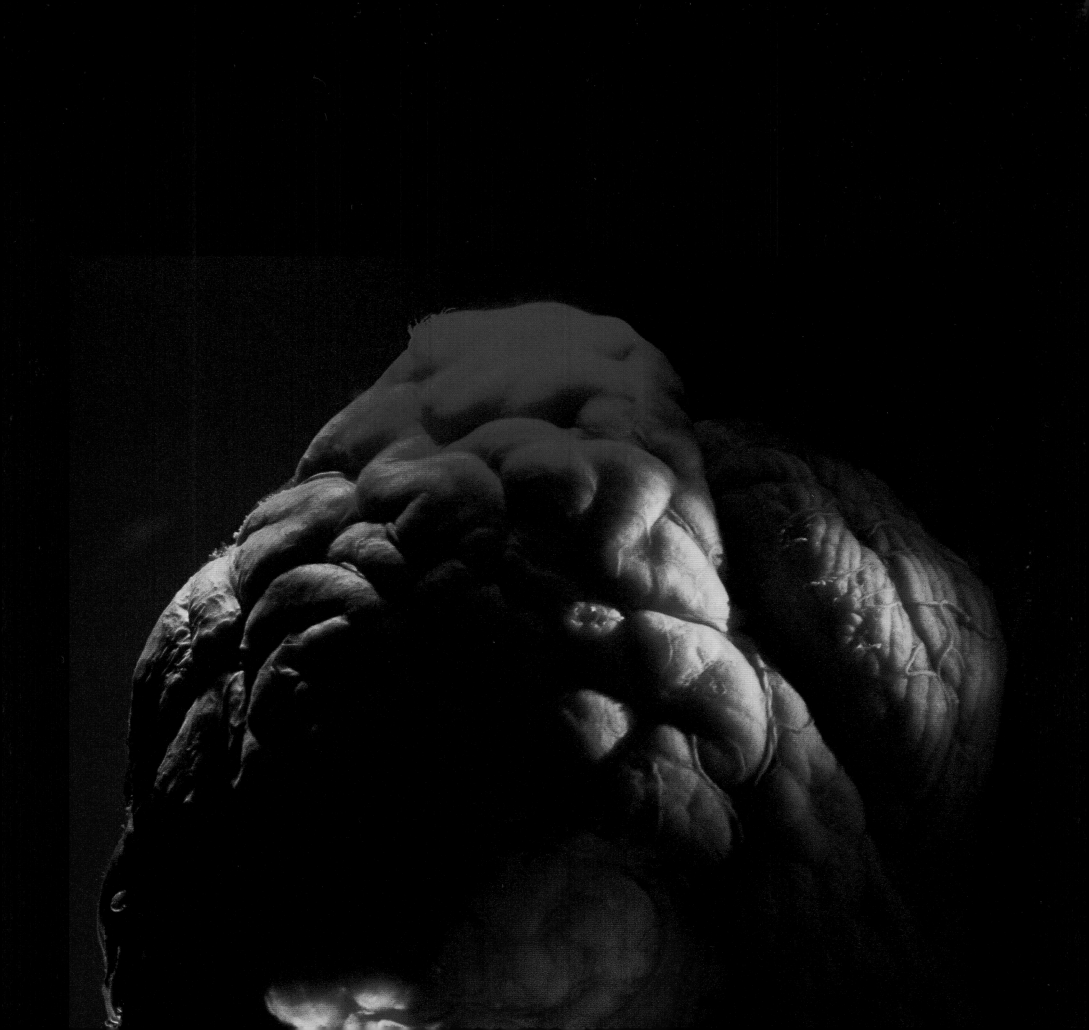

The brain's four ventricles form a network
of interconnecting passages filled with cerebrospinal fluid

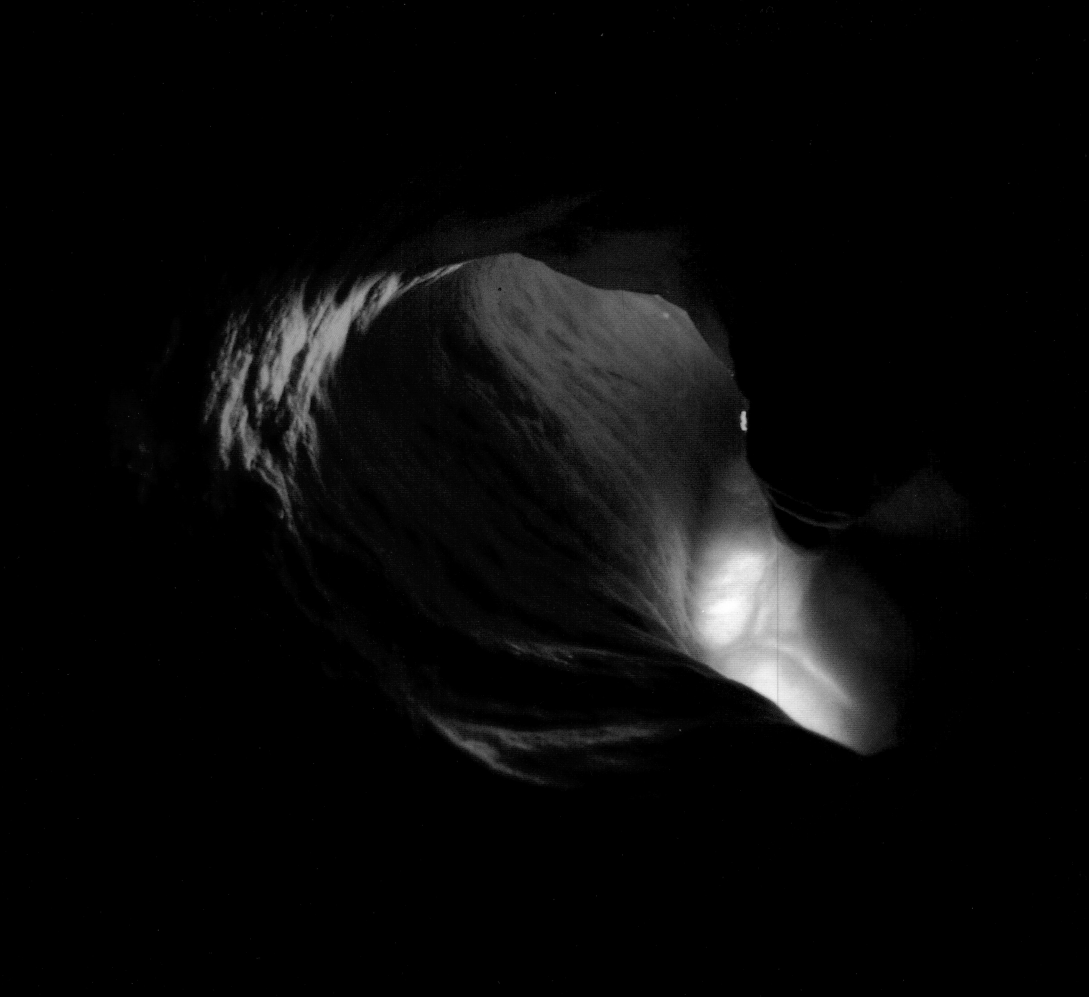

Spinal cord through the neck

The spinal cord from behind (page 200)

Cauda equina, the horse tail (page 201)

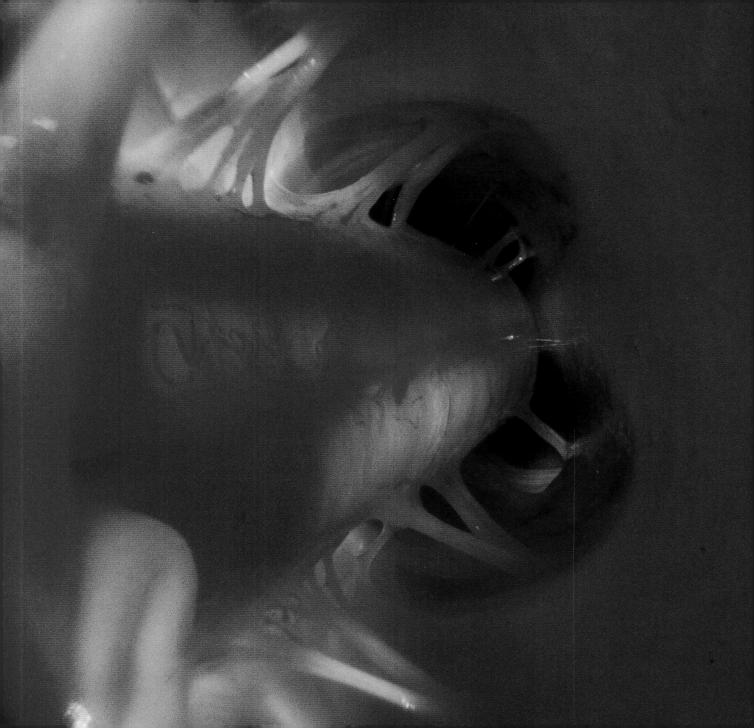

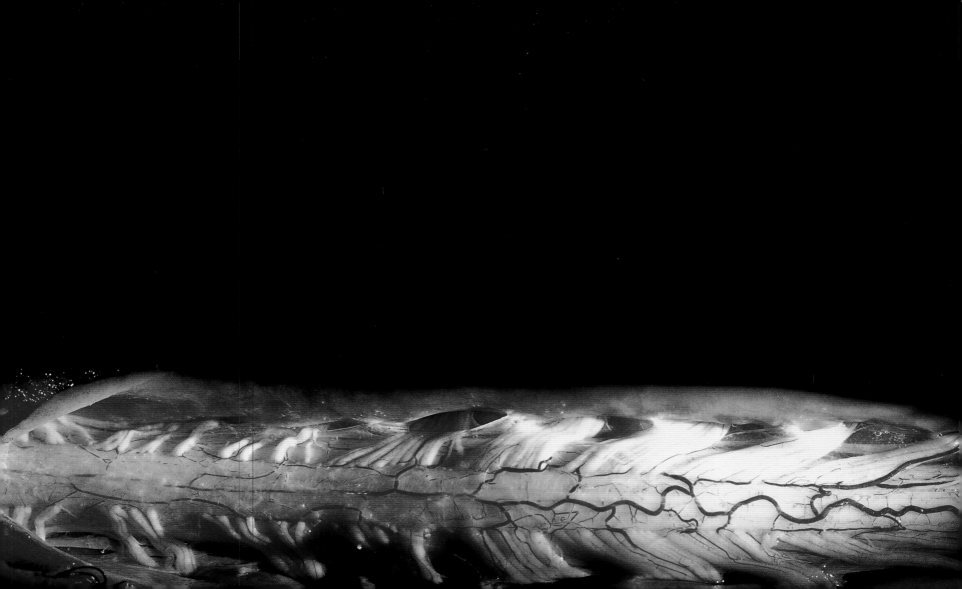

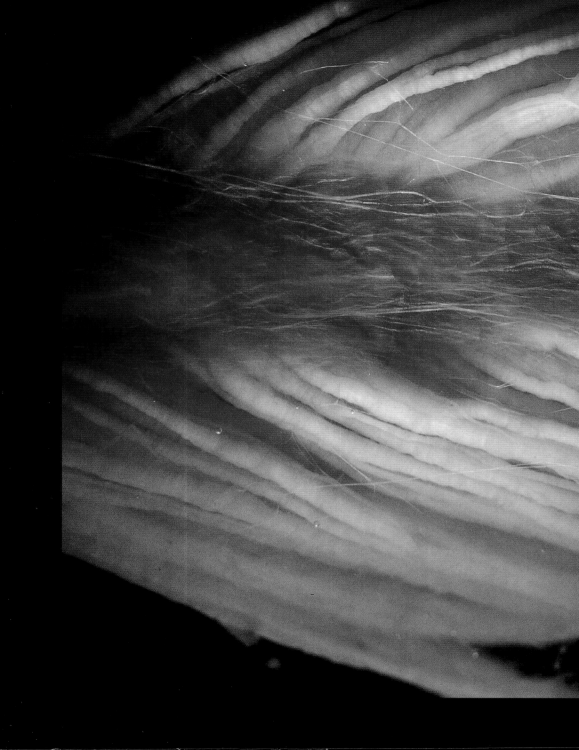

The pineal body, which produces the hormone melatonin

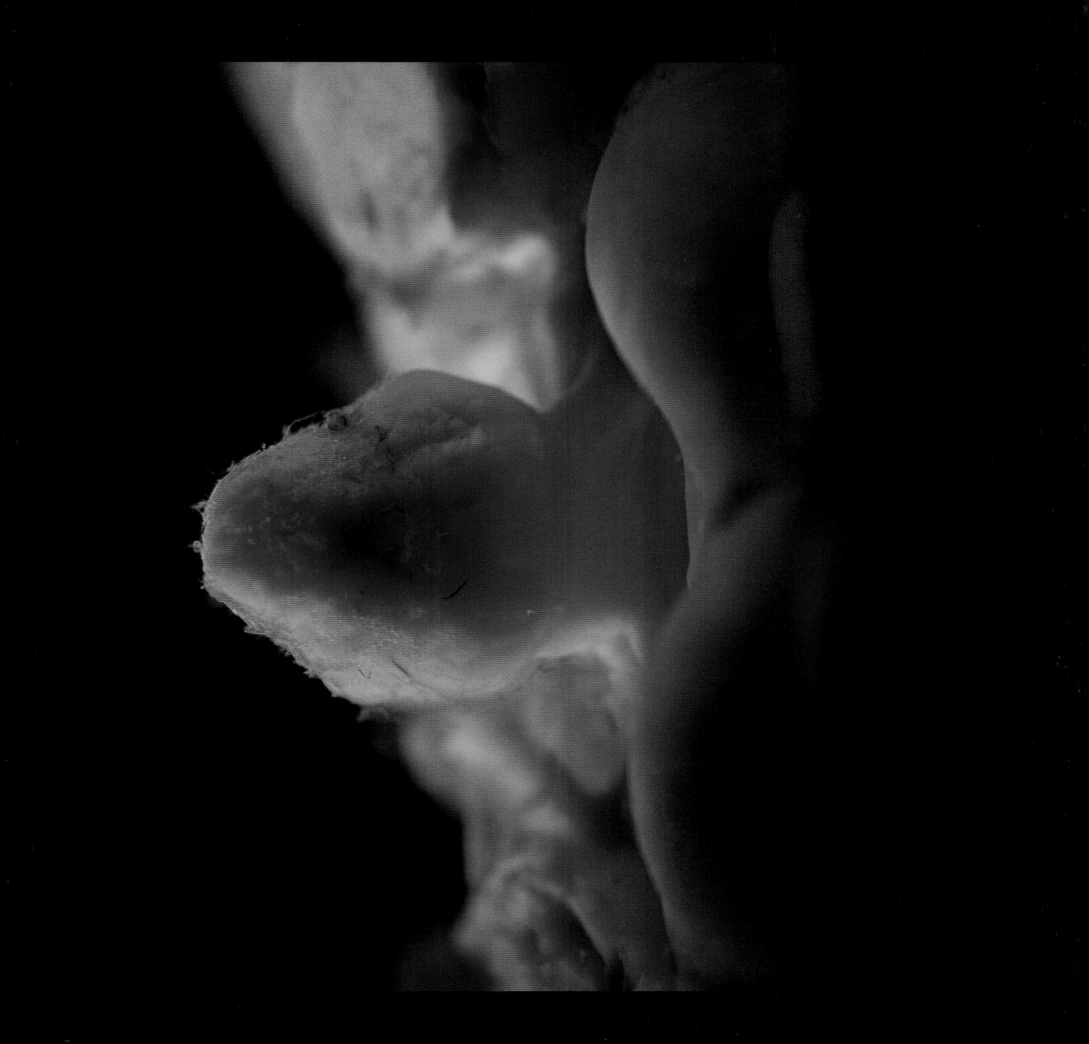

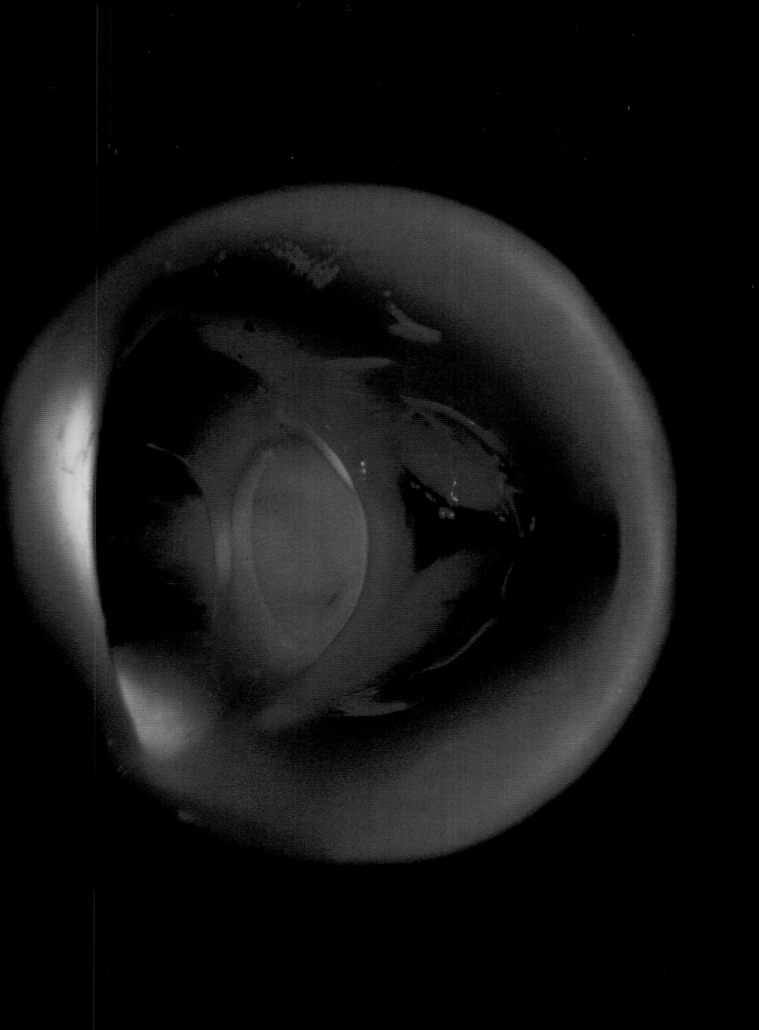

The hypothalamus

The pituitary gland,
the most important producer of hormones (opposite)

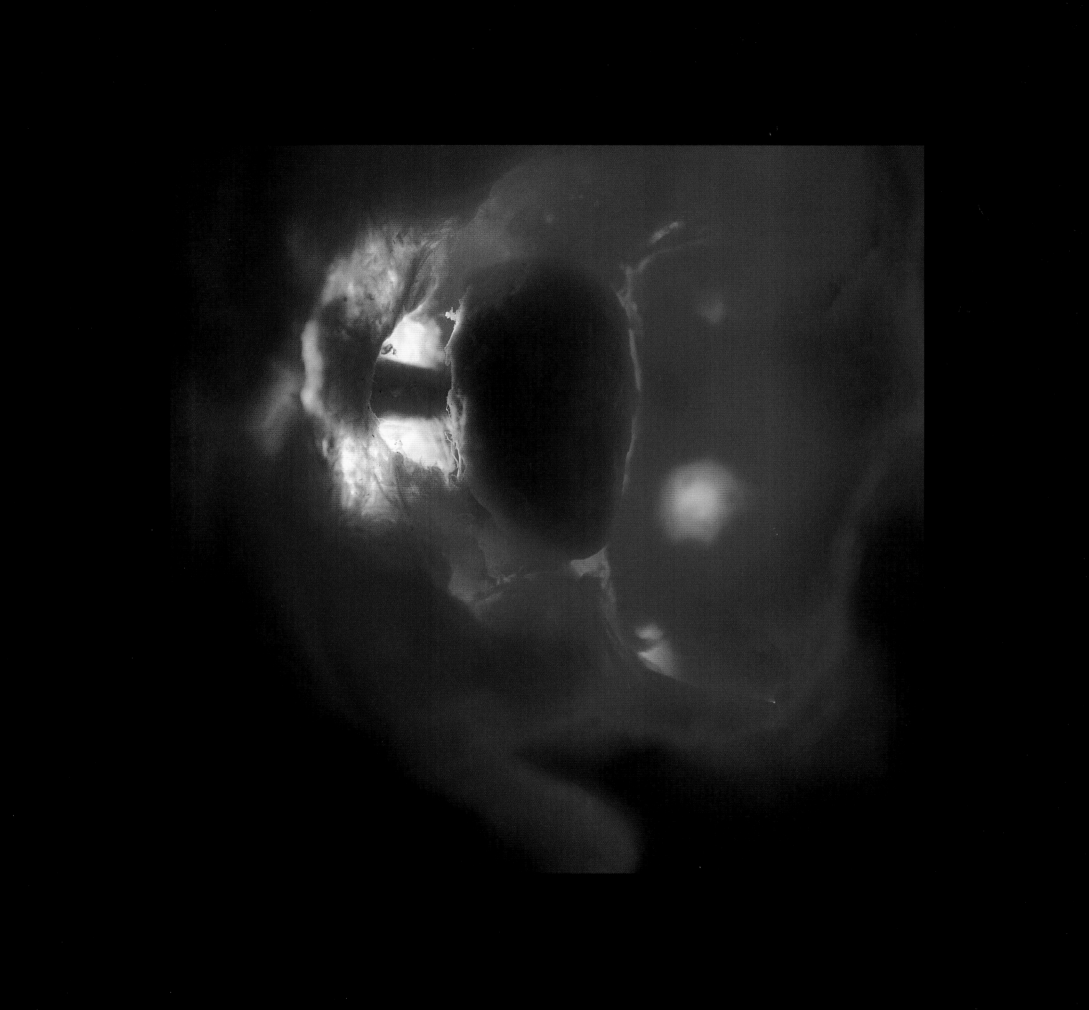

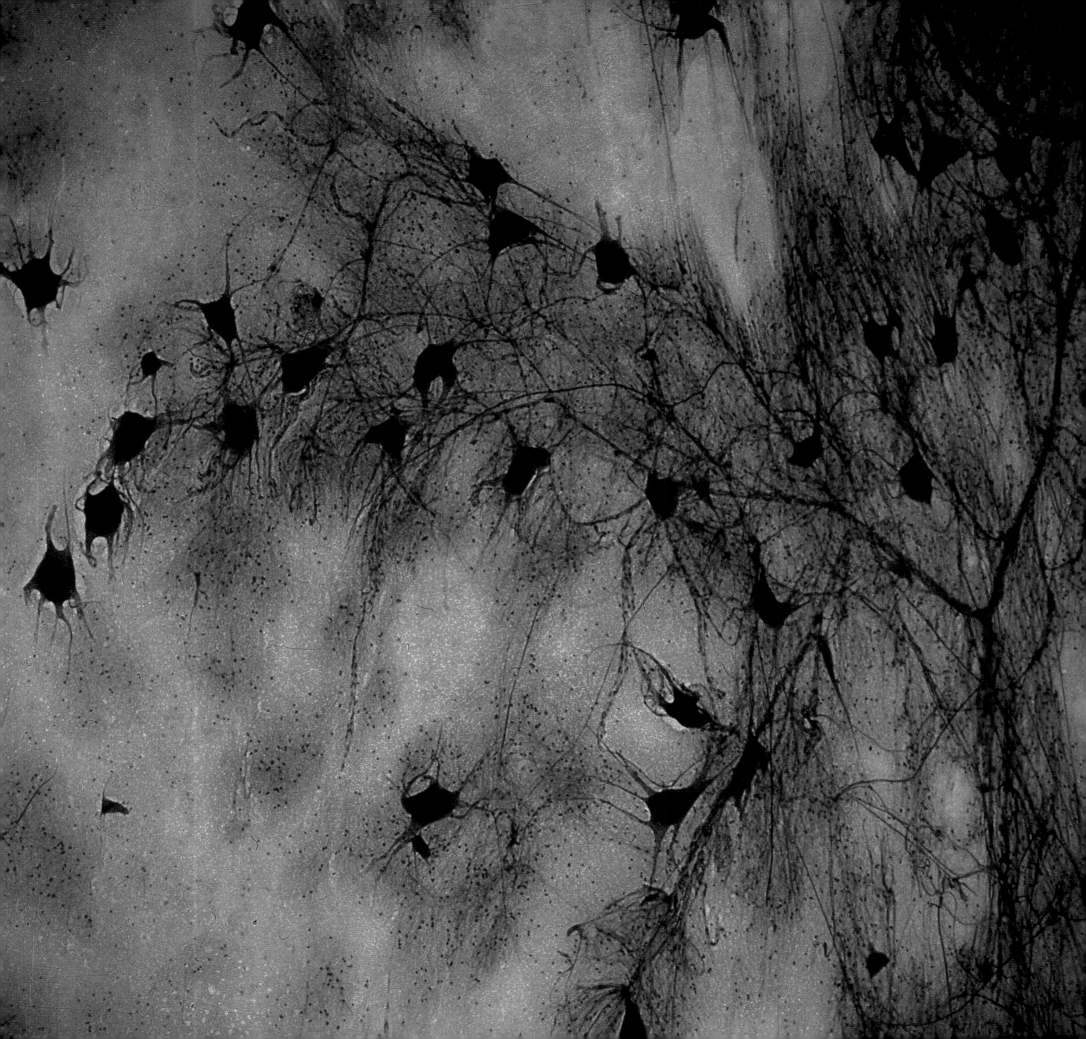

THE SENSES

THE RETINA

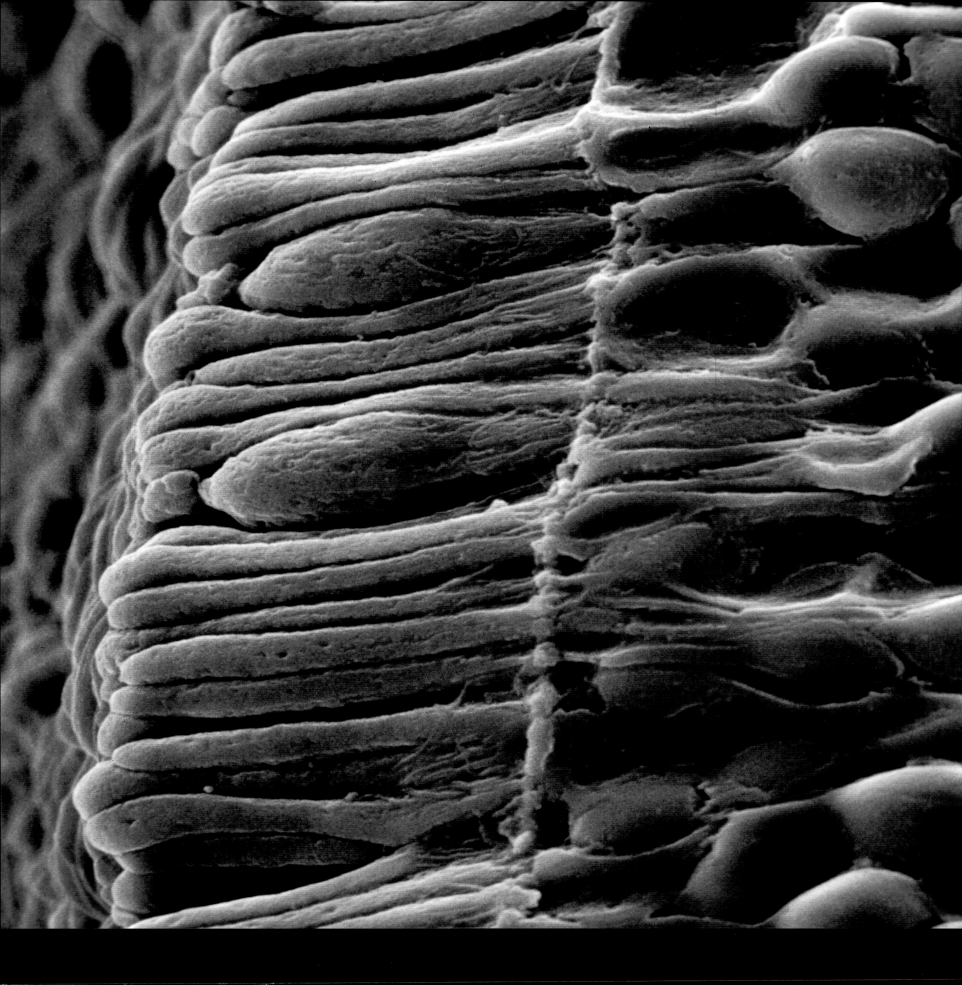

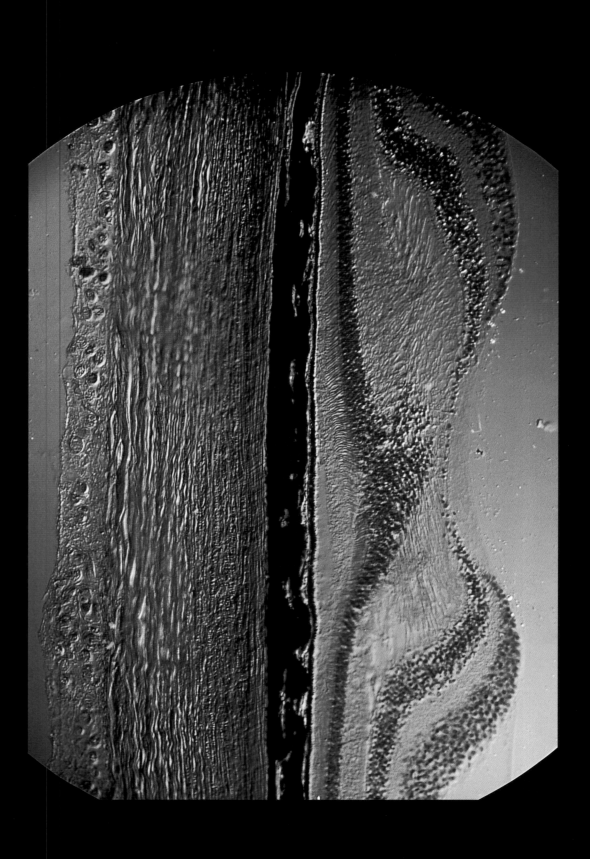

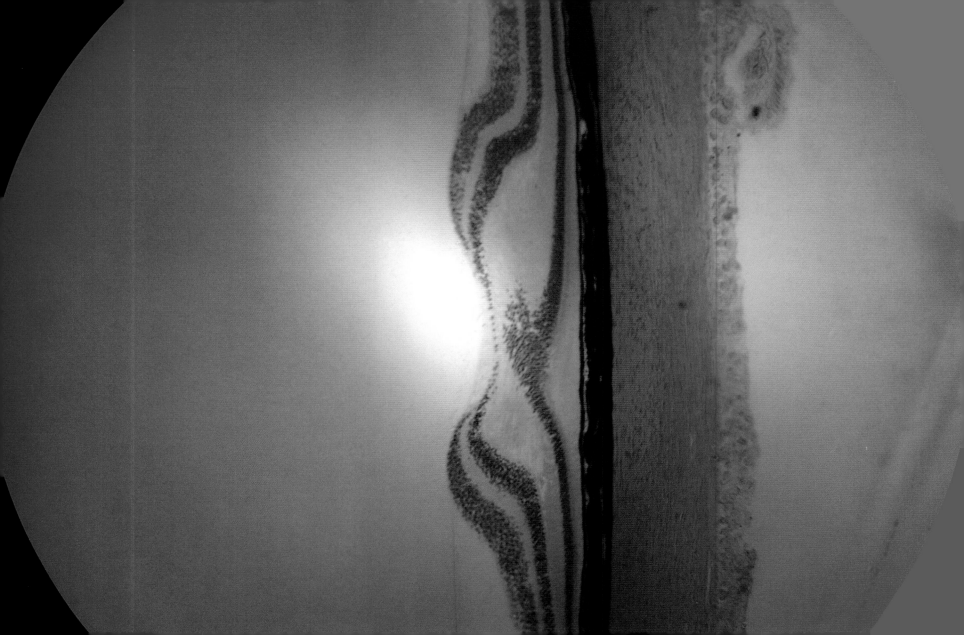

TOUCH

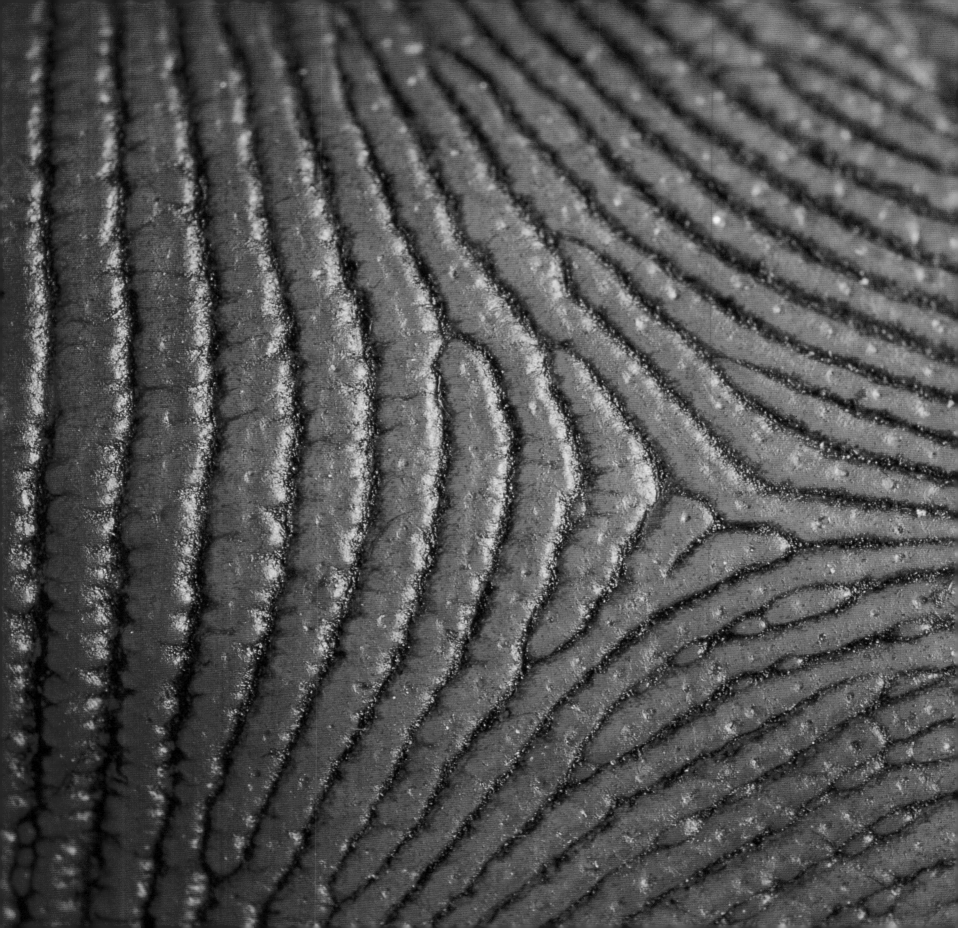

214

Pacinian corpuscles in the skin which respond to touch

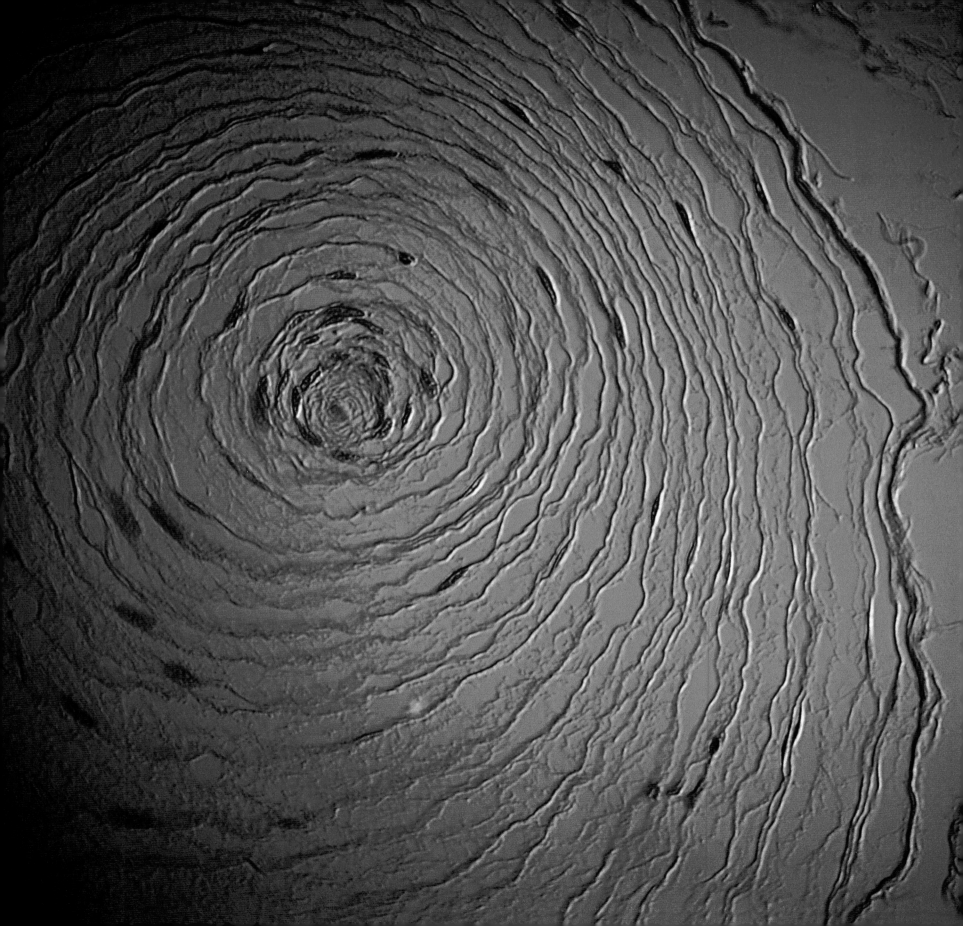

THE EAR

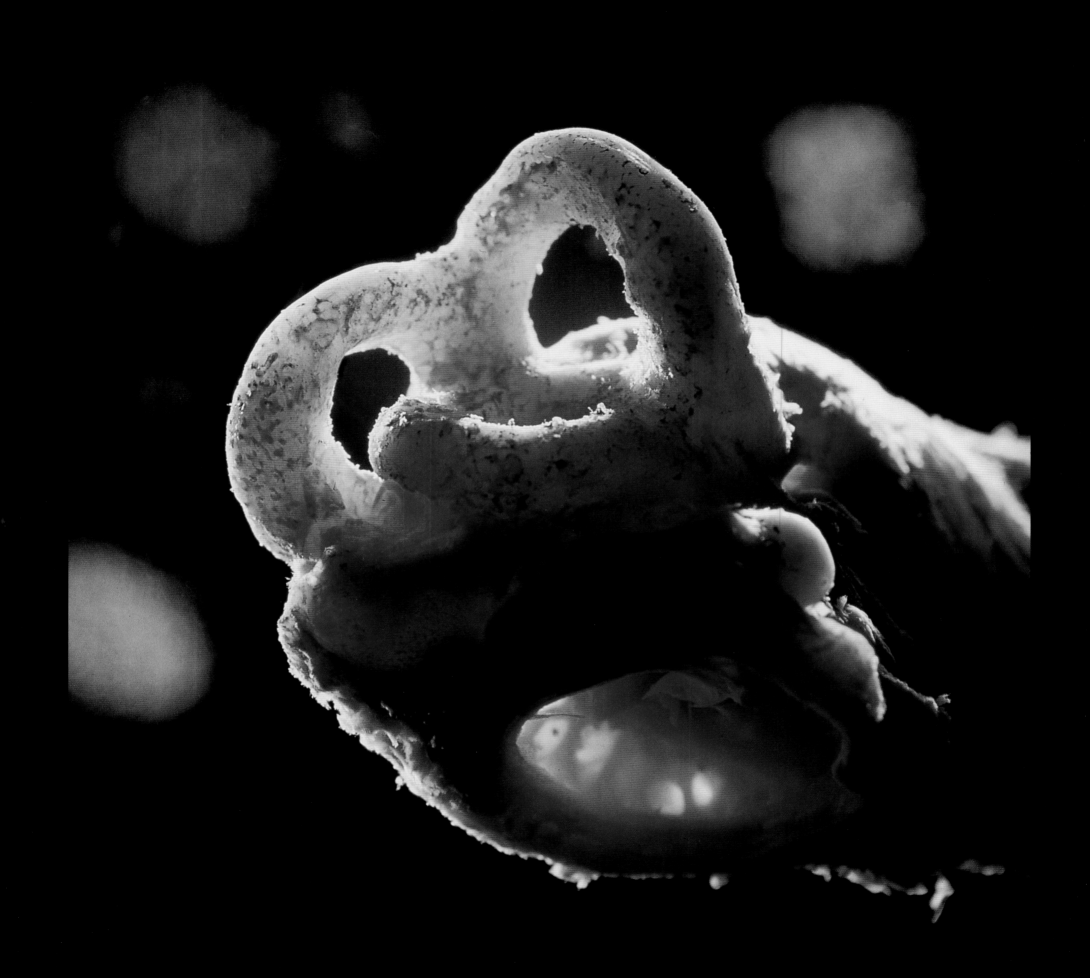

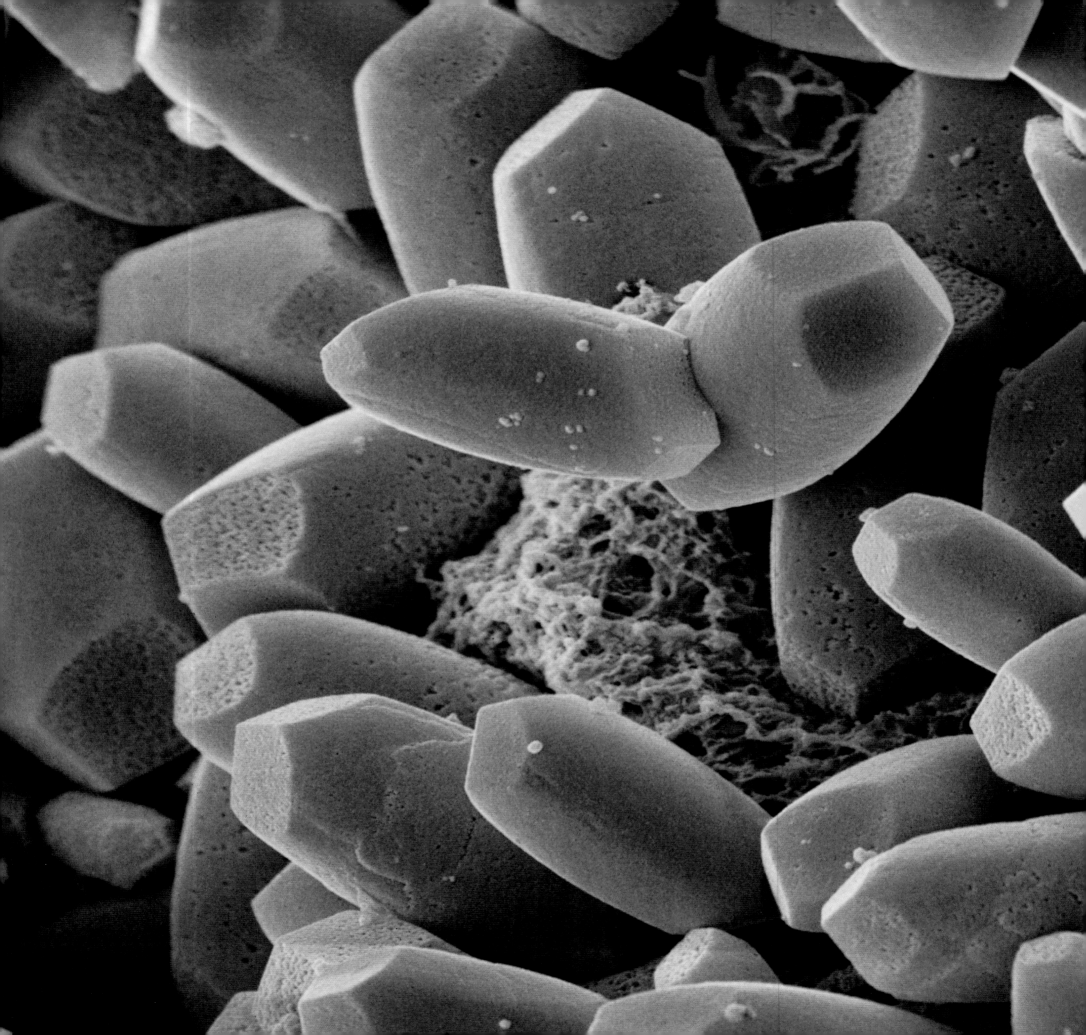

SMELL

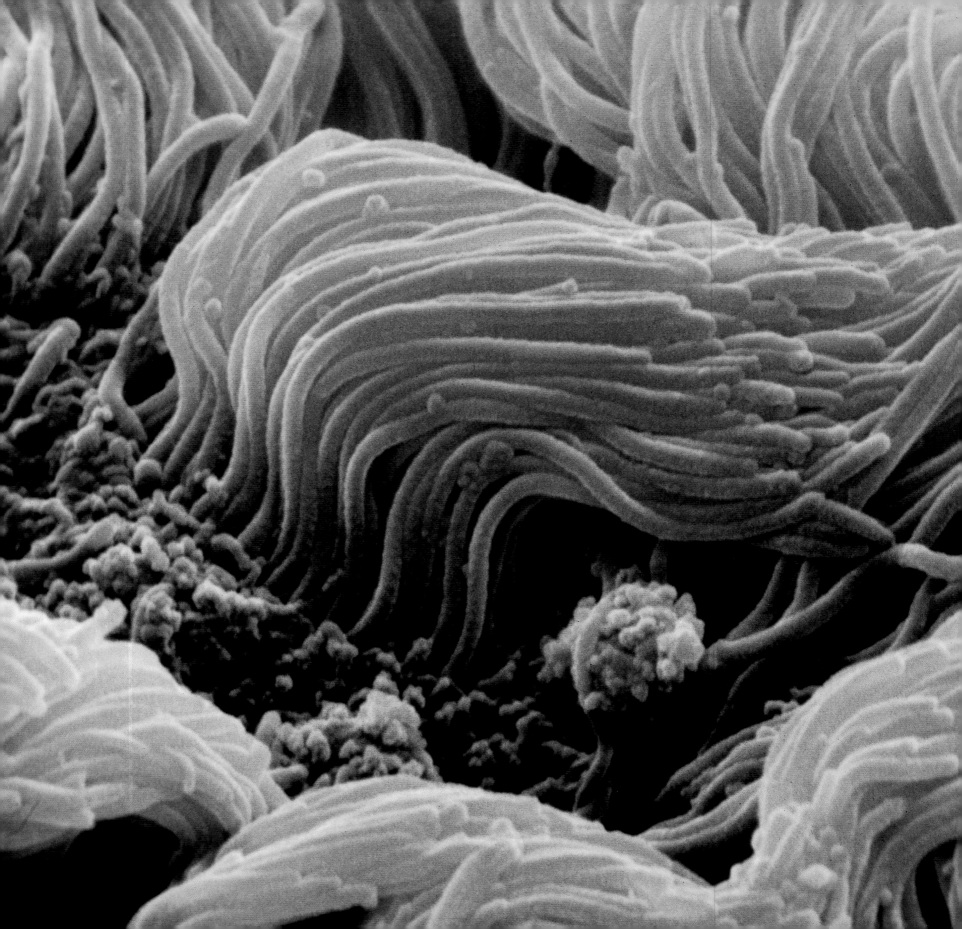

TASTE

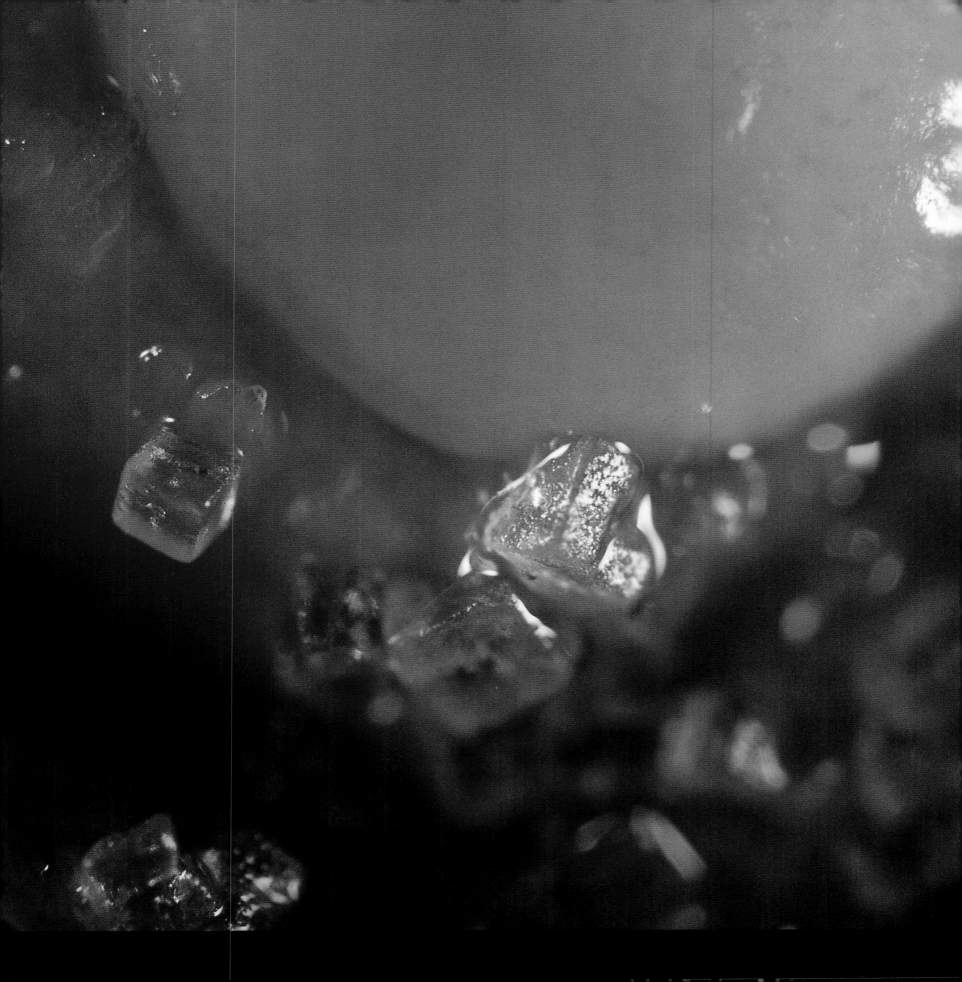

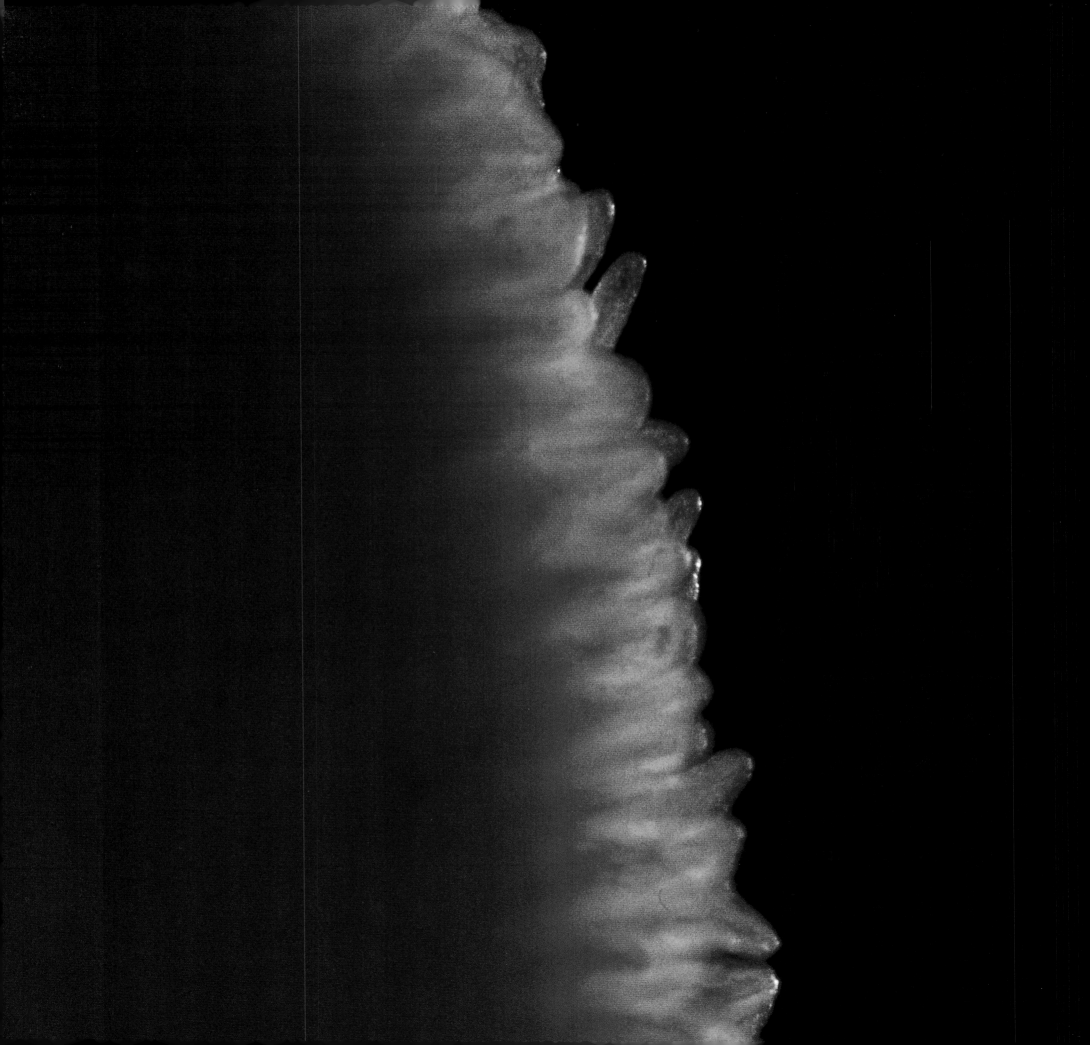

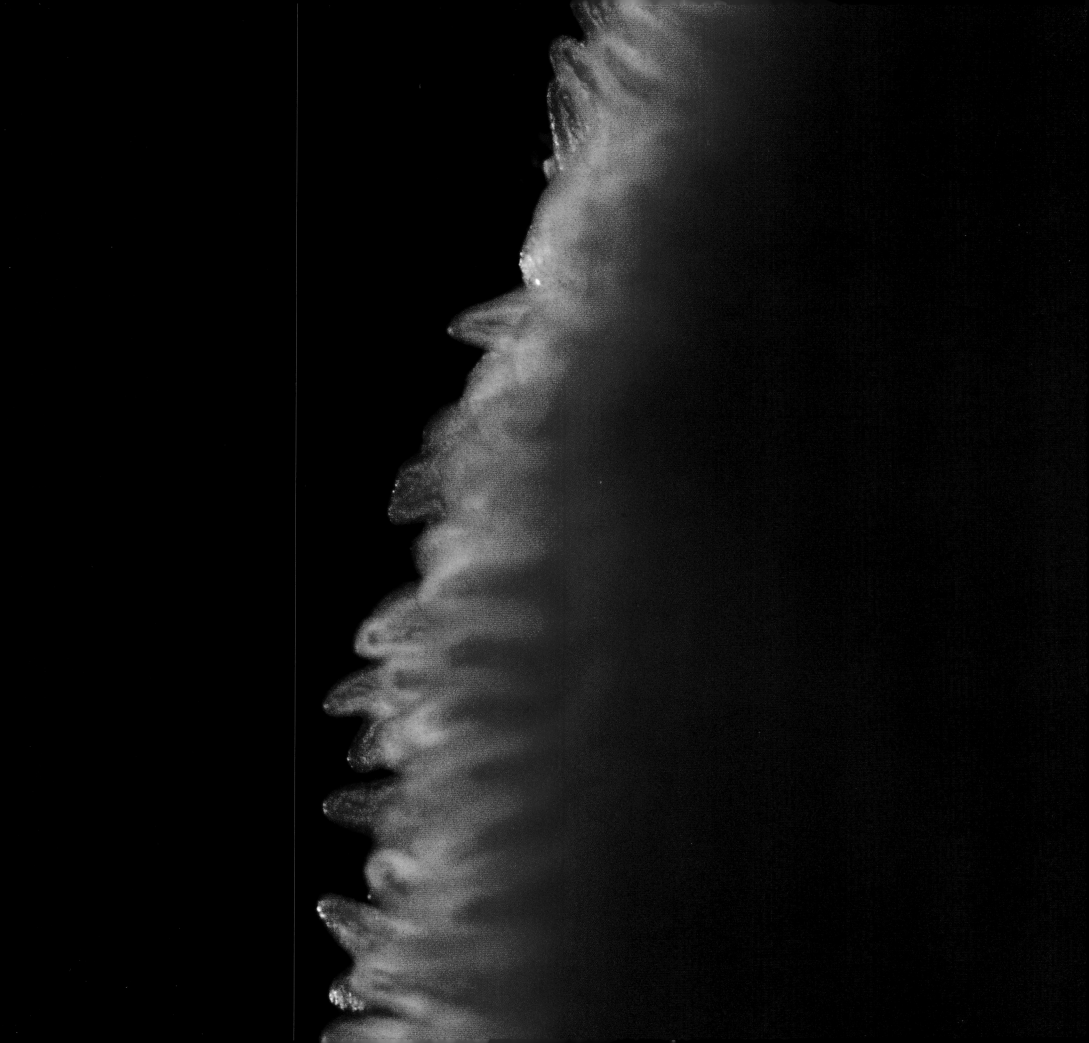

MUSCLE

Nerve fibers winding over muscle fibers

Cross section of a tendon (following pages)

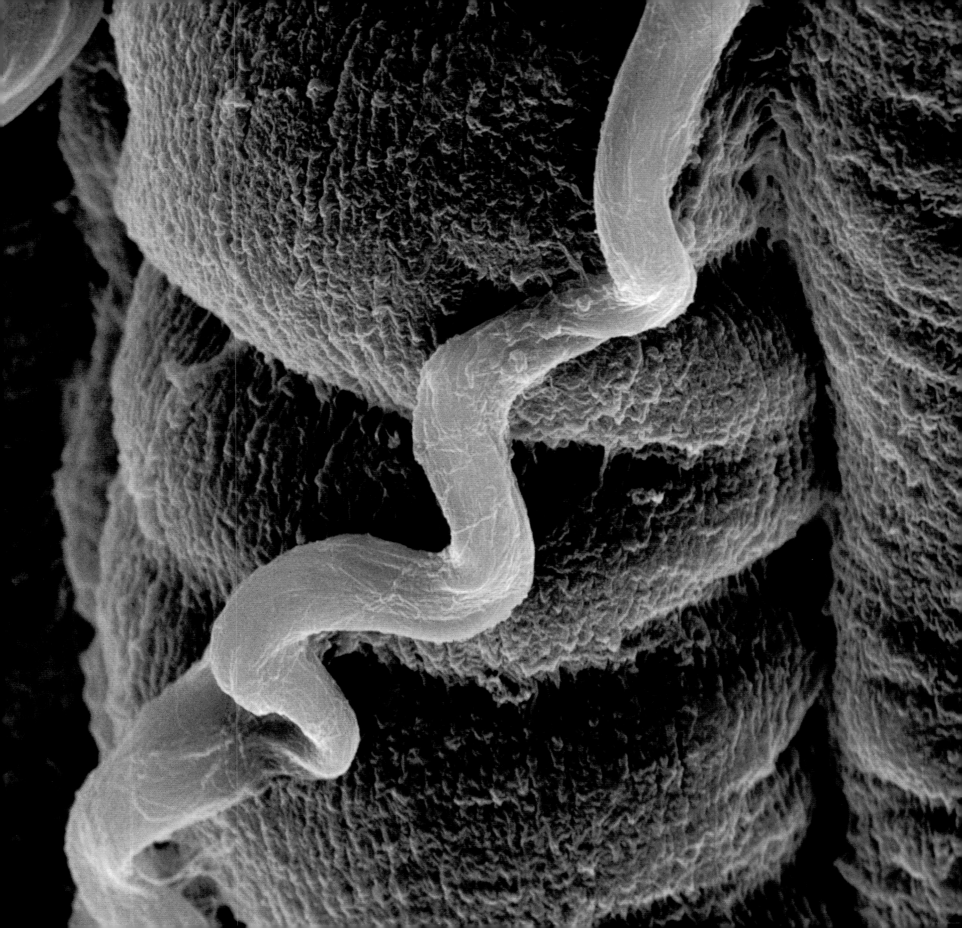

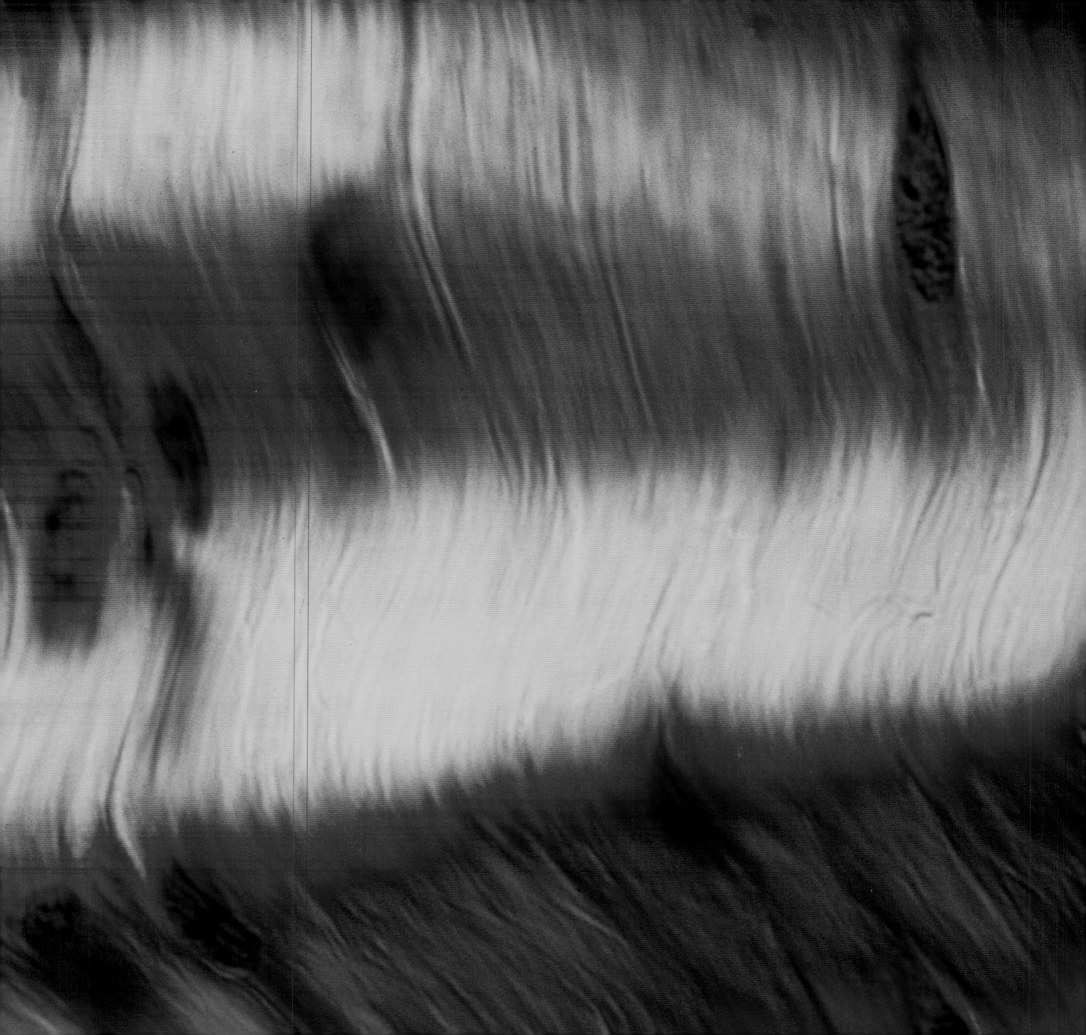

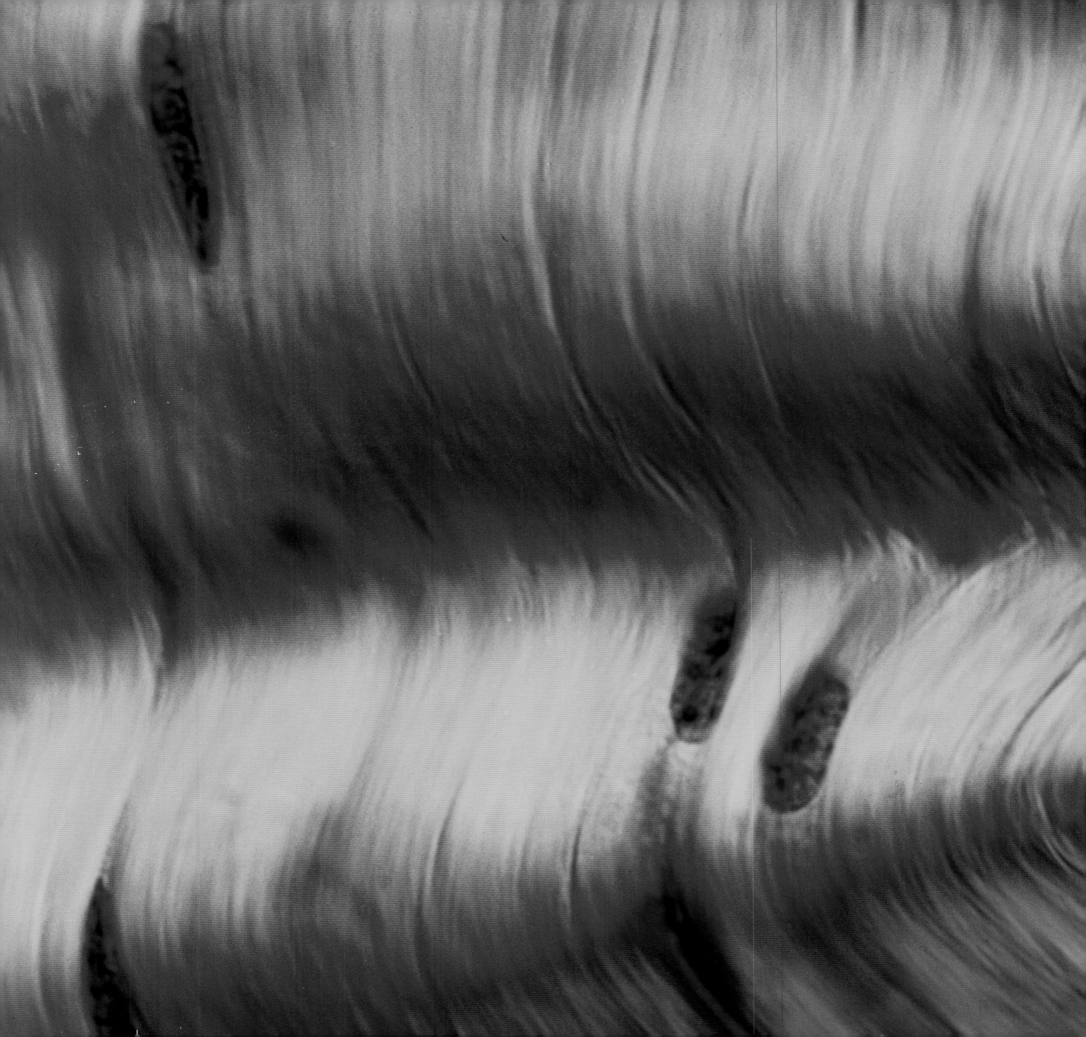

BONE

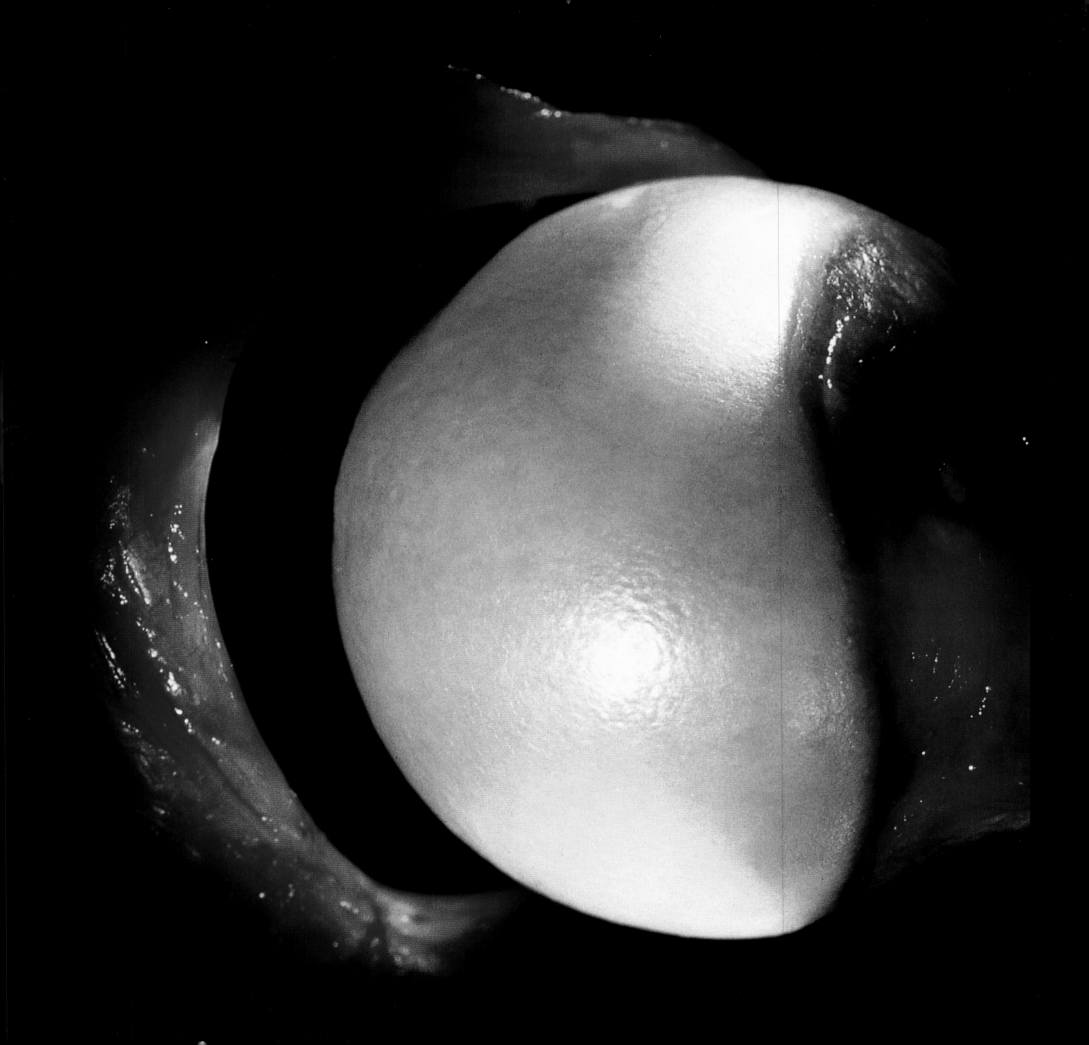

Bone tissue in a spinal vertebra

Bone tissue with the concentric formation of collagen
(following pages)

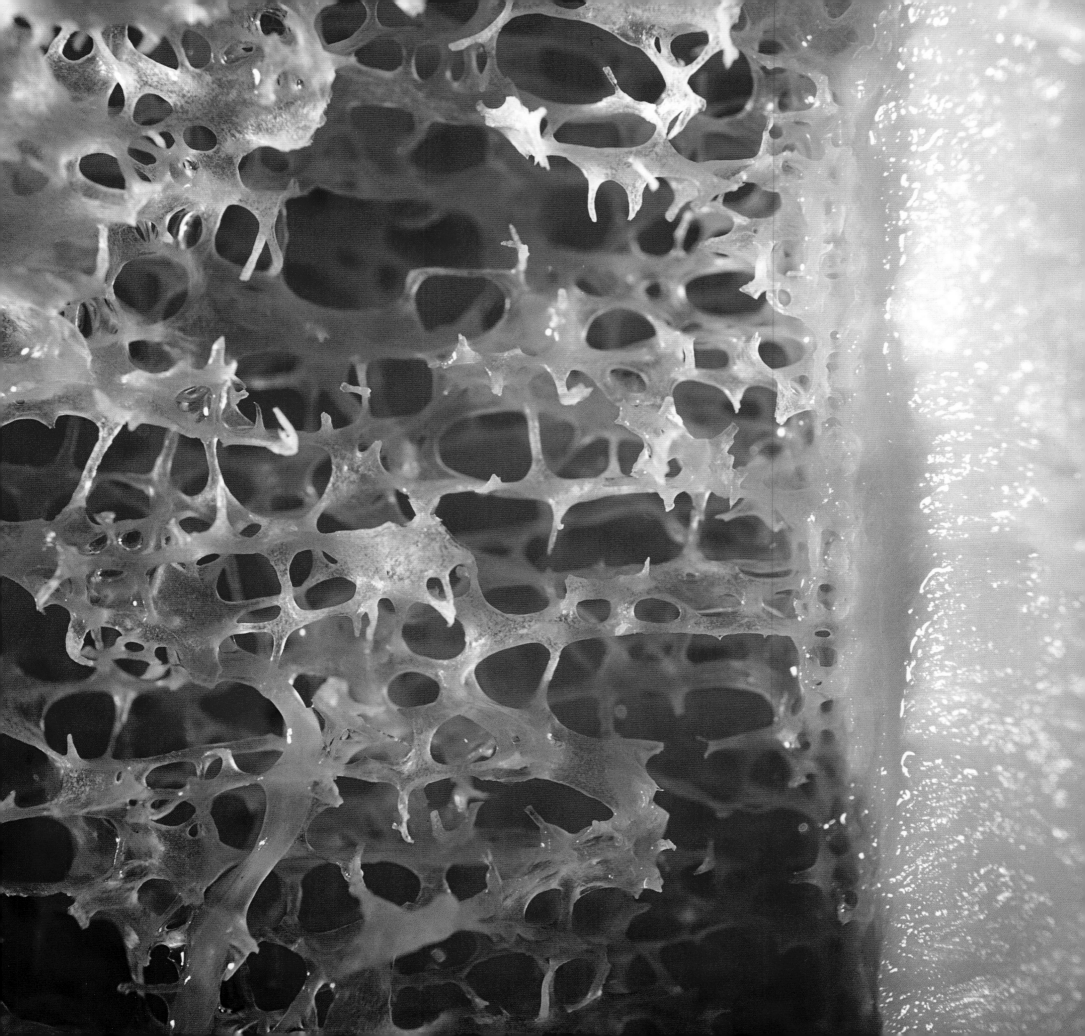

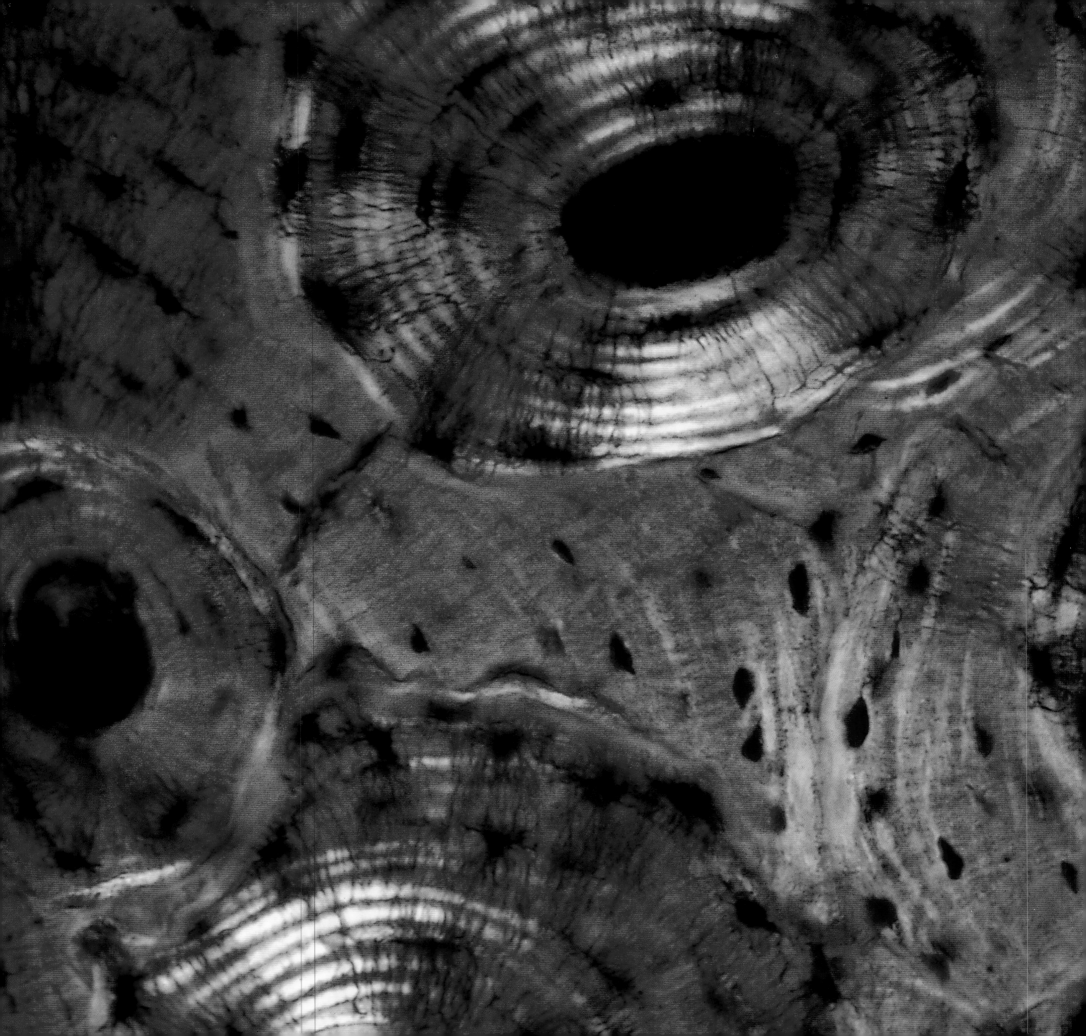

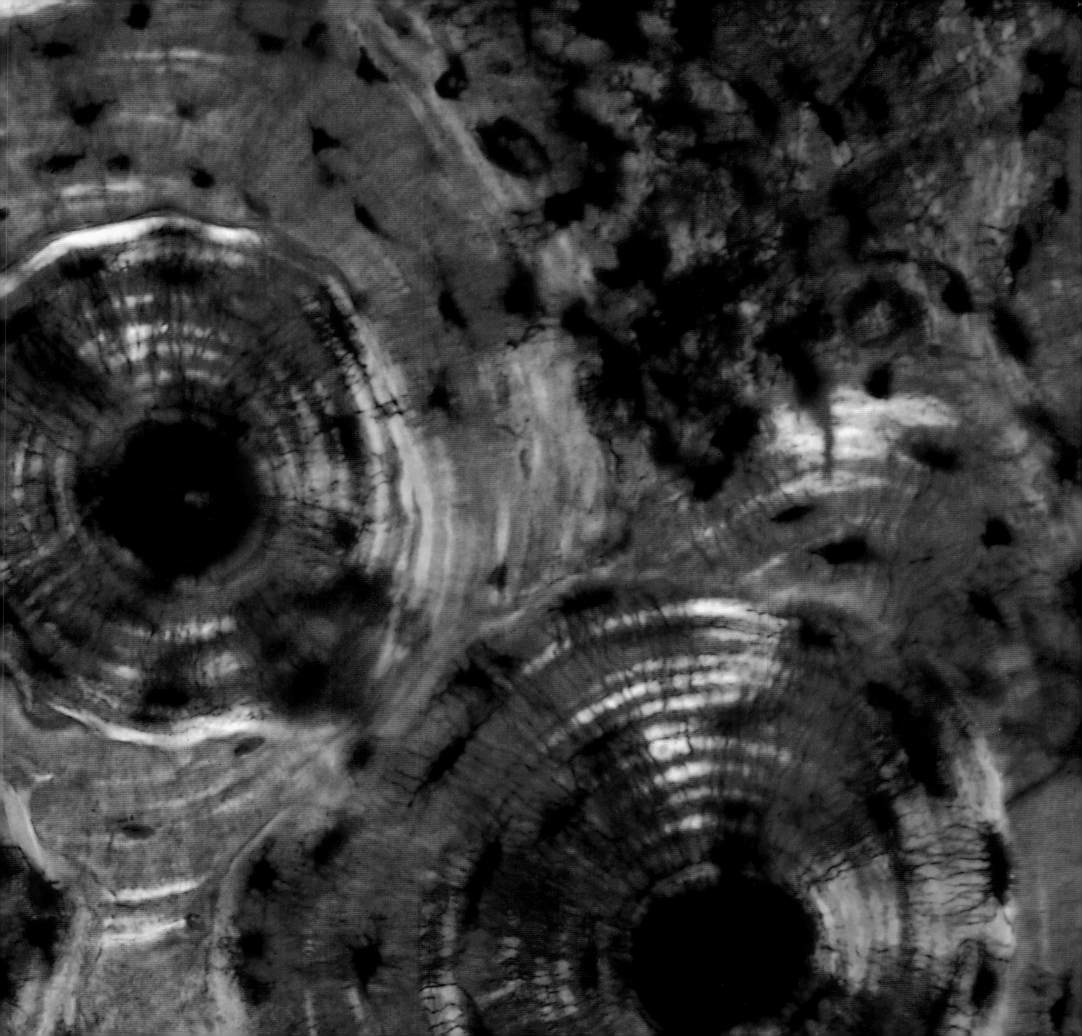

A femur damaged by rheumatism

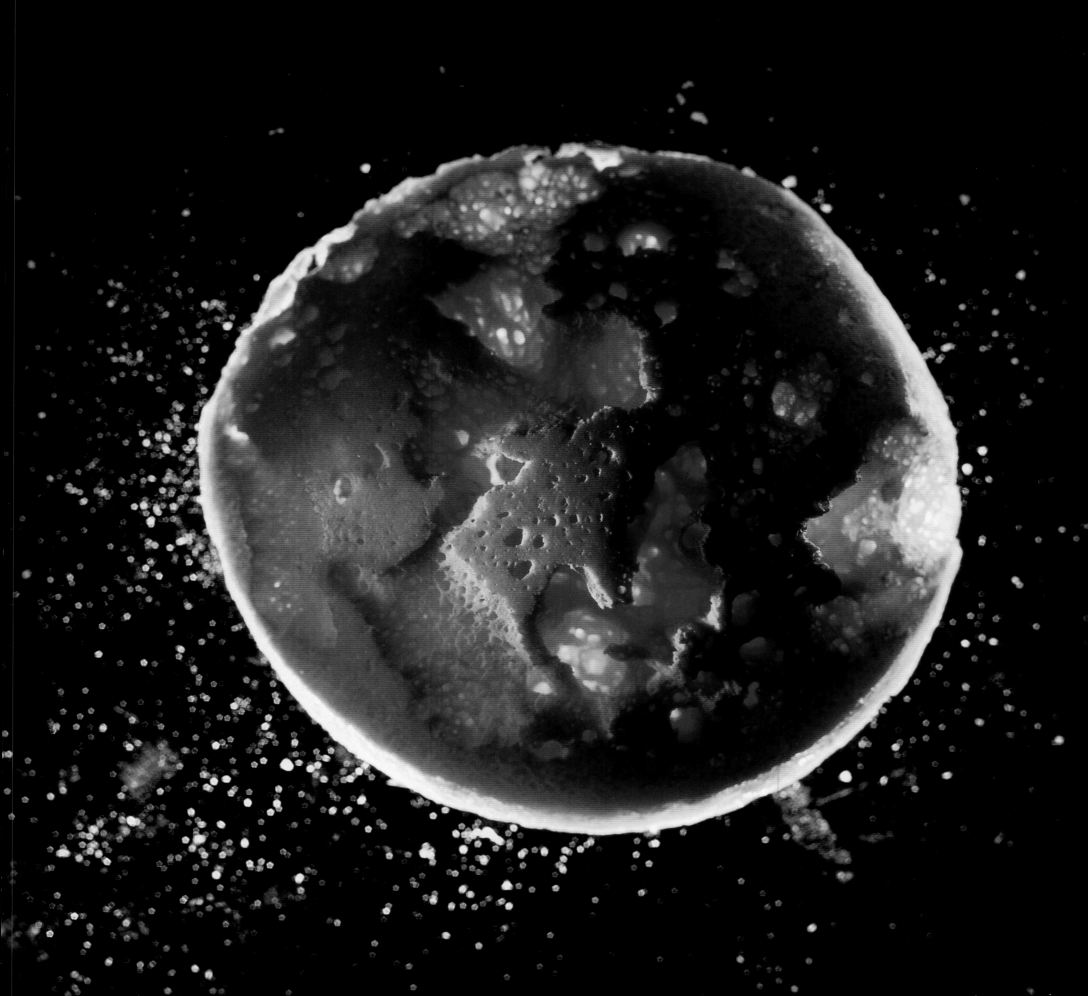

HAIR

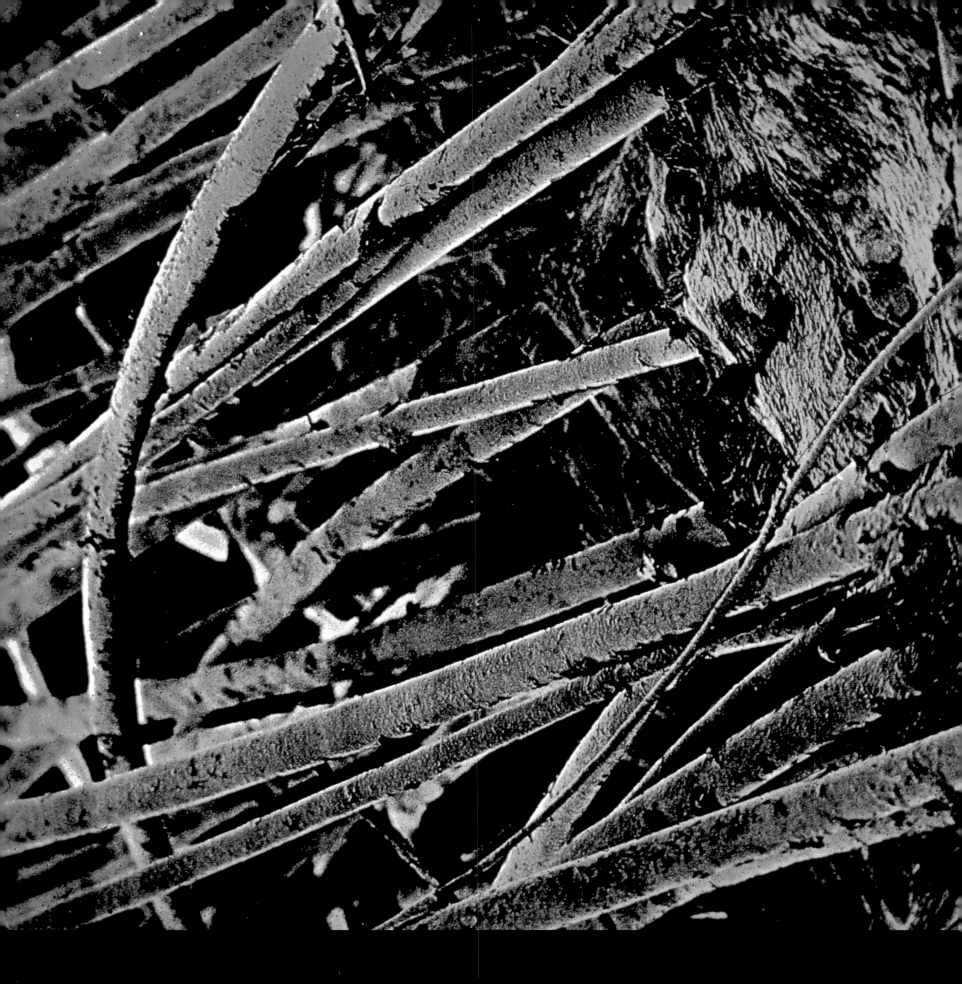

THE TOOTH

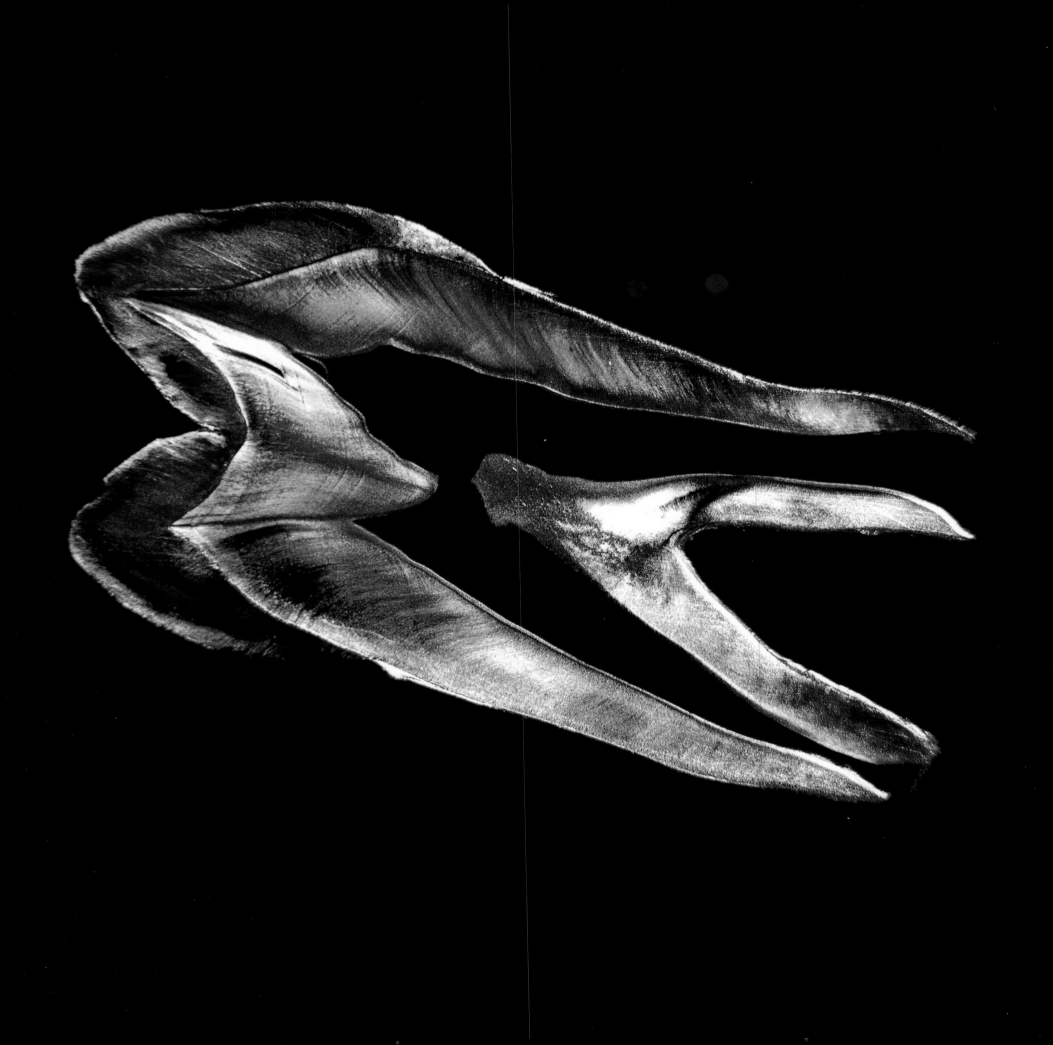

DIGESTION

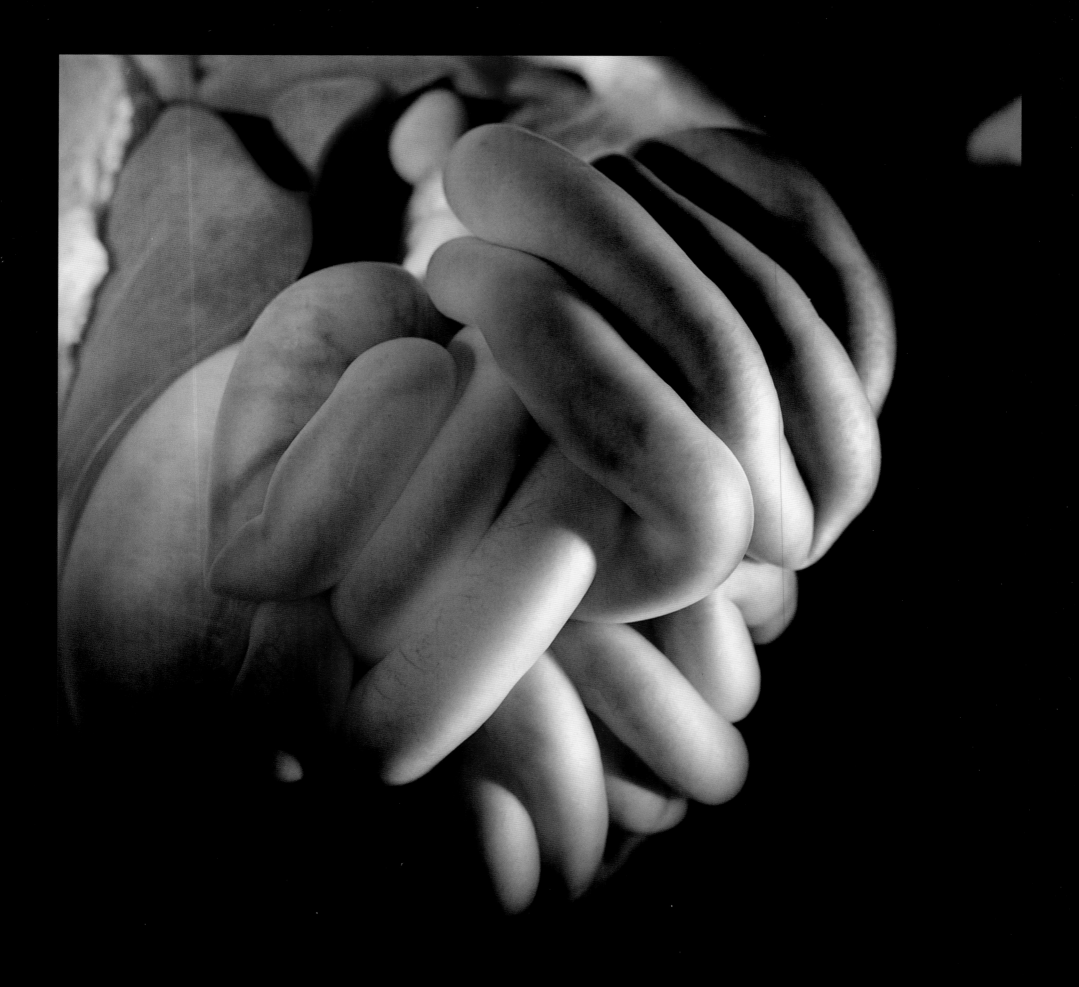

The interior of the stomach, showing entrance and exit

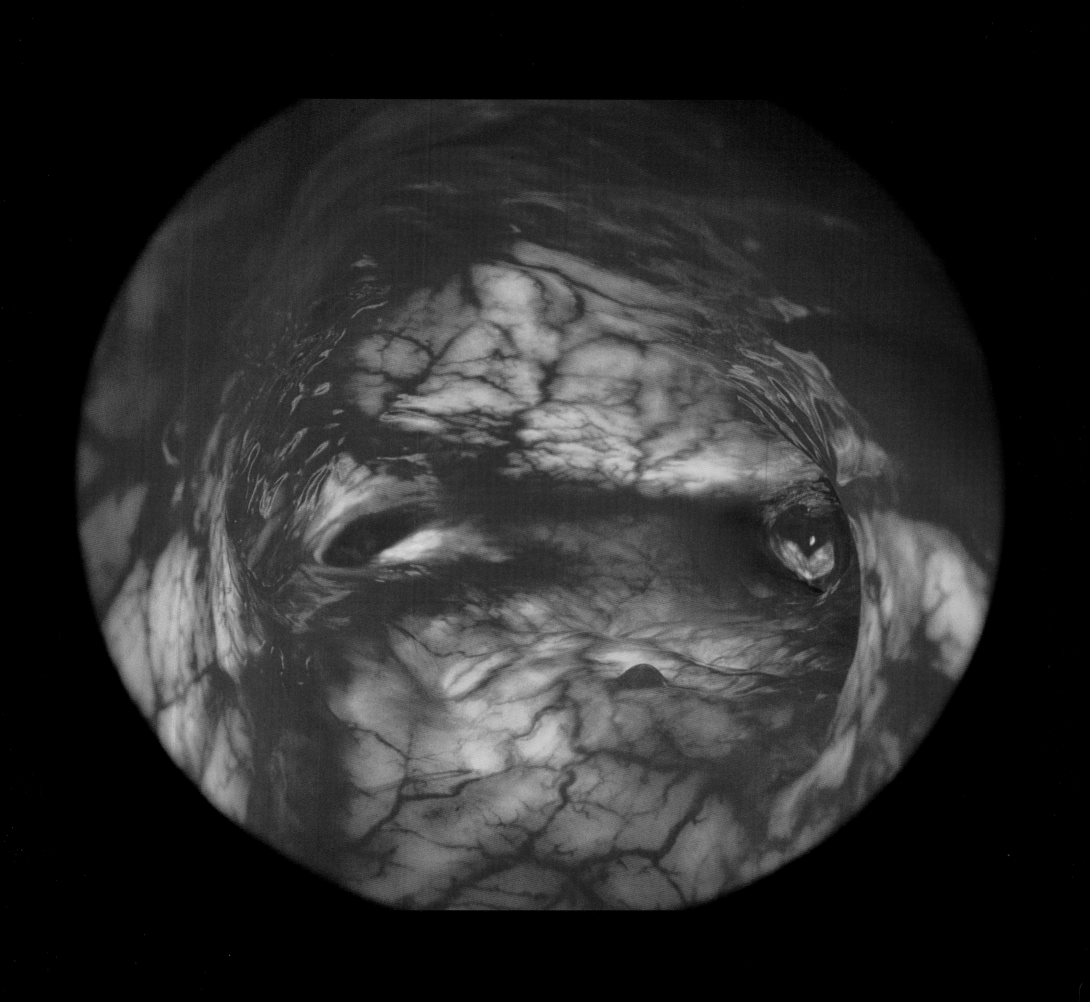

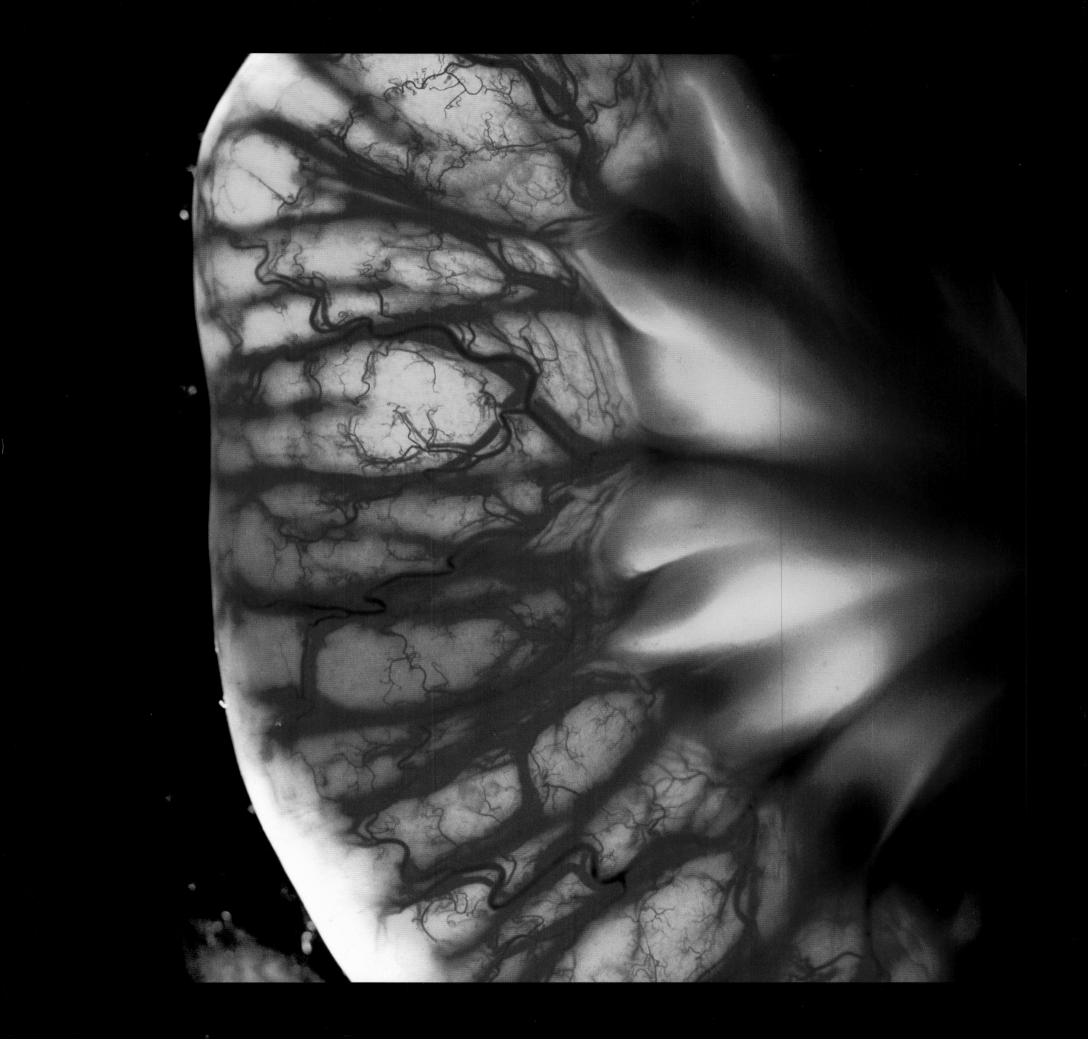

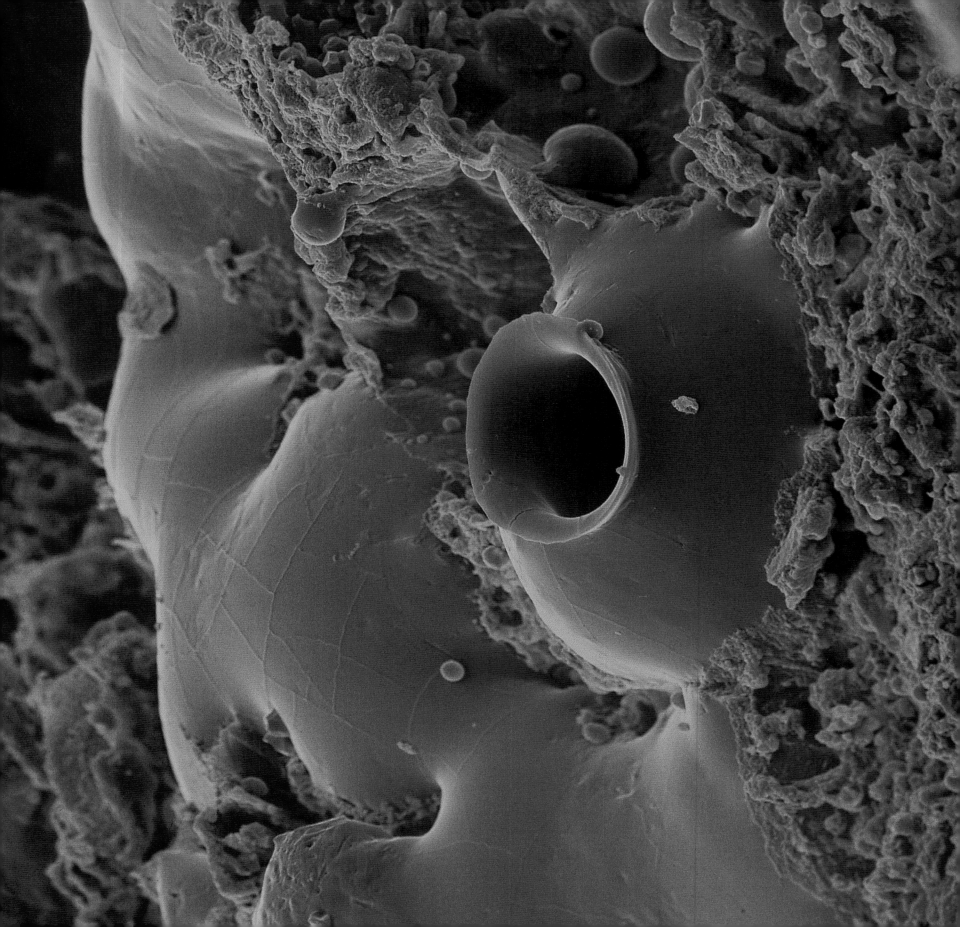

BACTERIA

Toothbrush and plaque deposit on teeth and gums (pages 252–253)

Bacteria, absorbed one by one, then destroyed by chemicals in the macrophage

A macrophage extends pseudopods to ensnare

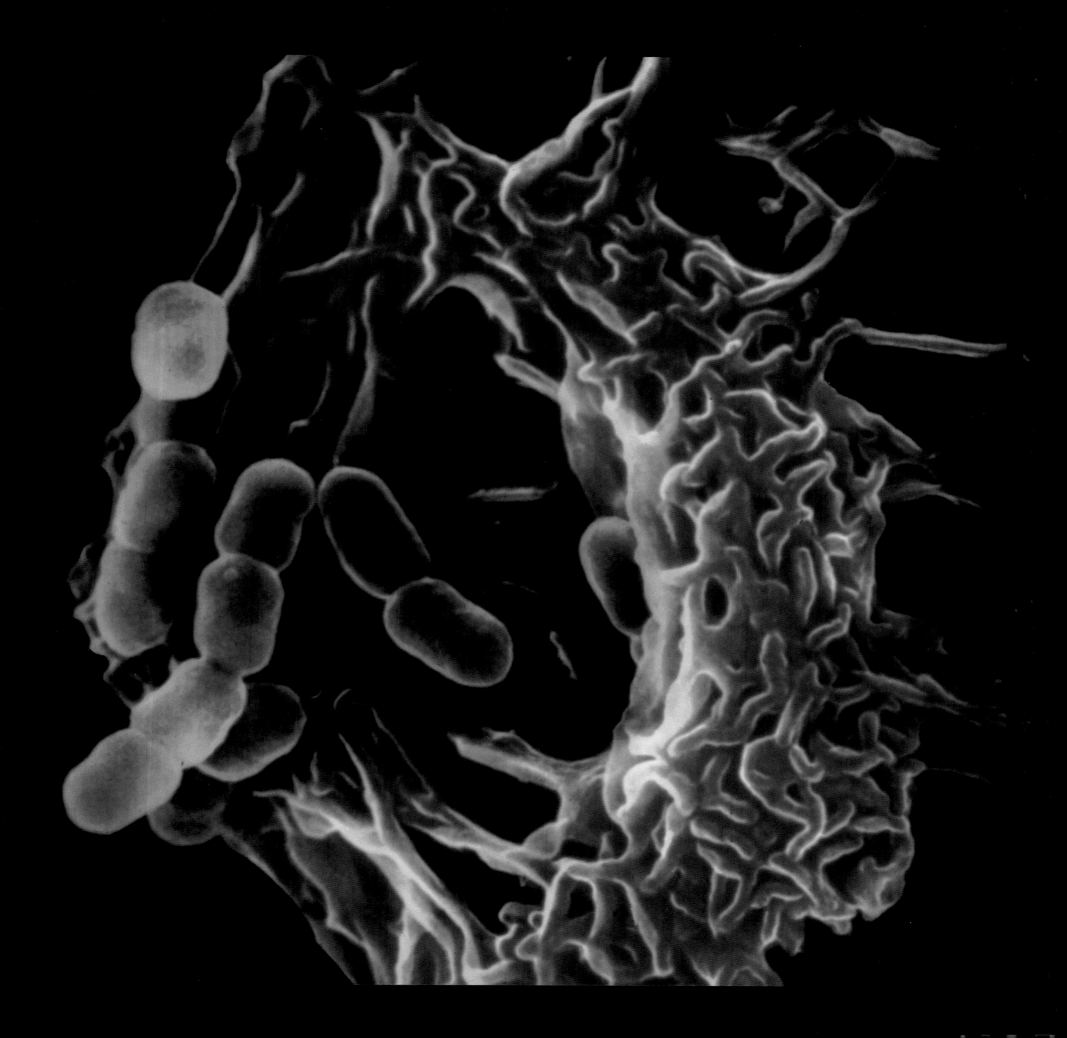

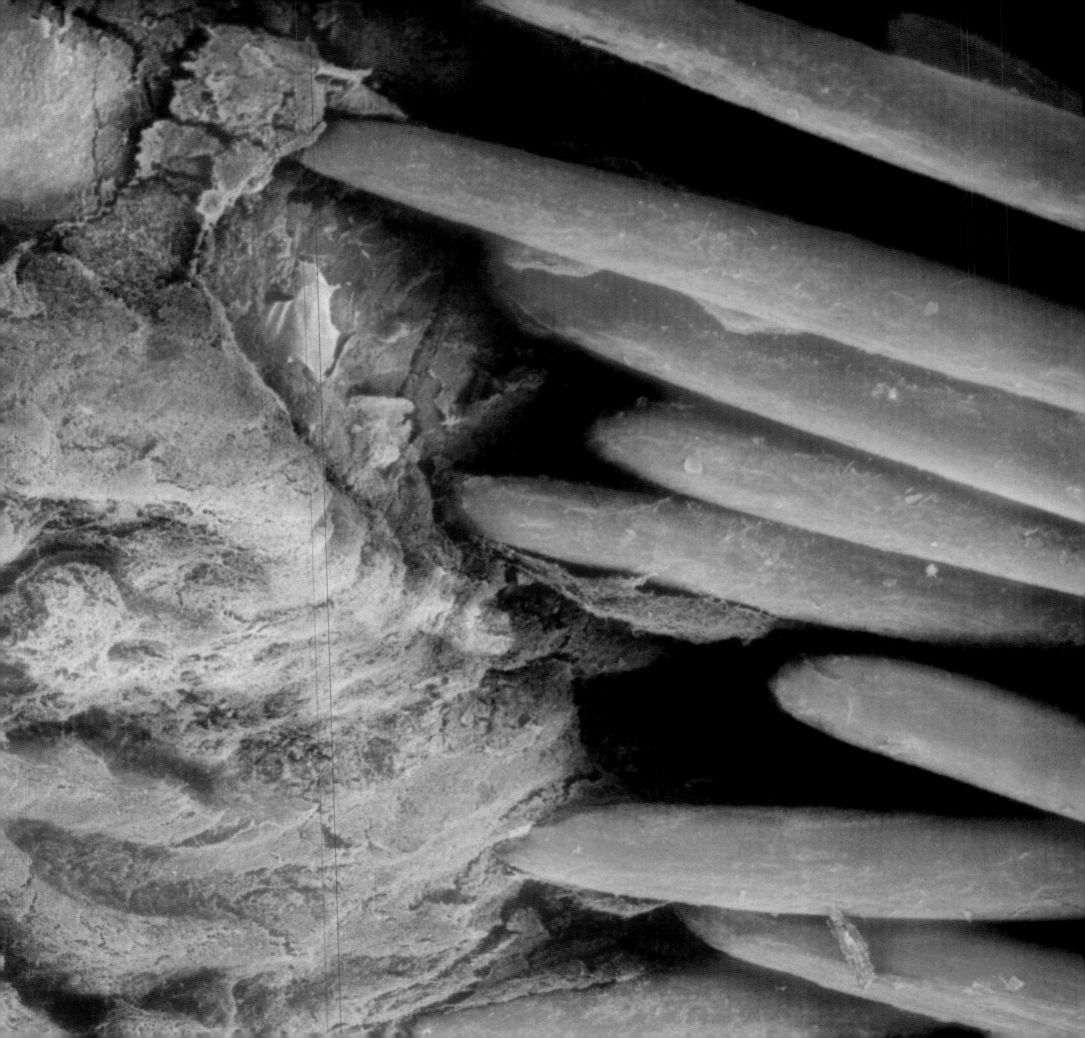

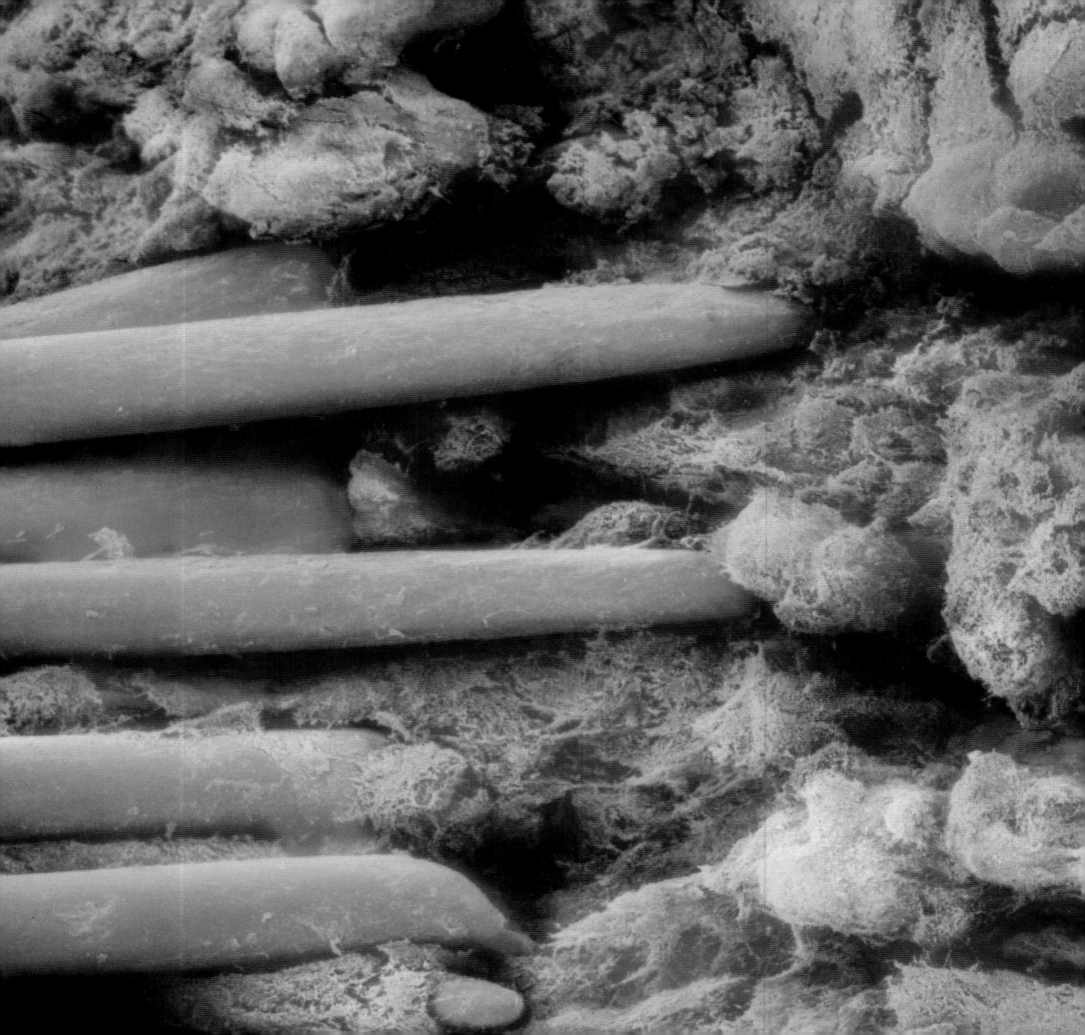

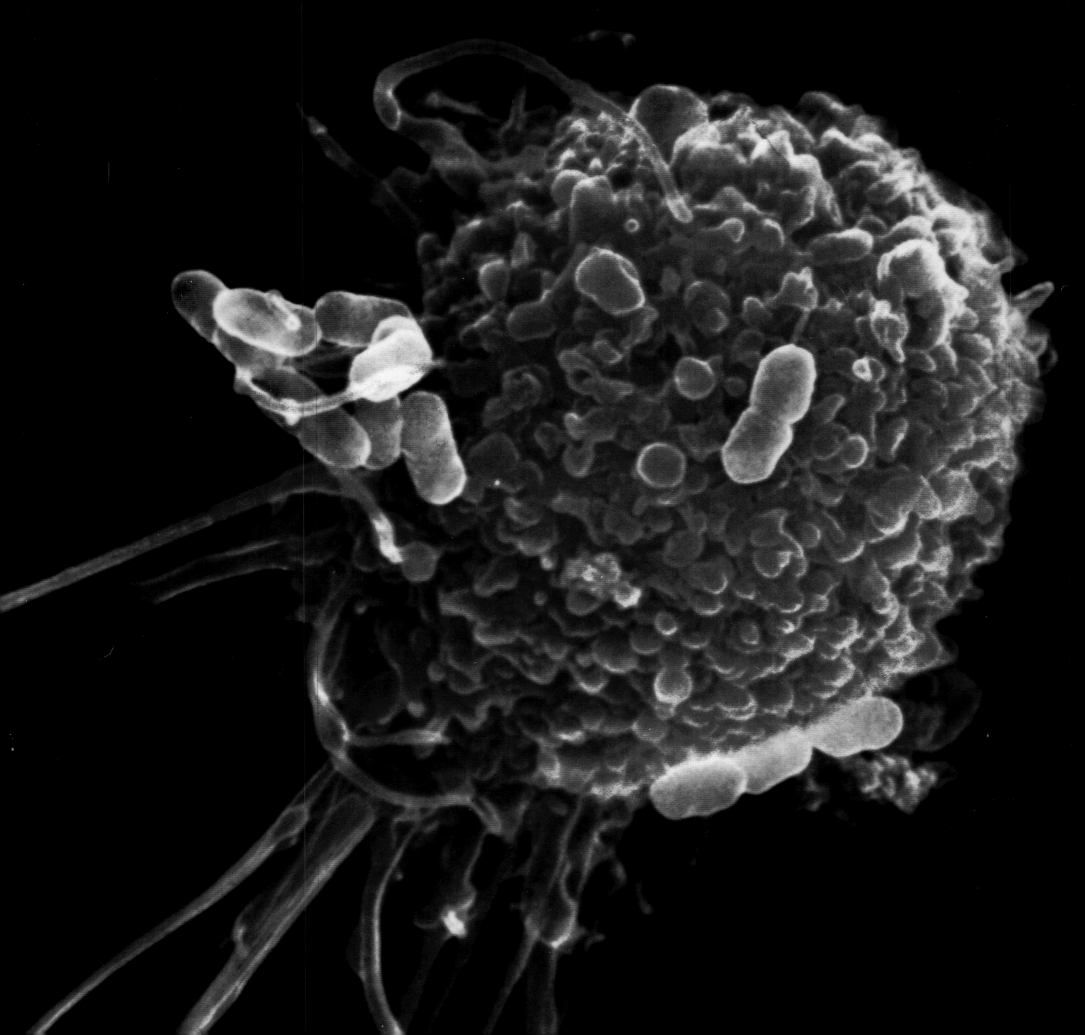

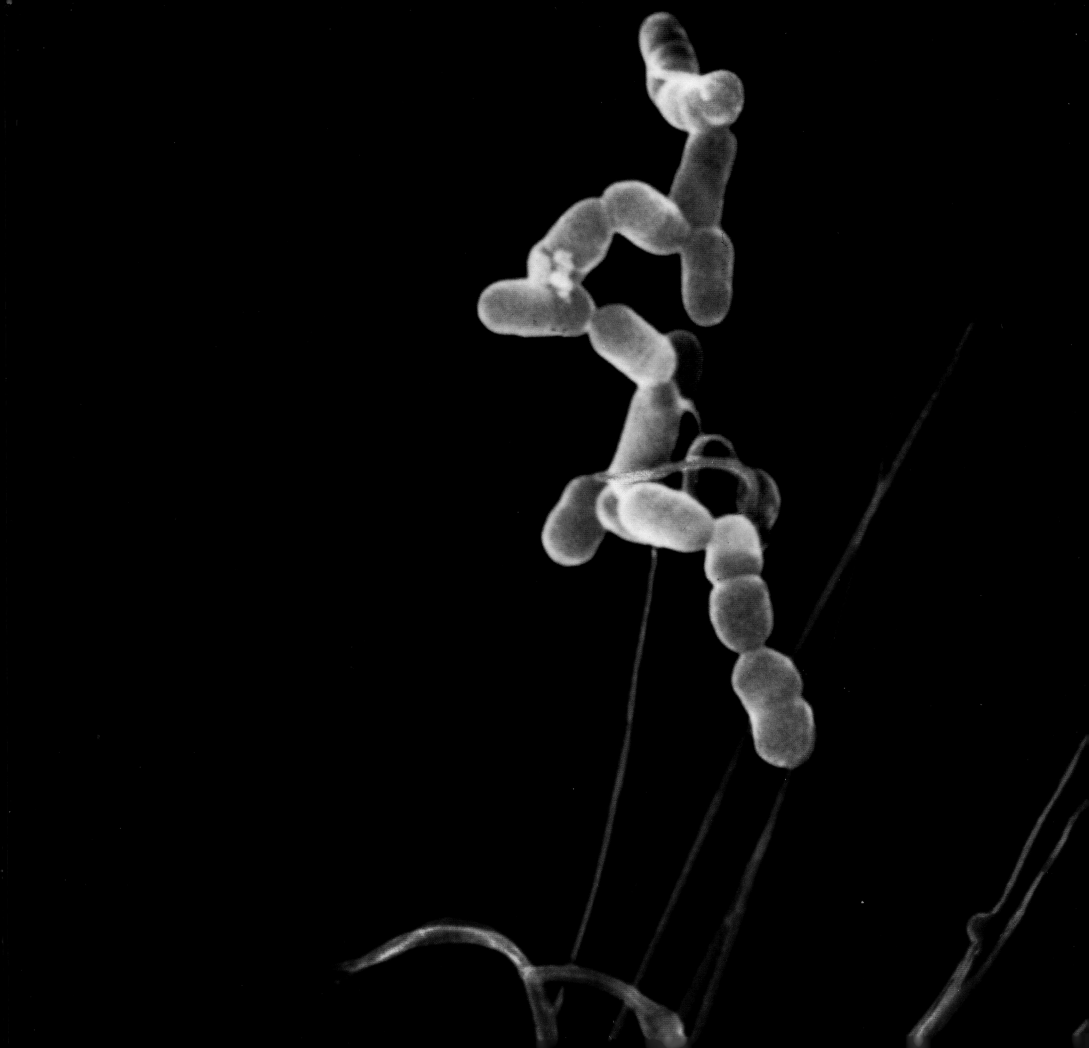

CANCER

Killer T cells acquire the elongated shape
of active fighters as they attack a cancer cell

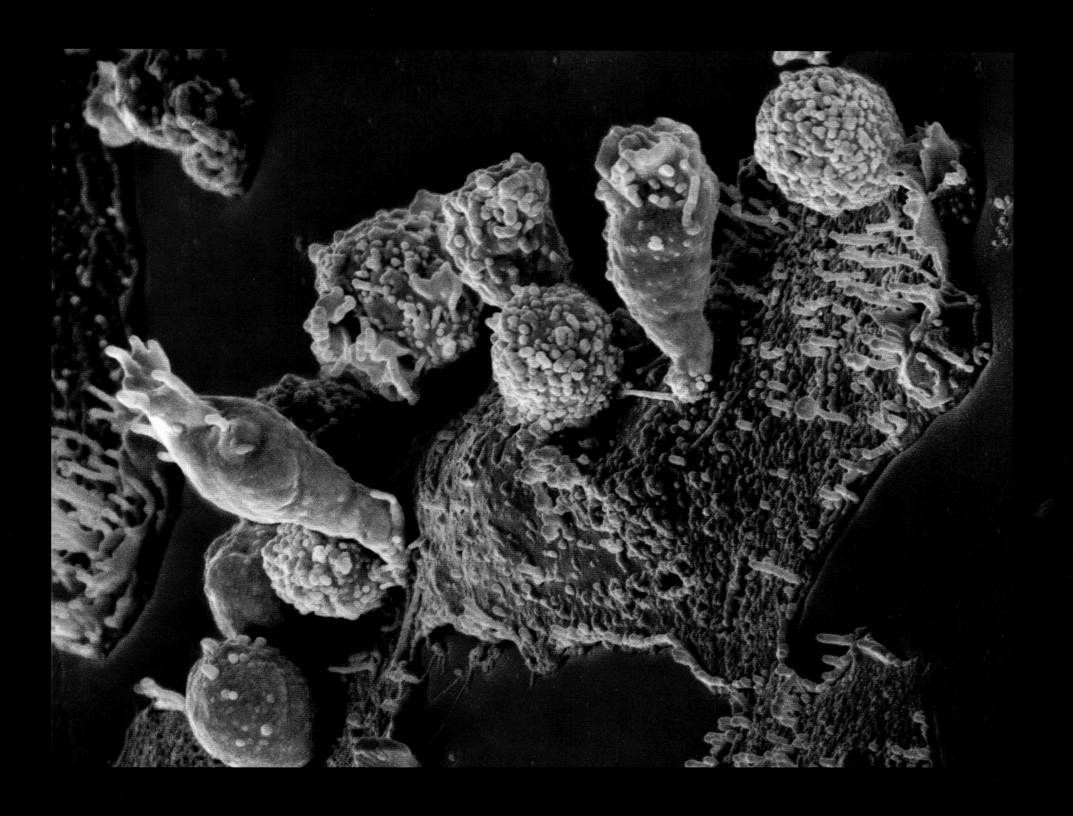

The empty shell of a cancer cell with the perforation made by the "kiss of death."
In front of the empty tumor cell lies a Killer T cell in its resting shape

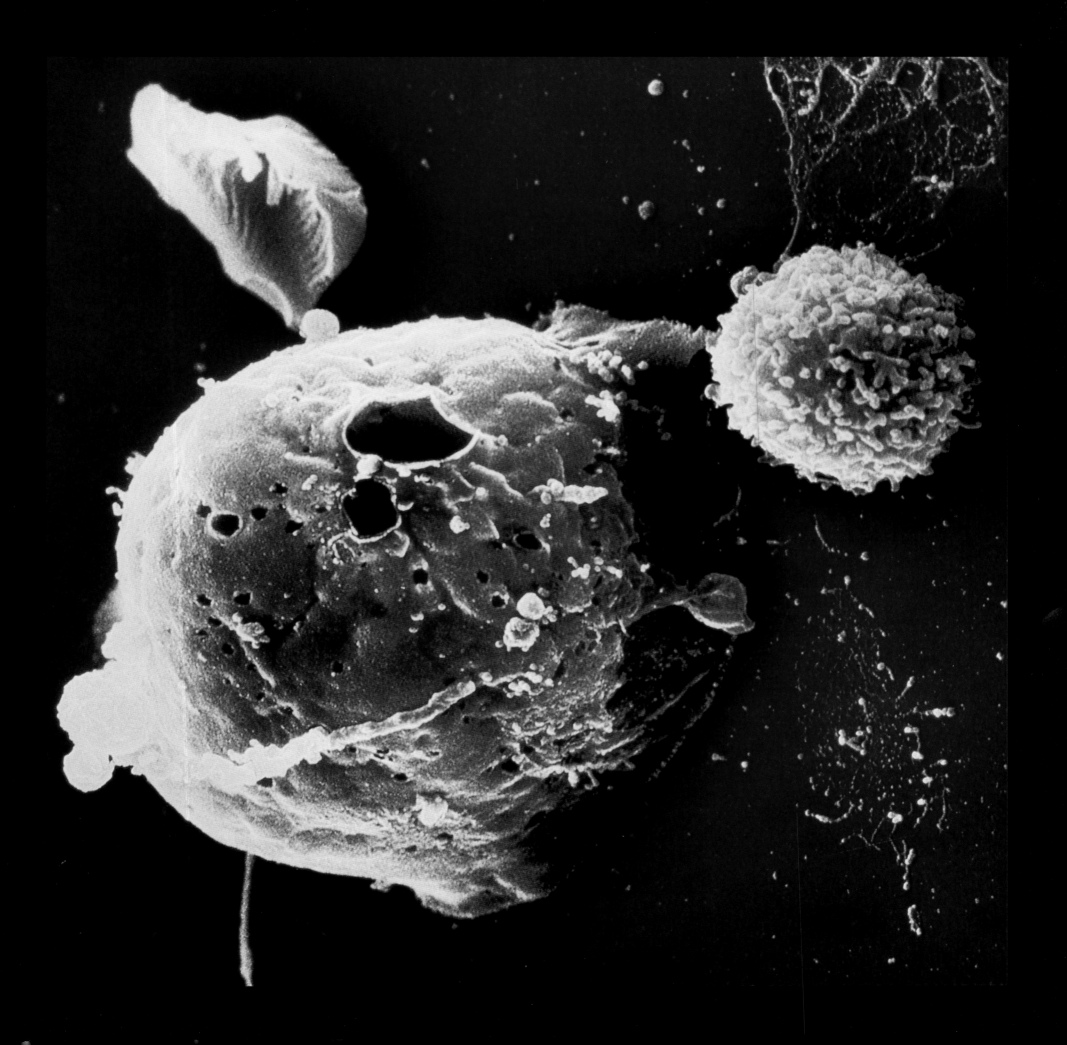

The cancer cell is dead. A fibrous cytoskeleton remains

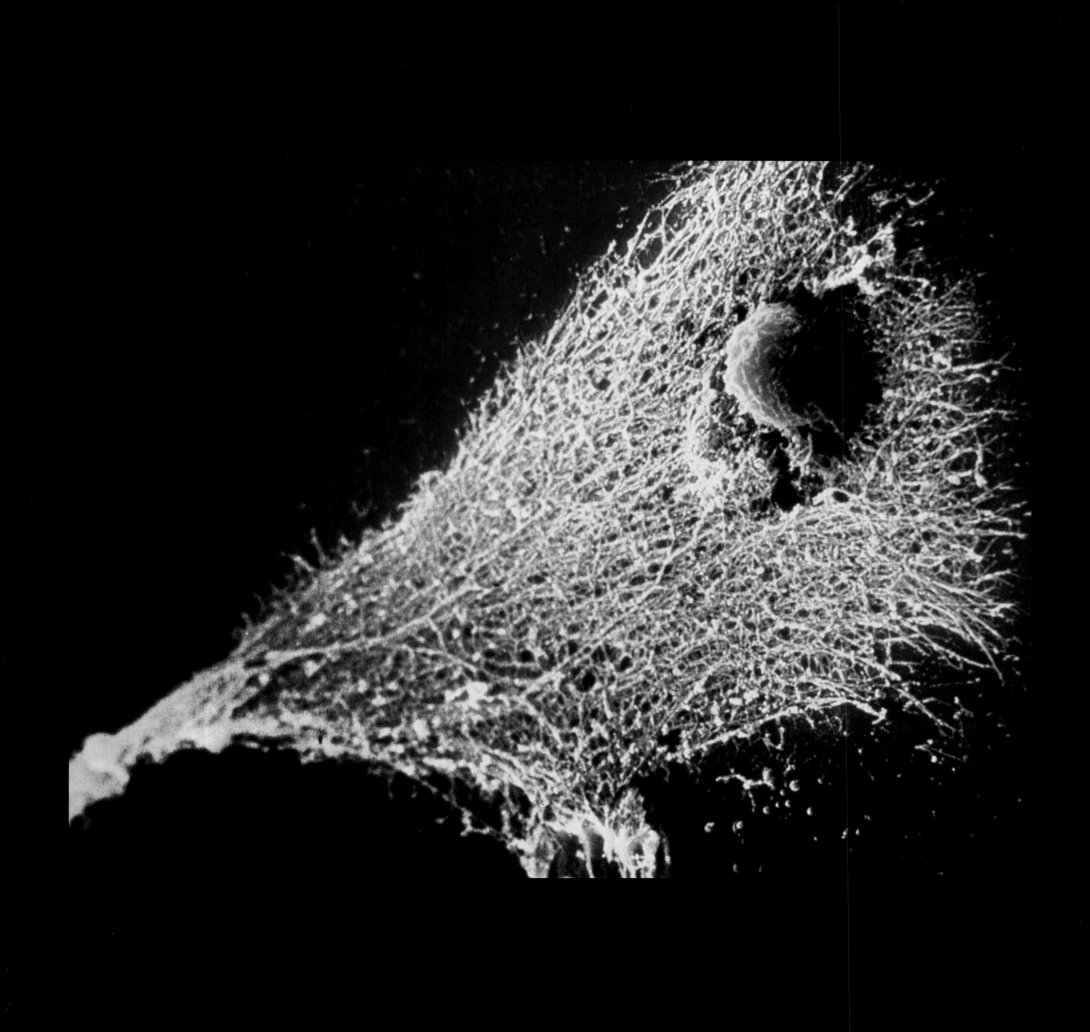

ATMOSPHERIC PARTICLES

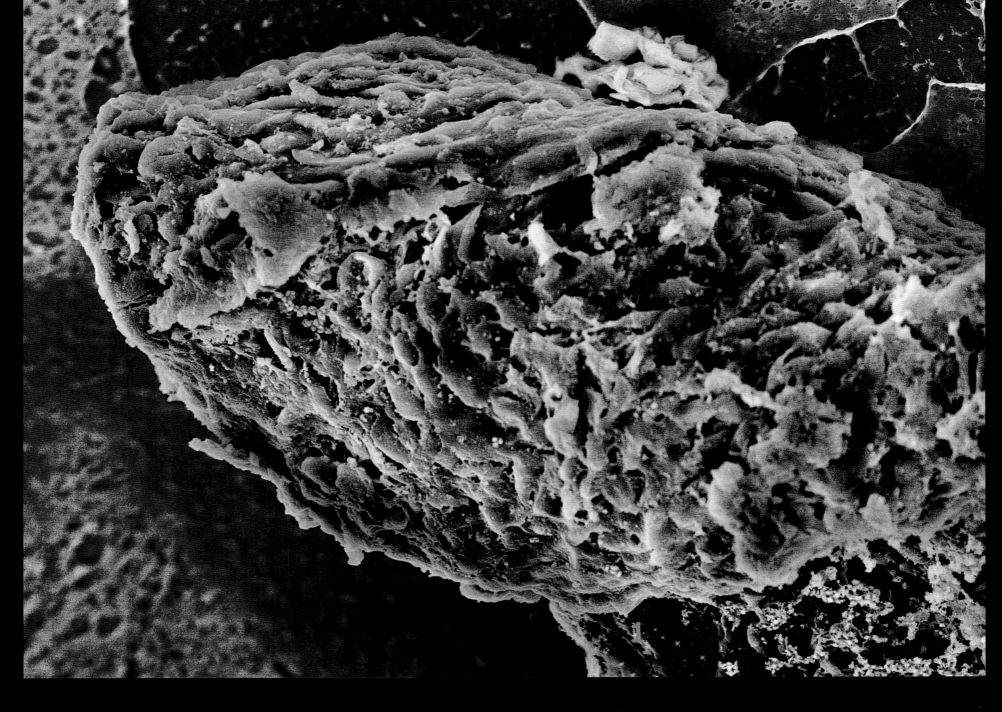

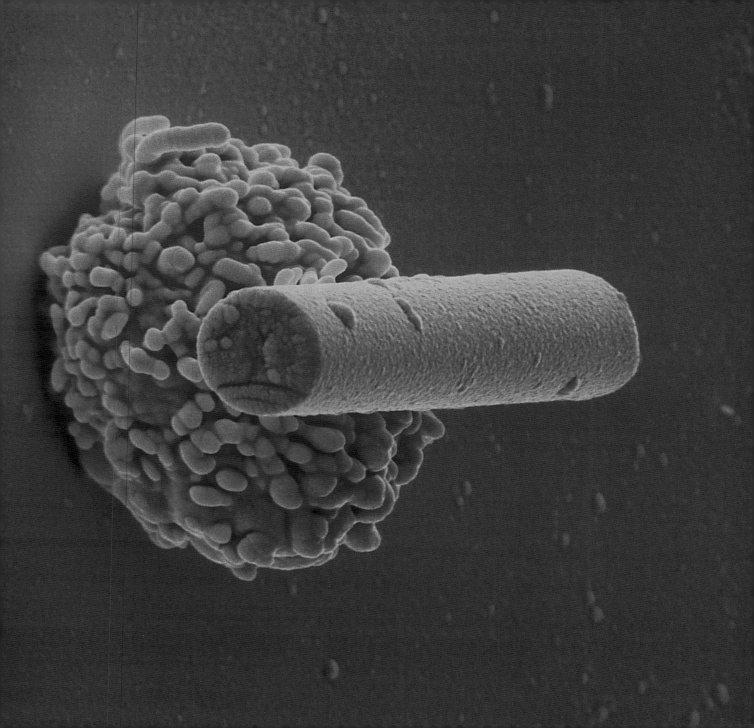

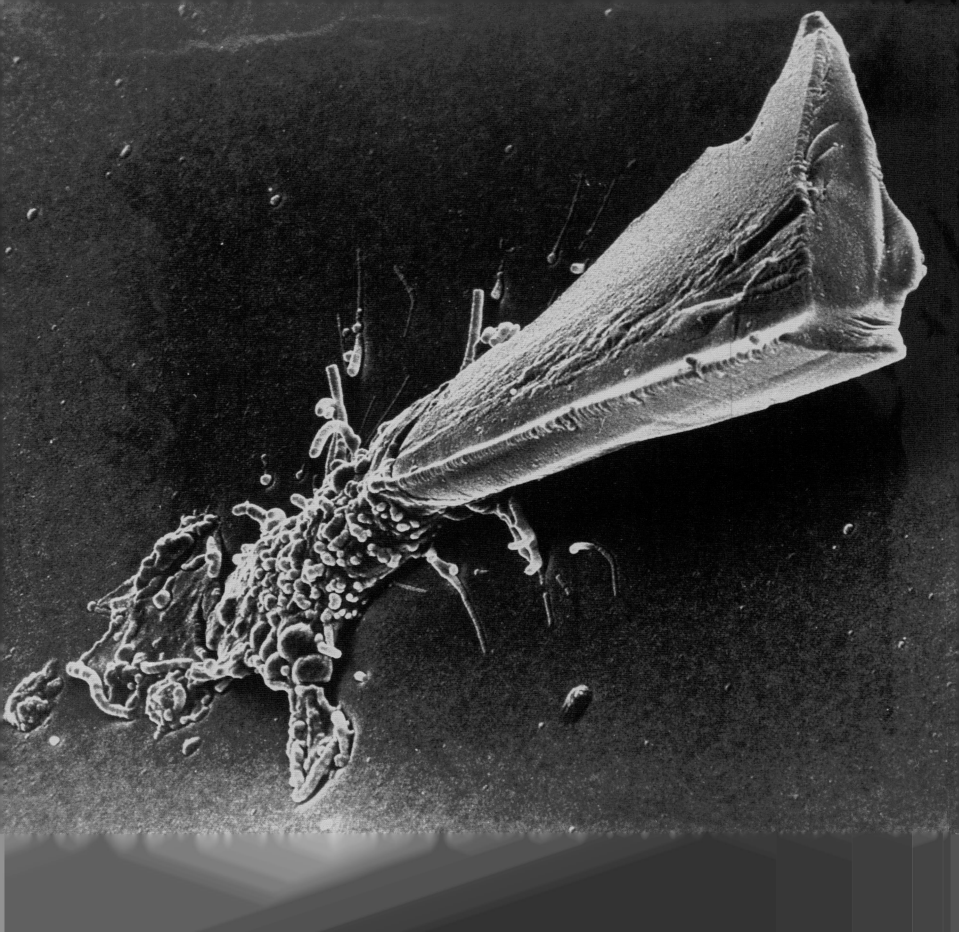

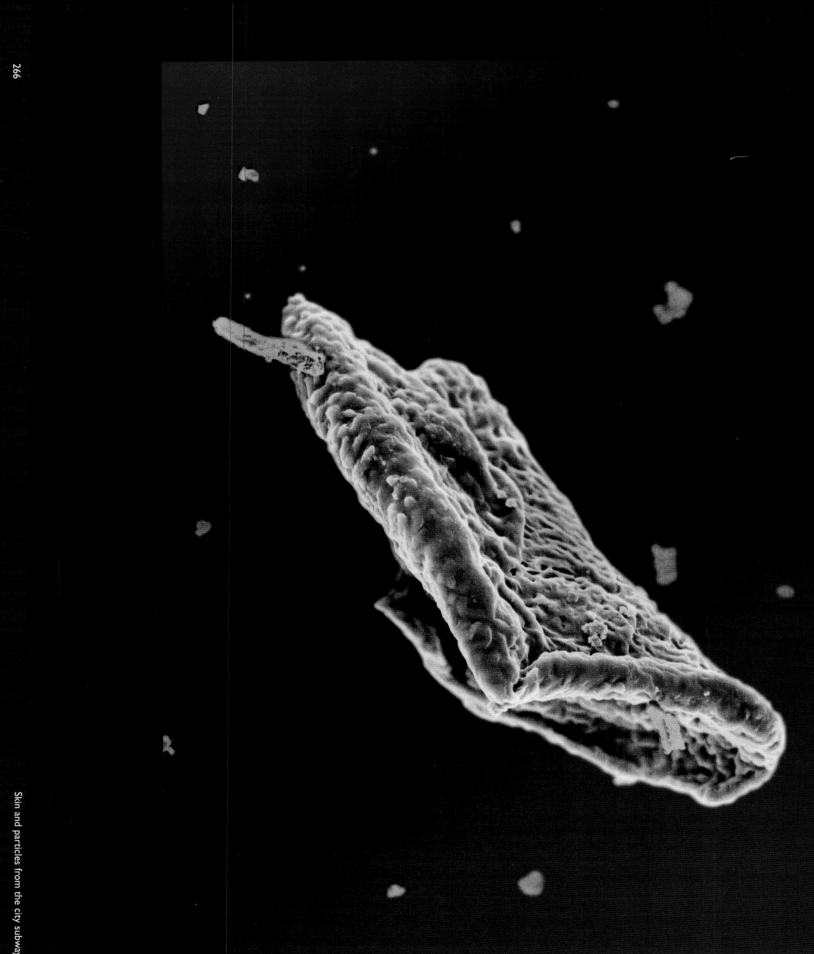

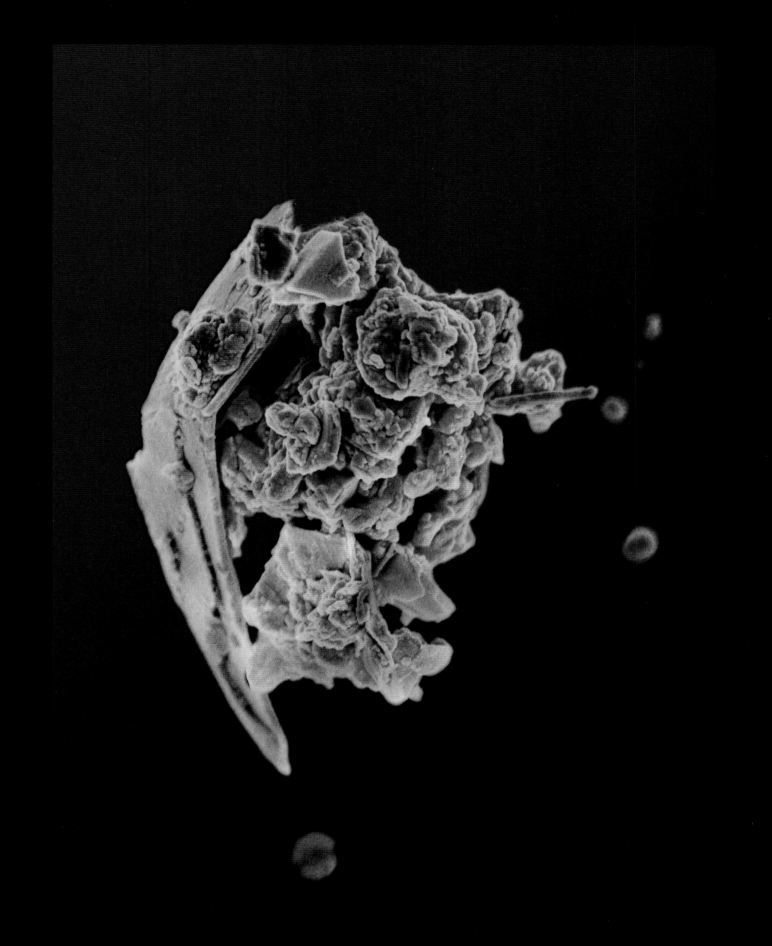

VIRUSES

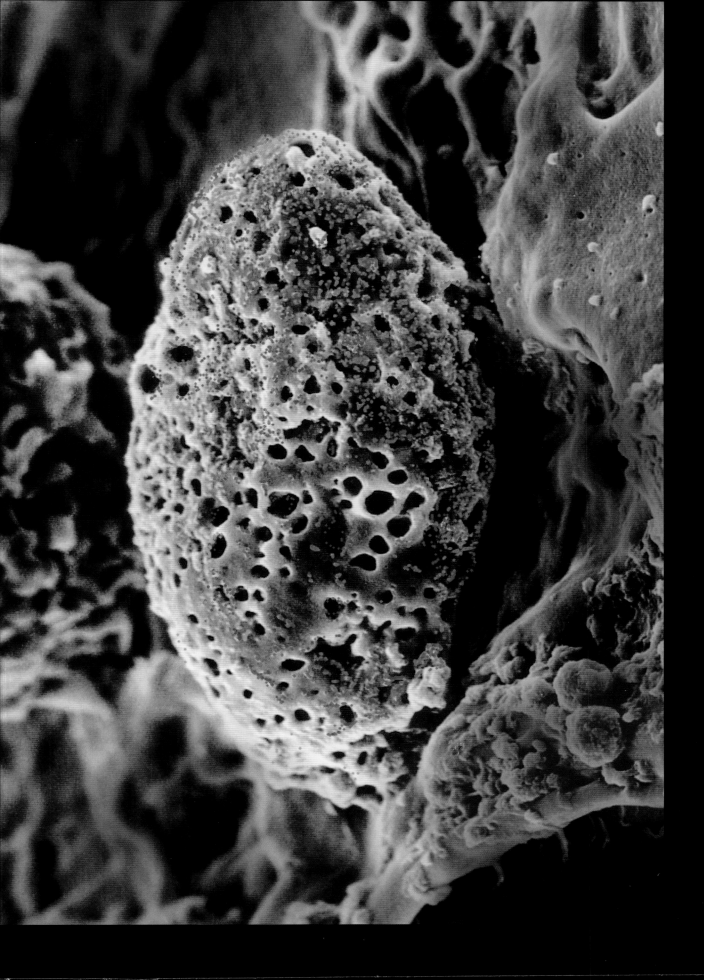

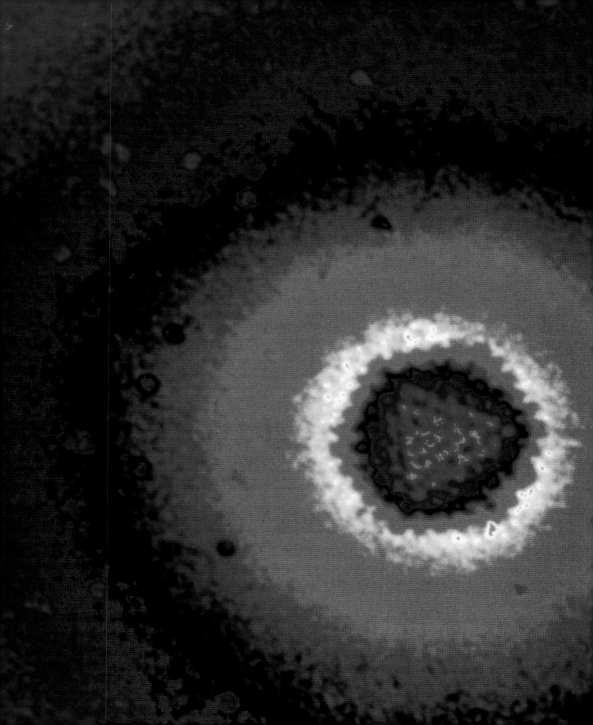

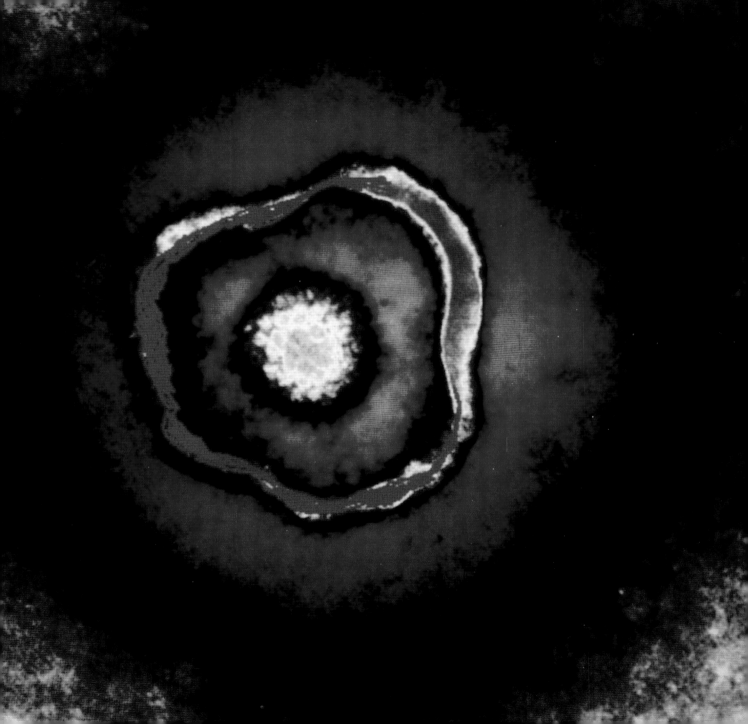

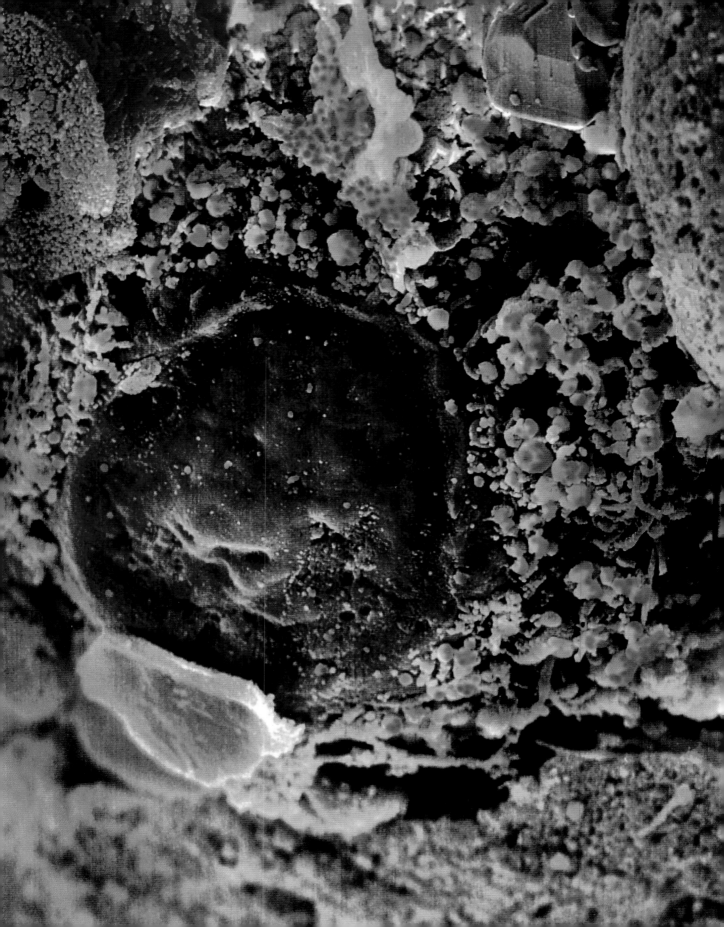

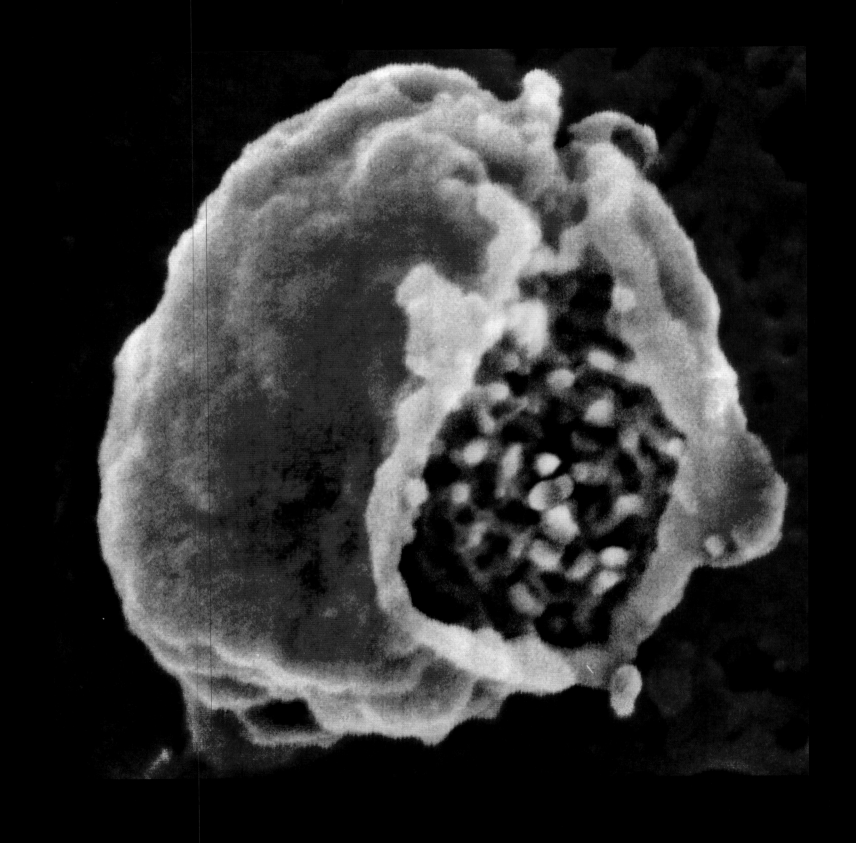

The poxvirus cell emits its contents

Poxvirus emerging from the cell (opposite)

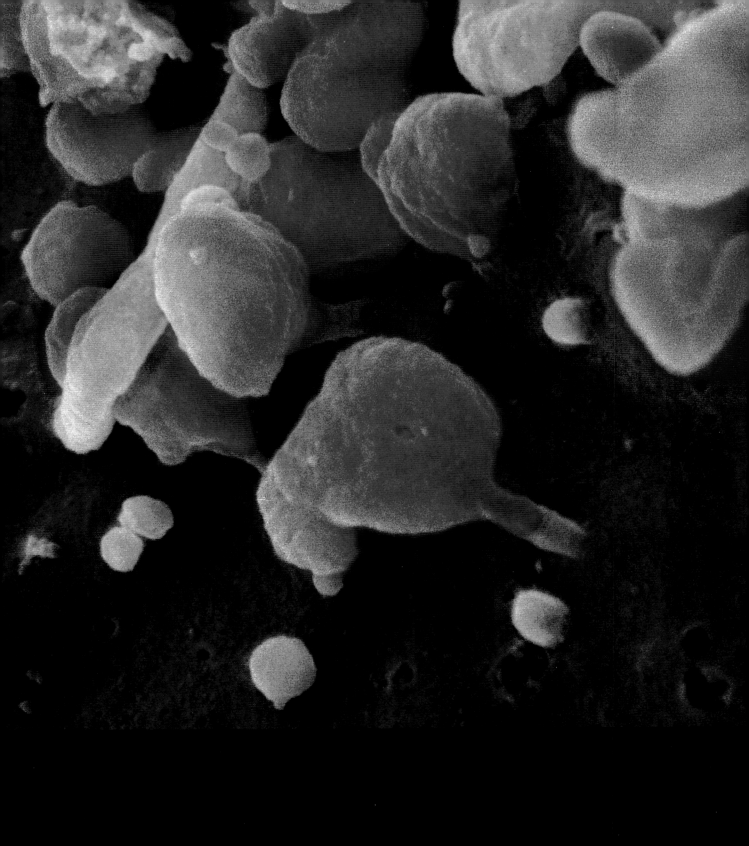

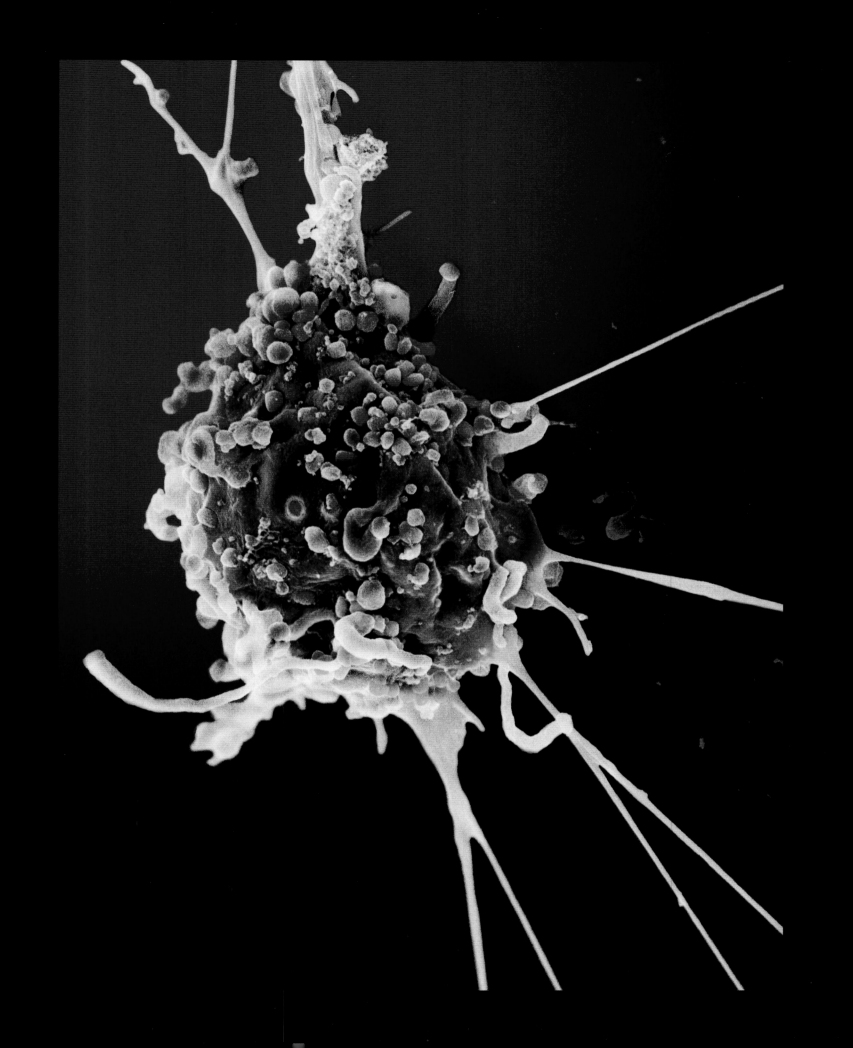

HIV virus spreading over a white blood cell

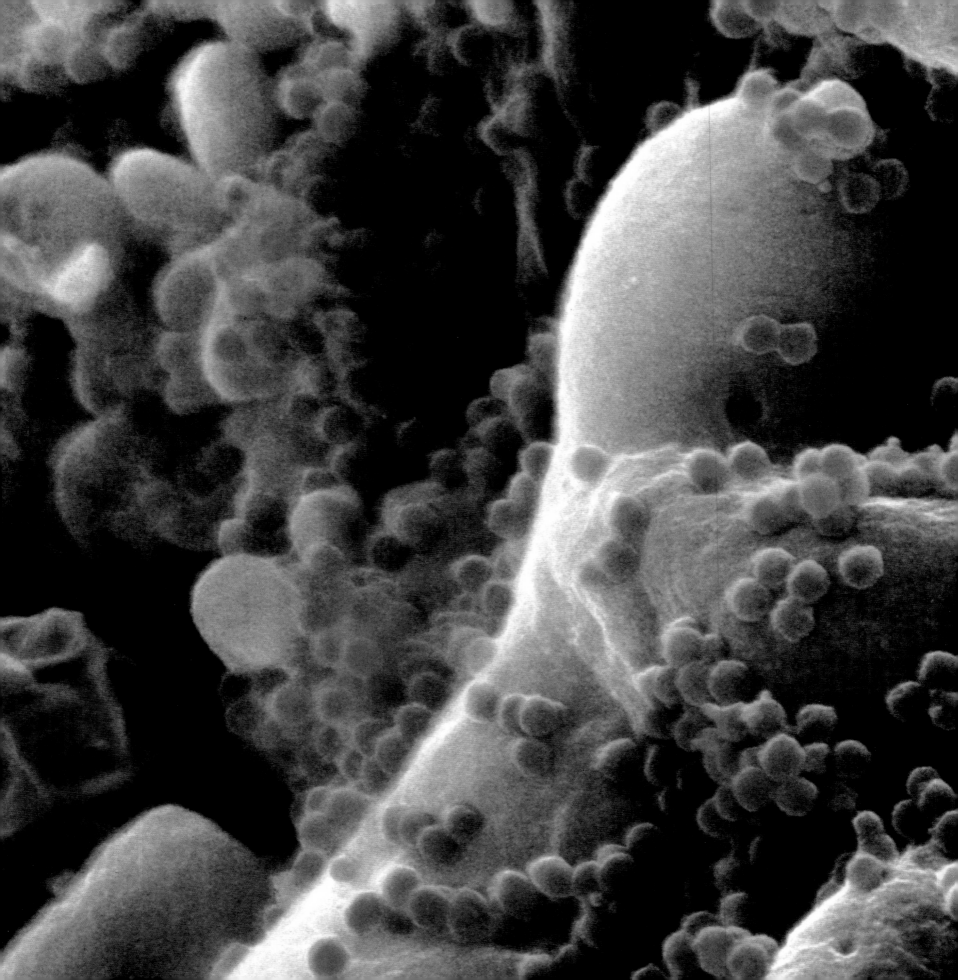

HIV virus on the surface of a white blood cell

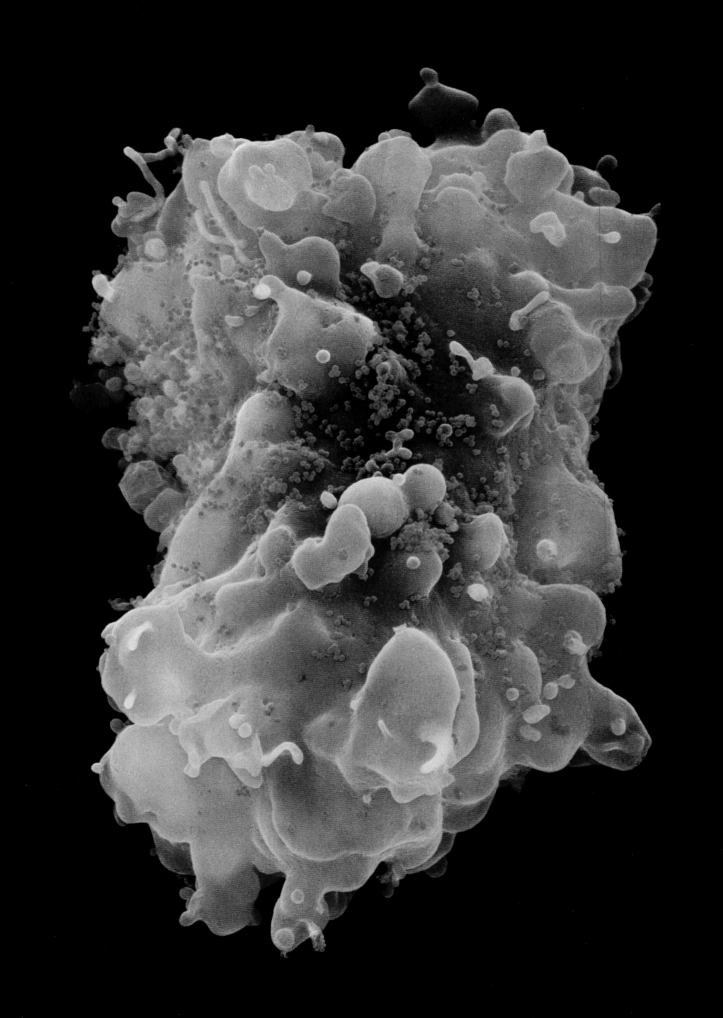

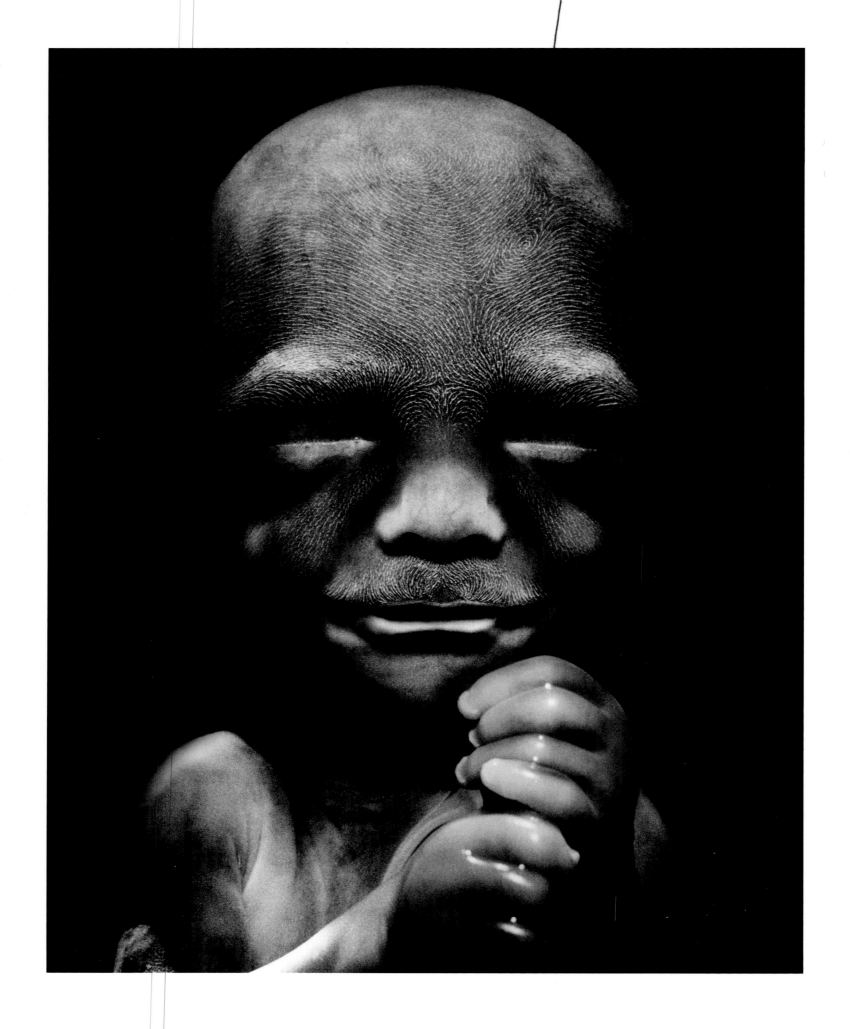

LENNART NILSSON AND PHOTOGRAPHY

Lennart Nilsson occupies a unique position in the history of photography. He began his career as a photojournalist, adapted his work with technical virtuosity to the discipline of scientific research, and applied his aesthetics with the sensibility of an artist. As a photojournalist, he thinks in terms of narratives. As a technician, he can operate with immense precision, and as an artist, he colors previously invisible worlds with his own sense of visual drama.

He was born in Strängnäs, sixty miles south of Stockholm, in 1922. His father, a keen landscape photographer, gave him his first camera at the age of eleven and built him his first enlarger. He published a number of photo-stories in Swedish magazines in the forties, one of which resulted in an eight-part serial about the Belgian Congo. The subjects of his stories included the traveling salesman, the postman, and, most famously, a traveling midwife in a remote region of northern Lapland. The midwife's story appeared in 1945, preceding Eugene Smith's famous story "Nurse Midwife," published in *Life* in 1951. Nilsson drew inspiration from the photography he was seeing in *Life* and *Fortune* magazines. His story on a Norwegian polar bear hunt, published in *Life* in 1947, created an outcry in America. On assignment to photograph Dag Hammarskjöld's arrival in New York as UN Secretary General in 1953, he took with him his first photographs of the human embryo, which stunned his colleagues at *Life* magazine, who commissioned him to photograph embryonic development. It was a story that took him eleven years to complete. In 1954 he revealed the unexplored insect world of ants in another groundbreaking photo-essay. His work was included in "The Family of Man" exhibition at The Museum of Modern Art in New York in 1955.

Nilsson taught himself everything he could discover about the human fetus. In order to show fetal development from the earliest stage he used macro-lenses and super wide-angled endoscopic lenses made for him by Karl Storz in Germany and Jungners Optiska in Sweden. In addition to his work using Hasselblad and Nikon cameras to photograph extra-uterine pregnancies, he used the endoscope to photograph the living fetus in the amniotic sac. The flexible endoscope, introduced into the body like a catheter, is no larger than eight-tenths of a millimeter in diameter including lens and case. It has a focal length of less than one-tenth of a millimeter and its precision and tiny dimensions enabled Nilsson to produce his classic embryonic studies.

The publication in 1965 of Nilsson's cover story for *Life*, "The Drama of Life before Birth," was a landmark. His views of prenatal life were awesome in their beauty. That issue of the magazine sold eight million copies in a few days. The impact of the pictures was only matched by the imagery of the first moon landing four years later. His book, *A Child is Born*, followed shortly after and became a classic illustrated account of human conception and birth, selling tens of millions of copies worldwide.

Nilsson had a contract with *Life* for the following seven years and produced stories on the heart and heart attacks, the microscopic view inside the body, and the brain. His experiments with photography and light microscopy were succeeded by his use of the scanning electron microscope, which provided not only magnification of hundreds of thousands of times, but also a sharp three-dimensionality. He could photograph the earliest stages of development in unprecedented detail and he could begin to enter the cellular world. The photographs from the scanning electron microscope are in black and white. In order to make them more legible he has collaborated with Gillis Häägg to translate the gray scale into full color, which provides Nilsson's photographs with their own particular color identity. Some of the most recent color has been applied digitally and is conspicuously different.

The introduction of ultrasound technology has enabled Nilsson to work from outside the body to reveal three-dimensional images of the features within. This is the technique for future embryological study, but such photographs are not included here. Nilsson's most important work now involves a new scanning electron microscope installed at the Karolinska Institute in Stockholm. The new frontier is the cell itself, and his intention is to photograph within it. The evidence of internal cellular architecture will be the next landmark in human knowledge.

Nilsson has established an international reputation for his films on the human body, for which he has received an Emmy award three times. He has also directed his attention to the animals and evolution, and to plants and insects. In that sense, he is one of the great travelers to unknown worlds. His mission is to make the invisible visible.

MARK HOLBORN

The first portrait of a fetus by Lennart Nilsson,
16 weeks old, specimen from ectopic pregnancy, 1958

LENNART AND LEONARDO

The feeling of being alive is created through signals that our sensory organs communicate to our inner self, the brain. Personalities and lives are shaped by imagery, which is the form in which the eye sees these signals, along with other sense impressions, and by the brain's conversion of experienced reality into lifelong memories. Although we are imprisoned in our bodies, life is experienced both externally and internally.

The mysterious, complex, and beautiful human body has obsessed artists throughout history. Leonardo da Vinci (1452–1519) was the first, however, to make it both a subject for his painting and an object of scientific enquiry. By understanding the functions of its separate parts, he believed he could discover the harmony between them that enabled the body to operate as a living machine. In *Divina Proportione* (1509), by the Renaissance mathematician Luca Pacioli, mathematical formulae describing ideal proportions found in nature and art were exemplified by Leonardo's illustrations of the human body. Though Leonardo's wonderful sketches are often anatomically correct and always immediately recognizable, at times they would have involved creative guesswork. Leonardo's tool in this pioneering exploration was his own eye with all its limitations. He lived at a time when only simple magnifying lenses could offer any enlargement and the rich microscopic world of the body was unimaginable to him. His was an age when the origins of infectious diseases were completely unknown and the subject of rich speculation. The presumption that bad air seeping from the swamps around Rome – *mal aria* – produced malaria had long been accepted as fact in Italy, causing the popes to move their residence to higher ground in summer. Bizarre doctors' uniforms, reminiscent of the carnival masks of Venice, were used in times of pestilence. The long, narrow beaks of the bird's-head caps were thought to ward off infection. But without the ability to see and recognize the enemy, doctors were powerless.

Leonardo was strongly intrigued by conception – how new life was created – and he devoted great attention to depicting the fetus and the body in pregnancy. Here, too, the optics of the eye imposed limits; the sperm and eggs were invisible, and studies of the inside of the body could only be made through post-mortem examination. Even so, his drawings are among the most beautiful depictions of human reproduction ever made. Given his gifts and the conditions under which he was working, they were both subjective aesthetic expressions and, in anatomical terms, extraordinarily accurate documents.

In the twentieth century the technical capabilities of pictorial art were revolutionized. We can now observe details down to a thousandth of a millimeter. Medical technology has advanced to allow pictures from inside living people and has facilitated surgical operations in a way that only a few decades ago was judged beyond possibility. Our knowledge of the details of the human body has advanced in ever more intricate ways. We understand conception better because we can now study it at a cellular level and see an individual sperm's search for the female egg in the wash of human fluids. Our enemies – the parasites, bacteria, and, more recently, viruses – can now be captured and depicted, their faces uncovered, to improve our means of defeating them.

Leonardo da Vinci,
Coition of a Hemisected Man and Woman,
c. 1492–1493, pen and ink, 27.3 x 20.2cm,
The Royal Collection © 2005,
Her Majesty Queen Elizabeth II

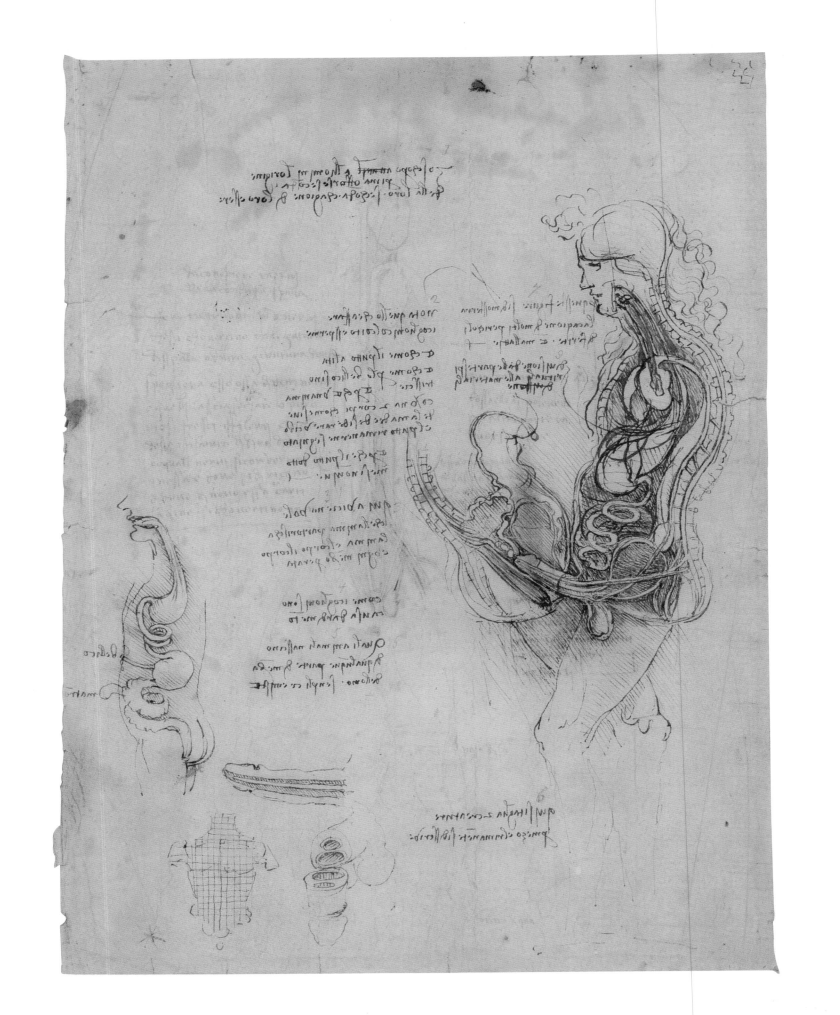

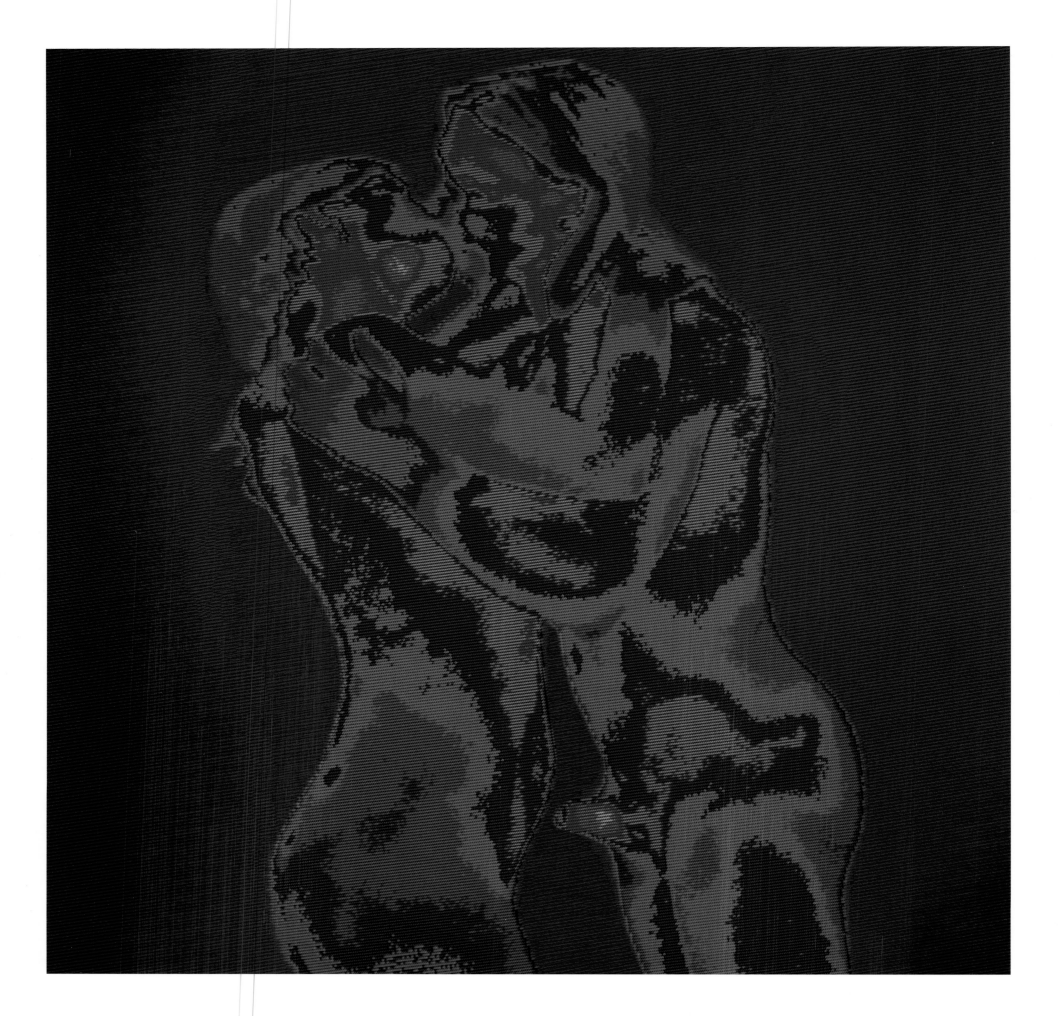

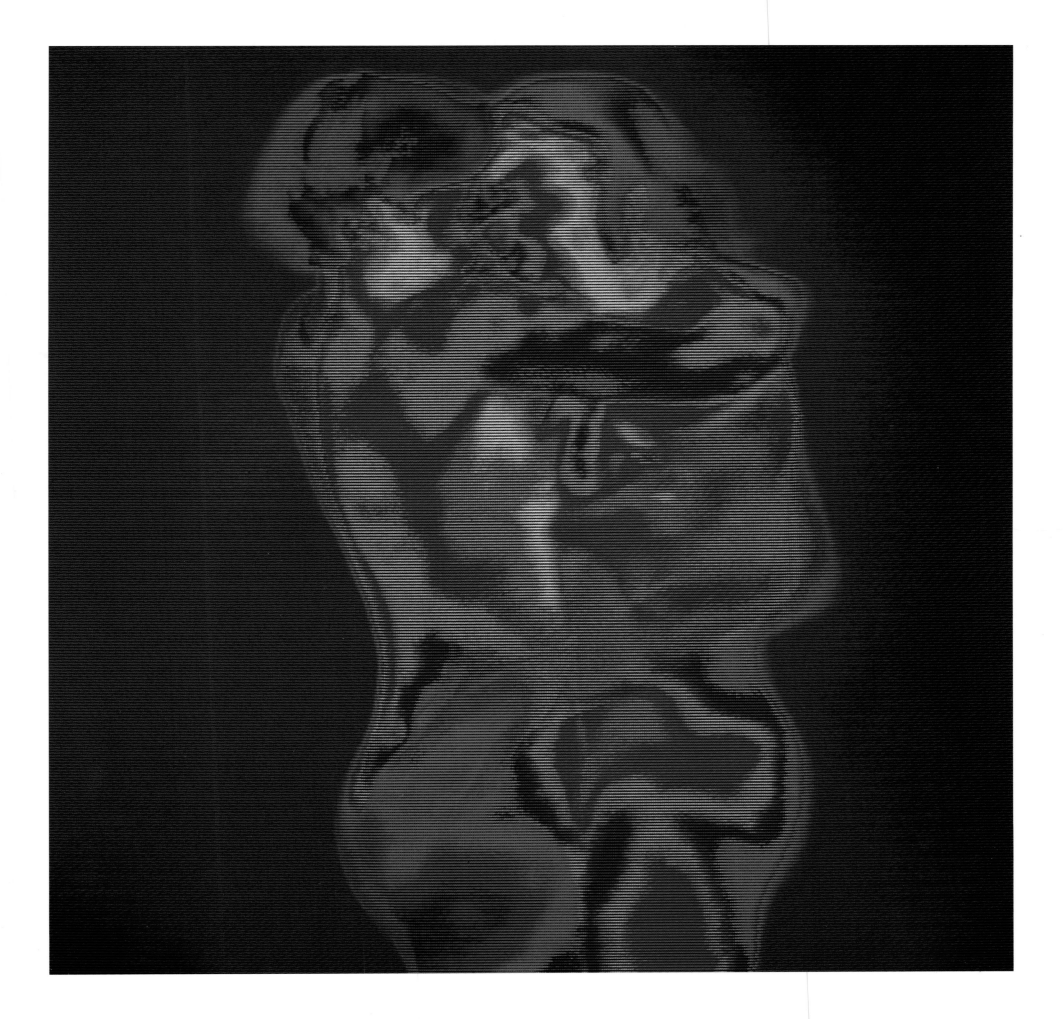

For more than forty years Lennart Nilsson has been Leonardo da Vinci's counterpart in his photographic portrayal of this huge field of study. Like Leonardo, Lennart has shown through his numerous series of pictures how the body's landscape develops and functions. Using the sophisticated technology of the camera lens and the microscope, Lennart, like Leonardo, makes pictures that are precise and yet fire the imagination. They are exact but at the same time oddly personal and recognizable as Lennart's. Over the four decades of his search for an internal aesthetic within the body, he has always been at the frontier of technical research in medicine and at the forefront of photographic technology. His aestheticism is coupled with an incredible work capacity and a resilience that allows him, for example, to sit for twenty-four hours in a tent in freezing temperatures and high humidity to film living cells. The results include classic pictures, especially those of the origins of life or the emergence of the new being. In recent years, his attention has been drawn to making visionary pictures of the body's immune defenses and its bitter enemies: cancer and the new viruses. This book may be seen as an art publication derived from the beauty of the human body, but it is also scientifically accurate and relevant to the study of medicine.

The book begins with the searching eye, that biological and emotional camera so important for our contact with life around us. The eye's rear surface, the retina, is in fact part of the brain. "The mirror of the soul" is a fitting description of the eye as an organ that reflects feelings and reacts to both danger and beauty. The size of the eye's pupil increases on observing pleasing objects; belladonna was originally used by Italian women to enlarge their pupils and so become more appealing — we like people with large pupils because it appears as though they find us attractive. Friendship and love arise, kisses are exchanged; longing and the urge to create new life are indispensable aspects of life. Hormones, both male and female, stimulate our sexual drive and activate various areas of the brain. Male and female scents collaborate to heighten that drive to kiss, touch, and conceive.

Darwin's theory of natural selection is immediately understandable when we grasp the fact that only one of the millions of sperm swimming toward the egg actually succeeds in its mission. When the sperm establishes contact and bores into the egg cell, the walls close around it. The late-arrivers are regarded as intruders and repulsed. Sperm are genetic messengers seeking to link the genetic heritage from the DNA in the chromosomes of the father with the egg's maternal genetic make-up. A total of forty-six chromosomes in the form of thin DNA threads contain all the information necessary to make a new human being, coded in sequences of different combinations of four molecules known as nucleotides. The DNA threads in the chromosomes within the nucleus of a single cell, if joined, would reach a length of nearly two meters. The human body houses a vast number of cells – approximately 10,000,000,000,000. If all the DNA threads from an adult person's body were laid end-to-end, they would reach to the sun and back many times. The length or volume of information used to create a single person has astronomic dimensions.

After that single sperm enters and fertilizes the egg in the first step in the creation of a life, the egg floats down the Fallopian tube and attaches itself to the wall of the uterus. In Lennart's pictures, we can see the human embryo begin to develop, the various organs take shape, and the little fishlike fetus grow to assume the appearance of a baby. The eyes develop; the fetus begins to hear, see, and suck its thumb. From being entirely dependent on the mother, the fetus starts to prepare for its liberation; heart, lungs, kidneys, the brain, and other organs grow and mature, becoming increasingly ready for the great leap of birth.

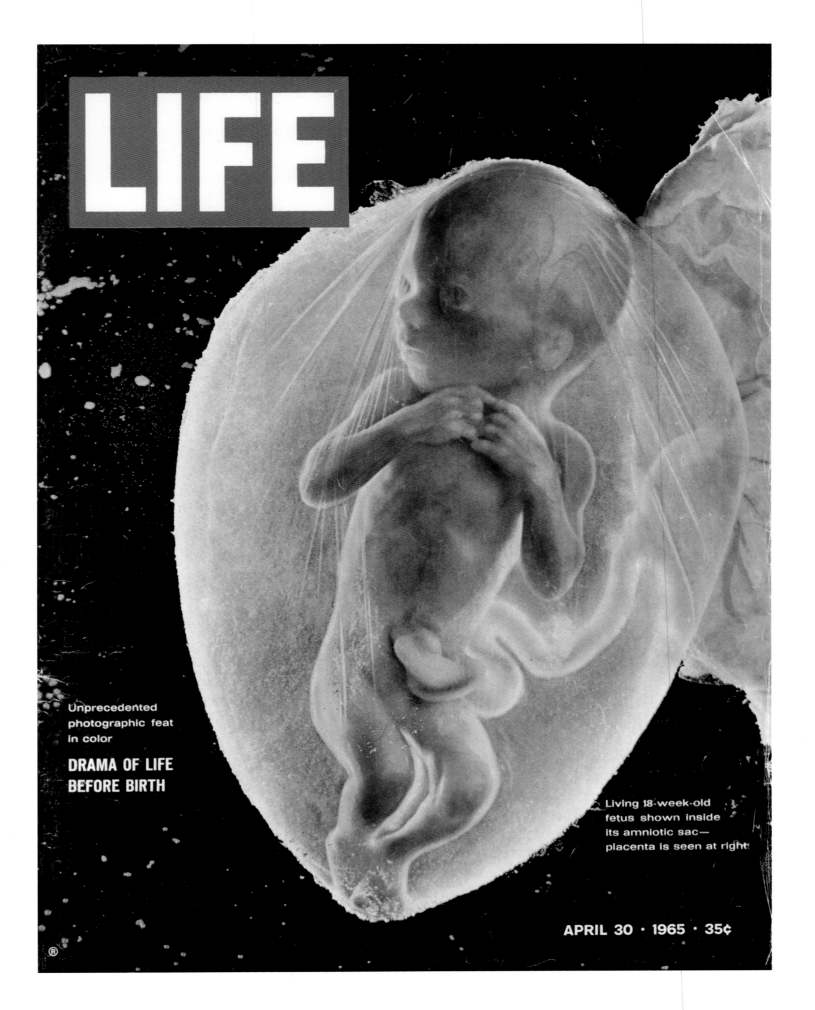

LIFE

Unprecedented photographic feat in color

DRAMA OF LIFE BEFORE BIRTH

Living 18-week-old fetus shown inside its amniotic sac— placenta is seen at right

APRIL 30 · 1965 · 35¢

A miraculous machine is assembled, in which complicated chemical and physiological processes happen automatically, so that many future injuries will repair themselves and large portions of the body will be renewed during its lifetime. Like all known living organisms, it contains information that creates auto-assembled, auto-maintaining, and auto-repairing systems. Nobody has so faithfully and beautifully revealed the development of the fetus of the human infant as Lennart Nilsson.

Birth takes place and the heart starts pumping blood that carries oxygen from the lungs, which have been expanded by their first breath, to the body. Through the creation of small pulmonary alveoli during fetal development, the lungs' contact surface with the air dramatically increases to a total surface equivalent almost to the area of a tennis court. The lungs absorb the vital oxygen from the air and expel the anaes-thetizing carbon dioxide that builds up inside the body. Blood forms principally in the bone marrow, where from then on many millions of cells will form every single minute of a lifetime. The blood cells are created from less mature cells called stem cells. Different types of stem cells are found in most human organs and in the bone marrow. The great liver, the body's chemical factory, starts up. Food molecules are broken down by enzymes in the intestines, to be transported by the blood to the liver, where they become fuel for bodily functions and building blocks for bodily renewal or growth. The liver is also the major organ for the elimina-tion of poisons from the body. Via the kidneys' sophisticated canal system, the body can regulate its salt and water balance, filtering out excess liquids and retrieving valuable salts. By cooperating with the brain, the kidneys ensure that the body is neither saturated nor dehydrated. Only a portion of the liquid filtered through the kidneys exits the body as urine, via a passage to the reservoir of the bladder. Like the liver, the kidneys also detoxify, filtering away the poisonous substances that have found their way into the body.

The hub of the body is the central nervous system. The brain, "the seat of the soul," is continuously bombarded with signals from the outside world. The brain is the organ with the cell content that remains most stable over the course of a lifetime. In some parts of the brain, new cells are to a certain extent formed from stem cells, while in other parts, such as the small brain, the cerebellum, virtually no new cells are created after birth. Functions in the brain mature mostly through an increase in the density of connections between existing brain cells, rather than through the production of new cells. Tactile organs in the skin react to touch and guide the body functions through the brain's signal system to meet any needs that arise. Picking fragile raspberries, for example, would demand a completely different touch from catching a baseball.

Our olfactory organs are much more sophisticated than we might expect; a surprisingly large number of our genes go into creating a well-functioning olfactory system. It seems that we are neither as logical nor as rational as we might believe. Our individual scent reflects the genes we carry. Our olfactory receptors sense an especially pleasing smell from another individual if they fit well with our own set of genes, especially, say, if the combination indicates that pairing with that individual will produce children with strong immune systems. Smell is also extremely important for a smoothly functioning life. It assists our search for food and avoidance of danger. The taste of what we eat is continually analyzed and the memory of what we find good or repul-sive is firmly etched into our brain by signals from the taste organs.

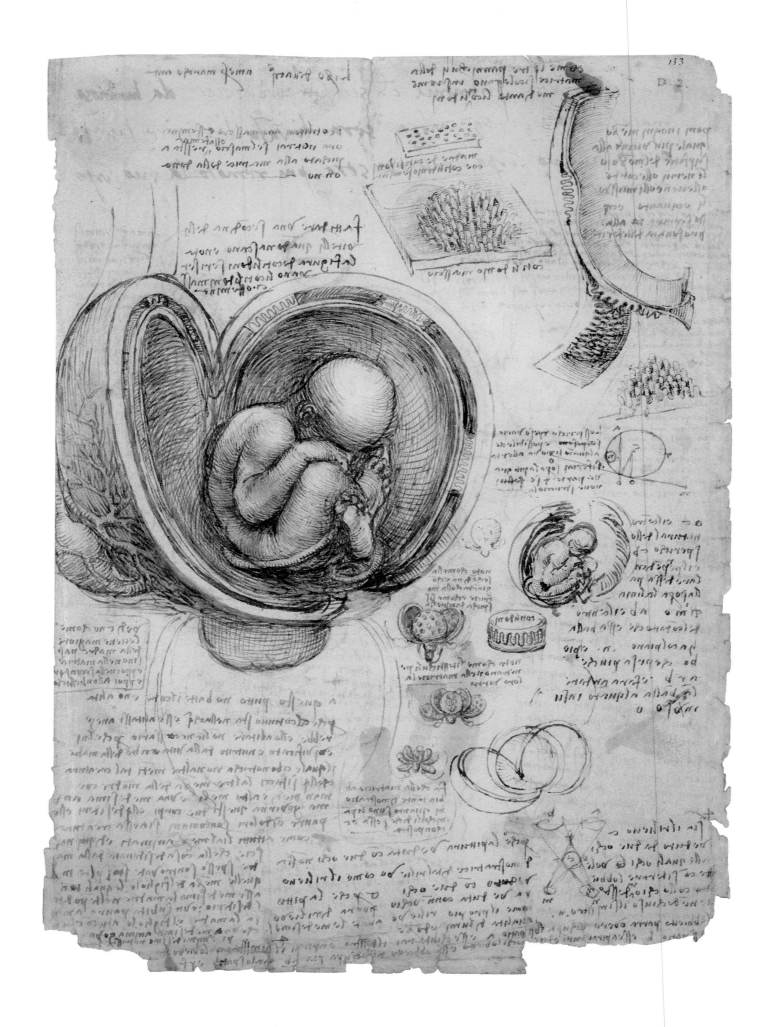

To monitor reality via the brain, the eye moves in both large and extremely small increments. The small movements on the retina allow the eye to sense the structure of an observed surface in much the same way as a hand. In tests where the eye's ability to move is blocked, the subject can no longer see the difference between an orange and an orange-colored tennis ball. When movement is no longer restrained, the subject will immediately see the difference. The central importance in our lives of sight, hearing, and balance is proved by the way these senses work as part of the brain within the physical protection of the skull. Each of us suffers through the deterioration of balance, hearing, sight, taste, and smell as we age. The entire complicated web of organ systems is hung on a supporting structure, the skeleton, to which are attached muscles guided by nerve signals to create a properly functioning mobile system.

This wonderful organism has a limited lifetime, probably at most slightly over a hundred years. Attacks can come from within the body in the shape of the genetically transforming, asocial cancer cells. They can come from outside as infections from bacteria, parasites, or viruses, or through inhalation of harmful particles from the atmosphere. The body's sophisticated immune system has a number of defenses against these incursions. Few know that in the intestines, which normally host large volumes of bacteria, human cells produce antibiotics to target various disease-producing bacteria. A newborn baby's skin is covered at birth by a layer of white fat filled with these antibiotics. The immune system, alongside the brain, is alone in being able to create a lifelong memory of an incident. In the case of the immune system, these incidents would be infections: the body's memory of the infection is the basis for vaccination. Cells with the capacity to destroy cancer cells or virus-infected cells can be mobilized to eliminate enemies with killing mechanisms – a kiss of death. Other more primitive cells have a gargantuan ability to attack enemies far larger than themselves, enfold them, and simply engulf the enemy. The medical name for these cells is fitting: macrophages – the body's internal gourmands.

Regardless of the immune system's fascinating arsenal and despite the progress made by the pharmaceuticals industry, the threat against us from grave infectious diseases is growing. AIDS is now causing one of the worst epidemics in history. Around one percent of the world's population is infected by HIV. The sheer size of the world's population means we have a growing and fertile nursery for such viruses. We can assume that AIDS is only a precursor to the global spread of other infectious diseases. Knowledge in the shape of images of the enemy is of the utmost value, for as the saying goes, seeing is believing. Viruses were Leonardo da Vinci's frightening, invisible enemies. Today, Lennart Nilsson's pictures provide true close-ups of the faces of these deadly foes. The photographs reveal their behavior – how the HIV virus kills the cells it infects; how the SARS virus acts; and the diverse, frightening, yet beautiful architecture of other viruses.

A unique combination of technical genius and an artistic spirit with an unfettered imagination are necessary to produce that special picture from the infinite possibilities the human body offers – that equivalent to a Kyoto stone garden or the Mona Lisa. Lennart Nilsson has this combination: an eye and a sense for what is beautiful, true, and remarkable; a pedant's need for precision and exactitude coupled with the curiosity of a child.

HANS WIGZELL

Fetus, 16–17 weeks old,
ectopic pregnancy, 1958

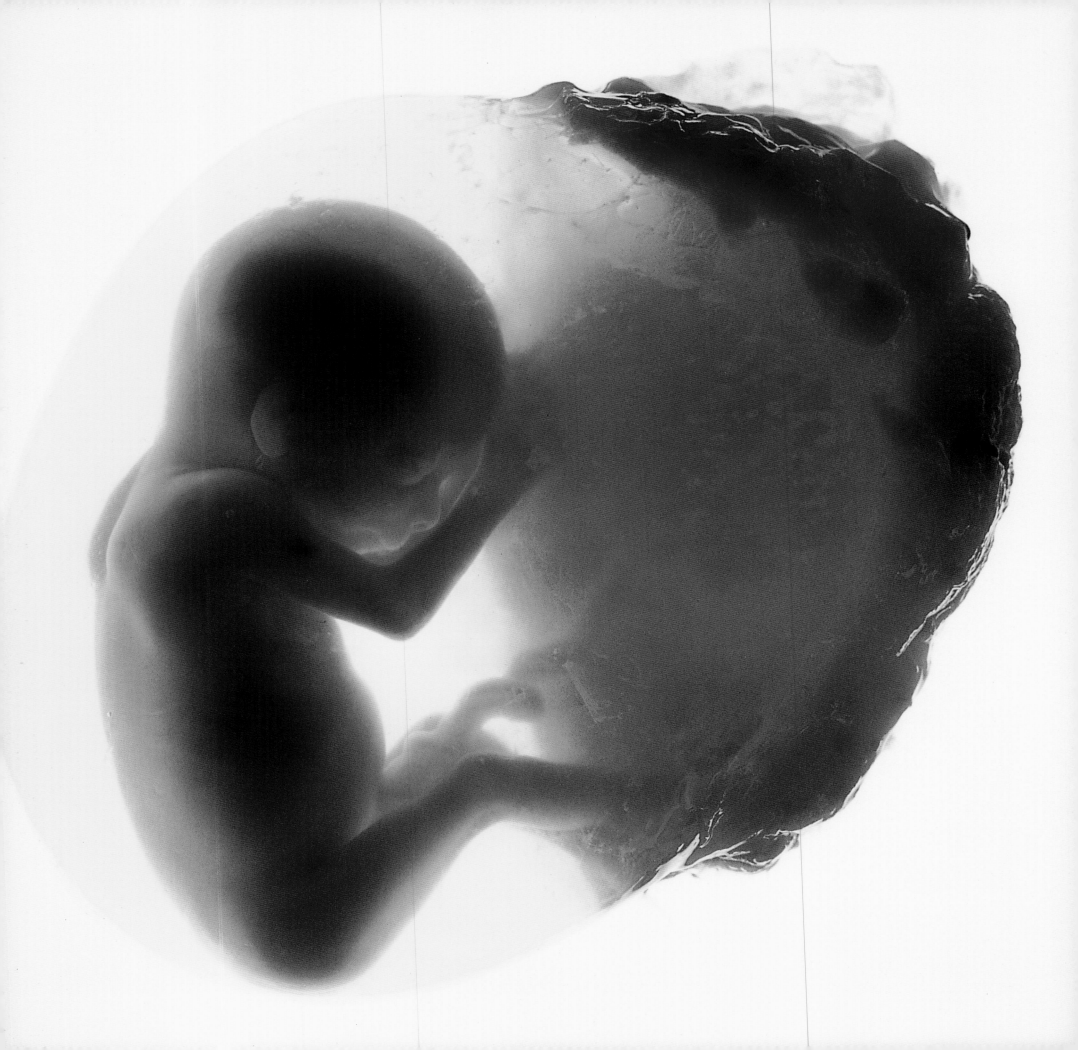

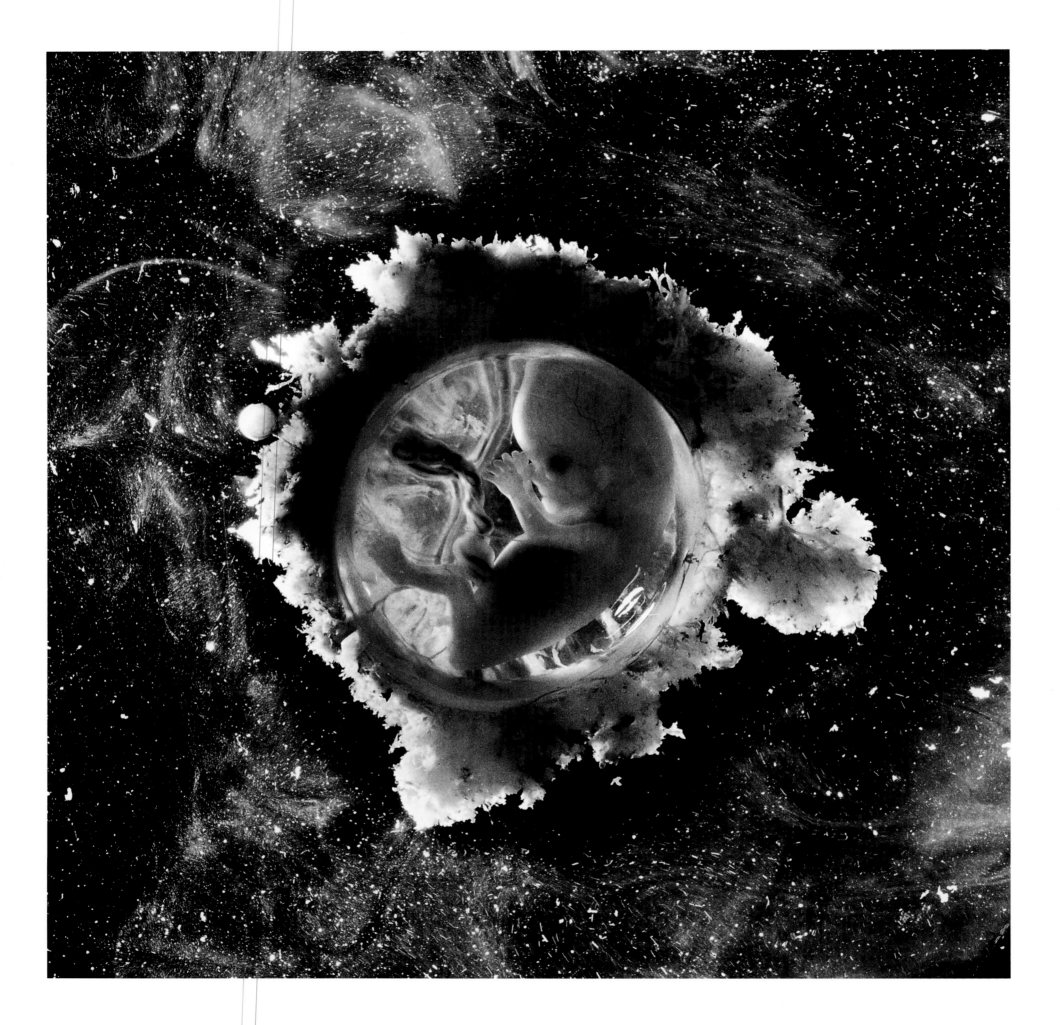

EDITOR'S ACKNOWLEDGMENTS

The genesis of this book was the publication in 1999, on the eve of the millennium, of Michael Light's book on the photographs from the NASA Apollo missions to the moon, *Full Moon*. The photographs formed a record of those manned flights into space and of the first landing on another planet – the greatest human journey. Shortly after its publication, Jeppe Wikström of the Swedish publishing company Max Ström suggested that the only parallel journey would be Lennart Nilsson's of the human sperm into inner space on its path to fertilizing the egg, with the subsequent development of the human embryo and fetus: one defines how far we have gone, the other, who we are; one takes us out into space, the other takes us to our own inner space. This was a subject that Lennart had photographed in Stockholm since the early sixties (the NASA spacecraft Voyager I and Voyager II carried his photographs of the human fetus on their missions to Jupiter, Saturn, Uranus, and beyond a decade later). For many years he had been working at the Karolinska Institute in Stockholm, one of the most important centers for medical research in the world, so I went to Stockholm to suggest that we might be able to collaborate with him on a new book. This book would not have been possible without the enormous contribution made by Jeppe Wikström and Max Ström in enabling such an ambitious project to take shape, and we are indebted to Michael Light for providing us with such a constantly inspiring model as *Full Moon*.

At a later meeting with Lennart in Stockholm, when he excitedly produced his recent photographs of atmospheric particles, I saw examples of organic molecules captured in the atmosphere fifteen kilometers above the Indian Ocean. I then saw his new photographs of the hatching of viruses. It became clear that in a true account of Lennart's work on human life, birth would not be the conclusion but the center of a photographic sequence. Lennart's photographs of the viruses are highly important resources for our understanding of one of the greatest threats we now face. The Karolinska Institute, where Lennart's microscopes are housed, is leading in the battle to understand this threat. I am hugely grateful to Hans Wigzell, the former President of the Institute, the Chief Scientific Adviser to the Swedish Government, and himself an expert on infection and immunity, for his wisdom and support in making Lennart's book.

I am grateful for all the kindness shown to me in Stockholm by Lennart's wife, Catharina. I am greatly indebted to Lennart for the generosity of his response and the freedom he has granted. Finally, none of this would have been possible without the organizational burden of managing Lennart's massive archive, which was achieved with such efficiency and grace by my collaborator on this venture, Anne Fjellström.

M H

"The Spaceman,"
a fetus 11 weeks old
and 6 cm in length, 1965

Lennart Nilsson, New York, 2004
Photographed by Irving Penn for the Swedish National Portrait Gallery

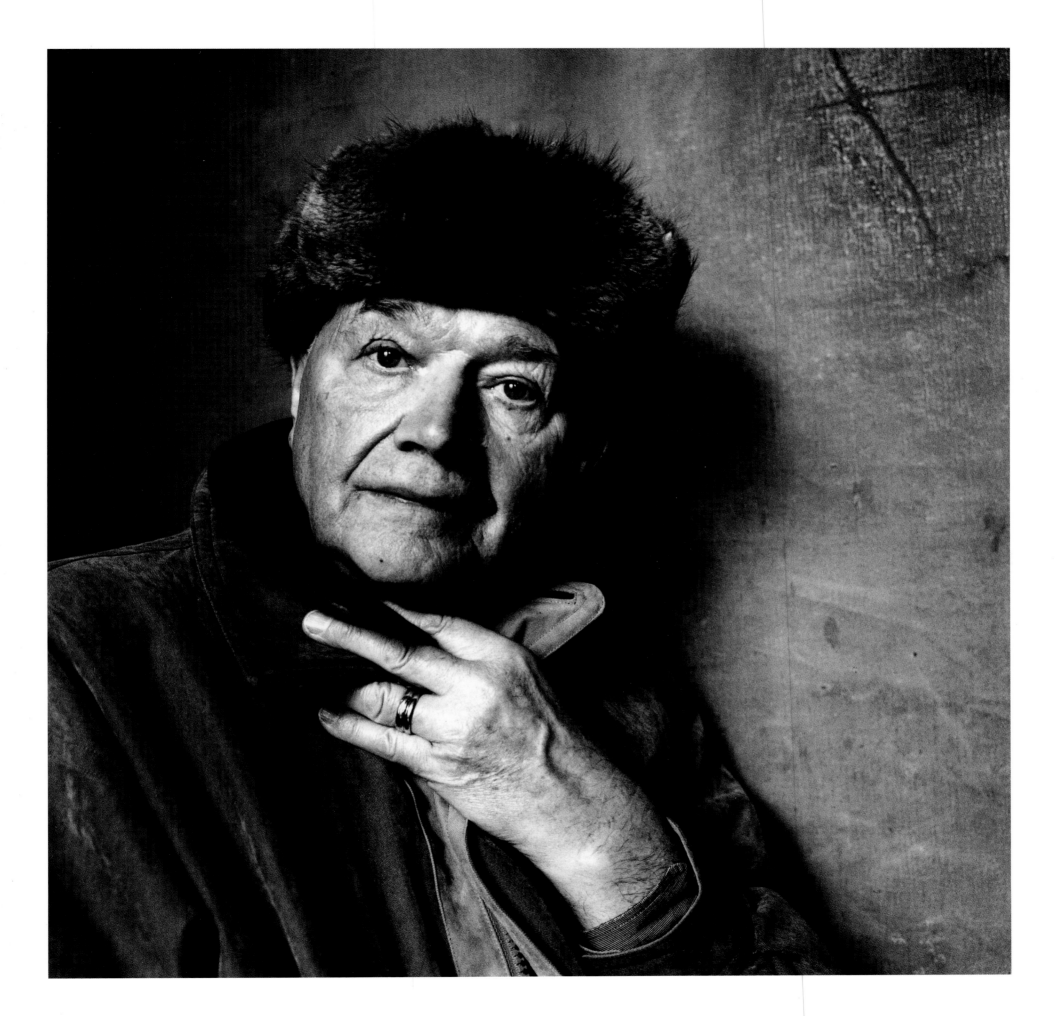

View from the back of the spinal cord
into the skull

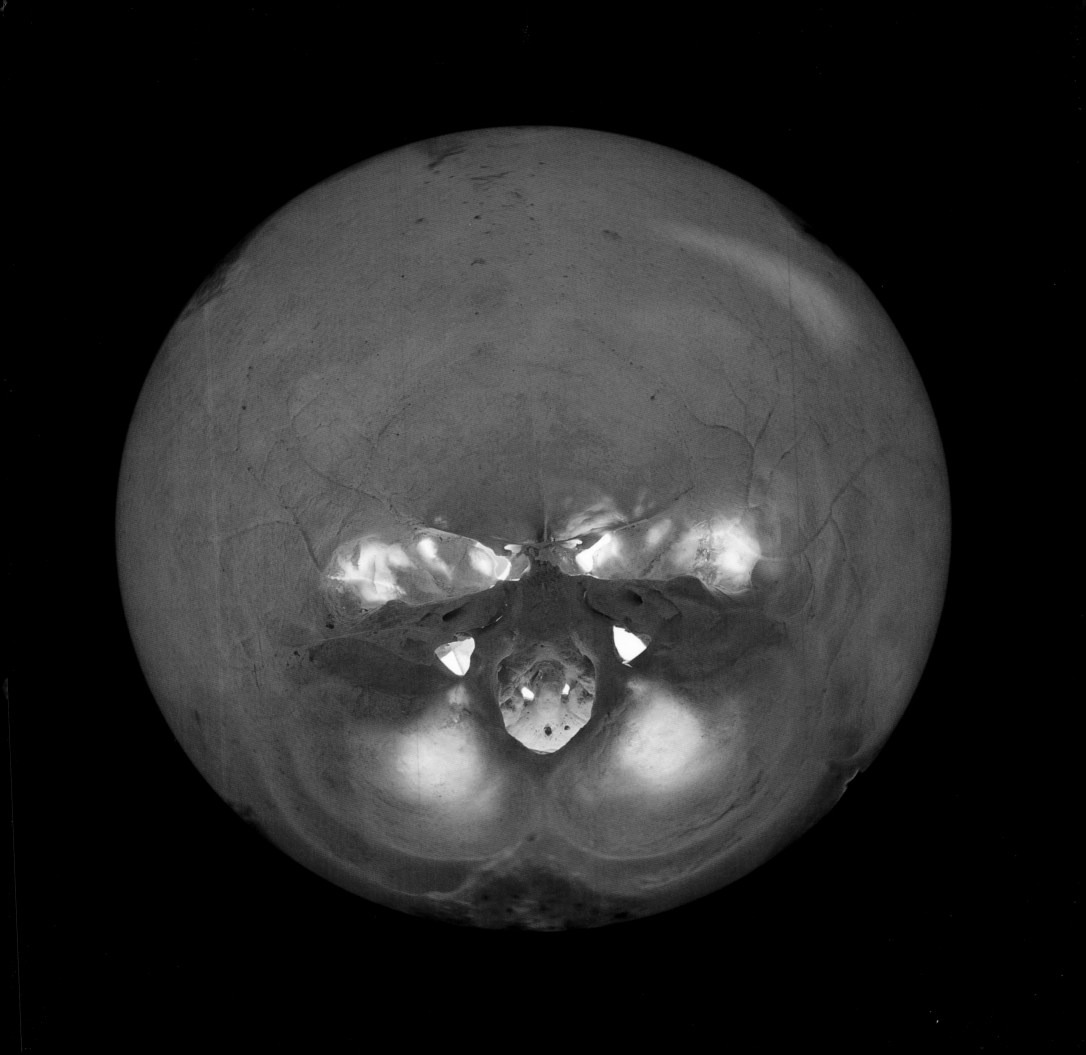

View from inside the eye of a specimen
to the outside world (following page)

Editor: Mark Holborn
Designers: Mark Holborn and Friederike Huber
Production Manager: Neil Bradford

Library of Congress Cataloging-in-Publication Data

Nilsson, Lennart, 1922-
Life / Lennart Nilsson.
p. cm.
Includes bibliographical references and index.
ISBN 0-8109-5842-2 (hardcover : alk. paper)
1. Medical photography. 2. Human anatomy—Pictorial works.
3. Human biology—Pictorial works. I. Title.
TR708.N55 2006
779'.9612—dc22

First published in Great Britain in 2006 by Jonathan Cape, Random House,
20 Vauxhall Bridge Road, London SW1V 2SA

Printed and bound in China
10 9 8 7 6 5 4 3 2 1

HNA ▌▌▌▌▌
harry n. abrams, inc.
a subsidiary of La Martinière Groupe
115 West 18th Street
New York, NY 10011
www.hnabooks.com

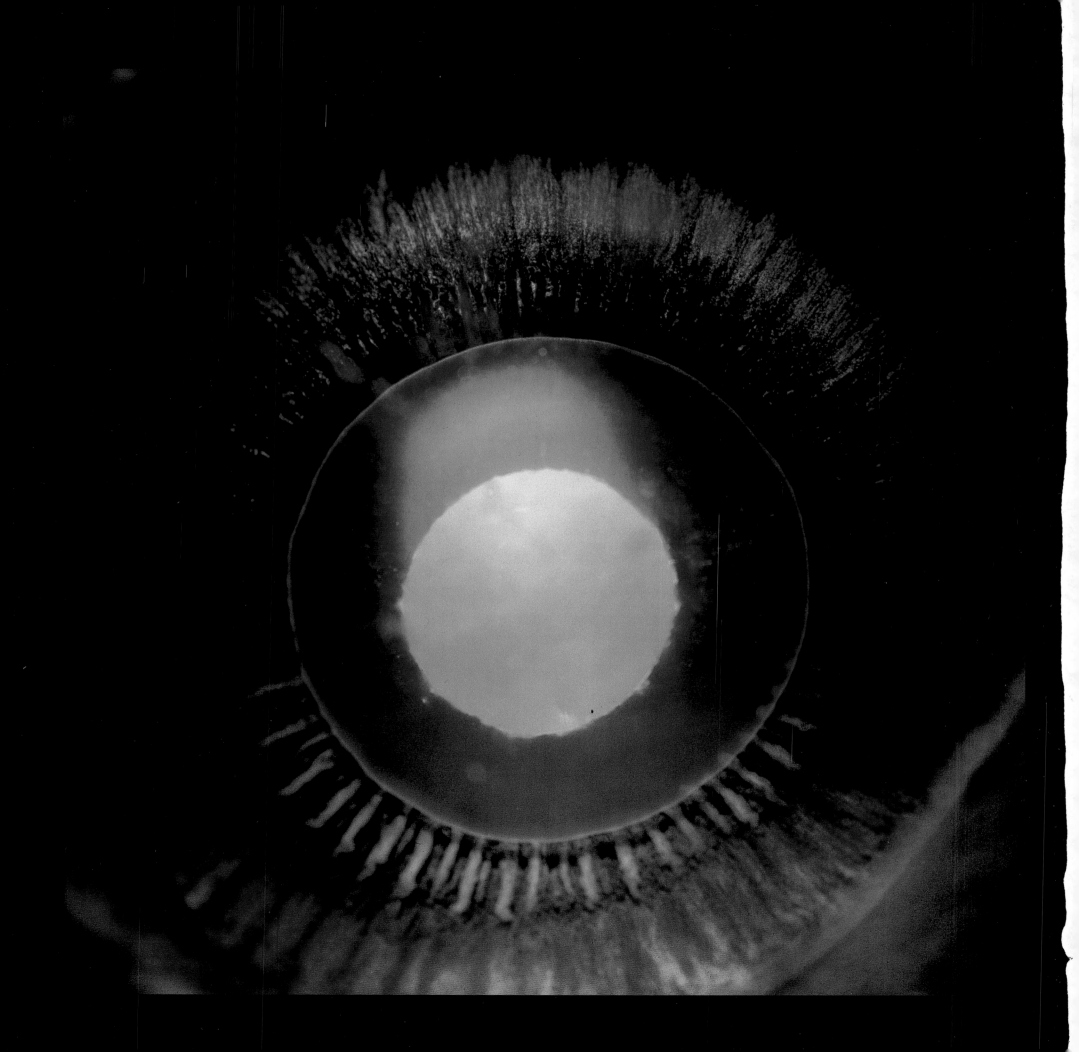